A SHORTER HISTORY OF GREEK ART

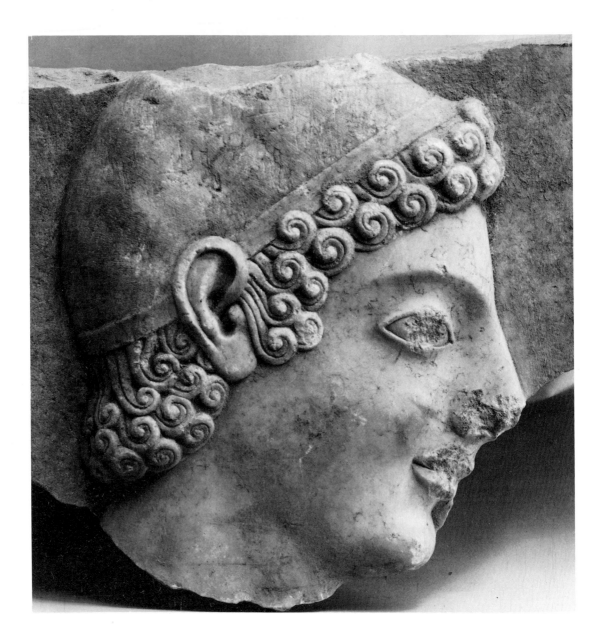

A SHORTER
HISTORY OF GREEK ART

MARTIN ROBERTSON

CAMBRIDGE UNIVERSITY PRESS

CAMBRIDGE
LONDON NEW YORK NEW ROCHELLE
MELBOURNE SYDNEY

Published by the Press Syndicate of the University of Cambridge
The Pitt Building, Trumpington Street, Cambridge CB2 1RP
32 East 57th Street, New York, NY 10022, USA
296 Beaconsfield Parade, Middle Park, Melbourne 3206, Australia

First published 1981

Printed in Great Britain by
Balding and Mansell, London and Wisbech

British Library Cataloguing in Publication Data
Robertson, Martin
A shorter history of Greek art.
1. Art, Greek
I. Title II. History of Greek art
709'.38 N5630 80-41026

ISBN 0 521 23629 0 hard covers
ISBN 0 521 28084 2 paperback

To the memory of
HUMFRY PAYNE
(1902–1936)
and
DIETER OHLY
(1911–1979)

CONTENTS

PREFACE

This is a shortened version of *A History of Greek Art* (Cambridge, 1975). Since it is less than a quarter the length the scope is very different, but I have tried to keep the character of a history rather than a handbook, though a history with far more stringently selective documentation.

The book is meant to be a more or less self-sufficient introduction to the subject. I therefore illustrate a high proportion of the objects I mention, and keep references as brief as possible. Supposing that those who want to carry study of the subject further will be able to get access to the big book, I refer primarily to that: by chapter, note and, if applicable, plate-number. Beyond these basic references I cite an illustration of anything I mention but do not illustrate either here or in the *History*. I also give some references to books which appeared too late for me to cite them there. I list in the bibliography here only works referred to in the notes and list of illustrations of this book, marking with an asterisk any that does not appear in the long bibliography, or the addenda to it.

Chapter divisions are as in the *History*, but sections within the chapters do not always correspond, and some matter has been shifted between chapters. I have therefore added in the notes, at the beginning of each section, references to the pages of the big book where the material is treated.

This book is dedicated to the memory of two great scholars who were my friends. Humfry Payne first fired me with a love for Greek art and its study, and I cannot dissociate him from my first falling in love with Greece itself. I do not know how I came to omit his name from the acknowledgement of my debts in the *History*. Dieter Ohly, my contemporary, I got to know and love much later, but from him too I learned a great deal.

Cambridge
December 1979

Martin Robertson

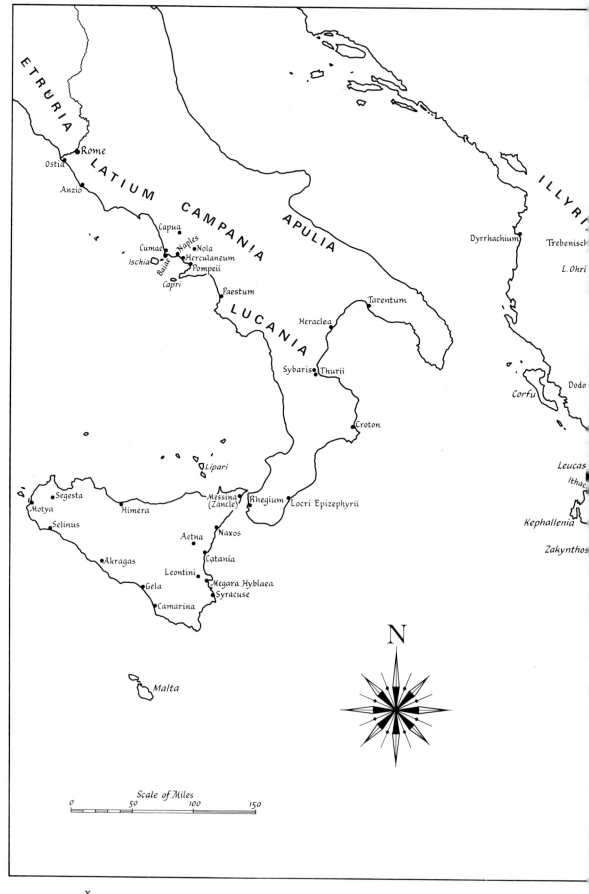

ETRURIA

LATIUM

CAMPANIA

APULIA

LUCANIA

ILLYRI

Rome

Ostia

Anzio

Capua

Cumae
Naples
Nola
Baiae
Herculaneum
Ischia
Pompeii
Capri

Paestum

Dyrrhachium
Trebenisch

L. Ohri

Tarentum

Heraclea

Sybaris
Thurii

Dodo

Corfu

Croton

Lipari

Leucas

Ithac

Segesta

Motya

Messina
(Zancle)
Rhegium
Locri Epizephyrii

Himera

Selinus

Kephallenia

Aetna
Naxos

Zakynthos

Catania

Akragas

Leontini

Megara Hyblaea

Gela

Syracuse

Camarina

N

Malta

Scale of Miles

0 50 100 150

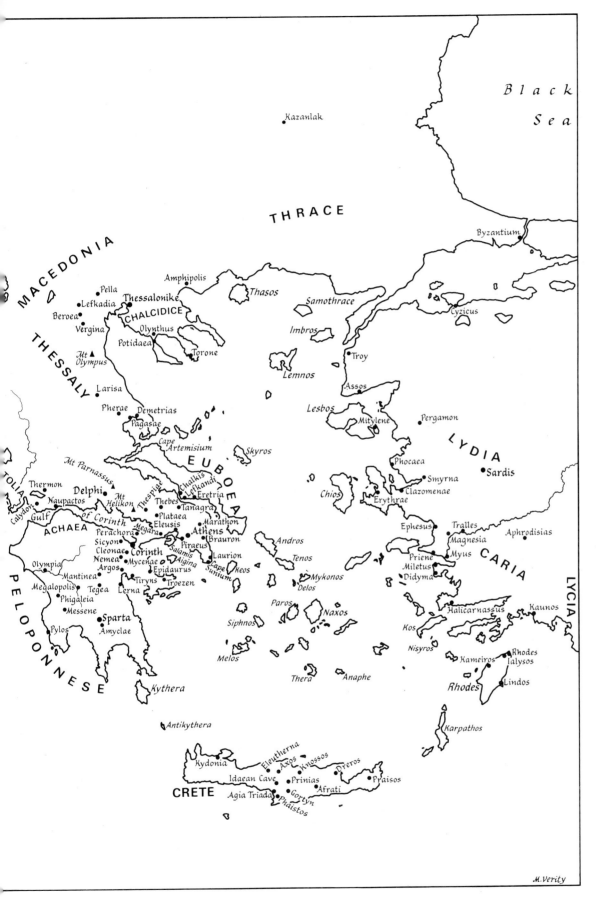

Black Sea

Kazanlak

THRACE

MACEDONIA

Pella
Lefkadia
Beroea
Vergina

THESSALY

Mt Olympus

Larisa

Thessalonike
CHALCIDICE
Olynthus
Potidaea
Torone

Amphipolis

Thasos

Samothrace

Imbros

Troy

Lemnos

Assos

Byzantium

Cyzicus

Pherae
Demetrias
Pagasae

Cape Artemisium

Skyros

Lesbos

Mitylene

Pergamon

LYDIA

Mt Parnassus
Thermon
Delphi
Naupactos
Gulf of Corinth
Calydon
ACHAEA
Olympia
Mantinea
Megalopolis
Phigaleia
Messene
Pylos
Amyclae

PELOPONNESE

Mt Helikon
Thespiae
Thebes
Plataea
Eleusis
Megara
Perachora
Sicyon
Cleonae
Corinth
Nemea
Argos
Tegea
Lerna
Tiryns
Mycenae
Epidaurus
Troezen
Sparta

EUBOEA
Chalkis
Lefkandi
Eretria
Tanagra
Marathon
Athens
Brauron
Piraeus
Salamis
Aigina
Laurion
Keos
Cape Sunium

Andros
Tenos

Mykonos
Delos

Paros
Siphnos
Naxos

Melos

Thera

Anaphe

Phocaea
Smyrna
Sardis
Clazomenae
Chios
Erythrae

Ephesus
Tralles
Magnesia
Priene
Myus
Miletus
Didyma

Aphrodisias

CARIA

Halicarnassus

Kos

Nisyros

Kaunos

LYCIA

Kameiros
Rhodes
Ialysos
Lindos

Rhodes

Karpathos

Antikythera

Kydonia
Idaean Cave
Agia Triada
Phaistos

Eleutherna
Axos
Knossos
Prinias
Gortyn
Afrati

Dreros
Praisos

CRETE

M. Verity

1

The seeds of Greek art:
Geometric and Orientalising

I. Geometric

There were great civilisations during the Bronze Age in the peninsula and islands which became Greece, and they produced splendid arts. We now know too that in the later part of that time a form of Greek was widely spoken there. However, in the last centuries of the second millennium B.C. the Bronze-age cultures collapsed, and among the casualties of that troubled and impoverished age of retrenchment was the whole tradition of monumental art and architecture, and of representational art in any form.[1] The renderings of men and animals in what we call Geometric art are a new beginning, whereas from that point there is unbroken development into archaic, classical and Hellenistic.

The obscure circumstances of the collapse of the old culture involved invasion, or infiltration, by further Greek-speaking tribes; and it is with their assimilation that the new world begins. In the schematic dating we apply to this period it seems to be around the last century of the second millennium that an upward turn becomes traceable, notably in pottery and specifically the pottery of Athens. Here the degenerate 'Sub-mycenaean' style common to Greece gives place to what we call Protogeometric. The change is marked by improved technique, introduction of new and tauter pot-shapes, and the replacement of old decorative motives, derived from naturalistic floral and marine designs of the earlier age, by purely abstract drawing: triangles and other rectilinear forms, hatched or cross-hatched, and especially concentric circles or semi-circles drawn with compass and multiple brush. Much of the vessel is often black, and there seems a desire to emphasise the sharply defined contours which is to remain a feature of Greek ceramics, and *mutatis mutandis* of Greek art in general.[2]

Protogeometric is tentatively imitated or paralleled in other parts of Greece,[3] and the fully developed Geometric of the succeeding centuries becomes a universal Greek style; but it is in Attica that the

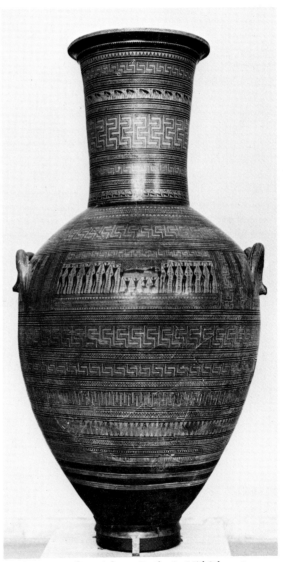

1 Grave-vase from Athens. Prothesis. Mid 8th century. H. 1·55 m.

1

development can be most clearly seen, and all other Geometric pottery-styles remain provincial beside Attic. It is on Attic Geometric pottery too that representational art first appears again in Greece. In Protogeometric an occasional animal is seen, haphazardly placed,[4] but it is first in Attic Geometric of the eighth century that a figure-style is incorporated in the decorative scheme. This scheme differs from the Protogeometric in a reduction of the black areas and of concentric circles and semicircles, and in a careful selection of the the rectilinear motives and the ordering of them to cover the pot with a skin of graded zones which emphasise its shape. The most characteristic of these motives is the hatched maeander or key-pattern, which occurs constantly in a great variety of simple or complex forms.[5]

There is no natural place for figure-work in this sophisticated decorative system; but when the urge to represent prevails, forms are fascinatingly adapted to make them fit in. The occasional row of repeated birds or quadrupeds may be substituted for abstract designs in one of the zones; but much more interesting is the introduction of complicated scenes of human activity. The most important of these are on huge pots, designed not for use but to stand on graves. Some are as much as five feet high, and the floor is pierced, whether for libations to the dead or just to prevent accumulation of rain-water. Fig. 1 is an example. It shows both the classic system of abstract geometric decoration: small black areas, graded zones of pattern with varied maeanders; and at the same time the introduction on the neck of two zones of repeated animals (grazing deer, resting goats) and just above the broadest point of the body, on the shoulder between the handles, a scene of human action. The picture is of a body on a bier, mourners around; that in fig. 2 the same, with warriors in chariots, part of the funeral procession. Others have battles by land or sea; all subjects connected with death, as suits the purpose of the pot. Fig. 2 is the picture on an open bowl with a high foot, a monumentalisation of the krater, mixing-bowl for wine and water, the centre of the symposium (drinking-party). This was essentially a male occupation, and vessels of this form stood on the graves of men, while the monumentalised store-jar (amphora, fig. 1) adorned those of women. A plain stone sometimes stood beside the vessel on the grave. In earlier times carved or painted tombstones had occasionally been used. It seems as though, when the need was felt again for a monument to adorn the last resting place of the rich and great, it was met by monumentalising the only existing art, that of painted pottery.

The distinctive character of the drawing is determined by two quite independent principles. First, it is basically conceptual, like a child's drawing. The artist puts down less what he sees than what he knows is there. The corpse is drawn suspended above the bier, the cloth that covers it suspended above again, and individual figures are similarly itemised. Profile is the natural elevation for figures in narrative art, since

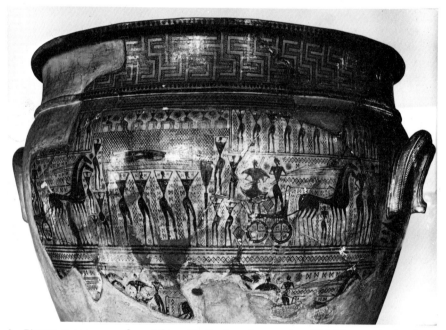

2 Picture on grave-vase from Athens. Prothesis and procession. Mid 8th century. H. of part shown *c.* 0·40 m.

they are concerned with each other and their activity, not with the spectator; so head and legs are in profile; but the chest is shown frontal, because that is its fullest extension and the attachment of both arms can be made clear. The conceptuality is not consistently applied. The chariot is itemised as wheels, car, people standing in car; but the two horses that draw it are allowed to overlap, so shown as one body with two necks and heads and eight legs. Confusion is not always avoided: the two wheels here are probably near and far wheels of a two-wheeled chariot, but in some cases rather the two near wheels of a four-wheeled cart.

The other principle which determines the character of the drawing is its deliberate adaptation to fit in with the character of the surrounding ornament. These pictures are not the work of children but of highly skilled craftsmen, and the thin silhouette with the triangular torso and angled, linear arms is carefully planned to dominate but not to stand apart from the overall pattern. What seem to be the earliest human figures on Geometric vases are less precisely geometrised than these,[6] and later they fill out and loosen up a little; but from beginning to end of the period they are thin silhouettes conceptually conceived. When this approach is finally abandoned in the late eighth century, it is under the influence of eastern arts; and it seems clear that in Geometric Greece there was no indigenous drawing, not on vases, of a freer kind. These vase-figures are the real beginning of Greek art.

The same style is found in another art which develops in Greece during the Geometric period: bronzework. This is manifested in big tripod-cauldrons and in statuettes, sometimes adornments of cauldrons, sometimes independent. The bronze tripod-cauldron, like the clay grave-vase, is the monumentalisation of a piece of household furniture: a cooking-pot. In its monumental form this was not to mark a grave but to be a prize in the games and other competitions at festivals in the great sanctuaries of Greece; especially Olympia, where the games were traditionally founded in 776 B.C. and where most of the best of these vessels have been found dedicated. The form is a basin supported on three stout legs and with two big ring-handles standing upright on the rim, these often supported by human figures and crowned by a horse. The legs have geometric relief-decoration, with in late examples an occasional geometric figure-scene; and the figurines, whether on tripods or separate (fig. 3), have the same conceptual itemisation and the same sharp geometric forms as those on the painted pots of Athens.[7]

Clay figurines are also made, but they are mostly styleless work (as are some bronzes), toys or cheap offerings. There are however a few large and careful

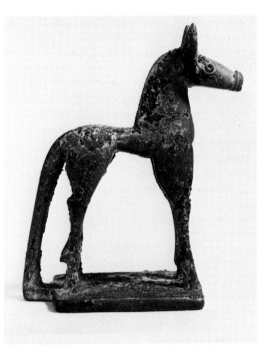

3 Bronze horse from near Phigaleia. Mid 8th century. H. 0·099 m.

4 Terracotta figurine from Lefkandi (Euboea). Centaur. 10th to 9th century. H. 0·36 m.

terracotta figures of more significance. From a late Protogeometric grave at Athens comes a stag, body made on the wheel, head with long neck and limbs hand-made and attached, the whole decorated in contemporary vase-painting style. Closely similar but even larger (some fourteen inches high) and more splendid is a Centaur (fig. 4) from a near-contemporary grave at Lefkandi in Euboea.[8] Such impressive figure-work at the very beginning of the Geometric period is surprising. Large figurines mainly thrown on the potter's wheel and decorated in vase-painter's technique are known from several Greek sites in the late Bronze Age; and this may be a line where we shall one day be able to trace continuity of production through the dark ages.

The Centaur, man–horse, appears in late Geometric both in bronze and on vases. It has generally been thought a manifestation of the taste which in the immediately following period adapted many fabulous monsters from the East; but it has no close eastern parallels, and the discovery of the Lefkandi Centaur pushes back the concept in Greece a long way. We shall meet it often again, for it remains a powerful symbol throughout the history of Greek art and beyond.

II. Orientalising

Greek Geometric shows little contact with contemporary arts in neighbouring lands. In the preceding dark age, it seems, there was real lack of communication, isolation; but in the high Geometric time this was hardly so. Geometric pottery is found in Cyprus and Syria; goldwork of oriental origin in Attic graves with Geometric vases. Local goldsmiths evidently learnt from this, but in general Greek craftsmen and patrons seem to have been content with their own style. During the second half of the eighth century this gradually changes, part of a larger change. Growing prosperity, growing population, encouraged trade and colonisation, and consequent closer contact with foreigners led to emulation and borrowing. It was now that the Greeks (illiterate for several centuries, since the clumsy syllabary evolved in the later Bronze Age had died with the social system it served) borrowed the suppler consonantal alphabet developed by the Phoenicians and improved on it by using some of the symbols for vowels. It was certainly also from the Phoenicians, the other great traders of the Mediterranean and famous craftsmen too, that Greeks took some of their new artistic ideas. Phoenician art was itself a great borrower – from Egyptian, neo-Hittite and Assyrian – and it is impossible to disentangle the particular influences, direct and indirect, on Greek artists at this time. What is clear is that it was by

looking at these eastern arts, whose strict conventions embodied far more of nature than the near-abstract Geometric, that Greek artists were able to break from that and establish a comparable style of their own.[9]

In painted pottery precise connections are particularly hard to trace because this, the leading art of Greece, was an unpretentious craft in most eastern countries, and the influential works were of other kinds. In bronze the great tripod-cauldrons give place to a new fashion: tall, conical stands supporting big bowls with incurving rim, their ring-handles held by attachments in the form of human-headed birds (sirens); and, standing round the shoulder between these, long-necked griffin-heads. Fig. 5 shows a contemporary representation on the leg of a late tripod-cauldron from Olympia; fig. 6 a griffin-head from Rhodes. This type of vessel seems to have originated in Urartu (south of the Caspian), but it was imported and imitated all over the Near East and in Italy as well as Greece. Oriental examples have heads of lions or eagles rather than griffins; and while the sirens on Greek pieces are purely eastern in style, the griffins, often of superb quality, have a distinctive character of their own: Greek. The griffin, an ancient oriental creature,

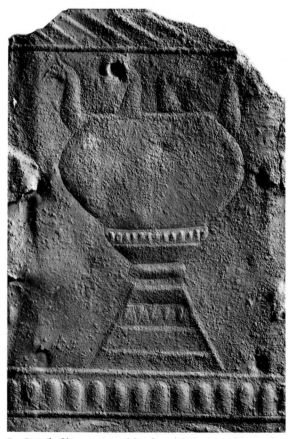

5 Detail of bronze tripod-leg from Olympia. Griffin-cauldron. Early 7th century. H. of part shown *c*. 0·20 m.

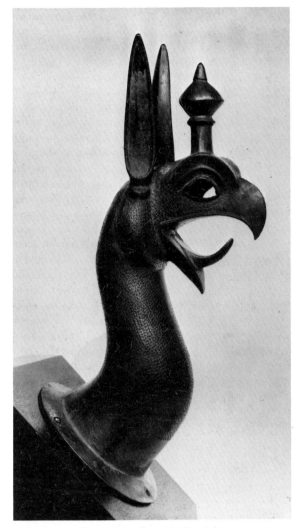

6 Bronze griffin-protome from Rhodes. 7th century.
H. 0·32 m.

as no doubt they were at Olympia too. Whatever the social and political structure of Greece in the Bronze Age and its aftermath, in the Geometric and Orientalising periods we see the pattern emerging which persists in archaic and classical times and in some degree even after Alexander: small, independent city-states, often at war with each other but united by language, legend and religion. One expression of this unity is the growth of great interstate sanctuaries, many of which had four-yearly festivals and games open to all Greeks. For that at Olympia, the oldest and most prestigious, it was customary for cities at war to call a truce.

If bronzework is particularly associated with sanctuaries, painted pottery is essentially local to cities. We saw that Attica produced the best and most influential Geometric. So it was again later, but from the mid eighth century to the mid sixth she found a rival who at times surpassed her, Corinth.[11] Corinthian Geometric goes in for small vessels of very high technical quality, simply and elegantly decorated. Before the middle of the eighth century a system prevails there of ringing the vase with close-set fine lines, giving a very different effect from ordinary Geometric. New shapes are developed with this, especially the aryballos, a tiny round pot with a very narrow neck (a later example, fig. 7). The city's site on the Isthmus made her a natural centre for trade, and the aryballos seems to have been created to meet a new need: to bottle scented oils, imported from the East, for re-export east and west. Corinthian aryballoi are found far and wide, especially in Sicily and Italy, where Corinth long dominated trade and was early involved in colonisation. Dating in this period is largely dependent on correlating finds of Corinthian pottery with traditional dates for the founding of western colonies; an imprecise and unreliable method but, with a little help from the East, the best we have.[12]

The earliest aryballoi have abstract linear decoration, but it is on this shape, linked to the eastern trade, that the first oriental motives appear in Greek vase-decoration, perhaps not long after the middle of the eighth century. Most of the pot is still covered with fine lines, but a zone left for decoration with animals or flowers – forms drawn in outline. A free zone not divided into panels, outline instead of silhouette, florals drawn as though growing, mark a break with Geometric, conscious emulation of another approach; but it is all very cautious. Decorative stylisation is very marked, surfaces are dotted or outline clings round a solid core. The potter–painter seems afraid of losing the necessary decorative emphasis on the surface of the shape, and his next step shows a brilliant solution. In seventh-century Corinthian vase-painting beautiful outline drawing is still found, but it belongs to a

known in Bronze-age Greece and now reintroduced, is essentially a lion-body with eagle's wings and head, but the head is modified in various ways. Greek specimens of this time have always eagle's beak, hare's ears and a knob or spike on the brow. In complete figures the head generally sits straight on the lion-neck, but the long, sinuous bird's neck is a constant feature of the cauldron-heads. The sirens are cast solid, like Geometric bronzes, but the griffin-heads are the first examples in Greece of hollow-casting, another thing now learnt from the East of immense importance for Greek art (below, pp. 50f.).[10]

These cauldrons, like the Geometric tripods before them, are found mainly in the great interstate sanctuaries, especially Olympia and that of Hera on Samos. Two spoiled griffin-heads were found at the Samian Heraion, showing that they were made there,

5

special style which seems intimately related to free painting on a flat surface. The literary tradition associates the beginning of painting with Corinth and neighbouring Sicyon. This is part of the rebirth of monumental art in Greece, treated in the next chapter where these and other exceptional vases will be considered. The accepted way of drawing on a pot at Corinth in this time is different: a reversion to silhouette, but not the thin silhouette of Geometric figures adapted to geometric ornament – full, rounded forms with swinging contours, inner details marked with sharply engraved lines and patches of added colour. The forms tell strongly on the curving surface and the figure-zone is widened for them, its background left bare or scattered with small flower-shapes, a calyx of pointed leaves or petals at the base and the areas of fine lines reduced to narrow borders of two or three (figs. 7 and 8). This 'black-figure' method of vase-decoration was to become widely accepted throughout Greece for a long time. The best Corinthian work of the seventh century, with its tense strength and controlled balance of decorative and repre-

7 Protocorinthian aryballos from Lechaion (Corinth). Battle. Early 7th century. H. 0·05 m.

8 Protocorinthian kotyle from Rhodes, probably Kameiros. Hound. Second quarter of 7th century. H. 0·19 m.

6

sentational, has just the same character as the great bronze griffin-heads.[13]

The breakdown of Geometric tradition under eastern influence in Attic vase-painting follows a rather different course.[14] There is still a superficial resemblance to the old style, especially on larger vases which often have a figure-frieze on neck and body, the rest being covered with graded bands of abstract ornament; but this has shrunk to little more than varied groupings of zigzags, while massed zigzags among the figures of the main friezes make a shimmering ground on which the fuller, curvier silhouettes or dot-filled outlines of men, women, animals, monsters, flowers stand out. Soon the subordinate zones shrink to narrow pattern-borders and all the concentration is on the figure-scenes, executed in a variety of techniques: outline, outline filled with white, a mixture of black and white silhouette, and sometimes black-figure, used with more colour than is common at Corinth and seldom for the main figures. The tradition of large, sometimes very large vases, probably still grave-markers, continues and the spreading of the figure-zones on these leads to drawing on an unprecedented scale (fig. 9): a monumental art of which there will be more to say in the next chapter.

Corinthian and Attic are far the most interesting styles of orientalising vase-painting. A provincial style in Boeotia looks towards Attic, another in Laconia towards Corinth.[15] One important piece from Argos is

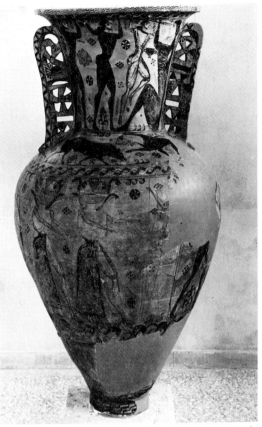

9 Protoattic grave-vase from Eleusis. Gorgons pursuing Perseus; animals; blinding of Polyphemus. Mid 7th century. H. 1·42 m.

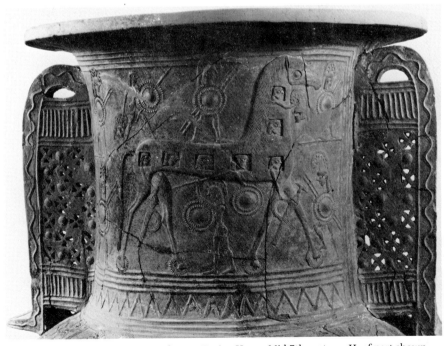

10 Neck of relief-pithos from Mykonos. Trojan Horse. Mid 7th century. H. of part shown c. 0·45 m.

7

discussed below (p. 13). In the cities and islands of the eastern Aegean a provincial Geometric is followed by a pretty but conventional orientalising style: jugs and bowls, the clay covered with a white slip, adorned with friezes of animals (goats, deer, geese; sometimes lion, sphinx, griffin) and florals in outline and silhouette with added colour but no incision.[16] The Cycladic islands had produced a good late Geometric, and their orientalising is finer and more varied than the East Greek but still a minor flowering.[17] The finest Cycladic products of the time are huge jars decorated with figure-scenes not painted but in relief, the best from Mykonos with panels on the body showing warriors putting women and children to the sword: a savage view of the sack of Troy, as is made clear by the superb rendering on the neck of the Wooden Horse (fig. 10).[18] Stories from legend, rarely and doubtfully recognisable in Geometric, are common in Corinthian and Attic vase-painting from this time on (fig. 9, and probably the battle fig. 7), the figures sometimes named – vase-painters are early literate.

The shape of these Cycladic pots is that of the common store-jar (pithos), and such decorated relief-pithoi are found elsewhere also, particularly in Crete which has an artistic history different from that of the rest of Greece.[19] A sub-Minoan tradition in painted pottery lingers long, and is replaced by a very individual form of Protogeometric, the later stages of which show, surprisingly, powerful influence from the East. Probably contemporary with this are some bronze shields with relief decoration of purely if crudely oriental character. It looks as though there had been a Phoenician settlement on the island which introduced this strain; and though in pottery a true Geometric style supervenes, the eastern tradition seems to linger on, especially in fine gold work, to link up with the orientalising phase proper. Crete plays a full part in this and, as we shall see in the next chapter, in the revival of monumental art, but around the end of the seventh century goes into decline and for the rest of antiquity is an artistic backwater.

Another important source of inspiration from the East is ivory.[20] Its first workers in Greece probably came in with the material, but they soon found native pupils. Some special pieces are discussed below (pp. 12, 23), but there is a big body of early dedications from sanctuaries: animal and human figurines, ornaments. Some have intaglio designs, as though for sealings. It is doubtful if the material was actually used in this way, but the engraved sealstone is another art that does revive in Greece at this time. The inspiration for the first stones seems to come less from the East than from Bronze-age pieces found and imitated. The Cyclades seem to take the lead, especially perhaps Naxos;[21] the same area that a little later sees the beginning of monumental marble sculpture.

2

The beginning of monumental Greek art: the early archaic period

I. The 'Daedalic' style and the early stages of monumental sculpture

In an ivory sphinx from Perachora[1] the oriental creature is given a head of a distinctive style found in Greece at this time in works on many scales and of many materials. Commonest are small terracottas, but the bronze statuette fig. 13 and the large limestone statuette fig. 12 both show it, and the big marble fig. 11 is almost the same. A long straight nose forms a T with the straight fringe close down on the brows; a rectangular block of hair frames a triangular face which tapers to a pointed chin. The straight lines and angles are curved and rounded off in the interest of naturalism, but the geometrical basis remains most marked; and the imposition of this formula is analogous to the reimposition of Geometric discipline in the changed form of black-figure on the experimentalism of orientalising vase-painting. Heads with wig-like hair are frequent in various eastern arts and surely served as a model, but the Greek geometry is entirely absent from them. This style is conventionally and conveniently known as Daedalic, after Daedalus, the first sculptor in Greek tradition.

By another of the technical innovations or borrowings which mark the art of this time, terracotta figurines and heads are no longer generally made freely by hand or turned on the wheel but pressed into moulds. The quality can be high, but terracottas are on the whole cheap products for the local market, and so give valuable indication of the styles prevalent in particular places. Daedalic terracottas are found in quantity in the Peloponnese (Corinth, Argos, Sparta), Crete and Rhodes, all Dorian centres. The Dorians were traditionally descended from Greeks who entered the country during the dark ages, the Ionians and Aeolians from those who were there already. Daedalic has been claimed as a Dorian style; but purely Daedalic heads are found on marble lamps made in the Ionian Cyclades, and the first monumental marble sculpture from the same area is inseparable from the Daedalic

tradition. In general differences in artistic character seem to follow less tribal divisions (Ionian, Aeolian, Dorian) than geographical (the mainland, the Cyclades, East Greece).[2]

The first Daedalic pieces seem to date before the middle of the seventh century, and the style merges in other movements before the end. The earliest large-scale sculpture we have in limestone or marble does not go with the earliest Daedalic; but the wide acceptance of such an individual style is most naturally explained by supposing it the creation of one artist or school producing major works at major sanctuaries. This might be an argument for postulating a stage of monumental sculpture in wood, now lost to us, preceding that in stone. We know from literature that wood was used for statues in the archaic period, and very early wooden statuettes (some Daedalic) have been found on Samos.[3]

The oldest-looking piece of Greek sculpture we have is an over life-size marble of a woman (fig. 11) from the sanctuary on Delos which Artemis shared with her brother Apollo. A verse inscription on the skirt tells that it was dedicated to the goddess by Nikandre of Naxos, whose father, brother and husband are also named.[4] This was evidently an important offering, neither cheap nor provincial; Delos was one of the great sanctuaries of Greece. Behind the weathering, however, one can clearly see that it is a work of primitive technique, simply, even crudely, shaped from the shallow rectangular block. This is surely not only the earliest marble statue we possess but one of the first made. The marble is Naxian, and Naxos dominates early marble sculpture, though quarries soon opened on neighbouring Paros and that marble was afterwards preferred. Rather later Attic sculptors began to use their own marbles, but early sculpture from Attica is in Naxian marble and under Cycladic influence. Peloponnesian and Cretan sculptors work at first not in marble but in local limestones; later sometimes in marble imported from the Cyclades, but the softer and more readily available stone is long used everywhere

9

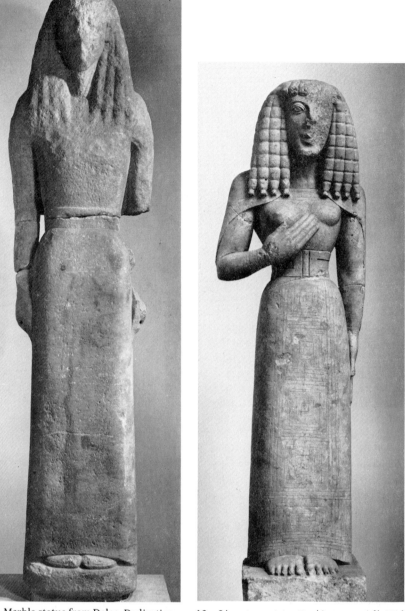

11 Marble statue from Delos. Dedication to Artemis by Nikandre. Mid 7th century, or later. H. 1·75 m.

12 Limestone statuette. 'Auxerre girl'. Mid 7th century, or later. H. 0·65 m.

for building and for architectural sculpture.

The body of Nikandre's statue is as formally constructed as the head, and similar clothed bodies with Daedalic heads are found on a smaller scale in many materials: terracotta, bronze, ivory, gold-relief. A well-preserved and slightly more elaborate example is a large limestone statuette in the Louvre (fig. 12), known as the Lady of Auxerre since when first noticed she was in the museum there. Her origin is unknown, but there are resemblances to Cretan work. She seems a little later than Nikandre's marble. Shoulders and upper arms are covered by a cape, or perhaps rather a cape-like adjustment of the dress: seen from the back it does not seem to be a separate garment. The right hand is laid on the breast, but as with Nikandre the belted waist makes a sharp horizontal accent below which the skirt is a straight pillar, emphasised here by rectilinear incisions, guidelines for paint no doubt also present on the marble though perhaps more discreetly (see below, p. 28). The upper dress has a curved pattern of overlapping arcs, and in spite of the extreme formalism the work has vivid charm.[5]

10

This beginning of monumental sculpture in Greece accompanies a revival of monumental architecture and apparently also of painting. In this renaissance the influence of the East seems present in a new way: not the effect on craftsmen and their patrons of the style of imported objects, but the emulation of a way of life seen by travelling Greeks who reported the great enduring buildings and statues of Egypt and the eastern monarchies. In the case of architecture it is the idea that is seminal – little or nothing of the form is taken over; but in sculpture what was to become the dominant type of Greek statue through the archaic period, the naked young man, kouros, owes a direct debt to Egyptian models. There are fragments of kouroi from Delos as early or nearly as Nikandre's girl, but before we go on to these a few more general remarks are in place.

Monumental architecture in Greece was first developed in temples and long largely confined to sanctuaries; and sculpture in the archaic period and even after is exclusively associated with religion. Statues were either images of deities, especially the cult-statue within a temple; or dedications, that is gifts to the gods, set up in the temple or more often outside it in the temenos; or they stood on graves. The cult of the dead at the tomb was a strictly religious function. Relief-sculpture was likewise confined to adornment of temples and other sanctuary-buildings, or of tombs.

Cult-statues were often of precious or perishable materials and few survive. Grave-statues were the fashion in various times and places; but the majority of the statues we have were dedications like Nikandre's. These might represent the deity, the donor, or neither. Of the many marble figures offered to Athena on the Acropolis some have attributes of the goddess, but the great majority are girls with nothing to suggest that they are she; many have inscriptions showing that they were given by men; and they seem to be simply themselves, servants or companions for the deity. In the case of Nikandre we cannot know.[6]

The male figures from Delos were gifts to Apollo, and again the question is open. When archaic figures of this type first became known they were called 'Apollo', and it may be that they have an early association with his worship, but certainly not all can represent him and the non-committal 'kouros' is preferable.[7] Three fragments from Delos are plainly very early. One torso is so weathered that little can be said but that it does seem to show the same primitive technique as Nikandre's. Two others are more sophisticated. One, head to waist, is fearfully weathered; the other, waist to one knee, has on the contrary a finely preserved surface and forms of great if primitive power.[8] We are lucky in being helped to envisage

13 Bronze statuette from Delphi. Youth. Middle or later 7th century. H. 0·20 m.

these statues by possessing a fine bronze statuette of identical character (fig. 13).[9] This was dedicated at Apollo's other great sanctuary, at Delphi in central Greece. The beaky profile resembles works from Crete, but the likeness to the Cycladic marbles is also great and we cannot say where it was made. The boy stands, arms at sides, absolutely frontal without turn, twist or bend; were one to bisect him vertically the two halves would be mirror-images, except that the left leg is forward, the right back. The lower marble fragment from Delos stood in the same way, and no doubt the

upper also; and throughout the archaic age the naked male statue stands always just as these. Constant too is the bare chin – youth is the rule; but this bronze and the Delos marbles share two features which are not regular in later kouroi: the Daedalic wig, and the belt.

The pose is certainly borrowed from Egypt, where it had been used for male figures for centuries. Only, the Egyptian is normally skirted and, while putting the left foot forward, keeps all the weight on the right, whereas in the Greek works the weight is evenly distributed, as though in the act of walking. Egyptian sculptors had long known far more than their first Greek emulators about the structure of the human body, but the general effect of their work is (as it was surely meant to be) much less alive. A concern with *life* (manifested in relief-sculpture and painting as an interest in story-telling) is a central feature of Greek art. This is what sets off its archaic phase from the oriental arts to which it owes so much; what drives Greek artists to be always changing, developing, till they find themselves forced to abandon the inherited conventions and create their own, classical, style which becomes the basis of European art. In the kouros this development takes the form of ever more accurate rendering of observed natural forms, always controlled by a strong feeling for pattern; but the idea is hardly yet present in these first efforts. The grandest and perhaps latest of them, the lower fragment from Delos, the first truly impressive piece of Greek sculpture, shows a beginning in knee and thigh and genitals (and from the side in the powerful buttocks); but it is not only weathering that makes, in the upper fragment, the relation of shoulders, breast and arms so wholly inorganic – it is the same in the little bronze fig. 13. Probably that is why these earliest youths wear a belt. Odd on an otherwise naked figure, it is a borrowing from the belted dress of Nikandre and her sisters, to make an accent at the centre of the statue, achieved later by a schematic pattern of musculature. The nakedness itself is much stranger. It is paralleled but surely not accounted for by the Greek practice of naked athletics; but, whatever its origin, from now on it is a basic convention of art in Greece that males (not females) may be shown naked in any context.

The next phase is best illustrated by statues from Attica. An exceptional sense of sculptural form is already present in ivory figurines of naked women (on an oriental model but wholly Greek in character) found in a late eighth-century Athenian grave.[10] The marble statues of a century later, though in Naxian stone and closely derived from the Cycladic pioneers, show the same quality. The unnatural caesura at the waist of the ivory points to the reason for the belt on the early statues, but the Attic marbles, illustrated here (fig. 14) by the best preserved of several colossal

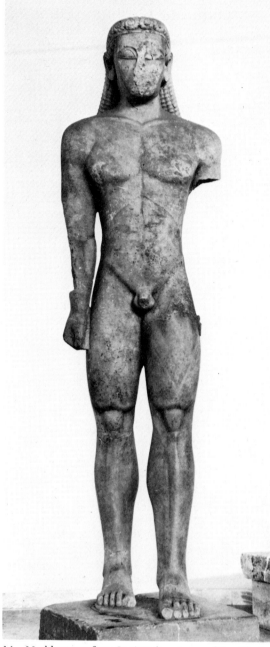

14 Marble statue from Sunium (sanctuary of Poseidon). 'Sunium kouros'. Late 7th or early 6th century. H. 3·05 m.

figures from the sanctuary of Poseidon at Sunium, are not belted. The torso is unified by being mapped in linear anatomical patterns: exceedingly schematic; but this is the beginning of the road to the classical athlete-statue.

The feeling for structure – something which endures in Attic sculpture – is well illustrated by comparing a splendid head (fig. 15) from an over life-size grave-statue in Athens[11] with a Daedalic head, or

12

with those of two contemporary large marbles made in a centre of Daedalic tradition (fig. 16). These are the famous twins Kleobis and Biton, in Cycladic marble but signed by an Argive sculptor (. . . medes) and dedicated by the people of Argos at Delphi, where they were seen by Herodotus who tells their story.[12] The faces of the Argive youths have a more natural look than the Athenian, but the Attic artist has a far stronger grasp of form, of the relation of face to skull. Beside it the others look like masks set in wigs.

I previously called this the 'second generation' of sculptors, but 'phase' is safer since dating is difficult. The relations of Daedalic with orientalising pottery, and of the earliest marbles with Daedalic, suggest, in our schematic time-structure, a point around the mid-century for Nikandre's dedication, the Delos kouros fragments and the Delphi bronze coming perhaps a little later. The evolution of sculpture through the sixth century, however, makes it hard to date the figures we are now considering before 600 and they might be well after. Possibly the beginning of marble sculpture should be brought down.

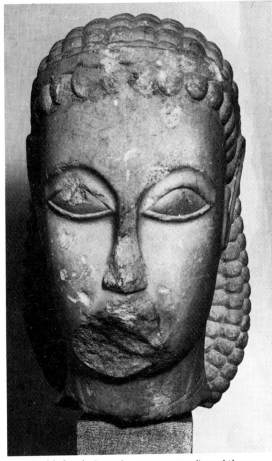

15 Marble head of youth, grave-statue, from Athens. 'Dipylon head'. Late 7th or early 6th century. H. 0·44 m.

Other works from this and even from the earlier phase will be discussed in the last section of this chapter, on relief and architectural sculpture, since that is the area in which the formation of the ripe archaic style can most clearly be traced. Before we do that we must see what we can glimpse of what seems to have been another major achievement of the seventh century, the revival of the art of painting.

II. The beginning of free painting

The beginnings of monumental architecture and sculpture in Greece are evidenced by actual remains. For the inception of monumental painting, as for most of its history, we are reduced largely to conjecture, based on often ambiguous evidence from vase-painting and on the literary tradition. That tradition claims Corinth and Sicyon as 'inventors' of painting;[13] and the material evidence too points to that region. A fine fragment from Argos of the mid seventh century, with the blinding of Polyphemus (fig. 17), differs in composition and colouring from the run of vase-painting. Within a black outline skin is brown, as in Egyptian wall-painting; and the figures, of varying heights, are irregularly disposed in a roomy space. Contrast the same scene on the neck of a contemporary Attic jar (fig. 9), where the figures are conventionally coloured black or white and reach from bottom to top of the picture. The Argive krater is far smaller than the Attic amphora; and it looks as though Athenian artists preferred to monumentalise vase-painting rather than venture into the new world of free painting. No early Attic painter is named in the literary tradition.[14]

Corinth on the other hand had kept its vase-painting on a small scale; and the tradition of an early Corinthian school of painters is borne out by certain vase-paintings which stand aside from the rest: not in scale (indeed they are often miniature work) but in composition and colour. Black-figure's incision is used for details, but men's skin is coloured brown, women's drawn in outline, and compositions show much overlapping which, with its implication of depth, is foreign to most Greek vase-decoration. The most remarkable example is a battle on the shoulder of a jug (the Chigi vase), drawn out in fig. 18. The feet are all on the base-line of the picture, and there is no diminution in size with distance, so that the surface-plane is still emphasised; but the notion of a receding space in which ranked armies meet is inescapable.[15]

That the difference of this style from that of ordinary vase-painting is due to influence from wall-painting is confirmed by the existence of slightly later terracotta metopes from temples at Calydon and Thermon in Aetolia, an area under Corinthian domination. These square panels from high up on a

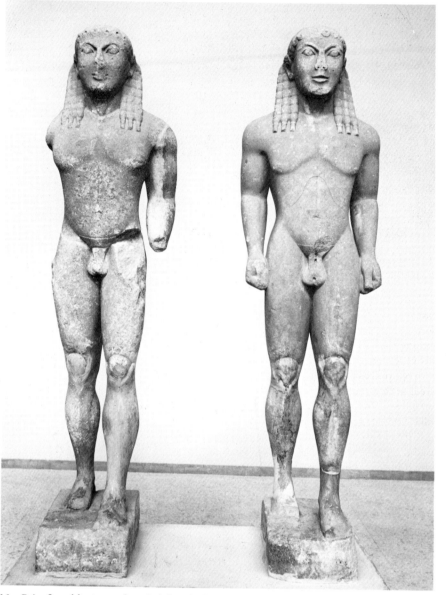

16 Pair of marble statues from Delphi. Kleobis and Biton, carved by Argive sculptor
. . . medes and dedicated to Apollo by Argives. Early 6th century. H. as restored with
plinths 2·16–18 m. Modern in l. hand figure ankles and most of feet, in r. hand figure most of
legs and feet.

building, with only one, two or at most three figures
on each, are not the kind of model on which the vase-
painter drew for his battle. Moreover they are pro-
vincial and inferior in quality to the vase-paintings;
but the colouring is the same and on one metope there
is similar overlapping. Surely both vase-paintings and
metopes (which run over the middle and later decades
of the century) owe much to great wall-paintings in
Corinth. Evidence for wall-painting is also given by
fragments of painted plaster from the exterior of an
early temple of Poseidon on the Isthmus.[16]

III. The beginning of relief and architectural sculpture

I have left this subject to the last because of the
peculiar character and importance of relief-sculpture
in the development of Greek art. A statue in the round
was surely conceived as in some sense a being to be met
face to face, so was designed primarily to be seen from
in front. Drawing and painting are narrative arts
where the figures are concerned not with the spectator
but with one another and the action they are taking

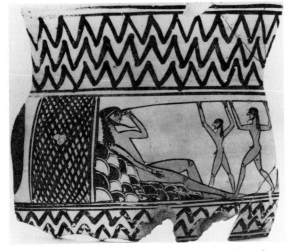

17 Fragment of Argive krater from Argos. Blinding of Polyphemus. Mid 7th century. H. 0·25 m.

monumentalisation a new architecture is created, in a radically redesigned temple: a long, narrow room, its focal point a cult-statue at the back looking out through an entrance-porch at the east end. This is balanced by a false porch at the back, and the whole surrounded by a close-set colonnade and covered by a low-pitched roof which gives long, low gables at the ends, the pediments. The function of the sacrificial pit is transferred to an altar outside (often opposite the east door) and the building becomes a house for the god in the statue. This Doric temple was created in the Peloponnese in the middle or later seventh century.[18] There are many variations, but plan and elevations remain fundamentally unchanged in the great temples of the fifth century: of Zeus at Olympia (plan fig. 120) and the Parthenon (view fig. 129). Fluted columns rise without bases from the topmost of three steps. Their simple capitals support the plain beam of the architrave or epistyle, and between that and the cornice comes the frieze of triglyphs (a grooved upright over each column and each interval) and almost square metopes. Apart from the statue within, sculpture is not a necessary part of this design, but it is often added, always in certain set positions: akroteria, freestanding statues above the three angles of the gable; and reliefs on the metopes and in the pediments. These relief-areas are high above the viewer's eye-level and are overhung by cornices. The sculptor is encouraged to deepen the relief to make the figures stand out better; and this in turn, making them more like statues, encourages him to treat them in the convention of free sculpture rather than that of drawing. What starts as a kind of confusion between the rules accepted for sculpture in the round and those for drawing, ends with the realisation of a new art-form, sculpture in high relief, with conventions of its own:

part in, so the opposite convention prevails: they are normally shown with faces and feet in profile. In Egypt and the Near East relief-sculpture (mostly in very flat low relief) goes in this respect with drawing and not with sculpture in the round. Such low relief is found in Greek art too; but Greek sculptors seem to have begun with free-standing statues, and when they came to relief their approach was affected by the conventions of that art. Moreover from an early stage the Greeks used sculptural decoration on their temples in a way which had no close parallel in earlier arts and, as it developed, encouraged a new approach to relief.

The earliest Greek temples were small buildings, simple in construction and design: a rectangular or apsidal room, entered through a porch at one end and centred on a hearth or sacrificial pit.[17] In the age of

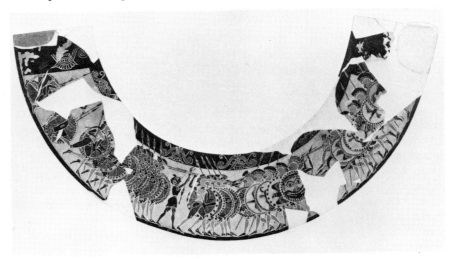

18 Drawing of picture on Protocorinthian oinochoe (olpe) from Formello (Veii). Battle. Third quarter of 7th century. H. of picture c. 0·05 m.

15

figures given their full bodily roundness but grouped in two-dimensional compositions against a flat background to which they are attached or, in developed pedimental sculpture, from which they are carved separate as complete statues. This enrichment of the repertory of art, achieved by the end of the archaic period, is of incalculable importance for the development of Greek art and in general of art in Europe.

The earliest temple-sculpture we possess is not from a Doric temple but from an attempt to monumentalise the old form. A little temple at Prinias in Crete, centred on a sacrificial pit, is built in part of dressed stone and adorned with sculpture.[19] Somewhere on the outside was a frieze of armed horsemen; and over the doorway in from the porch was a stone beam with animals in low relief on its outer face and, seated above it, two statues of goddesses (or a goddess) facing each other. This seems an effort to fit a cult-statue into a building with a sacrificial pit; and though it was in profile that one saw these statues as one came in or went out, if one looked up as one passed under the beam which hid them, one saw them again, carved in very low relief on its underside, standing frontal and looking down at one: altogether an astonishing conception. The horsemen outside too, whose position on the building is not clear, instead of being in profile like their mounts turn each his face towards us.

These sculptures must date from the middle or later seventh century, and from much the same time come the first carved fragments plausibly associated with a Doric temple. These are from Mycenae, and perhaps were metopes.[20] The most interesting shows the upper part of a woman wrapped in a cloak, who was evidently standing in profile but turns her Daedalic face to us. The carving is quite deep, and the frontality is surely because the sculptor, used to working figures in the round, felt that this is how a carved figure should look. The same may be true of the Prinias horsemen, but the relief there is rather low, and an alternative is that they turn their eyes on us as guardians of the house: the 'terror-mask', a concept we shall meet again.

The first substantial remains of sculpture from a Doric building are from a temple of Artemis on Kerkyra (Corcyra, Corfu), which must date from the first decade or two of the sixth century.[21] The outer metopes were, as most commonly, left plain, and only scraps survive of sculpture at this level above the entrances within the colonnade; but both pediments were carved and much of one remains. In the centre a huge Gorgon (fig. 19), some ten feet high, kneels or runs; a swastika-like arrangement of the limbs, the rear knee almost on the ground, is a regular archaic formula for swift motion. At either side of her lies a leopard, face turned to us like hers. These three big

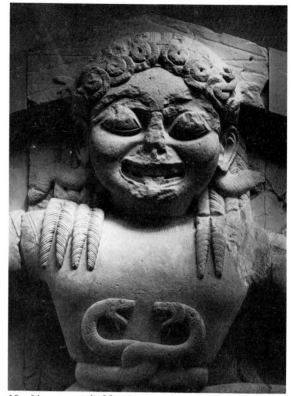

19 Limestone relief from west pediment of temple of Artemis, Kerkyra (Corfu). Medusa. Fairly early 6th century. H. of head 0·75 m.

creatures dominate the composition, but around them are introduced small figures. Next to the Gorgon are a winged horse and a youth, who again looks out at us. Behind the leopard on the left a man now lost thrust a spear at a seated figure (fig. 20), behind whom a corpse lies, his bearded head in the corner turned to face us. At the other end a beardless Zeus in near-profile brandishes a thunderbolt against a kneeling figure who again turns his bearded face towards us, and in the angle beyond must have lain another corpse. Masonry is traced on the background by the seated figure and a tree by the other group.

This is a singular mixture alike of scales and of subjects. Gorgon and beasts with their 'terror-masks' are apotropaic, guardians. An early temple in Sicily had a huge terracotta Gorgon-mask in the gable-centre;[22] and groups of fighting animals, which seem to have the same function, adorn other early pediments.[23] The Gorgoneion (Gorgon-face), adapted from eastern models, appears in Greek art in the mid seventh century and long retains this generalised protective role.[24] From the start, however, it is also associated with a particular story: the head of Medusa, cut off by Perseus with Athena's help, and thereafter

16

worn by the goddess on her aegis. As Medusa died the winged horse Pegasus and a son Chrysaor sprang from the severed neck. Here the monster is alive and well, but the children identify her as the Medusa of the legend.

In the other groups the figure with the thunderbolt can only be Zeus though he rarely lacks a beard. The one enthroned by a building has been thought Priam in Troy, and if so there are two subjects: Gigantomachy (Battle of Gods and Giants) and Iliupersis (Sack of Troy). There are arguments, however, for making the seated figure Rhea, Mother of the Gods, and then both scenes could belong to the Titanomachy (Battle of Gods and Titans) which would suit a young Zeus; a more economical theory, though there are difficulties. In any case there is no connection with the story of Medusa. We seem to see here a first concept of temple-decoration, the guardian symbols, beginning to give hesitant way to the idea which was to prevail: the devotion of temple-gables to narrative scenes from myth and legend.

In style the seminal confusion of a transitional phase is no less evident than in subject. The big creatures stand quite high from the background, but this depth of cutting is only to make the contours clear; the surface is a flat plane, details lightly modelled or engraved on it. Cutting the small figures to an equal depth, the sculptor found himself forced to consider their three-dimensionality, to think of them as statues; and it is this probably rather than emulation of the terror-masks that makes so many of them turn to look at us. The complicated postures are such as no free-standing statue of the time could show, and the sculptor has had great difficulties. The transitions are extremely awkward and the modelling angular, but this is the first step in the evolution of the new art of high relief.

A similar phase in metope-sculpture is seen in the remains of a set from Delphi. They were used in the foundations of a fifth-century building raised by the citizens of Sicyon; one of the little 'Treasuries' which crowded the site (below, pp. 40ff.). The metopes presumably came from an earlier monument of the same city, not apparently a treasury but an open colonnade, perhaps a *baldacchino* to shelter but not conceal some large offering. Instead of being nearly square uprights they have a length almost half as great again as their height, which is nearly two feet; the triglyphs apparently stood only over the columns, not between. Four are relatively well preserved, one showing a boar (no doubt the Calydonian), another Europa forcefully hunched over the bull's neck like a jockey. Both are carved in a basically flat plane parallel with the background, like the big creatures from Corfu though the modelling here is subtler. The other two are more

complex. Fig. 21 shows the Dioscuri (Kastor and Polydeukes) rustling cattle with the sons of Aphareus (one is missing; the names are written beside them). The artist has created a marvellous pattern out of the limbs of beasts and men superposed in parallel planes stepped back to the ground and punctuated by the frontal heads of the near oxen; a sophisticated and brilliantly successful design. The fourth (fig. 22) is perhaps less successful but even bolder. The side of a ship, the *Argo*, shields along the gunwale, lies in a plane parallel to the background. In it stand two heroes playing the lyre (one no doubt Orpheus; a third figure is lost), and at either end, outside the ship, a horseman, the Dioscuri again: and all these figures are absolutely frontal like statues. The difficulties of realisation have not been overcome entirely, but in a

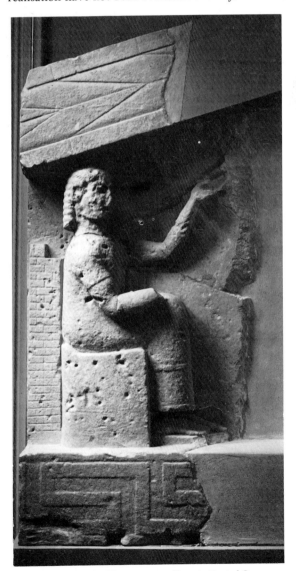

20 Limestone relief from same pediment. Seated figure attacked (Priam?, Rhea?). H. *c.* 0·62 m.

17

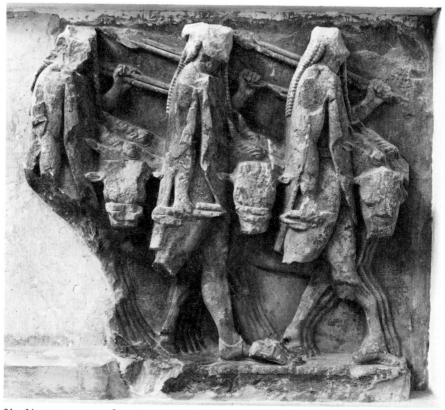

21 Limestone metope from Sicyonian *monopteros*, Delphi. Dioscuri and sons of Aphareus (one lost) on cattle raid. Second quarter of 6th century. H. 0·58 m.

22 Limestone metope, as last. The *Argo*.

23 Limestone metope from Selinus. Herakles and the Kerkopes. Mid 6th century. H. 1·47 m.

rigid and primitive form this is truly the concept of high relief: statues in the round grouped in a two-dimensional composition.[25]

The phase of confusion is strikingly illustrated in some metopes from a large Doric temple at Selinus in Sicily (fig. 23).[26] All the figures in the three complete metopes and many in fragments of others turn their faces directly to us, in total disregard of the action they are taking part in, as though smiling at the camera. Compare this rendering of Herakles carrying off the Kerkopes (mischievous goblins who had annoyed him) with the same scene on a metope from a building at Foce del Sele on the west coast of Italy not far from

Paestum, a sanctuary of Hera. The figures here are carved in a flat plane and in the profile view normal in low relief, which much better illustrates the narrative (fig. 24).[27]

The Doric temple became early popular in the western colonies and many more sets of archaic metopes are known from this area than from the homelands. It has been suggested that the carved metope was in fact a western idea only later imitated in Greece proper, and that the metopes from the foundations of the Sicyonian Treasury were not from a Sicyonian building but perhaps a Syracusan. This however is unlikely, and that the idea of decorating a

24 Sandstone metope from Foce del Sele. Herakles and the Kerkopes. First half of 6th century. H. 0·77 m.

25 Terracotta metope (?) from Reggio (Rhegium). Girls running or dancing. Third quarter of 6th century. W. 0·96 m.

metope with a figured scene goes back to the beginning of the Doric order is shown by the painted terracotta examples of the seventh century (above, p. 13). The buildings which these adorned were in large part of timber and terracotta, but they were true Doric temples like those in stone.

The dating of western sculpture is difficult, since there is certainly some provinciality. The lively and delightful pieces from Foce del Sele are in a style which finds its nearest parallels in minor arts, bronze and terracotta reliefs,[28] and seems outside the main line of sculptural development. They can hardly be very late in the first half of the sixth century. Selinus, to the far west along the south coast of Sicily, evidently became very rich very early, and of the many temples, some vast, which rose on its huge acropolis several belong to this early time.[29] Remains of at least two sets survive which must be older than those of 'Temple C' (fig. 23), but the date of those is hard to determine. One shows drapery-folds stacked in a way, based on observation, that becomes regular in Greek art around the middle of the second half of the century, but it is almost impossible to believe that the original date of these carvings is so late. It has been plausibly argued that the cutting of the folds (which is very shallow) was done during a retouching of the colour (something which must have been a regular operation; on colour see below, p. 28). The style of the figures is manifestly provincial and need not be so early as it looks at first glance, but it can hardly be after the mid century.

The gables of this temple were adorned with the huge Gorgon-masks in moulded and painted terracotta already mentioned (p. 16). Painted terracotta decorations for architecture are found in all areas of Greece in the archaic period and later; figure-work too, but that is far commoner in the west than in the rest of Greece and reaches its acme in Etruria. An enchanting Greek relief (metope or section of a frieze) from Reggio (Rhegium) with two running or dancing nymphs (fig. 25) shows in its sophisticated movement and modelling that it belongs later in the century, but from the fall of the hair we can see that here too the faces were turned towards us.[30]

Of the third type of architectural sculpture, the akroterion, we have fragments from the Acropolis of Athens: a Gorgon in marble.[31] All the architectural sculpture we have looked at so far is, like the buildings it adorned, in limestone (sandstone at Foce del Sele). The harder and finer material only made its way slowly in this field. The modelling of the Gorgon's face resembles that of the Dipylon head (fig. 15), and she stands to her perhaps slightly later sister of Corfu very much as that stands to the Delphi twins (fig. 16): the Attic works have perhaps less charm but more power. Fragments of this Gorgon's body show that she too was

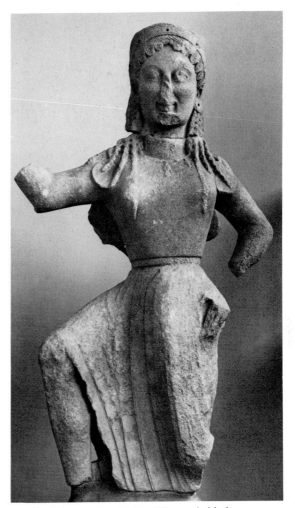

26 Marble statue from Delos. Nike, probably by Archermos of Chios. Mid 6th century. H. 0·90 m.

in the knee-run posture. Later akroteria are often such flying figures; it is a natural choice for the position high above the roof and was probably always common. Another marble figure of the type from slightly later, towards the mid century, is relatively well preserved: a winged Nike (Victory, fig. 26) from Delos. Near it was found a fragmentary base with a reference to Chios and names including Archermos. Pliny names Archermos in a family of Chiot sculptors, and another writer says he was the first to give Nike wings. Almost certainly in my view the statue belongs to the base and the two were the source of that story and of Pliny's apparently garbled family tree.[32] Others have thought the figure an akroterion, and one can be fairly certain that the idea of making a free-standing statue in motion was first developed in that architectural context. The figure is flatly composed, like an *ajouré* relief, and though head and breast front us the legs are in profile.

One sees here a complementary tendency to the influence of free sculpture on relief apparent in the evolution of high relief: a free-standing statue influenced by the conventions of narrative art.

One other type of statue is integral to the idea of a Doric temple, though not a part of it: the cult-statue within. A possible survivor is a colossal limestone head wearing a *polos* (small crown or hat) found outside the temple of Hera at Olympia. It probably comes from a throned statue of the goddess 'of simple workmanship' which Pausanias saw within the temple, Zeus in a helmet standing beside her. The columns of this building were originally of wood, replaced over the centuries by stone. Olympia has yielded magnificent bronzework from right through the archaic period, but stone sculpture there in this time is sparse and generally poor. This limestone head, for all its ambitious scale and care, seems hardly comparable in quality to the best work of the age in marble.[33]

3

Ripe archaic art

I. Sculpture: the rise and influence of an East Greek style

So far we have hardly looked east of the Aegean; and it does seem that the distinctive and influential East Greek style made a later start. The kouroi and early female figures all carry the aura of the block's four faces; the geometric basis of sixth-century East Greek sculpture is curved forms: sphere, ellipsoid, cylinder, cone. There are naked kouroi from the region, some from Samos colossal, but the marked preference is for clothed figures: an occasional draped kouros (something rare on the mainland or the Cyclades);[1] but female figures are far more frequent, and they show a concern with the rendering of stuff and its relation to the body, clinging or hanging free, quite different from anything we have yet seen.

The beginnings of the style appear in some ivories from the temple of Artemis at Ephesus.[2] They seem to date from the early sixth century, and while some are pure Greek others are almost purely oriental: a late phase of 'orientalising'. One of the most Greek, and most beautiful, is the so-called hawk-priestess (fig. 27), the handle of a wand topped with a hawk; the religion as well as the art of Ephesian Artemis was deeply impregnated with oriental elements. The round-faced, round-skulled head tops a body on which the skirt is almost a cylinder; and the cylindrical skirt reappears even more emphatically in a magnificent over life-size marble, now headless, dedicated a little later, perhaps already in the second quarter of the century, by one Cheramyes to Hera on Samos (fig. 28).[3]

Structurally there is some resemblance to Daedalic clothed figures of the previous century (Nikandre's dedication, the Auxerre girl) in that the composition is cut at the waist by a belt; a more primitive concept than the unifying pattern of the naked male torso. Like the Auxerre figure too, Cheramyes's lays one arm (the left) across her breast, while the other is held at the side. The right hand is closed on the cloak, the broken left no doubt on a bird or a fruit. The essential

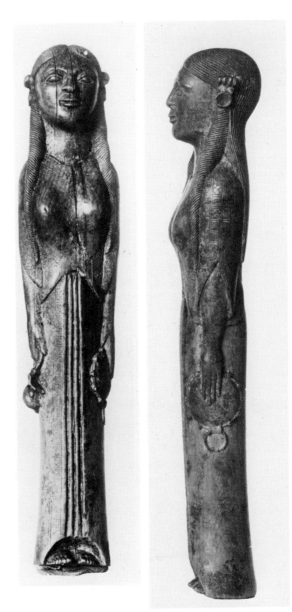

27 Ivory figurine from temple of Artemis at Ephesus. Handle of wand; 'Hawk Priestess'. H. 0·11 m.

23

character, however, is a world away from Daedalic angularity. On a basically cylindrical figure like the hawk-priestess's the swelling forms are modelled with far greater strength and subtlety, due not only to the slightly later date and much larger scale: this is the work of a great sculptor.

This figure also illustrates that other interest, in problems which scarcely seem to have presented themselves to sculptors in the rest of Greece: alike in the patterns discoverable in the pull and hang of clothes, and in the relation of clothes to the body beneath. This was to be the most influential East Greek contribution to the sculptural tradition. In Cheramyes's great figure the experiments are not perhaps perfectly integrated but show amazing boldness. On the back, quite without superficial decoration, the artist has concentrated on revealing the forms of the body, not adapted to a linear pattern but swelling in majestic simplicity under the smooth cloak which originally veiled the hair and falls almost to the ankles, held in the right hand and brought round under the left elbow to be tucked into the belt in front. The belly swells out under the belt, but the skirt falls thence to the feet free of the legs, and its simple cylinder, fanning out over the feet, is closely channelled in vertical folds which contrast with the smooth cloak (a scheme of oriental origin). It is in the treatment of the upper torso that the artist really shows his mettle. An upper garment is drawn diagonally across the breasts, revealing their broad forms and falling loose below them over the tight belt which it conceals at the sides, and it hangs in a shallow curve on the left hip, a long trail on the right. Where it hangs loose in front it is given wide, shallow vertical folds, plastically carved, and these are crossed by sharp-cut diagonal pleats. Such a play with different natures of fold in one area of drapery becomes a favourite ploy in the quite other conventions of Hellenistic sculpture (below, p. 199). It is scarcely found in the intervening period, but its presence here is no accident. This is the work of an exceptional artist, but he is only carrying further than usual ideas that occupy all archaic East Greek sculptors and are soon transmitted to those of other areas.

This masterpiece lacks its head; but if we look from the hawk-priestess to some marble heads of the later sixth century we see the beginning and end of the tradition in which it must have been made. Fig. 29 is from Ephesus, from a carved column-drum in the temple of Artemis (below, p. 40). Others are from similar drums in the temple of Apollo at Didyma, and there is one from a small statue at Miletus.[4] They show the same combination as the ivory and Cheramyes's statue: almost geometrically rounded forms with an extraordinary sensitivity of handling.

Two fragmentary statues with a strong superficial

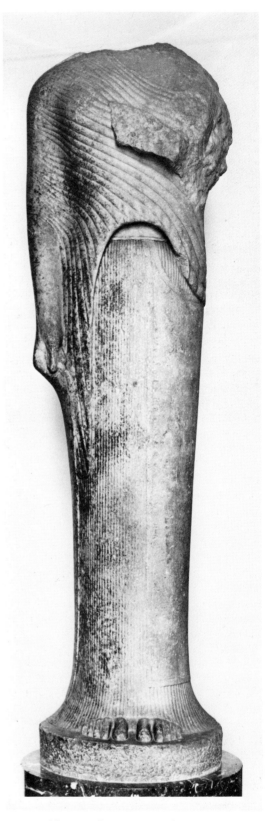

28 Marble statue from Samos. Dedication to Hera by Cheramyes. Second quarter of 6th century. H. 1·92 m.

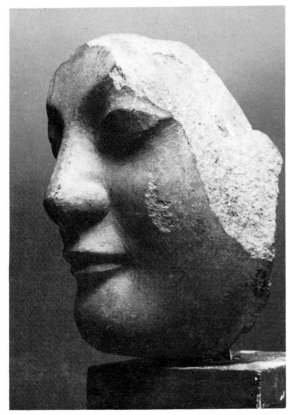

29 Marble face from temple of Artemis at Ephesus. Relief on column-drum. Second half of 6th century. H. 0·19 m.

resemblance to Cheramves's were found on the Acropolis of Athens; but they are much less subtle, squarer, and the head of one is preserved (fig. 30), long-faced, not at all in the East Greek mould. It somewhat resembles the Nike of Archermos (fig. 26), much more a colossal sphinx dedicated at Delphi by the Naxians. There can be little doubt that these are Naxian works, deeply influenced by the East Greek style and transmitting the first impression of that style to Athens where soon, as everywhere, its influence was to become pervasive.[5]

East Greek sculptors soon found ways to make drapery and its relation to the body more complicated. In the sanctuary of Hera on Samos a long base (fig. 31) bore, between a seated and a reclining figure, four standing, three certainly and perhaps the fourth too girls of varying age, each grasping her skirt in her right hand and holding it out, so that the folds curve and it is drawn tight against the left leg. Each figure bears its name, the seated Phileia also that of the sculptor Geneleos; the recliner, whose sex is uncertain (the name is mutilated) but is probably a man, is described as dedicator. It is a 'portrait' group, though the lost heads will not have been likenesses: a family (or, if all are women, a group of temple-servants).[6]

Seated and reclining figures are not uncommon in East Greece, and a massive simplicity is their usual character.[7] In some of the seated some play is made with clinging and hanging stuff, but the principal vehicle for this interest is the standing figure. When clothes were put on a kouros the forward step made for play between stuff and limb; the forward step and skirt pulled aside were combined in the creation, in the second half of the century, of a new type almost as regular as the kouros and known to us as kore, girl. Most often she stands with the left foot forward (a borrowing no doubt from the kouros, but it is not like his a full stride, rather so short a step as to seem like a dance-motion), left hand pulling the skirt to the side and letting a swag hang free, right forearm raised forward with an offering. She wears two garments: a long, short-sleeved shift of thin stuff, the chiton; and over that the himation, a heavy wrap brought over right shoulder and under left arm so that it makes a curved diagonal across the breast, an important accent in this complex design. Its heavy vertical folds mask much of the body and hang free under the right elbow, while the thin, tight-drawn chiton shows the legs almost as though naked.[8] Figs. 32–35 are all from the Acropolis of Athens, but the large 594 (fig. 32) is probably East Greek work. It displays the extraordinary virtuosity which this scheme encourages, but has at the same

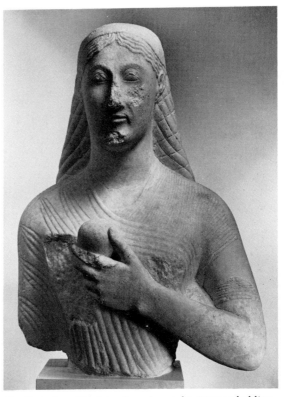

30 Part of marble statue from Acropolis. Woman holding offering. Second quarter of 6th century. H. 0·54 m.

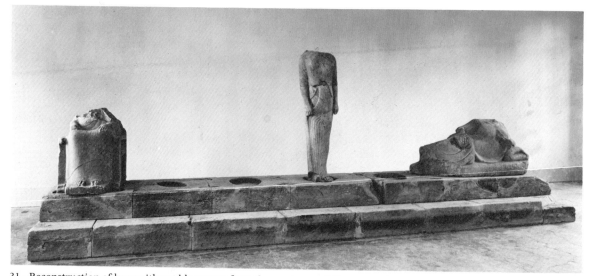

31 Reconstruction of base with marble statues from the sanctuary of Hera on Samos. Carved
by Geneleos and representing Phileia, Philippe and . . . rches (or possibly . . . rche), the dedicator;
Ornithe also survives. Towards middle of 6th century. H. of standing Philippe 1·61 m.

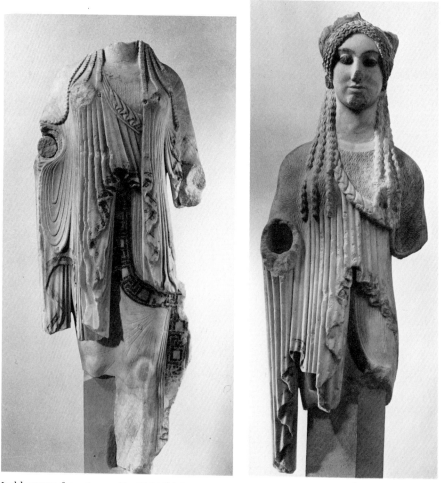

32 Marble statue from Acropolis. Girl. Third quarter of
6th century. H. 1·23 m.

33 Marble statue from Acropolis. 'La
delicata'. Late 6th century. H. 0·92 m.

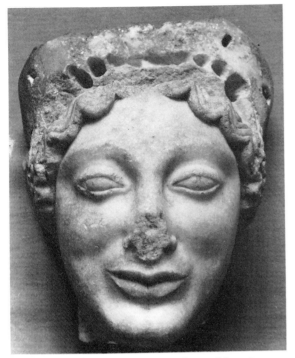

34 Marble head from Acropolis. Girl. Late 6th century. H. 0·16 m.

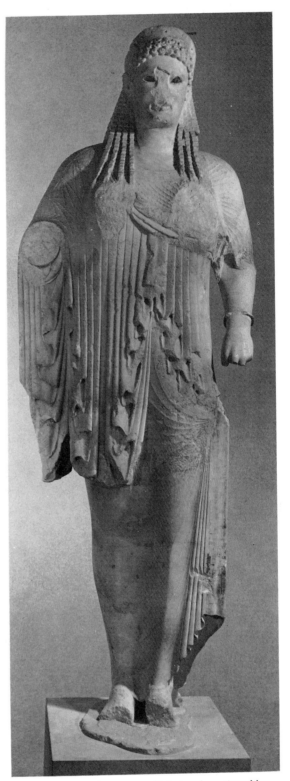

35 Marble statue from Acropolis (set on base signed by Antenor son of Eumares). Last quarter of 6th century. H. 2·55 m.

time great sculptural power. More typical is 674 (fig. 33): small, elegant, pretty, slight; but the face 643 (fig. 34) shows how much strength, as well as exquisite subtlety, can be achieved in this style. 681 (fig. 35), a little earlier than these last (which must belong to the very end of the century), is exceptional in being very large and in having the virtuosity deliberately played down, flattened out, in an attempt which could hardly be quite successful to monumentalise the type.[9] There are innumerable variations on the basic scheme,[10] but more satisfying than any is Acropolis 679 (fig. 39).

Influence from East Greece becomes general in the second half of the century, not least in Attica, but there native tradition remains powerful too. We have more archaic sculpture from Athens than from anywhere else. An economic and political crisis around 600 was resolved by the reforms of Solon. His economic measures bore fruit, but the constitution was overturned by Peisistratos, who made himself tyrant early in the second quarter and held power (with interruptions) and his sons after him till the expulsion of Hippias in 510. They were patrons of the arts, and the Acropolis became covered with dedications and decorated buildings. These were thrown down by the Persian invaders in 480, and shattered remains preserved for us in terraces and foundations of the fifth century.

We noticed the early Gorgon-akroterion in marble (above, p. 21). Most of the architectural sculpture from

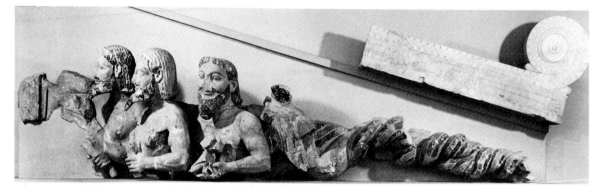

36 Limestone pediment-figure from the Acropolis. Three-bodied *daemon*. Second quarter of 6th century. H. *c.* 0·90 m.

the Acropolis is in limestone: pediments, some from small buildings, some from large temples. The small ones show mythological scenes,[11] but from the temples are several groups of lions pulling down bulls: terror-symbols analogous to the Gorgons and leopards at Corfu.[12] The latest of these (very fine) was probably flanked by two mythological groups: Herakles and Triton, and a three-bodied man–snake of uncertain identity (fig. 36). These are still before the mid century, and the splendid style is closely paralleled·in a marble work of subtler finish, the statue of a calf-bearer (fig. 37) dedicated by one Rhombos (probably; the beginning of the name is lost).[13] The powerful structure is in the direct tradition of early Attic heads (fig. 15), but has been brought far closer to natural forms. The man stands like a kouros, left foot forward, but differs from one not only in the calf and the arms raised to hold it, but in having a beard and a cloak. The garment leaves the front of the body bare, and clings tightly to the parts it does cover, marked only by the hems and a tiny free hang below the elbows. Cloak and beard are symbolic, turning the traditional statue (naked youth) into a 'portrait' of the dedicator making his eternal offering. The artist has achieved more than that though; he has created a real group. You cannot think the calf away: man and beast are integrated into one whole; and there is an intimacy and charm, reached partly by a slight shift off centre of the man's head, a slight tilt of the animal's. The eyes were inlaid (so also 681, fig. 35, where there are remains of glass and a metal socket), and hair, beard, cloak, calf will have been painted. The limestone sculpture (fig. 36) is covered with paint, but other marbles preserve much colour and show that it was more selectively applied, the skin being left in the bare marble, the texture of which can be sensed also through the colour. Colouring is unnaturalistic: blue beard on fig. 36, carmine hair on fig. 39.[14]

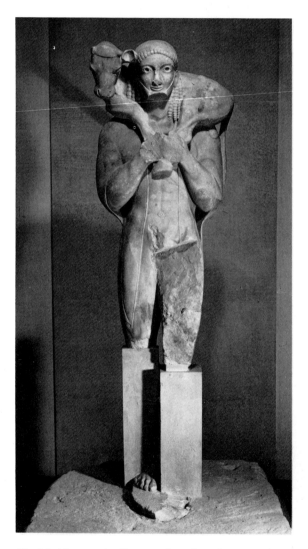

37 Marble statue on limestone base from the Acropolis. Man carrying calf (the *moschophoros*), dedicated by [Rh]ombos. Second quarter of 6th century. H. of figure (head to knees) 1·65 m.

There are very many sixth-century kouroi from all over the Greek world. They form an incomparably useful line on which to trace the gradual mastery of natural forms, and a few of them are great works of sculpture. One of the grandest is a colossal torso of the mid century from Megara (fig. 38): all the power of the youth from Sunium (fig. 14) with a new subtlety.[15] The calf-bearer is one of the comparatively few male figures dedicated on the Acropolis. The long series of girls begins before that with some rather blockish figures in the simple symmetrical belted dress of mainland tradition.[16] Around the mid century the new complex fashion comes in from East Greece, but later than the first of these is the last of the old, the exquisite 'Peplos kore' (679, fig. 39). Here the Athenian artist (the face is directly in the tradition of the calf-bearer) has learnt from beyond the Aegean to realise the body under the clothes but has rejected the elaborate

38 Marble torso from Megara. Youth. Mid 6th century. H. 2·00 m.

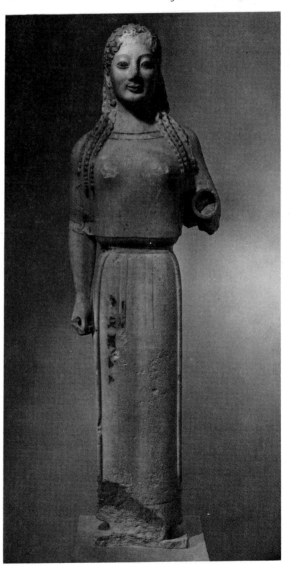

39 Marble statue from the Acropolis. 'Peplos kore'. Third quarter of 6th century. H. 1·20 m. ▶

schema. Face and figure are vibrant with life, yet seem in no way constricted by the old formal structure. This masterpiece gives us the classical moment of the archaic style.[17]

The last archaic temple on the Acropolis, built by the sons of Peisistratos perhaps around 520, had marble pediments, one a group of lions and bull, the other a battle of Gods and Giants; fine work but horribly ruined.[18] Not much later the temple of Apollo at Delphi was rebuilt. The contractors were a rich aristocratic family of Attica, the Alkmaionidai, exiled for opposition to Peisistratos, and they evidently employed an Attic artist.[19] The west pediment, a Gigantomachy, was in limestone, but the east front was finished in marble. The pediment showed a rather stilted composition: a frontal chariot, probably an epiphany of the god, flanked by kouroi and korai, groups of lions pulling down stags in the corners. The korai, and a fine Nike-akroterion, are strikingly like the big kore 681 from the Acropolis, fig. 35. The base on which this is probably rightly set bears the signature of Antenor. He, we know, was employed by the young democracy of Athens at the end of the century to make bronze statues of the Tyrannicides – two aristocrats who had failed in an attempt on the life of Hippias but killed his brother Hipparchos. The same man might well have worked for the Alkmaionidai in exile.

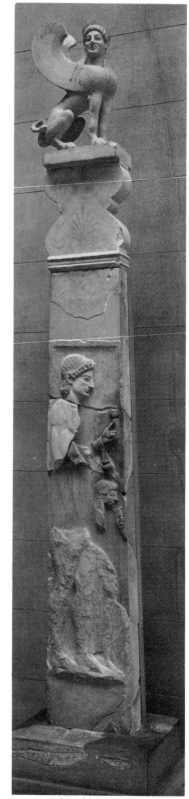

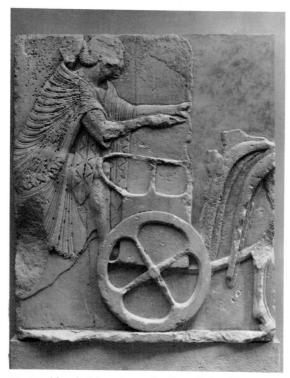

40 Marble relief from Acropolis. Part of frieze (?): charioteer. Late 6th century. H. 1·20 m.

41 Reconstruction of marble gravestone from Athens. Sphinx; brother and sister. Third quarter of 6th century. H. 4·24 m.

None of these Athenian Doric temples had carved metopes, but fine big relief-slabs from the Acropolis (fig. 40) seem architectural and have been thought part of a continuous frieze from the Peisistratid temple, like that of the fifth-century Parthenon. The style, however, seems decidedly later than that of the pediments and the pertinence is not sure.[20] These slabs are carved in low relief, which is also used on a series of Attic tombstones.[21] We noticed that some graves in the eighth century had a plain stone beside the big Geometric vase. About the time of the early Attic kouroi, some of which (e.g. fig. 15) stood on graves, a fashion begins for a tall, narrow tombstone supporting a sphinx. Later the stele is adorned in low relief, sometimes still with a sphinx (fig. 41), sometimes with simpler palmette-finial. Generally there is a single figure, as suits the shape and purpose, but sometimes a second is added, as in fig 41: brother and sister, as the epitaph tells us, the monument erected by their parents. Reliefs or statues on Attic graves in this period seem to have been a fashion among the rich aristocracy, especially for those who died young. The statues (a late example, fig. 72) seem always to have been undifferentiated kouroi or korai, but the stelai, perhaps because low relief belongs essentially to narrative art, show the dead man bearded or beardless and often as warrior or athlete. Splendid examples are a youth with a discus and a bearded boxer, his hand bound with thongs, the face almost a portrait as we understand the term. The quality can be very fine indeed, as in the exquisite youth's head, fig. 42. Women's stelai are much less common, and a broader format is sometimes, perhaps regularly, used, the

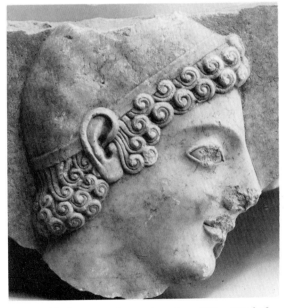

42 Marble fragment of gravestone from Attica. Head of youth. Third quarter of 6th century. H. 0·25 m.

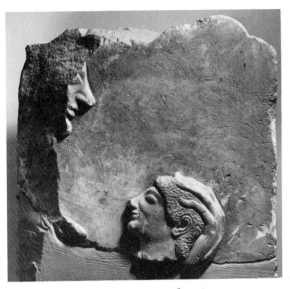

43 Fragment of marble gravestone from Anavysos (Attica). Mother and child. Third quarter of 6th century. H. 0·38 m.

figure seated; so the lovely mother and child, fig. 43.[22]

Low relief was also used for bases, of statues (fig. 94) or of stelai (fig. 44). The heads of these charming horsemen are so like that of the boxer that one might think his was the stele this base supported.[23]

Statue-bases and stelai from Attica are sometimes signed, and the artist sometimes indicates that he is not Attic but Cycladic, at least in origin (so Aristion of Paros).[24] Much fine sculpture of the period has been found on Paros and Naxos as well as other islands, especially kouroi and korai.[25] There is a big series of kouroi from Boeotia, others and other types from the Peloponnese and elsewhere.[26] Samos has yielded stelai with floral finials but no figures;[27] Laconia an uncouth series of limestone reliefs, gravestones or dedications to the heroised dead.[28] There are beautiful marbles from Cyrene in Libya;[29] and the west has produced other things besides the architectural sculptures noticed in the last chapter.[30] In the next chapter we shall touch on archaic sculpture again, but there is no room to do justice to all its riches.

II. Painting and vase-painting

By a rare chance some fragmentary wooden panels with pictures of high quality, datable to the third quarter of the sixth century, have been found in a cave at Pitsa near Sicyon.[31] They are small easel-pictures, but stand clearly apart from vase-painting and in the tradition of wall-painting as we glimpsed its beginning on the Chigi vase (fig. 18) a century earlier. The most complete (fig. 45) is a charming picture of a family going to sacrifice at an altar. The ground is white, and

44 Marble relief from Athens. Base of grave-stele: horsemen. Mid 6th century. L. *c.* 1·00 m.

45 Wooden panel from cave at Pitsa, near Sicyon. Painting: family going to sacrifice; dedicated to the Nymphs by a Corinthian. Third quarter of 6th century. H. 0·15 m.

on it women's skin is outlined in red, men's and boys' in black filled in with a pinkish colour, the same distinction as on the Thermon metopes (above, p. 13), and clothes are in flat washes of clear, bright red and blue. Names are written beside the figures in the Corinthian alphabet, and a dedication to the Nymphs by a Corinthian whose name is lost. The writing on the background, the figures all in profile, their feet all on the base-line: these are the same conventions as are kept in contemporary vase-painting, but the effect is wholly other; not only in colouring but in composition. The figures are irregularly spaced and of varying heights, like those on the much earlier Argive fragment (fig. 17).

Before the end of the seventh century the black-figure convention had been accepted by Attic vase-

painters to the virtual exclusion of any other, even when they painted flat plaques analogous in intention to the wooden ones. Corinthian vase-painters use more colour, and on plaques approximate to the manner of panel painters.[32] Some other centres produced figured vases in outline and polychromy. Athenian work, however, dominates sixth-century vase-painting, not only by the quantity produced and exported but by the superb quality of the best.

The first Attic black-figure coincides with the last phase of the old Geometric and orientalising tradition of the monumental grave-vase. Comparing the Gorgons on the body of the amphora fig. 46[33] with those in fig. 9, or the better-preserved pictures on the necks of the two vases, one sees why vase-painters felt black-figure a better decorative system for their

46 Grave-amphora from Athens. Attic black-figure: Gorgons; Herakles and Nessos. Name-vase of the Nettos Painter. Late 7th century. H. 1·23 m.

curved surfaces. This type of grave-marker, however, now gave place to marble monuments, and the masterpieces of sixth-century black-figure are on a more modest scale. After a generation in which we can detect only rather humdrum work in the Kerameikos,[34] the Athenians established their supremacy in the second quarter of the century. For us the key piece of this period is the François vase (detail, fig. 47), found in an Etruscan tomb at Chiusi; Athens is now capturing the western market from Corinth. It is more than two feet high, a very big vase for its time but little more than half the height of the grave-vase fig. 46. In place of the few massy figures on that we see scores of small ones, ranged in six registers which give us seven stories from legend as well as a band of animals and florals, a battle of Pygmies and cranes on the foot, and other figures on the flat of the handles. Everyone is named (many things too) and on each side are the signatures of the potter Ergotimos and the painter Kleitias, who share a wonderful precision of eye and hand, combining elegance with strength. Besides the detail I illustrate (fig. 48) a fragment of another vase painted by Kleitias and dedicated on the Acropolis, where the surface is better preserved.[35]

The François vase is a krater (mixing-bowl for wine and water), a shape with many varieties of which this, with high-swung volute-handles, only becomes re-

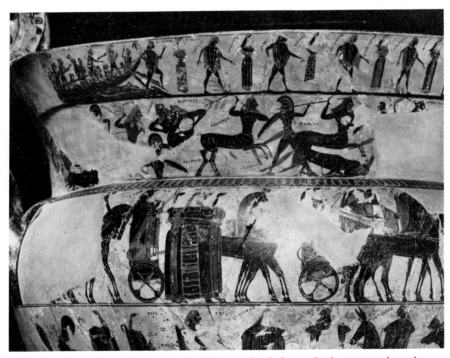

47 Volute-krater from Chiusi. Attic black-figure: detail, dance of Athenian youths and maidens at Knossos, Centauromachy, procession of gods at wedding of Peleus and Thetis. 'François vase', signed by potter Ergotimos and painter Kleitias. Second quarter of 6th century. H. of part shown *c.* 0·30 m.

gular in clay later. Ergotimos had looked to a metal model (a slightly later example is the superb huge bronze from Vix, fig. 58), but he has rethought it in his own medium. Kleitias's style tends to miniaturism, and a miniature tradition develops from it, especially on cups. The type of cup commonest at this time is shown in fig. 49, by a decent but less distinguished painter, whose love of rich colour, red and white, links him to Corinth. Ergotimos and Kleitias seem to be the in-

ventors of a more elegant type, the 'Little Master', which in the next generation settled into two forms, 'Lip-cup' (fig. 50) and 'Band-cup' (fig. 51). They are decorated in a miniature style, and the name 'Little Master' derives from the German use of *Kleinmeister* for the minor artists around Dürer in the sixteenth century.[36] An integral part of lip-cup decoration is an inscription, often a signature. One potter names Ergotimos as his father; and Tleson, who signed the cup in fig. 50 as well as many of the best others, names Nearchos as his. We have works signed by Nearchos both as potter and painter (fig. 52).[37] This lovely fragment from a larger drinking-vessel, the kantharos (one is held by Dionysos often, as in fig. 56), shows how Kleitias's elegant strength could be raised to monumental weight and power; and it is this combination that marks the central tradition in Attic black-figure. One painter who carried it on was Lydos, active from before the middle of the century (fig. 53) for many years;[38] a younger and greater, potter as well as painter (but see below, p. 68) is Exekias (figs. 54, 55).[39] Figs. 53 and 54 are plaques, not dedications (like the Pitsa panels and many clay pieces) but facings from built tombs, the last ceramic monuments among the marbles of sixth-century Attic graveyards. These are serious painters, Exekias (like Nearchos before him) showing sometimes a sensitivity of feeling one would hardly have thought attainable in this formal decorative medium. An agreeable contrast is furnished by the light-hearted productions of an exquisite artist who worked with, and may have been identical with, a potter Amasis (fig. 56).[40] The surface of this vase has

48 Hydria-fragment from Acropolis. Attic black-figure: Nereids. Attributed to Kleitias. Second quarter of 6th century. H. of part shown *c.* 0·09 m.

52 Kantharos-fragment from Acropolis. Attic black-figure: Achilles harnessing his chariot. Signed by Nearchos, painter and potter. Second quarter of 6th century. H. 0·15 m.

49 Kylix from Siana, Rhodes. Attic black-figure: warriors leading horses. 'Siana cup', attributed to C Painter. Second quarter of 6th century. H. 0·14 m.

50 Cup from Vulci. Attic black-figure: satyr. 'Lip-cup' signed by potter Tleson son of Nearchos and attributed to the Tleson Painter. Third quarter of 6th century. H. 0·15 m.

51 Cup from Vulci. Attic black-figure: battle. 'Band-cup' signed by potter Glaukytes. Third quarter of 6th century. H. 0·22 m.

and clumsy imitations of Attic in Boeotia and Euboea.[43] There are also independent traditions in the Cyclades and East Greece;[44] but the central line of vase-painting is now and for many years to come in Athens.[45]

III. Other arts

During this period Greek sculptors learnt, no doubt from the East, to hollow-cast bronze statues on a large scale. Almost nothing survives, however, and the real significance of this immensely important development comes later (below, p. 51). Bronze statuettes, often very fine, continue to be cast solid, and these are often very bold and free in pose and structure. Here, as in pediment-groups and the high relief of metopes, sculptors worked out ideas which ultimately undermined the accepted conventions of archaic art.[46] Such statuettes often adorned vessels. One such vessel, the masterpiece of archaic metal-work, is a prodigious volute-krater (the shape of the François vase but two and a half times as high) found in the grave of a Gaulish princess at Vix on the upper Seine (fig. 58).[47] The grave is of the late sixth century, but the krater was probably

53 Plaque from tomb-facing at Spata (Attica). Attic black-figure: men lamenting at funeral. Ascribed to Lydos. Mid 6th century. H. 0·37 m.

suffered, but the figures on the right show the skilful, sophisticated rendering of this roistering scene. If the mood contrasts with Exekias's hieratic death of Penthesilea (fig. 55), the handling sets it off as sharply from the no less charming but more rustic picture in fig. 57. This is an early example of a class made outside Athens from before the middle of the century till towards its end. Known as 'Chalcidian' from the alphabet its painters use, it was probably made by Greek colonists in South Italy.[41] Analogous to these are some fine vases, all of one shape (hydria, water-pot) and decorated probably by only two painters, found mostly at Caere in Etruria and probably made in the Greek quarter there.[42]

Good black-figure cups were produced in Laconia,

55 Neck-amphora from Vulci. Attic black-figure: Achilles and Penthesilea. Signed by Exekias as potter and ascribed to him as painter. Third quarter of 6th century. H. 0·41 m.

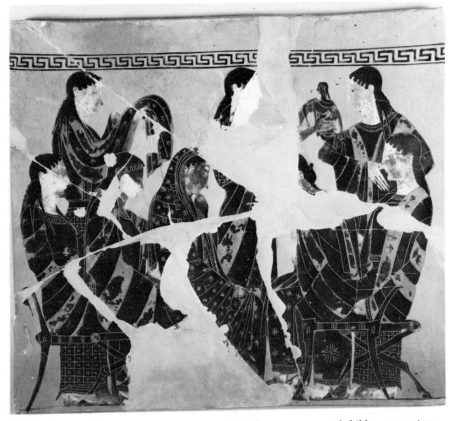

54 Plaque from tomb-facing in Athens. Attic black-figure: women and children mourning. Ascribed to Exekias. Third quarter of 6th century. H. 0·37 m.

56 Amphora, probably from Vulci. Attic black-figure: Dionysus dancing with satyrs; satyrs and nymphs. Ascribed to potter Amasis and the Amasis Painter. Third quarter of 6th century. H. of picture c. 0·16 m.

57 Psykter-neck-amphora from Caere. Chalcidian black-figure: satyr and nymph. Ascribed to Inscriptions Painter. Mid 6th century. H. of picture *c.* 0·16 m.

58 Volute-krater with sieve-lid from Vix (Upper Seine). Bronze: warriors and chariots; Gorgons and lions on handles; girl on lid. Mid 6th century. H. 1·64 m.

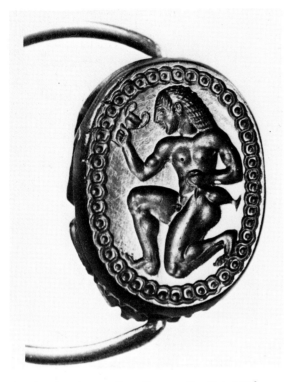

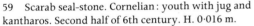

59 Scarab seal-stone. Cornelian: youth with jug and kantharos. Second half of 6th century. H. 0·016 m.

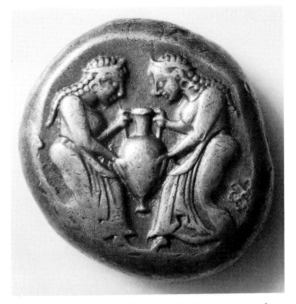

60 Coin of Macedonia. Silver tetradrachm: two nymphs with wine-jar. Late 6th century. D. 0·02 m.

made some decades earlier, most likely in Laconia though some argue for a South Italian colony. Without this single find in a remote country we should only have doubtful knowledge, from some remarks in Herodotus, of archaic decorative metal-work on this scale. Another archaic art-form known to us only from one find is the gold-and-ivory cult-statue: not on the vast scale of Pheidias's creations in the next century (below, p. 102), but fragments of several life-size figures have been found buried under the Sacred Way at Delphi, probably from a burned treasury.[48]

The series of bronze statuettes is paralleled by terracottas, slighter, poorer work as a rule but some

very fine.[49] A small-scale art which reaches the heights is that of seal-engraving.[50] After the dark age this was revived in the seventh century, evidently under the influence of Bronze-age stones, and the centre of production seems then to have been the Cyclades (above, p. 8). It is especially in East Greece that in the middle and later sixth century engravers (like two Samians, Theodoros and Mnesarchos, father of the philosopher Pythagoras) produce the first tiny master-pieces of this art which is to flourish on through classical and Hellenistic times. Fig. 59, an Ionian reveller, or perhaps rather serving-boy, with cup and jug, may stand for them; as may fig. 60 with its charming nymphs and their wine-jar, for the related craft of die-sinking. This is a silver coin of Macedon.[51]

4

The great change: late archaic and early classical

I. Late archaic architectural marbles

Work like the Peplos kore (fig. 39), Exekias's neck-amphora (fig. 55) or the Vix krater (fig. 58) show archaic Greek art in its assured prime: craftsmen who are masters of their craft can develop their styles and express what they want happily within the general limitations of inherited convention. In the work of the next generation or two one often feels that this balance is lost or only precariously preserved. Sculptors of korai seem often content with virtuosity and prettiness which can become trivial (cf. fig. 33); or if, like Antenor in fig. 35, they try to monumentalise the form, the effect is uneasy. In much of the best late sixth-century work one senses a struggle, the artist hardly able to contain his vision within the conventions he has not yet brought himself to break. There are hints of this even earlier. It seems a miracle that Exekias can make black-figure carry all he puts into it, while sculptors working on the decoration of buildings sidestep the conventions they respect in their independent statues. A particularly instructive example is not a temple but an exquisite and in part well-preserved little marble building, the treasury set up at Delphi by the islanders of Siphnos. We know enough of the historical background to be sure that it was built little before 525 B.C.[1]

Such 'treasuries' abound at Delphi and Olympia: a small building raised by an individual city to house offerings and to glorify the place which erected it. They are like miniature temples: one gabled room, entered through a columned porch but without a surrounding colonnade. The buildings we have looked at so far have all been 'Doric', the order (style) evolved for temples in mainland and western Greece (above, p. 15). During the sixth century another order, 'Ionic', was brought into being east of the Aegean. While all early Doric temples are in limestone (generally with a wash of marble-stucco) Ionic from the start are usually in marble; and the harder, finer stone encourages a taste, not found in Doric, for marking junctions with

bands of delicately carved ornament. Other related differences are in the number and nature of flutes on a column, which has a moulded base as well as the complex volute capital, and the division of the architrave into three registers. An example from the later fifth century is illustrated in fig. 166. At frieze-level there are not triglyphs and metopes but usually a row of small, close-set blocks, dentils, which offer no field for figure-carving. There is more variety of design between buildings than in Doric, and at first no regularly accepted positions for sculptural decoration. Some temples are on a huge scale, unparalleled on the mainland, with a forest of columns suggesting, and no doubt suggested by, Egyptian or Near-Eastern buildings. Such are the temples of Hera on Samos, Artemis at Ephesus and Apollo at Didyma near Miletus; the last two with sculpture of which only tantalising scraps remain. Both had some drums of some columns carved with figure-scenes (above, p. 24 with fig. 29), and both stretches of low relief carved on a continuous band: at Didyma parts of the architrave, at Ephesus parts of the gutter. A frieze in relief along all four sides of the building was to become the accepted vehicle for figure-sculpture in classical Ionic, but in a different position from either of these: above the architrave, either below the dentils or replacing them (fig. 166), corresponding to the metopes and triglyphs in Doric.[2]

The first building so adorned which we know of is the Siphnian treasury, which is Ionic in character though it lacks the typical capitals, since instead of columns in the porch it had two Caryatids: supports in the form of girls, here canonical korai of immense elaboration.[3] The pediments also bore sculptures, but those from the front are lost while those from the rear, for whatever reason, are markedly inferior to the rest of the work.[4] The importance of the building for the history of sculpture lies in its superb frieze, or rather friezes, since the four sides have different subjects and show two distinct styles.[5]

The building, which faces west, lies below a turn in the Sacred Way which zigzags up the steep site to the

61 Marble relief from Siphnian Treasury. South frieze: chariot; altar. Shortly before
525 B.C. H. 0·64 m.

temple, on a little terrace just above the south wall of the sanctuary. The west frieze was in three slabs. Hermes at the left end holds the winged horses of Athena's chariot which she is mounting; on the central slab another goddess, almost certainly Aphrodite, steps down from a chariot which faces the other way. The southern slab is lost, but the design seems to demand a third chariot. It may have been Hera's, the scene connected with the Judgement of Paris. Chariots and horses are designed in strict profile and carved with great skill in a series of recessed planes parallel to the background. It is exquisite work of an artist content with the archaic tradition, and the same designer is clearly at work on the fragments of the long south frieze (chariots, horsemen, an altar; fig. 61).

The long north frieze shows a Gigantomachy, and on one Giant's shield is cut a signature. It was deliberately defaced in antiquity, but though we cannot read the sculptor's name we can make out that he carved these figures 'and those at the back', the east frieze that is. We do not in fact need this document to tell us that on these two sides we are in the presence of a different master from him of the west and south. The recessed planes are used in places, but more often they

are broken up by bold three-quarterings and massings which give a quite different sense of the third dimension. The depth of carving is not significantly different, but this artist is clearly strongly influenced by the concept of high relief evolved in metope-sculpture (above, pp. 17ff.). Design and execution throughout are of the highest quality; but while the artist of west and south is an untroubled archaic, the other is in the van of those whose innovations were to lead to the classical revolution. The east frieze has a combat before Troy (some painted names of heroes can still be read), and an assembly of gods no doubt disputing its outcome. The combat is flanked by chariots (fig. 62), which present the sharpest possible contrast with those of south and west. The teams are shown as though turning into three-quarter view, the charioteer appearing behind them, and the chariots are not carved at all but finished in paint on the background in bold foreshortening. Painters were no less involved than sculptors in the breakdown of archaic conventions, and this shows how closely they could work together. Here one would think, and perhaps often, they were the same man (see also below, pp. 64ff.).

The combat is on the right, the assembly on the left;

41

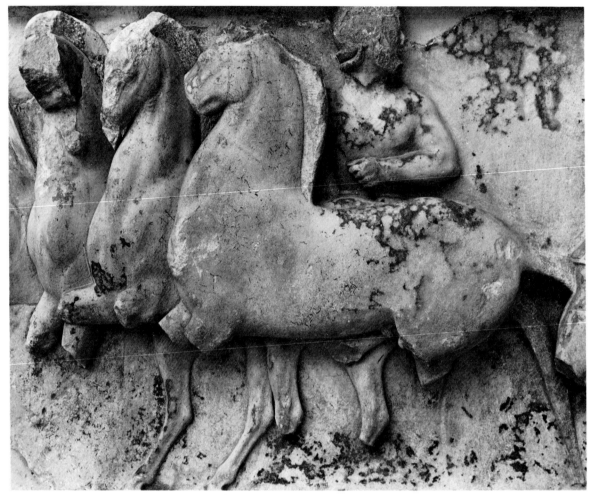

62 Marble relief from Siphnian Treasury. East frieze: charioteer and team. Shortly before 525 B.C. H. 0·64 m.

and looked at in isolation this abrupt division of the continuous frieze appears awkward. When one thinks, however, that coming up the Sacred Way one's first sight of the building would be the corner, the long Gigantomachy stretching in front of one, the combat of the east abutting on it and the seated gods closing the composition at the end, one understands that it is so designed to suit its position; as the formal archaic structure of the west frieze suits the highly decorated frontally approached entrance-façade. Much thought must have gone into the adornment of this little building.

North and east friezes of the Siphnian treasury stand at the beginning of the late archaic movement which culminated in the classical revolution. To the end of that phase belongs the sculpture of another treasury, built a little higher up the sanctuary slope by the people of Athens.[6] It stands on a terrace the top step of which bears an inscription recording a dedication for the victory over the Persians at Marathon

in 490. Pausanias thought this applied to the building. Some scholars follow him, but the step certainly carried offerings, and the style of the building-sculptures is often felt too early for that date. It has been thought a monument of the new democracy, immediately after the expulsion of Hippias in 510; by others placed, perhaps most convincingly, somewhere between the two, around 500. The marble building is Doric, and there was figure-sculpture, now terribly ruined, for akroteria, pediments, and a full circuit of thirty metopes, six on each end, nine down each side. Hardly anything survives from the gables. The akroteria included mounted Amazons, a theme which carries on from the metopes. These had deeds of Herakles and Theseus, and an Amazonomachy, presumably that at Themiscyra, the city of the Amazons, where Theseus accompanied Herakles on his quest for Hippolyta's girdle and himself brought back an Amazon bride, Antiope. There is little legend attached in early times to the name of Theseus; and his build-up

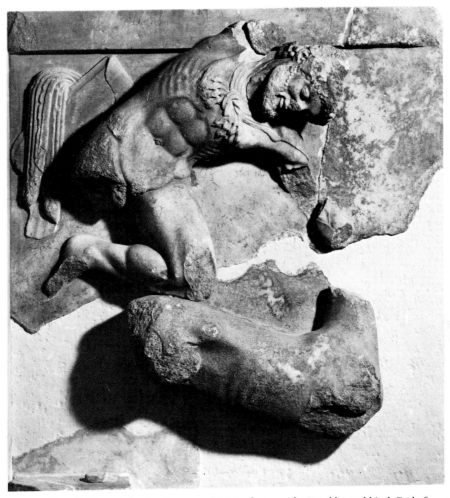

63 Marble relief from Athenian Treasury. Metope from north: Herakles and hind. End of 6th or beginning of 5th century. H. 0·67 m.

at this period as a companion and analogue of Herakles seems as a propaganda-figure for the Athenian democracy.

The carving, of superlative quality, shows two styles, analogous to the two styles on the Siphnian treasury though the difference here is less marked. Some metopes, for instance the beautiful and comparatively well preserved Herakles and the hind (fig. 63), show a precise, linear definition of forms in the archaic tradition. The broader, freer modelling in others, such as the Theseus and Amazon (fig. 64), looks forward to the classical style. The tight circle of the composition in the hind metope is relaxed here too, and the tilted heads inform the figures with a tragic emotion lacking in the other. All however show the full development of the idea of high relief: figures given the bodily roundness of statues but grouped in pictorial compositions against the background to which they are attached.

These metopes are small, not much more than two feet high. Theseus is shown again at just about the same time, lifting Antiope into his chariot, an over life-size group from a pediment (fig. 65). The complexity of action and posture demonstrates the liberties sculptors were prepared to take with archaic conventions in the context of gable-structure. The execution is elaborate almost to the point of fussiness or mannerism, in strange contrast to the bold strength of form and movement. The group is from the pediment of a temple of Apollo at Eretria in Euboea.[7] The rare story, part of the new Athenian Theseus-legend, is briefly popular on Attic vases at just this time. Athens and Eretria were the two cities west of the Aegean which sent help to the Ionians in their ill-fated revolt of 498 against the Persians, and were the object of Persian vengeance in 490. The two cities were evidently closely linked; and one might possibly see, in the apparent contradiction here between structure and detail, an Athenian artist's design executed by craftsmen trained in another tradition.

43

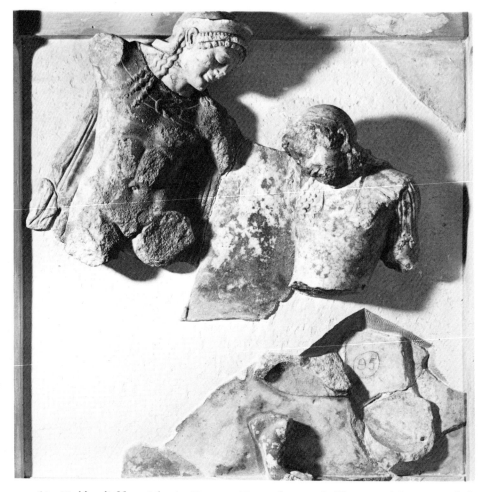

64 Marble relief from Athenian Treasury. Metope from south: Theseus and Amazon. End of 6th or beginning of 5th century. H. 0·67 m.

Only fragments of this composition survive. The most important other piece is an upper torso of Athena, who occupied the centre of the gable. Theseus and Antiope are finely finished all round; but the back of Athena is left rough (an important document for archaic technique) and she clearly stood in the old formal kore-pose.[8] One might be surprised to find Athena dominating the pediment of a temple of Apollo. It was the rear gable, but in any case the Greeks seem to have been less concerned than we should expect to relate the decoration closely to the temple's deity. Athena bears on her breast here a huge Gorgoneion, which perhaps deliberately recalls the terror-mask at the centre of early pediments (fig. 19); but the goddess is present here probably as part of the legendary scene: the hero's divine helper. We see her so with Theseus again on a near-contemporary Attic cup (fig. 98); and it is presumably in the same role that she dominates the latest and best preserved of all archaic pediments, at the two ends of a temple on

Aegina, dedicated to Aphaia, a local deity associated with Artemis rather than Athena.[9]

Here we have no historical grounds for dating, but the work is clearly on the border of archaic and classical. The temple was Doric. It had akroteria (at the centres elaborate florals supported by small korai, sphinxes at the outer angles); metopes not carved but perhaps painted panels; and marble pediments, each with a battle, Athena in the centre. Almost certainly these illustrate the two sieges of Troy: by Herakles over the east front and the Homeric in the west. Herakles was accompanied by Telamon, an Aeginetan hero whose son Ajax was prominent in the second siege. The style of the west is pure archaic and distinctively earlier than that of the east. The example of the Delphic treasuries shows that it is not safe to assume that it is actually earlier in date, but it probably is so. There is evidence that the present east gable is a replacement, made very soon, for another, likewise with a battle, which seems then to have been set up on

44

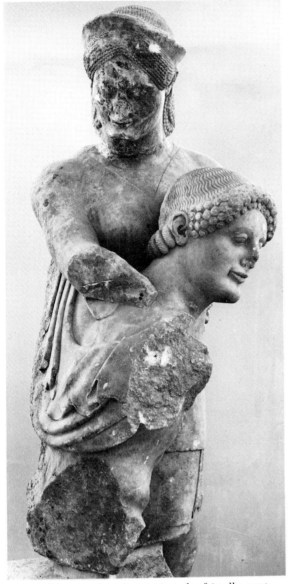

65 Marble group from Eretria. Temple of Apollo, west pediment: Theseus abducting Antiope. End of 6th century. H. 1·10 m.

a base in the sanctuary, its centre akroterion also. The remains of these figures resemble the present west pediment in style. This raises questions at present unanswerable, and complicated by the existence of a second long base in the sanctuary which seems to have supported a pursuit-scene (possibly Zeus and the Nymph Aegina on whom he begot Aiakos, Telamon's father); and this might have been a first *west* pediment.[10] Here we can consider only the final versions.

The Athena of the west (fig. 66) stands almost as a kore, only her left foot is turned to the side. The battle rages on either side of her in two self-contained halves which balance each other closely: a combat; an archer

shooting towards the angle; a crouching figure despatching a fallen one; a figure, his head towards the angle, struck down by the bowman's shaft; and beyond him, in the corner, gear (a shield, a helmet). At a glance the design of the east (fig. 67) looks similar, but it is both less crowded and knit more subtly into a whole. Athena (largely lost) moved to her left, aegis stretched out before her. In the combats on either side of her the outer figure falls back and another bends swiftly forward to support him. The archers face inwards, shooting across the composition into the opposite angle where the stricken victim lies, his feet towards the corner.[11]

The figures on the west still wear the archaic smile. It has faded from the lips of those in the east, and the dying man on the right has his teeth bared and one eye half closed; a kind of realism found in some late archaic and early classical vase-painting and sometimes in sculpture too.

Many of the figures were excavated in the early nineteenth century and acquired by Ludwig I of Bavaria, for whom some were heavily restored and arbitrarily grouped by the neoclassical Danish sculptor Thorwaldsen. At the end of the century Furtwängler made a new excavation, finding many more pieces, and he went far towards recovering the compositions on paper. Lately Ohly excavated further and also removed Thorwaldsen's restorations; and succeeded in arranging the surviving remains in what must be very close indeed to the original scheme: a revelation. The shooting Herakles from the east (fig. 68) illustrates the beauty of these carvings.

Most pedimental sculpture has a weighty, massive character. The sinewy elegance of these figures is unusual, and has perhaps to do with the fact that the Aeginetan sculptors are recorded as preeminent in bronze. A fine bronze head from the Acropolis of Athens is very like in style to the gable-figures, and is surely Aeginetan work.[12]

II. Sculpture at Athens in the time of the Persian wars

Around the mid sixth century the Greek cities of Asia Minor had come under the control of Croesus of Lydia, and when he fell to Cyrus of Persia in 546 they became part of the huge Persian empire. In 498 there was an attempt to get free, the Ionian revolt, to which Athens and Eretria sent aid. It was put down by Darius, who in 490 sent a punitive expedition which burned Eretria but was defeated by the Athenians at Marathon, a victory which became at once a legend. Ten years later Darius's son Xerxes led a great invasion to conquer Greece for the empire. In face of this the Greek cities achieved a brief and uneasy degree of unity. Xerxes's

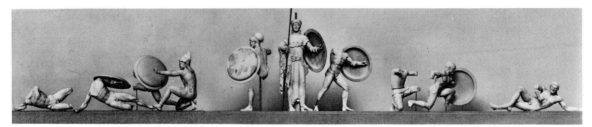

66 Marble figures from Aegina. Temple of Aphaia, west pediment: battle before Troy, with Ajax. First quarter of 5th century. H. at centre *c.* 1·70 m.

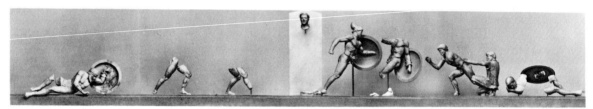

67 Marble figures from Aegina. Temple of Aphaia, east pediment: battle before Troy, with Herakles and Telamon. First quarter of 5th century. H. at centre *c.* 1·70 m.

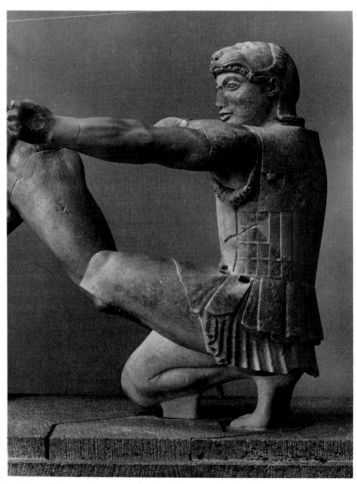

68 Marble figure from Aegina. East pediment: Herakles shooting. First quarter of 5th century. H. 0·79 m.

fleet was destroyed in 480 at Salamis under Athenian leadership, and his army defeated the next year at Plataea under the Spartans. However, after the initial annihilation of the Spartan force at Thermopylae, Greece north of the Isthmus had been abandoned, and Athens was twice put to sack by the Persians, in 480 and 479. It is this destruction that has given the wealth of shattered archaic sculpture from the city. It also gives us a date for the great change: the abandonment of archaic conventions (which we have seen being worked towards for some decades) and the creation of the new, classical, style.

This statement is a simplification in more ways than one. First, such a change does not take place overnight among all artists; and secondly it is very hard to be certain that a given statue from the Acropolis was actually set up before the invasion. However, as to the first point it does seem clear that changes once made by a Greek artist were assimilated by others with extraordinary celerity. On the other question, new temples were not built on the Acropolis until after the middle of the century (a 'Cimonian Parthenon' appears to me a mare's nest, and even its proponent does not think it was begun before the sixties; below, p. 93). It is clear too that sculptural dedications fell off sharply after the return. The statues in question are inseparable from the archaic series; their freshness of surface suggest that they did not stand long above ground; and it seems to me a reasonable conclusion that they were dedicated in the years immediately before the invasion. One of them bears a close anatomical resemblance to the marble copies we have after the bronze statues of the Tyrannicides by Kritios and Nesiotes which we know were set up in the Agora, the city centre north-west of the Acropolis, in 477. This leads some to claim it for immediately after the return, but it can as well be immediately before the flight, and in any case it dates the change securely to the time around 480.

Is there more than a temporal relation between the Persian wars and the change? In classical art we see the Greeks finally leaving behind any subservience to earlier traditions, and establishing their own style. One can imagine that if Xerxes had been successful and absorbed Greece into the Persian empire, Greek archaic art might have crystallised in the decorative academic formulae which characterise Achaemenian; while the threat and its repulse can be seen as the catalyst which released the spirit of Hellenism, flowering in the fifth century as richly in literature and thought as in the visual arts.

The girl in fig. 69 is a kore,[13] no different in dress or in formal structure from her sisters, and no one has

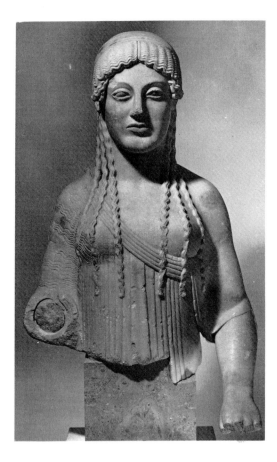

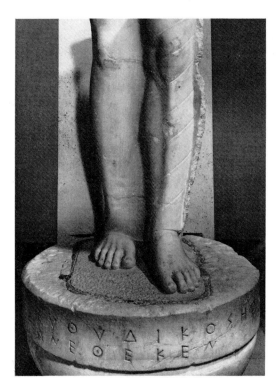

69 Marble statue from Acropolis. Girl, dedicated by Euthydikos. Early 5th century. H. of upper part 0·58 m, of lower, 0·41 m.

47

doubted that it was before 480 that Euthydikos, whose name appears on the very simple base, dedicated her; but she evidences a revolutionary change of spirit. The two fragments do not join, but they certainly belong to one figure and they share an extraordinary simplicity. Prettiness, elegance, virtuosity are out. The upper garment clings almost as closely to the forms as the under, which is carved without folds while those of the upper are flat and straight, or just indicated in light diagonals across the naked-seeming legs. But it is in the face that the change is most dramatic: no smile, a deliberate rejection of prettiness and grace; brooding, almost sullen; inturned, as the finest archaic faces seem to shine with an extrovert delight in life.

The polarity between the ideals the kore-type was evolved to express and the new ideals evident here perhaps makes this moving work not quite an artistic success. Sculptors after this give statues of women a new dress which better suits the changed mood. It is however in the naked male figure, always the central theme of Greek art, that we first see, alongside the changed spirit, the vital loosening of formal structure by which sculptors of this generation made clear their break with archaic conventions and opened the way to classical developments.

The carving of the features on the youth's head, fig. 70,[14] is so like that of the girl's that they may well be the work of one artist; but this has none of the other's contradictions. It is known as the fair-haired boy; yellow paint still faintly visible on the hair was much more strongly apparent when it came out of the earth. The statue cannot have stood long in the weather, and one would guess it one of the last set up before the Persians came, the girl perhaps a few years earlier. One would no more apply the word pretty to the boy than to her, but here one can speak of charm and surely of beauty; and these qualities are in great part achieved by the tilt. The girl looks straight before her, as a statue had always done; her brother's head is gently turned and bent.

The same thing is seen in a more hesitant form on another boy (fig. 71),[15] and here the very slight tilt and turn of the head are part of a change in the pose of the whole figure, as they must have been in the fair-haired boy also. This is the figure mentioned as so resembling the copies of the Tyrannicides that it is known as the Kritian boy. It is slighter than the fair-haired boy, and the face is a much less powerful evocation of the new spirit, but it is a work of quality and a perfect demonstration of the break with archaic conventions. Compare it with a late kouros (fig. 72),[16] a larger work set on a grave in central Attica, of one Aristodikos, and beautifully preserved through having been taken down and buried when it cannot have been standing very long, perhaps to avoid desecration by the Persian

invader. This differs from most earlier kouroi in having arms and hands carved free of the sides, but the sculptor has cautiously supported them by struts from hip to wrist: an extremely rare feature in Greek work but regular in marble copies of the Roman period after Greek bronzes; and bronze becomes the favourite medium for freestanding sculpture in the period we are entering. The anatomy of Aristodikos and the Kritian boy alike is simplified from nature, not quite in the same way, but in both natural forms are perfectly understood; only Aristodikos stands (like Euthydikos's kore) in the formal way a statue has always stood, the other relaxed as a boy might actually stand. The weight is on the left leg, the loose right bent at the knee, so the plane of the hips is not horizontal. That of the shoulders is neither quite horizontal nor quite parallel to that of the hips, and the head is very slightly bent and distinctly turned to the figure's right. These relaxations are minimal but vital. They open to the sculptor a whole new world in the balance of straight and bent limbs, taut and slack muscles. Henceforward the composition of a statue is based on its structure, not on its surface pattern.

Euthydikos's kore is classical in spirit but stands formally within the archaic series. What we may see as the first classical statue of a draped woman, corresponding to the naked male of the Kritian boy, is

70 Marble head from Acropolis. 'Fair-haired boy'. First quarter of 5th century. H. 0·25 m.

71 Marble statue from Acropolis. 'Kritian boy'. First quarter of 5th century. H. 0·86 m.

72 Marble statue and base from Attica. Grave-statue of Aristodikos. End of 6th or beginning of 5th century. H. 1·95 m.

likewise from the Acropolis and could likewise have been set there just before or just after the interruptions of 480/79. It is a figure of Athena (fig. 73), headless, which stood on a column inscribed with the names of Angelitos as dedicator and Euenor as maker.[17] The goddess wears her aegis symmetrically over both shoulders, and under it not himation and chiton but a peplos, in a different form from the archaic (fig. 39). It is a single piece of thick stuff fastened (as other representations show) on the right shoulder, the unjoined edges meeting down the right side in a broad simple pattern of stepped folds. It is belted over a long overfold the lower edge of which makes a second horizontal accent, less marked and less regular than that of the belt. The weight is on the left leg, and the bent right knee breaks the folds of the skirt, but over the left leg in front and the right behind the heavy stuff falls in broadly spaced columnar verticals. The right hand was high and rested on a vertical spear, the left is on the hip. The left shoulder is a little forward, and the long, narrow strip of hair down the back, the helmet-crest following it, shows that the head was slightly turned in that direction. This is the first statement of a theme, the fluted skirt broken by one knee, variations on which were to engage sculptors throughout the classical age (cf. figs. 80, 124, 142, 159, 161, 162, 190, 202).

A different treatment of the same garment, the columnar folds hanging virtually unbroken, is shown on a beautiful tiny relief from the Acropolis (fig. 74).[18] This scheme too is found in free-standing statues (e.g. figs. 75, 76), but only among the first generation or two of classical sculptors. On the relief the girl Athena, without aegis or shield (she is shown now even without helmet, or with it in her hand) leans on her spear, hand on hip, looking down at a small stele. We do not know what is meant. She has been called the mourning Athena, since the bent head suggests grief. This is fashionably dismissed as a sentimental modern aberration, but it is how I read the figure. The way the long folds follow the lean of the body instead of falling vertically is a primitive touch (offset by the charming observation of the skirt-edge caught on the lifted heel), but the treatment of the face seems to fix the work later than any we have so far looked at. If the dedication must have been made after the return, might the goddess be shown mourning her ruined citadel?

III. Bronze statuary and Roman copies

Historical circumstances allow us to trace the change from archaic to classical most clearly in Athens, but other cities – Argos, Sicyon, Aegina – figure largely in the literary sources for this period, especially for their artists in bronze, and it is likely that these were prominent in the revolution.[19] Greek tradition ascribed the 'invention' of bronze-casting to two Samians, Rhoikos and Theodoros, who worked for the tyrant Polykrates as architects (Theodoros also as gem-engraver, above p. 39).[20] Their date is unsure, perhaps around the mid sixth century, and it seems likely that it was near that time that Greek sculptors did learn to hollow-cast bronze on a large scale. We now possess one over life-size kouros in bronze, found in Piraeus in a cache of statues of various dates and origin. Its rather

73 Marble statue from Acropolis. Athena, made by Euenor and dedicated by Angelitos. First quarter of 5th century. H. 0·89 m.

74 Marble relief from Acropolis. 'Mourning Athena'. Second quarter of 5th century. H. 0·54 m.

greater tensile strength of bronze, which was to allow its use in the classical period for compositions which the Greek marble-worker would have shunned.

All Greek bronzes were probably cast by some form of the lost wax process. In hollow-casting by the direct lost wax method, a core is modelled in clay on a metal armature, the surface finished in wax to the thickness aimed at for the bronze. Bronze tie-rods are built in to hold the core to a clay mould then applied round the wax. The wax is melted out and molten bronze run in. The mould is broken away from the hardened bronze, the ends of the tie-rods sawn off, faults patched and the surface cleaned; and though much fine detail was completed in the model, more can be chiselled on the cold bronze. In the indirect method the model can be of any material. A mould is made round it in detachable pieces, and in these a wax casting-mould is moulded or cast and then filled with a core; and the bronze is cast from this as in the direct method. The mould-pieces are removed, and in principle can be used again to produce an identical statue, but there is little evidence for this being done in Greece.

From the beginning of the classical period large bronzes were regularly cast in sections, which is impossible in the direct method but easy in the indirect. The Piraeus kouros appears to have an iron armature inside, so was cast in one piece (one of the advantages of sectional casting is that the core can be removed); but it has not been properly studied or published and we cannot say what methods were used; nor do we know what was the nature of Rhoikos' and Theodoros's innovation.[22]

Our discussion has already made apparent a great paucity of large-scale bronzes compared to what survives in marble. The reason is simple. Marble can be sawn or broken up for building or burned for lime, and a great deal has certainly gone that way; but the melting down of bronze for conversion to tools, utensils, armour, coin, is far more tempting. In fact almost every large Greek bronze we have owes its survival to some accident which sequestered it in antiquity: a shipwreck, a fall of rock. Thus from this moment, the beginning of the classical period, when bronze becomes the favourite material for free-standing statues, the number of originals which has come down to us is sadly small. We have marvellous architectural sculpture, tombstones, votive reliefs and other things which continued to be made in marble; but most of what the Greeks themselves, and the Romans after them, considered the masterpieces of their sculptors are gone. An inadequate compensation is provided. This period, which saw the triumph of bronze, is also the first which interested Roman collectors. The demand for Greek work in the early centuries of the Empire far exceeded the supply, and a

strange style finds its nearest parallels in the third quarter of the century, and primitive elements in the technique suggest that it is an early piece of its kind. It differs from most kouroi in having the right foot forward and the arms raised from the elbow, something (probably a bow) grasped in the left fist and something lying on the open right palm. Such a scheme is described for cult-statues of Apollo, and this was probably one.[21] The character of the design does not differ from that of contemporary marbles, but arms and hands free of the body (cf. fig. 72 where, in spite of the struts, the hands are lost) demonstrate the much

busy industry arose in the production of marble copies (few could afford bronze) after popular bronze (and rarer marble) types. Hundreds of these survive; and though they can never be a substitute for the originals, and raise very difficult problems of reliability, the best are beautiful and many are of real value to the art-historian. We shall often have to invoke them in the following chapters, though we shall rely all we can on originals.

By luck we have one original bronze which can be dated to the earliest classical phase, immediately after the Persian defeat, and one pair of marble copies after bronze originals of the same time. The copies are of the Tyrannicides, Harmodios and Aristogeiton, by Kritios and Nesiotes (the nature of whose collaboration we do not know), set up in the Agora at Athens in 477/6 to replace those by Antenor, carried off to Persepolis by Xerxes. Antenor's were returned to Athens after Alexander's conquest, and stood beside their successors in Hellenistic and Roman times, but we know that the copies we have are from the second pair because they correspond to sketches on Athenian vases of the fifth century when the others were not available. What those looked like we do not know, but they too were in bronze. Antenor also signed the base of a marble statue (fig. 35). He belonged to a transitional phase, but it is likely that most sculptors at most times, though some certainly worked chiefly in one material, were at home in both.[23]

The later group are figures in action. All the free-standing statues we have so far seen have been quiet. The rendering of figures in action had been developed in pedimental sculpture, and perhaps extended occasionally to an independent group in the later sixth century: a fine marble torso from the Acropolis, under life-size, Theseus fighting one of his opponents, seems not to be from a pediment.[24] In the new age the 'action-statue' becomes a regular art-form. Since action implies narrative, such figures are generally designed primarily for a profile view (cf. above, p.14), while the 'repose-statue' (the Kritian boy, Euenor's Athena and their successors) is meant to be seen from the front, like kouros and kore.

The second Tyrannicide pair exists in fairly complete copies in Naples (probably from Hadrian's Villa at Tivoli) and fragments of others. The statues are on separate bases and the original disposition is unsure. Aristogeiton had his left arm extended, a cloak over it, his right back with a sword, so that his body is half-turned to his right. Young Harmodios, left arm back, half turns the other way, his right swinging the sword behind his head for a cutting stroke, the sharply bent elbow a peak at the top. They are generally arranged back to back, and a rough little relief of Roman date shows that then at least they were so set. The fifth-

century sketches are inconclusive on this point, and some scholars prefer to place them front to front. In the fifth-century versions Aristogeiton is a pace in front, on the Roman relief a pace behind – perhaps only for clarity; in the original they may have been level. They are generally thought to be striking at Hipparchos not shown, an interesting but rather surprising concept; one might rather see them as defending themselves against the bodyguard which cut them down.

It will be seen that these copies raise many problems, yet they are an unusually straightforward case. We know the authors and date of the work copied, and the identification is sure. They have the awkward

75 Bronze statue from Delphi. Charioteer. First to second quarter of 5th century. H. 1·80 m.

supports and struts which mark and mar marble copies after bronze, and the crisp detail and bright surface of the metal are dulled in the stone. We shall meet copies in which something of the original beauty seems to live through these disadvantages. Here we get little beyond some knowledge of the design of these figures; but that is something.

The original we possess from these years is the famous charioteer of Delphi (fig. 75).[25] Like most Greek bronzes this was cast in several sections: skirt, upper torso, limbs (one can see where the lost left arm was attached): and the side-curls separately from the separate head. Less the arm the figure is complete in itself, but it was part of a larger whole: a four-horse team, the charioteer in the car holding the reins, possibly the dedicator as a warrior behind him on the ground or mounting, probably a groom at the horses' heads (a small-scale arm was found, as well as scraps of the horses' legs and tails). The group was buried in a rock-fall (a common occurence at the site); the rest no doubt salvaged for scrap, these pieces preserved for us. One piece of the inscribed marble base survives with them, and shows that the dedicator was a Sicilian, one of the Deinomenid family who made themselves tyrants in these years of Syracuse and other cities. A line erased and recut seems to have described him originally as tyrant of Gela, and the political events reflected in this claim and its cancellation can only belong to the seventies. The dedication is for a victory in the Pythian games, and the possible occasions are 478 and 474. Thus it is very close in time to the Tyrannicides; and the face has very much the character of Harmodios or the Kritian boy. Names and schools have been freely suggested, but where one guess is as good as another one had better ignore them all.

The fragments show that the horses were standing, or walking quietly (a lovely little contemporary chariot-horse from Olympia[26] may help us see them; and cf. fig. 84), and the charioteer stands quite still, feet together, weight evenly distributed, hands forward with the reins (perhaps a goad also in the left). There is a slight twist of the torso to the proper right, and the head is turned a little further. The treatment of the short-sleeved belted chiton of light material is assimilated in the taste of the time to that of the heavy chiton (figs. 73–4, 76), though the structure of the garment is quite different. The deeply fluted skirt is unbroken by the limbs beneath. Cords over the shoulders and under the armpits cross on the back to hold the garment down at speed, and break up the surface in a more superficial pattern of folds. Arms and hands, feet, are modelled with a finely controlled naturalism, while the hair on the scalp is exquisitely engraved in a design of still archaic formality. There is silver on the hairband, copper on the lips, and the eyes

are inset in coloured glass. The face has the deliberately expressionless gravity of early classical. Often this is modified or informed by a tilt of the head affecting the character of the whole figure. That it is

76 Marble statue. Goddess (type 'Hestia Giustiniani'). Copy of Roman Imperial age after Greek original probably in bronze of second quarter of 5th century. H. 1·93 m.

not so here is perhaps because the charioteer was not designed to be looked at on its own but as part of a larger whole.

Several statues of women in the peplos show the same unbroken or scarcely broken skirt. Most impressive is the 'Hestia Giustiniani' (fig. 76; the best-known copy was long in the hands of the Giustiniani, and the statue certainly represents a goddess, though perhaps rather Demeter, Hera or even Aphrodite than the rarely represented Hestia).[27] The belt here is hidden under the overfall, and a further garment, a veil, is worn over head and shoulders. The heavy stuff masks the whole body, but the structure is as clearly realised as in the Peplos kore (fig. 39). The fall of the skirt is slightly broken at the back but in front shows columnar fluting, like the charioteer but fuller and broader. The treatment varies a little in different copies; but though one always feels the mechanical copyist's hand and the loss of the glancing metal, all convey a consistent beauty and power which surely reflect a masterpiece. The back of the right hand rests on the hip; the left, lost or restored, certainly held an upright sceptre. She looks a little to her right, and this is a case where the even classical features are somehow charged with meaning.

The simple, broad-based figure calls for no supports or struts to betray a bronze original; but the treatment of face and forehead-hair is so like that on two male figures, one a bronze original, the other known in many marble copies certainly after a bronze, that one can be pretty confident that that was the material here too. The statue known in copies is of a long-haired youth, almost certainly Apollo.[28] The work, evidently popular, is known in several nearly complete figures or torsos and a dozen heads. The independent head or bust is not a sculptural type known to the Greeks (except in the special case of the Herm, below p. 119); and the common copying in the Roman period of the heads alone from Greek statues shows a failure of understanding. Two copies of this figure are outstanding. One in the British Museum (fig. 77) has been known since the eighteenth century and is called the Choiseul-Gouffier Apollo after a former owner. The other, found in the theatre at Athens, is known as the Omphalos Apollo (fig. 78), since a base in that form lay near; but this is now seen not to belong. It would have clinched the identification as Apollo, which is probably correct: a head was found in the temple of Apollo at Cyrene; and the long, braided hair bound round the head, though a fashion of gilded youth at the beginning of the century (the fair-haired boy, fig. 70), was probably by now a sign of divine or heroic status (cf. fig. 79). With these statues we are well into the second quarter, probably the sixties or even fifties. He stands with his weight on the right foot, his face lightly

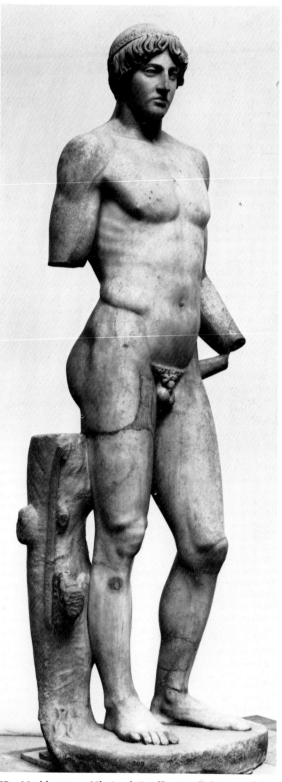

77 Marble statue. 'Choiseul-Gouffier Apollo'. Copy of the Roman Imperial age after bronze original of second quarter of 5th century. H. 1·78 m.

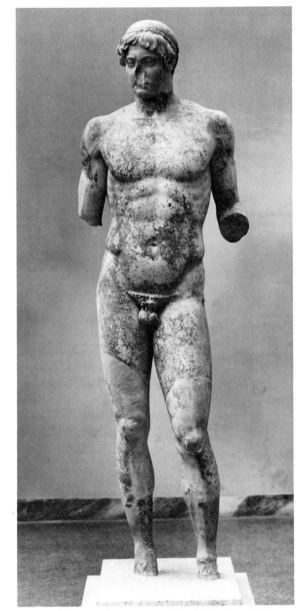

78 Marble statue from Athens. 'Omphalos Apollo'. Copy after same original as fig. 77. H. 1·75 m.

every copy and reflecting the original, there is considerable variation in detail. These two are very close to one another and probably reproduce the original fairly faithfully, but they are not identical. The finish of the Athens copy seems both clearer and subtler, though this is no doubt due in part to overworking of the Choiseul-Gouffier during its long modern history. In spite of this, and of its stump and strut, the Choiseul-Gouffier, perhaps because of the mutilation of face and feet in the other, makes on me a more powerful and moving impression. Here too, though not so strongly as in the Hestia, I seem to glimpse a masterpiece behind the marble.

Hestia and Apollo are repose-figures (above, p. 52) in the central tradition. The original bronze which goes with them is an action-figure: an over life-size bearded god, naked, striding, left arm straight out in front, right back and up to hurl some weapon (fig. 79). This is often restored as a trident and the god called Poseidon; but a trident-head would sit awkwardly with the head of the god, and a hurled trident is hard to parallel (as a fish-spear it is stabbed with, not loosed: cf. fig. 212). Almost certainly it is Zeus with a thunderbolt; that is usually grasped in the fist, but this open grip is found. The statue was dredged from a ship wrecked off Cape Artemision at the north of Euboea, with later works (below, p. 204). It is often called the god from the sea, and this may have encouraged the identification as Poseidon.[30]

The figure is widely extended in one plane, evidently designed for a primary view from an area in front of the torso with the head approximately in profile. The opposite view, with the fine back, is good too, but in between the extended limbs telescope awkwardly though the full-face is splendid. This 'two-dimensionality' of composition (the statue is of course fully realised in three dimensions) is common in classical action-statues (cf. fig. 157), and is inherent in the narrative character which relates them to gable-sculpture. The hair is like Apollo's, and it is particularly in the incisive detail of the head that one sees how much one loses in the marble. The figure is burlier, as suits a senior god.

I have no doubt that these three great creations represent the work if not of one artist at least of one school; possibly Argos or Sicyon, both prominent at this time. The athlete statues of Polykleitos, later in the century, might well stem from this tradition, and he is claimed for both cities.

We have no bronze original which stands to the Hestia as the Zeus to the Apollo. The charioteer is the nearest, but he is earlier and surely from another school, a man, and wearing a different, lighter garment. There are however very many statuettes (free-standing, mirror-handles, supports), some very fine,

turned in that direction. The Kritian boy looked even more slightly to his right, but his weight was on the other leg. From now on the head is generally turned in the direction of the firm foot. The anatomy is also more strongly stressed in this than in the earlier statue, perhaps to tell against reflections in the shiny metal; and this is something that becomes even more marked in succeeding generations.

Copies seem to have been made from casts of the original, with the help of a pointing machine which allowed certain basic measurements to be reproduced mechanically.[29] Within this framework, common to

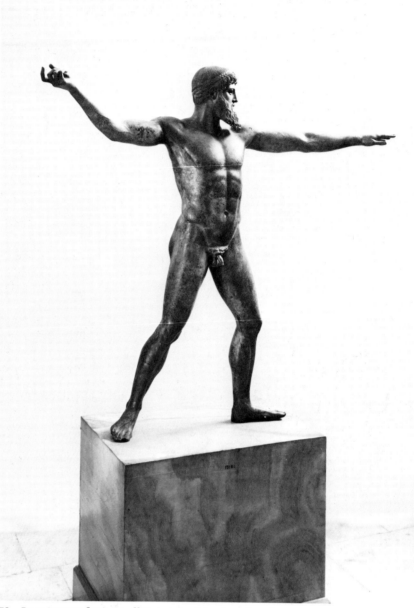

79 Bronze statue from sea off Cape Artemision (n. point of
Euboea). Zeus. Second quarter of 5th century. H. 2·09 m.

which show a variety of types of 'woman in peplos'.
Perhaps the most beautiful is from Delphi, a girl
supporting an incense-burner (fig. 80).[31] Here we have
the glancing metal and the freshness of original work,
but besides the small scale the skirt is strongly broken
by the left knee and the whole treatment is looser and
freer than in the Hestia. In feeling, though not in detail,
this stands closer perhaps to another figure known in
many copies through which a really great original
seems to shine: 'Amelung's goddess' (fig. 81), after the
scholar who reconstructed her from copies of the head
(known by a quaint tradition as 'Aspasia') and of the

body, one with a Roman portrait-head. He has since
been proved right by the discovery first of a statuette,
then of an unfinished statue, which combine head and
body. She does not wear the peplos, but the old chiton
and himation, treated however entirely in the new
spirit. The close folds of the fine chiton appear only
near the feet. Above that a heavy mantle is wrapped all
round the body and brought over the head. The right
hand is on the breast under the mantle. The open left
issues from the wraps at waist-level, close vertical
folds hanging from the wrist, while over the rest the
stuff lies in broad, smooth areas cut by a few sharp

folds determined by the left knee. She looks a little to her left. The face is younger and tenderer than the Hestia's. The work is surely from a different school, and there is nothing here to say for certain whether the original was in bronze or marble. 'Truth to material', like any other passionately held belief, can inspire good work, but it is no more a necessary than it is a sufficient condition, and Greek art is none the worse for being innocent of the notion.

This figure is often confidently stated to copy a famous statue which stood on the Acropolis, the 'Sosandra' by Kalamis (which in turn is identified, probably rightly, with an Aphrodite by the same artist on the same site). The sole grounds are that Kalamis belongs to this period and that the Sosandra's head was covered. There are more cogent reasons for believing that 'Amelung's goddess' is not really a goddess but the heroine Europa. A headless statuette of the type is inscribed with the name, and clear derivatives of the figure appear on a late fifth-century Athenian vase and

a Roman sarcophagus, in Cretan contexts where Europa would be entirely in place.[32]

IV. Early classical relief

The carved tombstone suddenly goes out of use in Attica in the late sixth century, possibly forbidden by a law of the new democracy. The fashion then appears in other places, perhaps spread by travelling sculptors. A tall, narrow stone like the Attic ones, of the early fifth century, was found at Orchomenos in Boeotia and is signed by Alxenor of Naxos. The basic design, a man leaning on a stick and playing with a dog, is found on archaic fragments from Athens and on several early classical pieces, one from Apollonia Pontica, a Milesian colony on the Black Sea which boasted a statue by Kalamis.[33] A series begins in Thessaly in the second quarter of the century and lasts through several generations. Many of these are of a broader form, with two figures; the most beautiful an

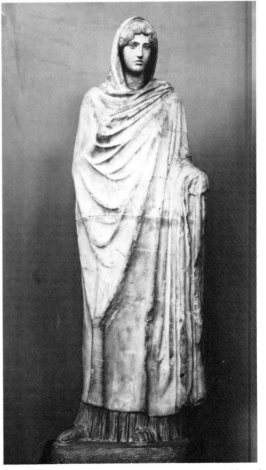

80 Bronze statuette from Delphi. Girl, supporting incense-burner. Second quarter of 5th century. H. 0·26 m.

81 Plaster cast of figure reconstructed from marbles of Imperial age. Europa. Date of original (bronze or marble), second quarter of 5th century. H. 1·97 m.

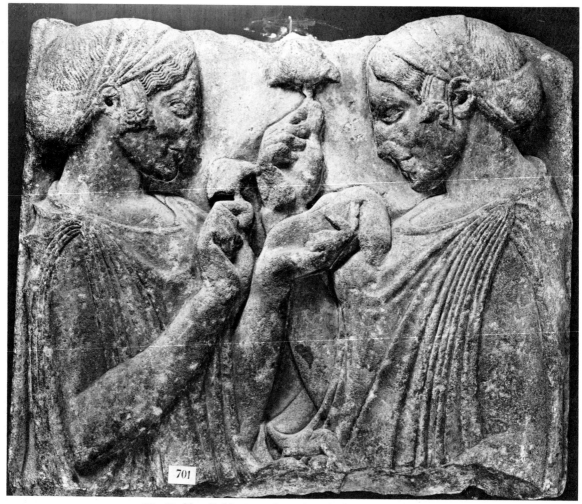

82 Marble relief-fragment from Pharsalos, Thessaly. Gravestone: girl and woman.
Second quarter of 5th century. H. 0·57 m.

early fragment from Pharsalos (fig. 82).[34] The woman on the right was probably seated, the girl standing in front of her. They wear the peplos, and the style has much of the classical, assuring its date; but there is a charming archaic calligraphy, especially but not exclusively apparent in the hair and hair-ribbons. This attractive mixture is found in a good many works of this time, particularly reliefs. Some, like this, are provincial, but there is a beautiful head from Athens[35] (where there is also a parallel in vase-painting, below p. 79), and one cannot really apply the word to the masterpiece in this manner, the 'Ludovisi Throne' (fig. 83), though one can fairly say that it is outside the main stream. This three-sided relief, and a second, the 'Boston Throne', of the same form and character but different and inferior style, present unsolved problems of use, interpretation and indeed date which cannot be discussed here.[36] They were found in Rome, where they were presumably brought in antiquity.

Both, but particularly the Boston, show stylistic likeness to small, pretty reliefs in terracotta dedicated to Persephone and Aphrodite at Locri in South Italy;[37] and this may well be their place of origin, though the Ludovisi might be the work of a sculptor from mainland or eastern Greece. The scene on the long side shows, I believe, the birth of Aphrodite from the sea, the figures on the wings her votaries, a veiled matron burning incense and a naked girl, a hetaira, piping (one of the first naked women in large-scale Greek sculpture); but many other views are held. The style seems to achieve a perfect fusion of late archaic grace with the gravity of the new age.

A similar character is found in some coinage of this time, in South Italy and particularly in Sicily which takes the lead in this art. The great silver decadrachm of Syracuse (fig. 84), commonly associated with the historically attested 'Demarateion' of 479 but now thought by many scholars to be a decade or

more later, is a marvellous example.[38]

The greatest sculptures from Sicily in this period have none of this backward-looking character: the metopes from the temple of Hera at Selinus.[39] There were many archaic temples at this site in the south-west of the island, some huge, most showing local characteristics in mouldings and plan and marked provinciality in their sculptural decoration (above, pp. 19ff. with fig. 23). The temple of Hera was built in the second quarter of the century, clearly under mainland influence. The plan is canonical, and the carved metopes confined to the same positions as those on the contemporary temple of Zeus at Olympia (below, pp. 79ff.), within the colonnade, six above each porch, though only four survive relatively complete. Two show combats: Athena and a Giant from the west, Herakles and an Amazon from the east, on almost the same design. The attacker on the left presses forward against the defeated who leans away to the right. More interesting are the other two, both from above the main porch at the east: Artemis and Actaeon (a subject which, like other brutal divine punishments of mortal error, becomes frequent in classical art; cf. fig. 119 and p. 72, below); and Zeus with Hera. Actaeon leans sharply across the field from the right bottom corner, struggling against three hounds, while the goddess stands at the left, quiet, head a little bent, lending a curious still beauty to the cruel scene. The other (fig. 85) is perhaps the masterpiece. Zeus sits on the right, his right hand raised to Hera's left wrist as she stands before him unveiling: the *hieros gamos*, holy wedding. Still groups are liked at this period, and this is one of the noblest.

All marble used in the west at this time had to be imported from the Greek islands, so it was husbanded. Here the reliefs are carved in the local limestone of which the temple is built, and only the naked parts of female figures (faces, hands and arms, feet) added in marble. The marble-stucco with which the rest was washed is gone with the colour, and the stone has weathered badly. I think this is not wholly responsible for a certain effect of fussiness in the drapery and slackness of form compared to the contemporary marble metopes of Olympia (figs. 121–3). A charge of provinciality might perhaps be justified, but the nobility of the design overrides the criticism.

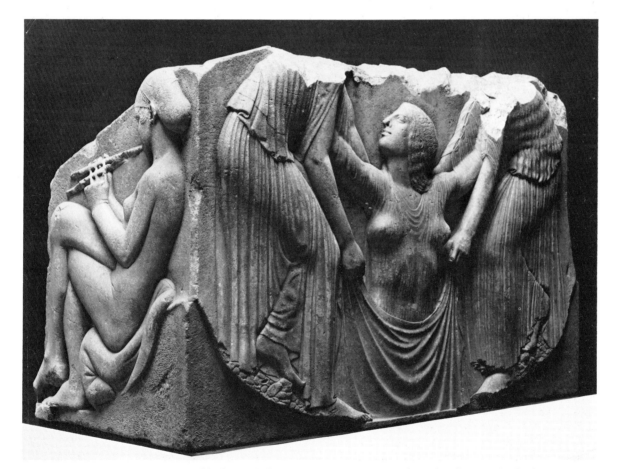

83 Marble three-sided relief from Rome. 'Ludovisi throne': girl piping; birth of Aphrodite (?); (woman burning incense). Second quarter of 5th century. H. at corner 0.84 m.

84 Coin of Syracuse. Silver decadrachm: chariot; head of Arethusa (these two dies are always used together). Probably second quarter of 5th century. D. 0·035 m.

A curious problem may be mentioned here. An early classical type exists in Roman copies, statues and reliefs: a seated woman turned to her left, leaning forward, left hand behind her on her chair, right elbow on knee, cheek on hand, an attitude of sorrow. The identical type is used on fifth-century vases and small terracotta reliefs for Penelope or occasionally Electra. A fragmentary marble statue of the type, an early classical Greek original, has been found in the ruins of Xerxes's treasury at Persepolis, burned by Alexander. The Roman copies cannot have been made from this, since it was not then available; so it gives the only

incontrovertible evidence for an exact replica being made in classical times. After Plataea an alliance of cities was formed under Athenian leadership, the Delian League, vowed to free the eastern Greeks from Persia (an aim largely achieved in the next quarter-century, though not for long). Might this type have been a symbol of the League: Penelope or Electra awaiting their deliverer standing for Hellas (or Ionia) in bonds? Had there been a version in each city, one might have fallen into Persian hands while another or others survived to be copied under the Empire. The type adapts easily to relief or drawing, since it is an extreme example of the 'two-dimensional' statue: broad rather flat front and back views, with very little depth between them.[40]

V. The revolution in painting, 1: the red-figure technique and the Pioneers of the new style

In the generation after Lydos, Amasis and Exekias a new technique was introduced in Attic vase-painting: red-figure. Basically this is simply a reversal of black-figure. The figures are left in the orange colour of the clay, the background painted in round them in the shiny black: a purely decorative variation; and it has been plausibly suggested that the strange 'negative' idea was inspired by the custom of washing the background of marble reliefs with a blue or red against which the mainly white figures were left standing out.[41] The *style* of the earliest red-figure does not differ from that of black-figure, and for long they flourished side by side; but the new technique was to prove better suited than the old to new ideas of drawing and composition that developed as part of the general late sixth-century movement which undermined the conventions of archaic art.[42]

The invention can be dated with fair assurance, since some of the earliest-looking examples, by a painter who may well be the inventor, show stylisations extremely close to those found on the friezes of the Siphnian Treasury at Delphi, carved little before 525. The links are closest with the west and south friezes (fig. 61), and like the sculptor of those the Andokides Painter (fig. 87; called after a potter with whom he worked) seems content with the archaic heritage; but a generation later his invention is exploited by artists developing a new style, foreshadowed by the forward-looking sculptor of north and east (fig. 62).

Pictures by the Andokides Painter often occur on vases which also carry black-figure pictures, repeating the scene (as in figs. 86–7, Herakles driving a bull to sacrifice) or different. These black-figure works are by a pupil of Exekias; but whether he is identical with the Andokides Painter or a regular colleague (the

60

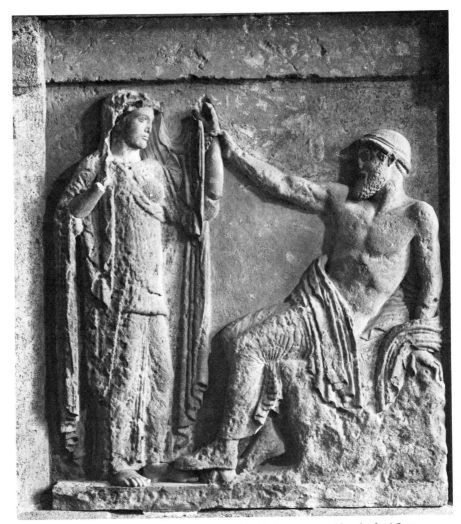

85 Limestone relief with marble additions (goddess's face, arms and hands, feet) from Selinus. Temple of Hera ('Temple E'), metope from over east porch: Zeus and Hera. Second quarter of 5th century. H. 1·62 m.

Lysippides Painter, after a youth whose beauty he praises) is disputed.[43] In the case of another very early practitioner, Psiax, who also worked with Andokides but whose stylistic links are with Lydos and Amasis rather than Exekias, the highly distinctive hand is unmistakable in both techniques.[44]

In black-figure details were engraved in the silhouette with a sharp tool and all is hard, precise. Much of the figures is covered in close-set pattern, and the decorative effect enhanced by patches of white and purple-red. The general effect is taken over in the first red-figure (fig. 87); but the black line which replaces incision is drawn with a brush, so by nature more malleable and fluid. Red-figure turns out to combine the silhouette-principle, dear to vase-decorators for its strength on the curved surface, with the freedom of outline drawing; and this encourages its practitioners to look outside the closed tradition of their craft to the work of painters on flat surfaces (cf. fig. 45, painted perhaps about the time of red-figure's inception). Technically however red-figure is not simply outline drawing with the background blacked in. If one does that, the background absorbs the outline and the figures appear unnaturally thin. To ensure their proper fullness they are first blocked in with a broad contour-band (the 'eighth-of-an-inch stripe') which gave the painter's eye the sense of the background to come.[45] The inner lines are of two kinds: a brush-stroke of variable thickness and employed with colour of varied dilution, from full black to a thin golden-brown also sometimes used for washes; and the so-called relief-line. It is not certain how this was produced, but it is a strong black line which does actually stand up in relief.[46] It has the emphatic clarity of black-figure incision but is capable of much more subtle modulation. It is used not only for inner lines

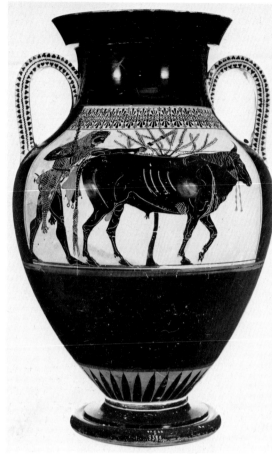

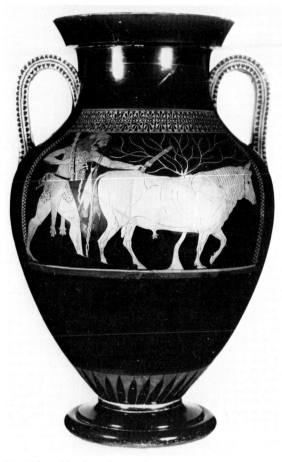

86 Amphora. Attic black-figure: Herakles driving bull to sacrifice. Ascribed to Lysippides Painter, perhaps identical with red-figure Andokides Painter (see fig. 87). Third to last quarter of 6th century. H. 0·53 m.

87 Other side of amphora in last. Attic red-figure: Herakles driving bull to sacrifice. Ascribed to Andokides Painter.

but often also to strengthen contours. Red-figure avoids colour-effects. Men and women's skin are the same colour; white is scarcely used, and red in a strictly limited way: for linear adjuncts like wreaths, for blood from wounds, and for inscriptions on the background.

Fig. 88 shows a plate, with a charming fancy of a boy riding on a cock, signed by a painter Epiktetos. One of his earliest works bears also the name of the potter Andokides, and he seems to have been a pupil of Psiax. He must have started working not many years after the invention of red-figure; but though he and his contemporary Oltos use black-figure on their early cup-tondos, and in their red-figure still show some liking for overall pattern, they differ from their masters in having been evidently trained from the start in the new technique. Added colour is much reduced, and the lines have a new suppleness. The Andokides Painter surely 'thought' in black-figure; Epiktetos thinks in red-figure; and one of the differences is a

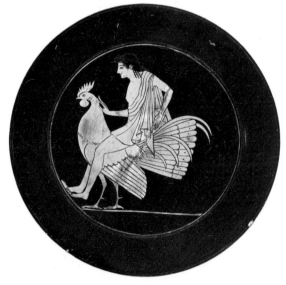

88 Plate. Attic red-figure: boy riding cock. Signed by painter Epiktetos. Last quarter of 6th century. D. 0·19 m.

62

renewed concern with *drawing* as we understand it, something hardly possible in black-figure.[47]

It is with a new generation of painters in the late sixth century that red-figure really comes to its own. They form a clearly defined revolutionary group, and have been called the Pioneers. They were fond of writing on their vases and several have left us their names, including the man who seems to have led the movement, Euphronios, and his great younger rival Euthymides. The vase in fig. 89 is signed by Euphronios. It is a large mixing-bowl of a form we have not met before, the calyx-krater (not an ancient name). The complete form is shown below (fig. 108), a later vase, taller and slenderer. It seems to have been invented by Exekias, and there are a few late black-figure and early red-figure examples, but Euphronios is the first to make it a regular vehicle for major work.[48] Most early red-figure appears on only a few shapes: cups, and pots like the one-piece amphora (figs. 86–7), in which much of the pot was traditionally black and the extension of that to the background of the picture was an easy step and one which integrates the picture

more fully with the pot. A traditionally light vase, like the black-figure neck-amphora (fig. 55) was avoided, and when it was later taken into the red-figure repertory the shape was rethought. This happened in the circle of the Pioneers, where many shapes were reworked and new ones created. The pattern above the red-figure picture in fig. 87 is taken unchanged from black-figure. Fig. 88 abjures pattern, making its effect entirely by the balance of light figures and dark ground; while Euphronios in fig. 89 makes his patterns too in red-figure: two ways of integrating the picture still further with the pot, both carried on in later generations.

The picture in fig. 89 shows winged Sleep and Death struggling with the weight of Sarpedon's huge corpse. The elaborate surface-pattern of wings and corslet is in the black-figure tradition; the symmetrical spearmen framing the scene also; but the strain, sensible in the humped backs, and the minutely observed anatomy are quite new, and the new spirit informs the whole.

The same interests appear even in slighter work: for instance the backs of the boys jumping to the pipe on

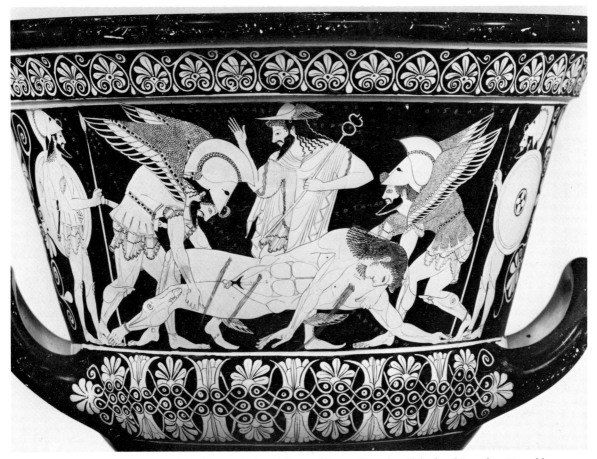

89 Calyx-krater. Attic red-figure: Sleep and Death with body of Sarpedon. Signed by potter Euxitheos and painter Euphronios. Late 6th century. H. of picture 0·19 m.

63

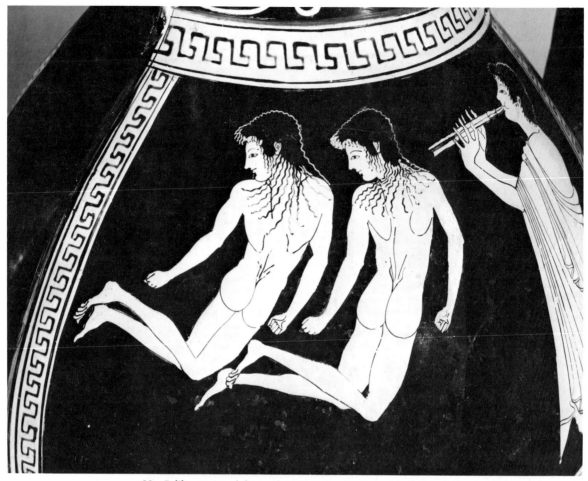

90 Pelike. Attic red-figure: boys jumping to pipes. Ascribed to follower of Euphronios, perhaps young Euthymides. Late 6th century. H. of detail *c.* 0·11 m.

an enchanting pelike (fig. 90; one of the new shapes, a version of the one-piece amphora).[49] This stands close to Euphronios but is hardly his; perhaps a youthful work of Euthymides, whose masterpieces are on big amphorae (details, figs. 91–3).[50] We noticed that the red-figure technique integrates the picture more completely with the pot than the black-figure (figs. 86–7). The process is carried further here by spreading the picture down the vase and reducing it to three big figures. This artist is less interested in ornament than Euphronios, often content with borders in black silhouette rather than red-figure; but in other respects he takes on from him and goes further. The way the girl carried off by Theseus on an early unsigned vase (fig. 91) overlaps the border – the action breaking out of the frame – is symptomatic. Old Priam (fig. 92) watching Hector arm is made bald and stubbly; and in the three great revellers on the back of the same vase (fig. 93) Euphronios's *écorchés* are given a more natural layer of fat over the muscle, and the foreshortening of the torsos is really remarkable.

Euthymides felt this himself, for he not only signed this vase on the front: among the figures on the back he wrote 'As never Euphronios'. This boast suggests that the vase-painters were not just copying the innovations of great artists but felt themselves in the van of the movement, true pioneers. Indeed there are things which suggest that not only did vase-painting at Athens in this time move *pari passu* with free painting and sculpture but that the same person may sometimes have worked in more than one of the three crafts. Interdependence of sculpture and painting is demonstrated on the east frieze of the Siphnian treasury at Delphi (above, p. 41). Of three bases, which were built together into the city-wall hastily thrown up by Themistocles after the return from Salamis and which probably originally supported a single group of statues, two are carved in low relief. The third bore instead a painted scene (obliterated), but also the signature of Endoios who is known as a sculptor. The signature no doubt referred to the statues, but the bases show that painting as well as relief was practised

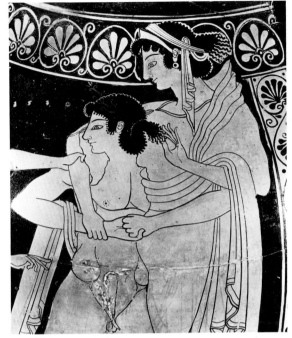

91 Amphora from Vulci. Attic red-figure: Theseus carrying off a girl. Ascribed to Euthymides. Late 6th century. H. of detail *c.* 0·14 m.

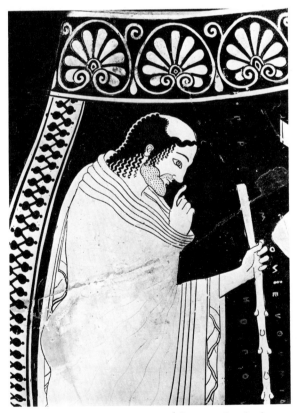

92 Amphora from Vulci. Attic red-figure: Priam (and Hecuba) watching Hector arm. Signed by Euthymides son of Polias. Late 6th century. H. of detail *c.* 0·10 m.

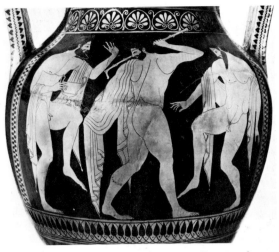

93 Other side of amphora in fig. 92. Revellers. H. of picture *c.* 0·25 m.

in his workshop; and the style of the low relief on the other bases (fig. 94) with its red background throwing up the figures of athletes is so like Pioneer red-figure that one could easily imagine it produced by one of those artists.[51] When a craftsman adds his father's name to his signature it can often be shown that the father was a craftsman too (e.g. above, p. 34); and the practice may regularly have meant that. The sculptor Antenor (above, pp. 30, 52) names his father Eumares; and it is tempting to identify him with a painter of Athens, Eumaros, known to Pliny, whose pupil Kimon of Kleonai is credited with innovations like those seen in the works of the Pioneers. (The difference in the name is not significant; Kritios, whose name is assured by signatures, invariably appears in the literary tradition as Kritias, a commoner name.)[52] Euthymides regularly gives his father's name, Polias or Polios (the genitive could belong to either); and on the Acropolis have been found signatures of a sixth-century sculptor Pollias (double letters are written double or single indifferently at this time). Also from the Acropolis come fragments of a large plaque dedicated to Athena by a Polias. The large figure of Athena is drawn in a modification of black-figure but in a style that could well be Euthymides's. A second Acropolis plaque, with a warrior (fig. 95) is very close in style both to the Athena-plaque and to Euthymides's red-figure, and is painted not in vase-painter's technique but partly in outline, mainly in brown wash outlined in black, like the Thermon metopes of a century earlier (above, p. 13); only the cloak knotted round the waist is black with incised folds.[53] Finally it has been suggested that the likenesses between the Andokides Painter's work and the Siphnian frieze might be explained by his having started as a sculptor there, then come on to the

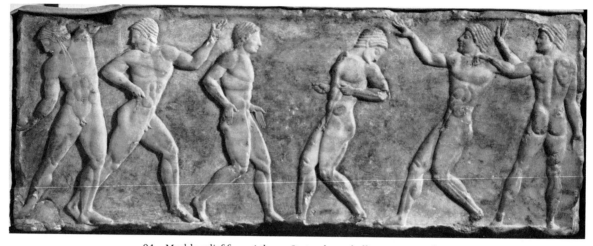

94 Marble relief from Athens. Statue-base: ball-game. Late 6th century. H. 0·29 m.

Kerameikos to invent red-figure under the inspiration of relief-colouring.[54]

Good black-figure continued to be produced. In the generation of the inventors of red-figure the Lysippides (Andokides) Painter and a companion of Psiax, the Antimenes Painter,[55] head the principal workshops, specialising in neck-amphorae and hydriai, shapes not much used in early red-figure. They are succeeded by a big workshop known as the Leagros Group.[56] The beauty of Leagros (possibly a

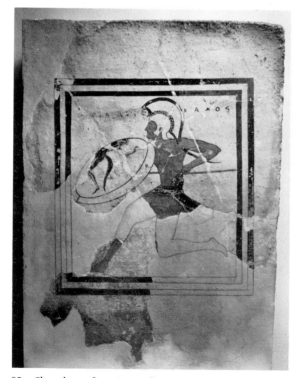

95 Clay plaque from Acropolis. Painting: warrior. Ascribed to Euthymides. Late 6th century. H. 0·65 m.

commander killed in battle in 465) is praised on many vases of the Pioneers (figs. 89 and 90 for instance), and a few of the black-figure group. These artists clearly stand close to the Pioneers and are attempting to adapt black-figure to the new movement, with some success: crowded compositions, figures overlapping each other or the borders or cut off by them, vigorous drawing with rather slapdash incision; but the elaborate foreshortenings and musculature are not much attempted and do not come off very well. Greek artists always preferred to combine vigour with fine finish, and red-figure proved better adapted to that ideal. Black-figure continues in use long for slight work, and for the prize vases at the Panathenaic games it far outlasts red-figure, going deep into the Hellenistic age;[57] but from the generation after the Pioneers all major vase-painters work primarily in red-figure.

The artistic ferment of the late sixth century led in sculpture directly to the abandonment of the central archaic convention, the formally posed frontal statue in traditional stance; a change which inaugurated the Greek classical style and set the course for European art. There is a corresponding and no less seminal change in painting: the abandonment of the single groundline on which all figures rest; a change which makes painting no longer simply the decoration of a flat surface but at the same time a feigned window on the three-dimensional world. This revolution, however, was not launched until a generation after that in sculpture. For painting other than on vases the evidence is as usual indirect; but it seems certain that the emergence of a great new revolutionary style of wall-painting with broken ground-lines belongs after the retreat of the Persians, in the seventies.

In vase-painting the late work of the Pioneers and the formation of a new generation of masters seem to come in the years around 500. These pupils of the

Pioneers are less concerned than their masters with experiment, rather with exploiting their teachers' discoveries for their decorative value. In varying degrees they reveal the new classical feeling, but formally their work, which includes some of the loveliest vase-painting, is the last flower of the archaic tradition. They fall into two groups (with some overlap): those who concentrate on the decoration of big pots, and those who prefer the kylix; pot-painters and cup-painters. Little Master cups (figs. 50–1) had gone out of fashion before a new type: a short-stemmed, deep-bowled vessel without offset lip, perhaps invented by Exekias; at least the earliest we have is decorated by him and bears his name as potter (fig. 96). This is the form used in early red-figure, at first with the same decorative eyes;[58] but the later

works of Oltos and Epiktetos, and those of the Pioneers, are of a new kind: a wide, shallow bowl curving in a single sinuous contour through a shortish, narrow stem to a low foot (fig. 97). This, the kylix *par excellence*, remains for a long time a vehicle for some of the finest vase-drawing, in the tondo and in many-figured compositions between the handles. This example is unusual in having the stem deliberately fired a bright coral red, also found within round the tondo-picture; a rare technique, practised in a few workshops from the time of Exekias. Within is a young horseman, inscribed with the praise of Leagros (above, p. 66); outside Herakles and Geryon, and (fig. 97) Geryon's cattle guarded by warriors. The cup bears the names of Euphronios as painter and Kachrylion as potter.[59]

96 Kylix from Vulci. Attic black-figure: eyes; at handles, combats; (inside, Dionysus in a ship). 'Eye-cup' signed by Exekias as potter and ascribed to him as painter. Third quarter of 6th century. H. 0·14 m.

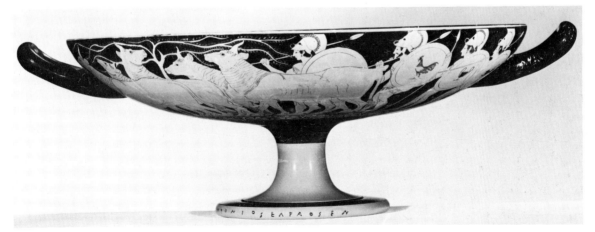

97 Kylix from Vulci. Attic red-figure: warriors with Geryon's cattle; (other side, Herakles and Geryon; inside, young rider). Signed by Kachrylion as potter and Euphronios as painter. Late 6th century. H. 0·17 m.

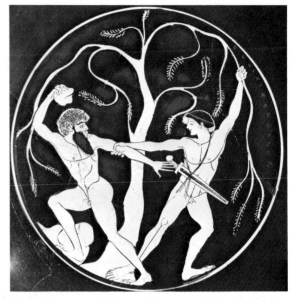

98 Kylix from Cervetri (Caere). Attic red-figure: Theseus at the bottom of the sea; (outside, deeds of Theseus). Signed by Euphronios as potter and ascribed to Onesimos. Early 5th century. D. 0·39 m.

99 Kylix. Attic red-figure: Theseus and Sinis. Ascribed to the Elpinikos Painter. Early 5th century. D. of picture c. 0·13 m.

'As potter' is ambiguous. *Euphronios egrapsen* certainly means 'Euphronios drew'; *Kachrylion epoiesen*, 'Kachrylion made', may mean that he actually potted the cup, or that he was owner of the workshop. I believe the former more probable, but the matter is in doubt and practice may not have been consistent. The presence or absence of signatures on vases, whether *epoiesen* or *egrapsen*, appears to conform to no rational system, a matter of whim. They are commonest on cups, a tradition probably established by the lip-cup (fig. 50), where an inscription is an integral part of the design.[60] Euphronios as painter worked with at least two 'potters', Kachrylion and Euxitheos (whose name appears on the vase fig. 89) both of whom worked with other painters. Painter-signatures of Euphronios and Euthymides cease around 500, and their styles of drawing cannot be traced further; but the signature *Euphronios epoiesen* begins about the same time and continues for twenty years or more, always on cups, most of them painted by one man, evidently his pupil and one of the greatest of the next generation, Onesimos.[61]

An early masterpiece of his is a lovely cup-tondo (fig. 98) with the boy Theseus in Amphitrite's underwater palace, Athena assisting.[62] This is unusual in the size and complexity of the composition and the border of palmettes within the rim. Commoner is a small circle in the centre of the black interior, often a two-figure composition: so, Theseus and Sinis (fig. 99) a tiny masterpiece by a minor painter;[63] or the two revellers (fig. 100) by Douris, a prolific cup-painter. He is a less subtle draughtsman than some, but many of his cup-

100 Kylix from Vulci. Attic red-figure: two revellers; (outside, revel). Ascribed to Douris. First quarter of the 5th century. D. of picture 0·20 m.

interiors, like this, are beautifully composed. He constantly signs his vases, whereas Makron regularly puts the name of the potter Hieron, hardly ever his own[64] (so also Onesimos with Euphronios). Of many cup-painters the greatest, perhaps, with Onesimos, is one who worked regularly with a potter Brygos but has not left his own name, so the Brygos Painter.[65] His fiery Sack of Troy (fig. 101) will be discussed in the

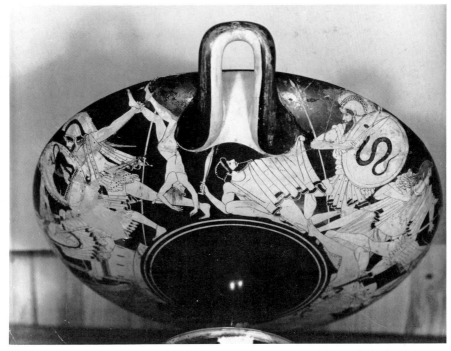

101 Kylix from Vulci. Attic red-figure: sack of Troy; (inside, Briseis and Phoenix). Signed by potter Brygos and ascribed to the Brygos Painter. Early 5th century. H. of picture *c.* 0·12 m.

102 Hydria from Nola. Attic red-figure: sack of Troy. Ascribed to the Kleophrades Painter (Epiktetos II). Early 5th century. H. of picture *c.* 0·17 m.

103 Calyx-krater, probably from Vulci. Attic red-figure: maenad (return of Hephaestus). Ascribed to Kleophrades Painter. Early 5th century. H. of picture *c.* 0·20 m.

104 Stamnos from Cervetri (Caere). Attic red-figure: maenad (death of Pentheus). Ascribed to the Berlin Painter. Early 5th century. H. of picture *c.* 0·17 m.

next section (p. 76), together with a rendering of the same scene in rather different mood (fig. 102) by one of the greatest pot-painters, the Kleophrades Painter,[66] in connection with Pausanias's description of a wall-painting by Polygnotos of Troy Taken.

The early amphorae of the Kleophrades Painter are almost indistinguishable in style from those of Euthymides, whose pupil he must have been; but he also favours the calyx-krater, something he owes to Euphronios's example. The Pioneers were surely one workshop, and the pupils of one will have had much to do with the others. The Kleophrades Painter is the most classical in spirit of these artists. His heads often remind one of the fair-haired boy (fig. 70): so the ecstatic maenad (fig. 103) on a calyx-krater with the Return of Hephaestus. The girls who accompany Dionysus and his satyrs earlier (figs. 56–7) may be called nymphs. From the later sixth century they are characterised by features of maenadism as actually practised: the 'wing-dance' here, and the thyrsus (a bunch of ivy-leaves tied to a fennel-stalk), as in fig. 104, from a picture of the Death of Pentheus by the Kleophrades Painter's great rival the Berlin Painter.[67]

A late amphora by the Kleophrades Painter carries further Euthymides's integration of 'picture' and 'pot-

105 Amphora from Vulci. Attic red-figure: Hermes, silen, fawn; (other side, silen). Name-piece of Berlin Painter. Early 5th century. H. with lid 0·81 m.

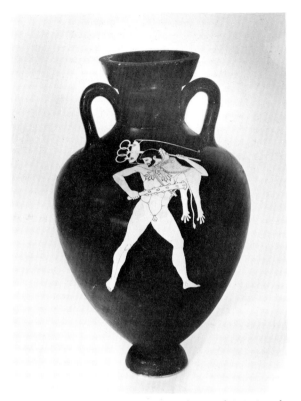

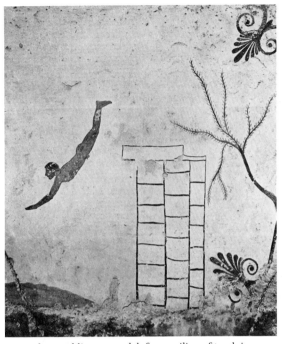

107　Plastered limestone slab from ceiling of tomb in Paestum. Detail of painting: diver. First quarter of 5th century. H. 0·98 m.

106　Amphora of Panathenaic shape from Vulci. Attic red-figure: Herakles with the tripod (pursued, on the other side, by Apollo). Ascribed to the Berlin Painter. Early 5th century. H. 0·52 m.

decoration': the frame dissolved into a strip of pattern under the two big figures on each side.[68] The Berlin Painter's name-vase (fig. 105) goes further still: two figures and an animal superposed and contained in a single complex but harmonious contour-line, a narrow strip of pattern below and an ivy-wreath between the handles above. On other vases, especially on his favourite form, an egg-shaped amphora with narrow neck, like those used for prize oil at the Panathenaic games, he reaches the logical conclusion of this trend: a vase totally black except for a single figure on each side, without even a ground-line (fig. 106); the figure is the whole decoration. He spreads such figures, with great care for the contour which is echoed by supple and delicate inner detail.[69] He has not the Kleophrades Painter's weight and power, but his grace has a spare strength. There are many more good pot-painters, as cup-painters, but these are the unquestionable leaders.[70]

VI. The revolution in painting, 2: wall-painting and vase-painting after the Persian wars

The idea of a single base-line for all figures is not universal in pre-Greek arts. Both Egyptian and Assyrian painting and relief often show a kind of bird's-eye view against which figures are set in profile at different levels. Sometimes a real sense of space is achieved, as on the second-millennium stele of Naramsin, where figures move up and down a tree-clad hill under the stars; but in general it seems no more than an alternative convention for the organisation of narrative over the surface. When the Greeks begin to use it, it is also part of their interest in mastering the appearance of nature, and leads on to perspective and chiaroscuro, to European painting.

Etruscan tomb-painting seems largely dependent on Greek wall- and vase-painting, and generally follows the rule of the single base-line. In the late sixth-century Tomb of Hunting and Fishing at Tarquinia, however, the artist has produced an astonishing seascape: rocks, boats, dolphins and birds, a diver in mid air. It is interesting to compare this intuitive vision with the more inhibited adaptation of it by a Greek artist at Paestum a decade or two later (fig. 107). In other parts of this small tomb he paints reclining banqueters, such as are constantly found on Etruscan tomb-walls and Greek vases, following the old conventions, though he puts much more variety into the expressive faces than is found anywhere else. In the diver-picture he shows himself ready to adumbrate the idea of a spatial setting, but he is far more cautious and conventional than his Etruscan predecessor.[71]

Ancient writers speak often of a wall-painter, Polygnotos of Thasos (the greatest member of a painter-family) and his colleague Mikon of Athens. They worked together in Athens, and are associated with Cimon, son of Miltiades the victor of Marathon, who became the leading political and military personality in the city as the position of Themistocles declined (he was exiled before 470), until he himself went into exile in 461. The earliest recorded work of these artists is in the shrine of Theseus, built or rebuilt by Cimon after he brought back the hero's bones from Skyros in 473; and there is a detailed description by Pausanias of Polygnotos's two murals in a *lesche* (clubhouse) dedicated at Delphi by the people of Knidos, perhaps after the liberation of the Asia Minor Greeks from Persia in Cimon's campaigns, which culminated in the victory at the Eurymedon in 468.[72] The terms of this description make it absolutely clear that Polygnotos did not adhere to the single ground-line but placed his figures up and down the field with some rudimentary indication of setting; and a few Athenian vases which must have been painted around the sixties show the same thing. Most vase-painters of the period ignore the innovation, and most of the pieces which show it are big, elaborate vases from a single workshop. The exact relation of what we see on the vases to what was shown on the walls is something we shall have to consider, but that in some way these vase-pictures do reflect the revolution in wall-painting cannot be doubted.

The clearest demonstration is on a big calyx-krater from Orvieto, by an artist known as the Niobid Painter after the picture on the back of this vase. That most terrible of the stories of divine punishment out of all mortal proportion to the offence appears often in the fifth century, like the punishment of Actaeon, and evidently had a powerful meaning for the time. The subject of what is evidently the principal side of the vase (fig. 108) is much argued over: the Argonauts, the Seven against Thebes, the Underworld; the morning of Marathon; but I believe it has now been made nearly sure.

At the bottom centre are two youths, their weapons about them, one a large and noble figure spread across the foreground; above him the other, seated, melancholy. In the middle above them stands Herakles, flanked by two warriors; behind one of these Athena, looking at the central group; more warriors to left and right. They stand or sit on thin irregular lines painted across the black in a white which has somewhat faded. The suggestion is of steeply rising broken ground, and one figure at the top left (hardly visible in the photograph) is half hidden behind such a fold in the land. It has been noticed that the six figures whose naked torsos are seen all show an extra horizontal line

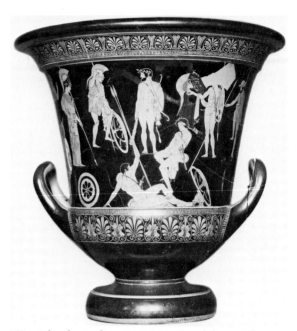

108 Calyx-krater from Orvieto. Attic red-figure: Theseus and Peirithous in the Underworld (?); (other side, slaughter of the Niobids). Name-piece of the Niobid Painter. Second quarter of 5th century. H. 0·53 m.

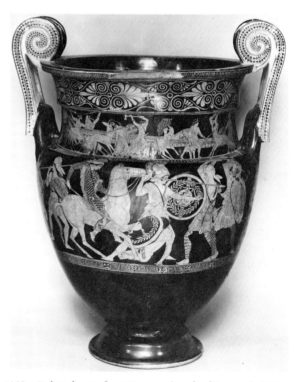

109 Volute-krater from Numana (south of Ancona). Attic red-figure: Amazonomachy (all round); Centauromachy (other side, youths and women). Ascribed to Painter of the Woolly Satyrs. Second quarter of 5th century. H. 0·63 m.

in the abdominal muscles, a feature which does not occur in the Niobid picture or elsewhere in the painter's work. It is found, however, on some figures in an Amazonomachy and a Centauromachy on a big volute-krater (fig. 109) by a less talented companion of the Niobid Painter known as the Painter of the Woolly Satyrs, in whose work too it is abnormal. These pictures too show compositional features which imply influence from the new wall-painting. The inclusion of this peculiar detail consistently throughout one picture strongly suggests that that picture is a direct copy of another man's work; and the Centauromachy and Amazonomachy will at least include elements from pictures by the same man. Pausanias describes Cimon's Theseion as including a picture by Mikon of Theseus at the bottom of the sea (the subject of fig. 98), and pictures of a Centauromachy and an Amazonomachy which he does not ascribe to an artist. (Polygnotos's participation in this project seems to be recorded in a brief and corrupt passage of another writer.) Pausanias goes on to talk of stories of Theseus's end; irrelevantly, it seems, but it has often been thought that the subject must have been suggested by a fourth mural which he does not specify. Theseus, having been helped by his friend Peirithous to carry off the girl Helen, in his turn accompanied Peirithous to Hades in an effort to abduct Persephone. Both were caught and held, till at long last Herakles came down to the Underworld and took Theseus back with him, leaving Peirithous behind. There are variant versions, but this perfectly fits the vase-picture: Theseus, the hero in the foreground; Peirithous, the sad figure above him; Herakles; Athena, his constant aid; dead heroes gathering round. It is extremely tempting to suppose that this picture and the Centauromachy and Amazonomachy on the other vase are copied from three of the murals in the Theseion. A vase from the end of the century with Theseus at the bottom of the sea may perhaps in its central group give us the design of the fourth, but it is not a document of the same kind as these contemporary vases. Whether the artist of these three was Mikon or Polygnotos the evidence does not allow us to say.[73]

We may reasonably think that the vase-picture of the Underworld does bring us really close to the composition of a lost wall-painting, but it is adapted to the small, curved surface of a pot (though, being a calyx-krater, the curve is only horizontal, and it does retain some of the character of a wall), and there are other important differences, in particular the nature of the red-figure technique. There is evidence to suggest that the walls which carried these pictures were not normally plastered but panelled, though plaster is used in the tombs of Etruria and Paestum, as it had been in Bronze-age palaces and was to be in Hellenistic

110 Kylix-fragment from Eleusis. Attic white-ground: Triton. Name-piece of Eleusis Painter. About 500 B.C. H. *c.* 0·11 m.

tombs in Greece (below, p. 176). Whatever the material it is likely that it was primed in white and on this the scenes were painted; the shiny black of the red-figure vase must give a quite contrary effect. Etruscan tomb-paintings and earlier Greek work – the little panels from Pitsa, the Acropolis plaque, the walls of the small Paestum tomb (figs. 45, 95, 107) – help us: unmodulated white background for the sky; male skin in pink or brown within a darker outline (less strongly marked, this, in the Paestum pictures than earlier); female drawn in outline on the white; washes of colour for garments and the like. Whether ground was distinguished from sky in any other way than by being outlined against it the evidence so far cited does not tell us, but probably some trees and flowers were shown on it, and it may have had something in the nature of shading. A tree is shown in the Niobid picture, trees and small plants in the vase illustrated in figs. 109 and 116. A primitive shading is found on a few vases of the generation before, by the Brygos Painter for instance to indicate the roundness of shields; and in this time it appears, very sparingly,

111 Fragmentary kylix from Locri. Attic white-ground: satyr and maenad (detail). Ascribed to Pistoxenos Painter. First to second quarter of 5th century. H. of part shown c. 0·18 m.

both in red-figure and on another class of Attic vase which we have not yet considered, those with a white slip.

From about the time of the invention of red-figure some black-figure vases are given a white slip covering the orange clay. The Andokides Painter experimented with a 'white-figure' vase: red-figure technique but over a white slip, choosing purely feminine scenes for both sides. This did not take on, but from the time of the Pioneers some red-figure artists sometimes draw in outline on a white slip, most often on the interior of a cup where there was not the problem of the receding surface. At first much of the drawing is in relief-line, as in red-figure, but freer use is made of washes in thinned glaze, as in a lovely Triton from Eleusis (fig. 110), drawn in the circle of Euphronios, perhaps by the very young Onesimos.[74] Gradually the technique develops its own style, moving away from red-figure as red-figure had early freed itself from the black-figure tradition; only white-ground long remains no more than a sideline of red-figure painters. Relief-line, and indeed any use of undiluted black, virtually disappears. All is drawn in variously diluted glaze, and there is increasing use of washes of colour. A cup from Locri (fig. 111) with a satyr attacking an unperturbed maenad is by the Pistoxenos Painter, whose career seems to begin about the time of the Persian invasion, and one of whose earliest cups is the last to bear the name of Euphronios as potter.[75] A little later,

to the time of the 'Polygnotan' red-figure vases, belongs a very small piece, not a cup-interior but the slightly domed surface of a covered cup (fig. 112; one can just see the orifice for drinking at the bottom).[76] This is from Attica, and most examples of the rare shape are from Greece or the East, not Italy. A Muse sits on a rock, and Apollo before her stands not on the base-line but on an irregular indication of ground just clear of it. This is, as it were, an extract from a big wall-painting; and while fig. 108 gives us a whole composition, this brings us much nearer to the colour-effect, though not quite there since the vase-painter is limited to clay-based colours which will withstand firing. Apollo's cloak is a dark purple, the Muse's dress a lighter red-brown. A clearer red, blue and green are found in the traces of painting on architectural members, and were no doubt in the wall-painter's palette, but there is no evidence for much mixing of colours and some for a deliberate restriction of choice.[77] There is no shading on the rock here, but it is used on two out of three tiny, marvellous cups from Athens (figs. 113, 114) made by a potter Sotades and painted by the 'Sotades Painter' who may well have been the same man.[78]

The fragmentary fig. 113 has an uncertain mythological subject, possibly the death of Opheltes (Archemoros): a man starts back, raising his arm to throw a stone at a huge snake which rears, belching smoke, from among reeds; and there is part of a figure

112 Covered cup from Vari (Attica). Attic white-ground: Apollo and Muse; (outside, red-figure, women running). Second quarter of 5th century. D. of picture 0·11 m.

falling against the framing circle behind or below the man. The hatching on the skin-cloak is surely meant for shading, and it definitely appears on the complete cup fig. 114. This illustrates another rare story: the seer Polyeidos shut in the tomb with Minos's dead child Glaukos, and reviving him by means of a leaf with which he has seen a snake revive its mate which he had killed. The tomb is a domed chamber, crowned outside by a tripod. It is drawn as though opened up in section, but shading marks the concave interior and a strip of the pebble-floor is shown beneath the figures. Glaukos in his cerements seems to be watching what is going on; Polyeidos to be striking at the snake; but the living snake is shown at the bottom approaching the dead one. These ambiguities in the narrative (which perhaps find some analogy in the conventions of tragedy as composed at Athens in this time) correspond to the ambiguities in the spatial conception, oddly (to our eyes) combined with the interest in naturalism. They remind us that this is the very beginning of the idea of representing the world about

us as it actually appears; that we must think away our hindsight and remember that these artists could not see the way ahead.

The limbs of the fallen figure in the snake-cup show through the clothes, a feature recorded in Polygnotos's work and which reappears in the third Sotades cup, again fragmentary, with a charming picture of girls (perhaps Hesperides) picking apples. These cups have little colour, but the subtle strength of the drawing, in spite of its miniature scale, surely brings us close to the great painting of the time. The same quality is found in the best of the painter's red-figure work (fig. 115). This vase is in the form of a knucklebone. There are others from the period; they were perhaps knucklebone-containers, a passing fashion. By the orifice, as though outside a cave, a man with vividly drawn, unideal features (so also the man with the snake) directs a dance of girls. Three advance hand in hand over irregular ground, the last half-hidden by the rim, and around the other sides (fig. 115) others, some with transparent drapery, have taken off into the air and

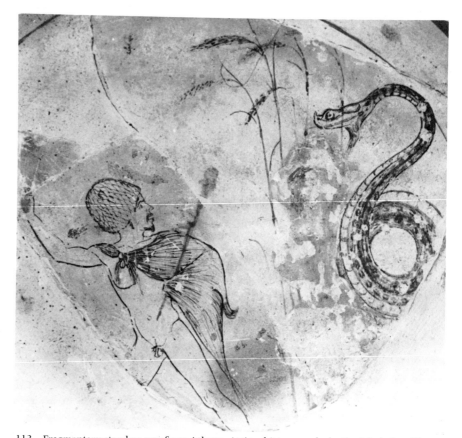

113 Fragmentary stemless cup from Athens. Attic white-ground: death of Opheltes (?). Ascribed to potter Sotades and Sotades Painter. Second quarter of 5th century. H. of part shown *c.* 0·08 m.

float free – an imaginative adaptation of the black background to the new idea of spatial setting. It has been called the Dance of the Clouds.

It is of interest to compare Pausanias's account of Polygnotos's Troy at Delphi with two earlier vase-pictures of the Sack.[79] The Brygos Painter's (part, fig 101) covers both sides of a cup-exterior, a palmette under one handle marking the beginning and end. A boy, Astyanax, runs away at one end, looking back as his mother Andromache heaves a great pestle to club a Greek who has struck a Trojan down. Behind him a Trojan woman storms by, hair wild – Cassandra? Another Greek has cut down a Trojan who falls under the handle, leading us to the other side. In the centre there Priam sits on an altar, a huge tripod behind, and reaches in supplication to Neoptolemos who strikes at him with the corpse of his grandson not saved by Andromache's effort. At the end Polyxena looks back as Akamas leads her away a prisoner. The night of horror is wonderfully suggested in half-a-dozen groups, beautifully related in the surface-design but episodically conceived and covering different times (Astyanax alive and dead).

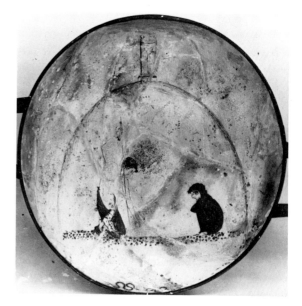

114 Kylix from Athens. Attic white-ground: Glaukos and Polyeidos in the tomb. Signed by potter Sotades and ascribed to the Sotades Painter. Second quarter of 5th century. D. 0·13 m.

76

115 Vase in form of *astragalos* (knucklebone) from Aegina. Attic red-figure: dance of the clouds (?). Ascribed to potter Sotades and the Sotades Painter. Second quarter of 5th century. W. *c.* 0·11 m.

other has a strong infusion of the classical though held strictly within the archaic framework. Polygnotos,[80] it is clear from Pausanias's description, took two important steps which allowed him to express the classical spirit without the constrictions of the archaic tradition. First, he changed the dramatic time. His picture is not given, either by Pausanias or in the epigram, supposed to be by Simonides, inscribed on the wall beneath it, the name *Iliupersis*, Sack of Troy, the title of several early poems and a correct description of the archaic vase-pictures. In the epigram it is 'the citadel of Ilium taken', and Pausanias calls it 'Troy taken and the departure of the Greeks'; and so the description shows it to have been – not the night of terror but the morning after. Not consistently: Neoptolemos was shown still slaughtering Trojans, but he alone, and even his action was changed. A man was crouching under his stroke, a child clinging to an altar beyond; but they were not Priam and Astyanax. Astyanax was a prisoner with his mother in the Greek camp (to be killed later), and Priam's corpse was shown lying among others within the wall. The artist uses images from the archaic tradition but adapts them to his new purpose. Dead men and grieving women are important already in the Kleophrades Painter's picture. Here they dominate the mood, and the victors too are mostly quiet. Ajax was not dragging Cassandra from sanctuary but standing trial before his peers for that impious act; yet she was still seated on the ground clasping the image fallen from its pedestal. Nor was the scene confined to the city: half the picture was outside the wall, a stretch of which was shown near the middle; and this brings us to the second great change, the opening up of space.

It is evident that the figures and groups were set up and down the field, surely very much as on the Underworld vase; only on this wall there were scores of figures and also certainly more indications of setting. The area outside the wall of Troy included both land and sea, with a strip of pebbled beach. There are pebbles under the feet of Aphrodite's helpers on the Ludovisi throne (fig. 83); and one thinks also of the pebbled floor of the tomb on the Sotades Painter's cup (fig. 114), where the ambiguities of time are likewise reminiscent of the Troy. On the sea was Menelaus's ship, a gang-plank to the shore, and on land his tent and another being dismantled. Within the city were two altars, a basin on a column, and at the further end a house: Antenor's, who had made his peace with the Greeks and was spared. His family were shown outside, loading a donkey and preparing with sad looks for their journey into exile. The group corresponds to Aeneas and his family escaping in the Kleophrades Painter's picture, and this change too marks the shift of time from the sack to its aftermath.

The Kleophrades Painter's picture (part, fig. 102) is on a similarly shaped field, between two concentric circles, but while on the cup the feet rest on the smaller circle, which encourages an explosive spread, the hydria-shoulder has the feet on the wider circle and the figures tend to lean together in more static pyramidal groupings. The only really spread figure is Neoptolemos, striking at Priam on the altar with a sword. The dead boy is on the old man's knees, and he clasps his bloody head and pays no attention to the attacker. The lordly tripod is replaced by a broken palm-tree overhanging a mourning woman. There are many more still figures, especially Trojans (dead men, mourning women and children) but some Greeks too: the spirit is changing. There is also more overlapping, of a kind which insists on the notion of depth: a despairing woman on the far side of the statue from which the lesser Ajax is about to drag Cassandra to rape her; hidden faces (Priam's and Aeneas's – he is shown at one end, escaping with his father and son). Nevertheless the single base-line is adhered to, so we still have a series of episodic groups only formally united.

The Brygos Painter's picture is pure archaic; the

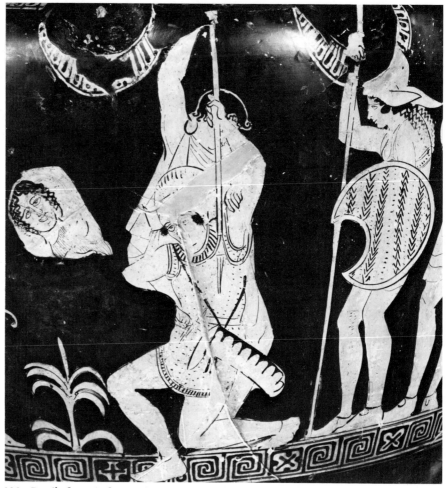

116 Detail of vase in fig. 109 (Amazonomachy).

The reason for the choice of different time is probably the liking for scenes of stillness rather than action which characterises much early classical art and almost all the subjects ascribed to Polygnotos in the tradition; in particular the Underworld, the great pair to the Troy in the Delphi club-house. This taste probably played an important part also in encouraging the abandonment of the single base-line. As the archaic sack-pictures show, the movements of figures in action can be used to build an effective unity from essentially disparate groups juxtaposed in the surface plane. To group interestingly in a unified design inactive figures ranged along a single base-line is much more difficult. Once they are set up and down the field groups can be interlocked, and figures united by gesture and look. The direction of gaze is often noted in the description of Polygnotos's work, and its importance can be seen on the Niobid Painter's vase. It is notable that the use of different levels is much more emphatic in this quiet scene than in the Amazonomachy of fig. 109, though it is found there too. (The retention of the single ground-line for the Centauromachy is probably due to its adaptation to the narrow field of the vase-neck; other reminiscences of the same picture do show broken ground.) On the other hand action-scenes perhaps made more use than quiet ones of the partial conceal-ment of figures by folds of ground. In an Amazonomachy by Mikon in the Stoa Poikile at Athens was a notorious figure named Butes of whom only the helmet and one eye were to be seen,[81] and there are less dramatic examples in some Amazons on the vase (fig. 116). Names were written by the figures in the wall-paintings, as often on the black ground of the vases; another example of the hesitancy with which the creators of this revolution approached the idea of the illusion of depth.

The three-quartered face of the stricken Amazon in the other extraordinary group in fig. 116 is a disaster; but this is a ham-handed painter. No doubt his model was better, and the Niobid Painter's Peirithous is not so bad though still not a great success. This was something the Pioneers seem not to have tried. The

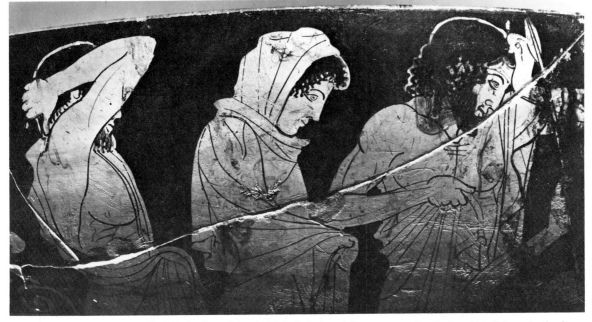

117 Kylix from Spina (Po delta). Attic red-figure: mourning Trojans (detail from death of Memnon; other side, quarrel over arms of Achilles; inside, two youths with horses going to altar; round this, deeds of Theseus). Ascribed to Penthesilea Painter. Second quarter of 5th century. H. of part shown *c.* 0·08 m.

attempt is found occasionally in the work of their pupils, and at this time becomes quite frequent, but in vase-painting at least it is not successfully achieved until quite late in the century. Peirithous is surely meant to look sad, and we often hear of sadness in the faces of Polygnotos's characters. We can get a feel of it in a magnificent detail from a huge cup by the Penthesilea Painter (fig. 117): Trojans grieving as they watch Memnon killed by Achilles.[82]

This master, who seems to have learnt from the Pistoxenos Painter, is clearly much influenced by the great painting of his time but always remains faithful to the single base-line, feeling it perhaps a proper convention for vase-decoration. Such is in fact general practice among early classical vase-painters and even later. They carry on their craft in its old conventions, but inform their work in varying degrees with the spirit of the new age. The figures in a picture of the Birth of Erichthonios have all the weight and solemnity of classicism, but the Loves unusually and charmingly introduced into the ornament of the vase (fig. 118) carry over a lyrical grace from archaic (the artist was a pupil of the Berlin Painter).[83] A few painters seem to look deliberately away from their own time, nostalgically retaining the late archaic style. Most of these are not of great quality, but they include one master, the Pan Painter, who plays the old conventions against the new spirit with exquisite skill. His great Death of Actaeon (fig. 119) has the same kind

of fusion of old and new as the Ludovisi throne (fig. 83), and is no less effective.[84]

VII. The sculptures of the temple of Zeus at Olympia

I have left this monument to the last because it gives the fullest and most splendid expression to the first phase of fifth-century classical art; and a comparison of it with the Parthenon makes clear both the essential unity of that style and the difference between its phases. Also there are elements in these sculptures which cannot properly be understood if one has not first considered the contemporary revolution in painting.

The building and decoration of this temple can be dated within fairly narrow limits. Zeus had been immemorially worshipped in the Altis, the sacred area between the little Hill of Kronos to the north and the river Alpheus to the south, just above the point where it is joined by the smaller Cladeus which skirts hill and sanctuary on the west. There was a temple here from the seventh century, but it was dedicated to Zeus's consort Hera, though in the early sixth-century reconstruction which endured throughout antiquity his primitive image, helmeted, stood beside hers enthroned (above, p. 22).[85] The god himself had his altar, not as commonly of masonry but a mound piled from the ash of sacrifice. In Zeus's other great sanc-

118 Stamnos from Vulci. Attic red-figure: handle-florals with Erotes (birth of Erichthonios; Zeus and Iris). Second quarter of 5th century. H. 0·39 m.

119 Bell-krater from Cumae. Attic red-figure: Artemis and Actaeon; (other side, Pan pursuing shepherd). Name-piece of Pan Painter. Second quarter of 5th century. H. 0·37 m.

tuary, at Dodona in the north, he seems likewise to have been without a temple until the fifth century; perhaps it is a function of his ancient role as sky-god. The building was completed by 457 B.C., for Pausanias saw on the apex of the east pediment a golden shield or bowl with a Gorgoneion and below it an inscription (still partly preserved) saying that it was dedicated by the Spartans, a tithe from the spoils taken from the Argives, Athenians and their allies at Tanagra, a battle which took place in that year. The building was paid for, we are told, out of the spoils of another internecine war, in which the people of Elis conquered Pisa (which had originally controlled the sanctuary) and its territory. This obscure conflict is thought to have occurred about 470; and the temple-builders' dump overlaid a statue-base signed by the Aeginetan sculptor Onatas who is known to have been active in the years after Plataea. The temple must have been built and adorned in a period of some twenty years at most, probably less.[86]

The building fell in an earthquake in late antiquity, but all its features are recoverable. It was in plan (fig. 120) and elevation a perfectly canonical Doric temple (above, pp. 15 and 59). Besides lion-head water-spouts,[87] in Parian marble like the rest, figure-sculpture consisted in twelve metopes, those above the east porch and the false porch at the west (those of the outer colonnade being left plain), and the figures in the two gables. Akroteria were later added in bronze: Victories at the apices and basins at the outer angles. Pausanias describes the sculptures, and the substantial surviving remains can be fitted to his description, though there is doubt about the arrangement in the east pediment.[88]

The metopes show the Labours of Herakles.[89] Among the hero's many adventures the twelve labours imposed by Eurystheus are only listed later; but the regular list corresponds to the choice here and it is likely that it was in fact these twelve carvings at the heart of Greece's greatest sanctuary that determined the canon. This is suggested by the fact that a local, Elean, story is included, the cleansing of the Augean stables. Findspots and masons' marks confirm Pausanias's division of the subjects between east and west, and his order (except that by a slip he omits the dragging of Cerberus from Hades). The series begins on the west, at the spectator's left, with the lion of Nemea, traditionally the first, and in this alone here Herakles is shown as a beardless boy. It ends at the east on the spectator's right, with the stables. Often Cerberus, the remotest and most difficult task, is made the climax, but here it is pushed into penultimate place by the local legend. Athena appears in the first and last and in one other at each end; Hermes with her in the first and without her in the Cerberus, where his presence is

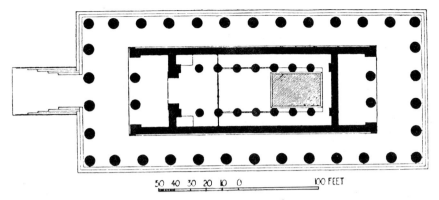

120 Plan of temple of Zeus at Olympia. Second quarter of
5th century.

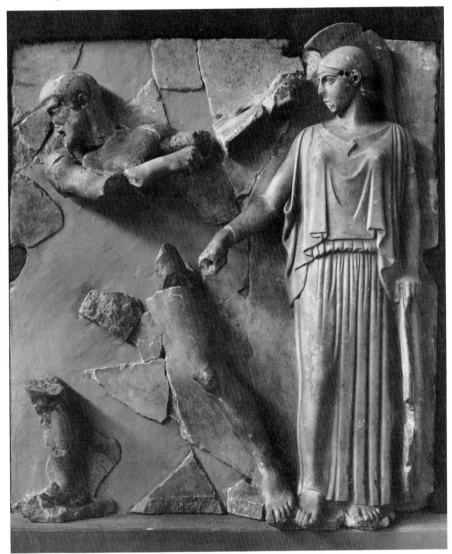

121 Marble relief from Olympia. Temple of Zeus, metope from over east porch: Herakles and
Athena at Augean stables. Second quarter of 5th century. H. 1·60 m.

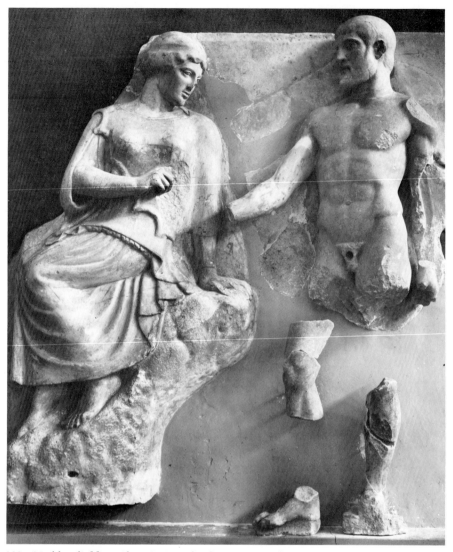

122 Marble relief from Olympia. Temple of Zeus, metope from over west porch: Herakles giving bodies of Stymphalian birds to Athena. Figure of Athena, head and right arm of Herakles, casts from originals in Louvre. Second quarter of 5th century. H. 1·60 m.

necessary as the hero's guide to the Underworld.

Building and sculptures certainly underwent repairs in antiquity; but a theory that the present order of the metopes is due to a rearrangement before Pausanias's time, the six Peloponnesian labours having been originally together on the west, the others on the east, seems to me unnecessary; indeed certainly wrong, since I find a stylistic distinction between the two ends as they are which cuts across the geographical division.

Consider two beautiful compositions with Athena: the Augean stables from the east (fig. 121), the Stymphalian birds from the west (fig. 122), both stories with a Peloponnesian setting. In the first Athena stands frontal on the right, her left arm and the shield in profile at her side making a vertical parallel to the fluted skirt-folds broken by the right knee. She looks towards Herakles, right hand out, originally with a spear to direct him and perhaps lend him divine power as he thrusts with a crowbar to open a way for the Alpheus to flood the stables. The movement is straight across the field, in a plane parallel to the flat background against which the figures are simply set. In fig. 122 Herakles stands three-quartered, offering the birds' bodies (lost; we know the subject from Pausanias) to Athena, who sits up on a rock on which her left hand rests, legs three-quartered away from Herakles, but she turns back towards him. It is a much more complex conception and much more pictorial; indeed it resembles the Apollo and Muse on the little

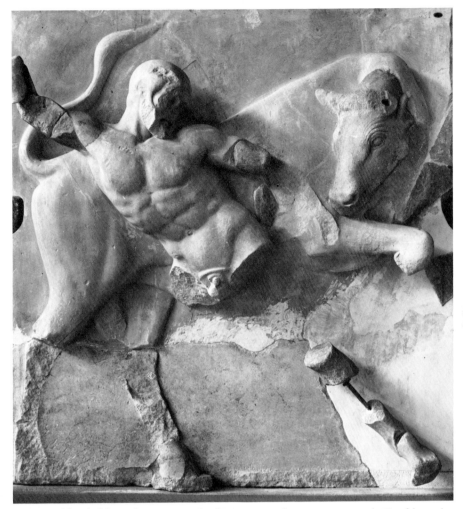

123 Marble relief from Olympia. Temple of Zeus, metope from over west porch: Herakles and the Cretan bull. Upper part, except bull's head, cast from original in Louvre. Second quarter of 5th century. H. 1·60 m.

cup (fig. 112), though that is simpler.[90]

There is a similar contrast between two representations of struggle with an animal, both outside the Peloponnese: the Cretan bull (fig. 123) from the west, Cerberus from the east. In the last a frontal foot shows that Hermes stood on the right above the head of the emerging monster, like Athena in fig. 121; and the placing of the hero is very similar though the movement (straight across the field as in the other) is pulling instead of pushing.[91] In fig. 123 the violent diagonal of the hero's body, twisting back as he throws himself across, lies over the counter-diagonal of the bull, carved in low relief on the background but it too turning its head out and back. The complex movement and the subtle merging of the planes of relief are analogous to the treatment in fig. 122, very different from the sculptural simplicity of the Cerberus and the stables (fig. 121). This composition – two figures moving across one another and turning back as they do

– becomes a regular 'strife-motive' in classical art; the west pediment of the Parthenon (fig. 132) is a major example. The metope is the earliest I know in monumental art, but the splendid little cup with Theseus and Sinis (fig. 99) anticipates it.[92]

Most of the other metopes are fragmentary, and it is hard to say if they carry out this distinction, though the little that remains of the lion suggests that it went well with the other western ones. The best preserved of all, beautiful and often illustrated, shows Herakles supporting the sky while Atlas brings him the golden apples and Athena prepares to help them exchange roles.[93] This comes from the east end and conforms strictly to pattern: figures ranged against the flat ground, in simple postures, frontal or profile. The significance of this difference in approach to relief-composition among works which share a style that is in other respects as consistent as it is distinctive, will best be discussed after we have looked at the pediments.

The metopes are about five feet wide and only a little higher, so the relief-figures are under life-size. The gods under the apex of each gable are some ten feet high, and all the figures well over life-size. None is completely lost, and many are quite well preserved; and we can get a good idea of the overall composition of each pediment.

That on the principal front, the east, represented a local story (fig. 124).[94] Oenomaus, king of Pisa, had a beautiful daughter Hippodameia whom he wished to keep unmarried because he was himself her lover. All suitors he challenged to a race: the young man set out in a chariot with the girl, while the father sacrificed a ram on the altar of Zeus in the Altis. If he caught them before they reached the Isthmus of Corinth he killed the suitor; and he always did, because he had divine horses given him by his father Ares. When Pelops came from Asia Minor he found thirteen heads nailed on the palace front; but he bribed Oenomaus's groom Myrtilos (with the promise of Hippodameia's favours) to take the lynch-pin from one of his master's chariot-wheels and substitute one of wax. This broke at speed, Oenomaus was thrown and killed, and Pelops got the princess and the kingdom, and gave his name to the Peloponnese. To avoid paying his debt he drowned Myrtilos, whose dying curse rested on the family: the sons of Pelops and Hippodameia were Atreus and Thyestes.

This is in essence a fairy-story, with all the brutality fairy-stories commonly have. We possess, however, a refined version, in an ode written by Pindar for a victory in the games here at Olympia in 476, not many years before this pediment was designed. Nothing is here said of lust, treachery and blood-guilt. Pelops wins because he is given even swifter horses by his lover Poseidon; Oenomaus's death is barely alluded to; Myrtilos not at all. Such treatment of an old myth is typical not only of Pindar but of his time. The nature of his art hardly allows the sculptor to reject the baser elements so explicitly, but I think we shall see that he makes it clear in his own way that he does so.

The west gable shows a stormy struggle, but the east is the quietest, the most inactive, of all pediment-compositions. Such a contrast between east and west is sometimes considered a principle of temple-decoration, the Parthenon being cited as another example. The Birth of Athena there is certainly a peaceful subject, opposed to the strife of two deities in the west, but it is a scene of activity and there is much movement in the treatment. A truer parallel is the archaic temple of Apollo at Delphi, with its battle in the west and on the east the frontal chariot flanked by kouroi and korai, a very still composition, the only action being in the animal-groups at the corners. It seems, however, to have shown an epiphany of the god, the theme represented by its climactic moment. The designer at Olympia chose to represent the race by the moment before it started, as Polygnotos showed the sack of Troy in its aftermath. This is the supreme surviving example of the early classical taste for stillness and indirect narrative.

The chariot-teams stand quiet, attendants sitting or crouching around, and between them stand the principals: Oenomaus with his wife Sterope, Pelops with Hippodameia. This is the moment when the contestants take the solemn oath at the altar of Zeus to abide by the result of the race; only the altar is not shown – in its place stands the god himself. These five columnar figures, facing us, standing still, might each be an independent statue in the style of the time, like the Choiseul-Gouffier Apollo or the Hestia (figs. 76–7). The composition is saved from monotony by the subtle characterisation of these figures, and united by the concentration on them effected by the inward-facing chariot-teams and the looks of some of the seated figures and of the two reclining in the angles who frame the design.

These two are called by Pausanias Alpheus and Cladeus, rivers of Olympia. The identification is often questioned, but so far as I can see on no adequate grounds. It is said that the reclining river-god is a Hellenistic invention. Certainly it was popular in Hellenistic and Roman times, and as a free-standing statue was no doubt a late idea; but the idea could very well have been suggested by such fifth-century pediment-statues as these. Scamander in Homer takes

124 Marble figures from Olympia. Temple of Zeus, east pediment: Pelops and Oenomaus before the chariot-race. Second quarter of 5th century. Original H. at apex 3·15 m.

human form to fight Achilles, and there is nothing in the least improbable in the personification of rivers in fifth-century art; indeed there are almost certain examples on coins. Here, immortal spectators, detached from the actions and passions involved, they frame the scene and also set it geographically.

Pausanias starts his account with the figure of Zeus, then speaks of others to left and right of him, but omits to say whether he means Zeus's proper right and left or the spectator's; and there is no general agreement about the correct disposition of the figures. In face and figure young Pelops is clearly distinguished from the foursquare sturdy elder Oenomaus. Zeus's head is lost, but seems to have been turned to his proper right, and on this, the side of good omen, one would expect Pelops to stand, as he does in fig. 124. Pausanias says he is on the god's left, and I conclude that he is using the words from the spectator's point of view, as I believe he does in his account of Polygnotos's paintings at Delphi. I find confirmation of this in the fact that in describing Pelops's wing of the gable he ends with Alpheus. Standing looking up at the east front, he knew that the Alpheus lay to the south, on his left, and the Cladeus flowed into it from his right. He must surely have supposed that Alpheus was shown in the southern gable-corner, Cladeus in the north; and if the designer intended these figures for the rivers he would naturally have set them so.

Identity and positioning of the two women is doubtful. Find-spots rather favour the arrangement in fig. 124, but the characterisation seems to fit better if they are made partners of the other men. Pausanias took all the seated and kneeling figures for grooms. This is probably wrong, as we shall see, in the case of two elders, and certainly in the case of one of the younger ones who is a girl. She is probably rightly placed in fig. 124, adjusting the sandal of one of the women, an action represented in very much this way on later vases and tombstones. It fits well with the way the figure placed next her in fig 124 is lifting the mantle on her shoulders; and this is against the suggested transfer. On the other hand these actions of preparation would better suit Hippodameia, who was to travel in the chariot; and the other is perhaps characterised as older. I suppose it is just possible that Hippodameia was set next her father, Sterope on the other side (cross-linking the wings, like the archers in the east pediment at Aegina, above, p. 45), and Pausanias was wrong in this point too.

The two older seated men can only be fitted in as they are in fig. 124: behind the chariot on our right; and next the figure in the other angle. They have been thought, surely rightly, seers attached to the two heroes. The ruined figure on our left has a curious head-dress, perhaps oriental, which would fit with Pelops's eastern origin.[95] The other (fig. 125) has a

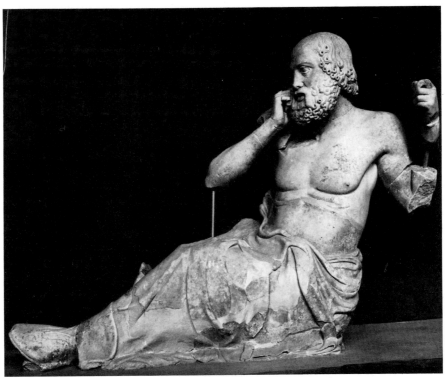

125 Marble figure from Olympia. Temple of Zeus, east pediment: seer. Second quarter of 5th century. H. 1·38 m.

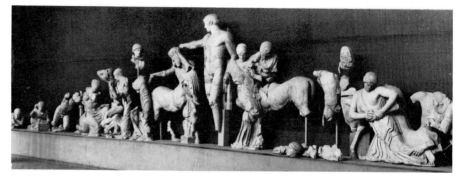

126 Marble figures from Olympia. Temple of Zeus, west pediment: Centauromachy. Second quarter of 5th century (figures on far left, later replacements). Original H. at apex 3·15 m.

hand to his chin, a gesture of disturbance or foreboding. Both look up to the centre. Zeus, I imagine, is thought of as invisible to the others, seen by the soothsayers, who mark the turn of his head to Pelops and know the outcome. The wonderful figure in fig. 125 may be Iamos, legendary ancestor of the Iamids, prophets at Olympia in historical times. There is no room between him and the chariot for a groom corresponding to the one holding the reins in the opposite wing; nor, if the girl is rightly placed, was there one at the horses' heads. The team is unattended, and this worries some, who wish to exchange the girl with one of the youths. Pausanias thought Myrtilos was under the heads of Oenomaus's horses, but since he certainly took the girl for male he may have meant her. I suspect that the unattended team is deliberate: a calculated suppression of Myrtilos. With the god's gesture and the seers' reaction to it, this emphasises the designer's Pindaric approach to the story.

The west pediment (fig. 126) shows the fight of Greeks and Centaurs at the wedding of Peirithous.[96] Peirithous, king of the Lapiths in Thessaly, invited to his wedding the Centaurs, wild man–horses of the mountains who were both neighbour and kin to him. They got drunk and tried to carry off the women, and were fought off by the bridegroom with his Lapiths and his bosom-friend, the Athenian Theseus. Like the east, this gable is symmetrically composed round a central still figure, but the construction is otherwise extremely different. In the quiet scene every figure, with the exception of the chariot-horses, is designed and carved as a separate statue. On the west, between the still central figure and those reclining in the angles, the strugglers are divided into three groups in each wing: two groups of three figures each separated by a short one of two. These groups are wholes, within which most figures cannot be detached either in execution or design from the others. Exceptions are the two heroes in the groups nearest the centre.

Pausanias, who describes this pediment more briefly than the others, calls the young figure in the centre Peirithous, but few modern scholars can accept this. In scale and attitude he stands apart, must be a god, balancing Zeus in the east, no doubt Apollo. Pausanias calls the heroes to either side of him (he does not specify right and left here) the Lapith Kaineus and Theseus with an axe. Theseus is no doubt right (the double axe is his distinguishing weapon), but the other must be Peirithous.

Fig. 126 shows the pediment as it was set up in the old museum, an arrangement that is certainly wrong. The groups flanking the god should be transposed so that the Centaurs carry their victims outwards and the heroes strike at them from next to the protecting god. The two short groups, Lapith and Centaur, Centaur carrying off boy, also fit better if transposed. Of one of the central heroes only fragments survive, including the head (shown on the ground in fig. 126). Of the other we have the head with the shoulders hunched by upraised arms, and the legs with the heavy cloak slipping down round them;[97] and we can reconstruct the figure almost exactly from the axe-man in the Centauromachy on the vase fig. 109. This then is Theseus; the other, under the god's right arm, the bridegroom.

The other two three-figure groups are fixed each in its own wing by its adjustment to the slope of the cornice. On the spectator's left (fig. 127) a Lapith drags down a Centaur who with right hand against the ground resists the pressure while his left is still buried in a woman's hair and drags her down with him as she claws at his beard with back-stretched hand. In the other[98] the Lapith's left hand must have been gripping the Centaur's head (lost) while with his right he thrusts a weapon into the breast of the creature, who yet will not let go of his prize with either hand though with both hers she tugs at one.

The angle-figures present special problems. At each

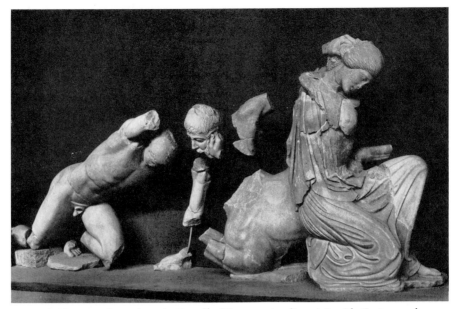

127 Marble group from Olympia. Temple of Zeus, west pediment: Lapith, Centaur and woman. Second quarter of 5th century. L. 3·25 m.

end are two women: a young one, lying on front and side, half-wrapped in her mantle as a blanket and beginning to pull it up on her shoulder as a dress while she lifts herself to look towards the centre; and an old one with cropped hair, a slave, fully dressed, beginning to get to her knees. These, framing the scene, are surely thought of as asleep in another part of the palace, roused by the tumult in the hall, as Penelope and her women listen to the fight with the Suitors. The old slaves are raised on slightly sloping platforms, that on the spectator's right (and once probably the other too) carved at the front as a cushion. This cushion, and the now headless figure of the young woman in the same corner, are carved, except for her right arm, of Parian marble, like the rest of the sculptures. The arm, the rest of the sloping platform, and the whole of the other three figures are in Pentelic, and the treatment of the eyes shows that they are certainly of later date. They must be replacements after damage, but the style is faithfully modelled on the originals. The cushion seems to be cut from the fragment of a statue. It has been suggested that the disposition of the slaves, raised, and overlapped by the others, is not of fifth-century character; that originally there was one figure in each angle, the doubling and raising due to changed taste at the time of restoration.[99] This may be so, but I see no compelling reason to believe it. The realism of the old heads seems to me strictly in early classical taste, and the raising and overlapping exactly in the spirit of contemporary developments in wall-painting; and there can be no doubt at all that the design of this gable is directly and powerfully influenced by those developments.

Most striking is the way, in the two short groups, the back half of the Centaur was never carved, but deemed to disappear behind a neighbouring group.[100] This purely pictorial device is something we should never have imagined possible in fifth-century sculpture if we did not have it before us. Then there is the linking of several figures within a single contour, especially in the lovely arabesques, fig. 127 and the corresponding trio, sometimes to the distortion of the individual figure: try thinking apart the Centaur and woman at the right of fig. 126. We can indeed speak of the influence not simply of painting but of one particular painting. We noticed the correspondence of Theseus to the Theseus on the neck of the vase fig. 109; and there are other close parallels, if none so exact, in vase-painting. In archaic art Lapiths and Centaurs are shown after the chasing from the feast, fighting a pitched battle outside, women not present, Greeks armoured, Centaurs brandishing rocks and trees; and a recurrent motive is their using these to beat into the ground the invulnerable Kaineus. The first phase, the brawl at the feast, where weapons are bare hands and teeth, spits and pots, the odd sword or axe snatched up, where the raped women are prominent and Kaineus's death not shown, appears suddenly on early classical vases and here. We have seen reason to connect the vases with the wall-painting in the Theseion at Athens in the late 470s; and that was surely also a direct inspiration to the designer of the gable. It may well have been in that picture that the new type was created.[101]

Pausanias says that the east pediment at Olympia was by Paionios, the west by Alkamenes. From half a

lifetime later we have two fine marble statues, one (fig. 171) certainly the work of Paionios, the other (fig. 161) probably of Alkamenes. These will be discussed in the next chapter (below, pp. 118ff., 126ff.). It is impossible to make any convincing stylistic connection between either of these and the Olympia sculptures. Given the time-lag, this does not rule out that one or both of these sculptors worked on this temple in their youth; but in the case of Alkamenes (about whose career we hear a good deal) it is a difficult supposition, and not very easy for Paionios. More interesting is the question whether on stylistic grounds one would postulate one designer or two at Olympia, but that too admits of no easy answer. Pausanias does not consider the authorship of the metopes, but the difference of approach we noticed between the two groups corresponds so exactly to the difference between the gables that we can safely postulate one designer for the sculptures at each end of the building; but can it be one man who designed both? The character of free-standing sculpture, so noticeable in the figures of the east, is abandoned in the chariot-teams, where the near horse alone is carved in full, heads and necks of the others being attached to it in a kind of receding relief;[102] but this was a special problem which required a special solution. Still, the application of different principles of design at the two ends could be accounted for in one man's work: either by supposing that he saw and was overwhelmed by the Theseion mural between designing the east and designing the west; or, perhaps more convincingly, that he felt a traditional, sculptural style proper to the entrance-front while allowing himself at the back to experiment with a new pictorial interest. Certainly there is a powerful overall 'Olympia style';

and likenesses and differences in details of carving cut across east and west. The sharp carving of the seer's locks (fig. 125) archaic in tradition, is precisely paralleled in the Apollo[103] (whose beautiful head is not, as I have carelessly asserted, cut from a separate piece of marble but is one with the body); while the marvellous smoothness of the Cladeus (fig. 128) is found on the west in the heads of Theseus and particularly of the bride,[104] and in heads of Herakles from metopes at both ends. The distinctive horizontal bar of the pubic hair is seen in metopes and gables, east and west (figs. 122–3, 127–8), as is a particular pattern of folds where drapery lies on the ground.[105] The old body of the seer, one of the great examples of early classical realism, finds no parallel on the west, but the furrow on his brow recurs in the western gable and a metope too. The soft, smooth bodies of young boys are rendered in both pediments.[106] If there were two designers they must have worked closely together and shared the same highly trained team of executants. Some work was probably done in the quarries on Paros, and it is likely that among the executants were islanders, used to carving marble; there is next to no marble sculpture from Olympia before this. The question of the origin of the designer or designers is much canvassed but does not seem to me, in the present state of our knowledge, susceptible of even provisional or doubtful answers.

Why did the designer of the west pediment choose for subject the Thessalian Centauromachy in its new Athenian guise? Or rather, why was it chosen? – for we know nothing of how such a choice was made in Greece. Raphael planned his frescoes in the Stanze to a programme provided by a humanist at the papal court,

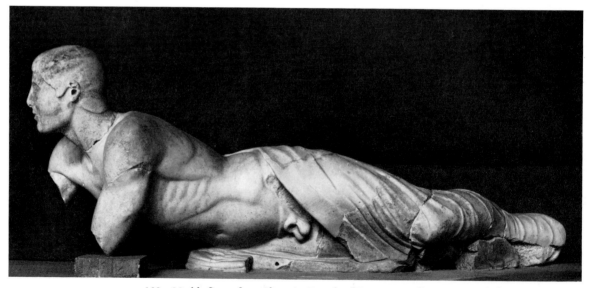

128 Marble figure from Olympia. Temple of Zeus, east pediment: river Cladeus. Second quarter of 5th century. L. 2·30 m.

and the inclusion of almost every detail in Enguerrand Quarton's marvellously constructed Coronation of the Virgin is laid down in the documents commissioning it. Probably it was not the artists who chose the subject-matter for the decoration of a Greek temple, but the priests or some other religious or civic authority. The choice at Olympia whosever it was, is interesting. In the metopes Herakles, mortal son of Zeus, to be raised after death to Olympus, hero of all Greece but in particular of the Dorians and traditional founder of the Olympic games, clears trouble from the earth with the help of his divine siblings, Hermes and especially Athena, goddess of wisdom and courage as well as of Athens. In the western gable north Greek and Athenian heroes are guided in the fight against barbarism by another child of Zeus, god of light and healing and lord of the two other greatest inter-state sanctuaries, Delphi north of the gulf and the Ionian island Delos; while on the east front Zeus himself supports the fortunes of Pelops who came from beyond the Aegean to give his name to the Peloponnese. The Persians had been driven from Greece not many years before the temple was begun, and the fight to free Greeks from them was still going on in the east. This struggle, and the Greek unity half achieved in the course of it, must have been in the programmatist's mind; but the project was paid for out of spoils from the conquest of one Greek city by another, and the golden shield proudly crowning the newly finished temple was set there to celebrate an early clash in the fatal hostility of Athens and Sparta which was to culminate in the Peloponnesian war and the ruin of Greece.

5

The classical moment

I. The Parthenon

In 454 the treasury of the Delian League was moved from Delos to Athens, crystallising the gradual transformation of the free confederacy against the Persians into an Athenian empire. The Greek cities of Asia Minor had been freed in Cimon's campaigns, and about 460 a fleet and army were sent to Egypt to support a Libyan attempt to oust the Persians, but this ended in catastrophe in the year of the transfer. At the same time the Athenians, under Pericles who had risen by Cimon's fall to directing their policies, were building up their power. Aegina was brought into the League by *force majeure* in 458–7 (as early as 465–4 Thasos had been forcibly prevented from leaving it); and for a time Athens attempted to extend her suzerainty to the mainland, conquering her great northern neighbour Boeotia. The Spartan victory at Tanagra, recorded in the dedication at Olympia (above, p. 80) was connected with resistance to this ambition, which failed definitively a few years later. After that Pericles concentrated on the consolidation of Athens's island and maritime dominion. What directly concerns us is his inception in 447 of a programme for using confederate funds to adorn the imperial city. Probably a formal peace had been concluded with Persia the year before, the Peace of Kallias (a name unfortunately given also to a better attested treaty in the following century, below, p. 139); and this was felt to release the Greeks from an oath supposed to have been taken on the field of Plataea not to rebuild the temples and shrines destroyed by the Persians, but to leave them as a memorial. Neither oath nor peace is attested by contemporary sources, and the authenticity of both has been questioned, in antiquity and at the present day, but they certainly fit nicely with the architectural history of the Athenian Acropolis.[1]

The principal ancient temple of Athena on the site had lain to the south of the Erechtheum, where its foundations can be seen. This was never rebuilt, and the temple which ultimately assumed its role was not the one with which Pericles began, the Parthenon, but the Erechtheum, built later in the century. Whether there was a second sixth-century temple to the goddess, on the site of the Parthenon, is doubtful, but a big one was certainly begun there shortly before the Persian sack, when it was burned along with the old temple and any other buildings. It was this unfinished Parthenon which the Athenians in 447 chose to begin by replacing.[2]

In both the pre-Persian and the Periclean Parthenon the plan is abnormal, the building within the colonnade being divided into two rooms: the temple-room itself, with an inner colonnade in two storeys (as at Aegina and Olympia, fig. 120), entered by the east porch; and a shorter room behind, with four columns of full height, entered from the west. The name Parthenon applied originally to the back room alone. It was used as a treasury, but the word *parthenōn* is of the same form as *gynaikōn*, women's quarters, and *andrōn*, men's room (dining room) in a private house, and may give a hint that originally on the site or part of the site was not a temple but a building for the maidens who played a large part in ritual on the Acropolis.[3] Both porches were shallow and had the columns set forward of the wall-ends (antae), not between them as at Olympia and commonly. The early building had the usual six columns on the ends, so four in the porches. It was exceptionally long, with sixteen down the sides. Aegina is six by twelve; Olympia six by thirteen, and it became the norm to make the sides double the ends plus one. The Periclean Parthenon (fig. 129) is larger than the earlier one and of a different proportion: eight by seventeen, with six on the porches. In the elongated early version the temple-room proper was of nearly normal proportions: in the Periclean it is much broader than usual, and the inner colonnade is exceptionally carried round the back. Probably a principal reason for the change in plan was to achieve this broad room; not for its own architectural effect (the Parthenon, like all Greek temples is essentially

exterior architecture) but to make a roomier setting for Pheidias's forty-foot statue of the standing goddess, veneered in ivory and gold. It is clear that statue and temple were built with and for each other.

Gold and ivory had been used on archaic cult-statues (above, p. 39), but those were life-size or less. There were colossal figures in archaic and early fifth-century Greece, but only in the open, in marble or bronze.[4] The idea of a colossal cult-statue within a temple, where precious materials could be used, seems to have originated with Pheidias — or perhaps rather with his patrons: there is a nice story of his remarking that marble would wear better than ivory, besides being cheaper. His Zeus at Olympia was fitted into a temple already built, but some observers felt that the setting cramped it. The architects of the Parthenon, Iktinos (who wrote a treatise on it) and Kallikrates surely worked closely with Pheidias who, Plutarch says, was general overseer of Pericles's work on the Acropolis. The statue, which must have taken long to construct, was dedicated before work on the building

was at an end; and there are correspondences which can hardly be coincidental between parts of the subsidiary decoration of the statue and of the temple. Building and image are inseparable.

Public works were recorded at Athens on marble, and we have substantial remains of the inscriptions covering this project.[5] The building was begun in 447–6, the statue dedicated nine years later. By that time the roof must have been on; so metopes and frieze-blocks were already in position. The metopes were certainly carved before being put on the building; as to the continuous frieze, this is disputed. Block-junctions are less regarded by the carvers of the long sides than on east and west, and it is often concluded that, while the west and probably the east blocks were carved before insertion, the long sides were executed *in situ*. The latest and most authoritative study, however, points to the intrinsic improbability of leaving such subtle work to be executed in such awkward conditions, and concludes that the whole frieze, like all the rest of the sculpture, was carved in

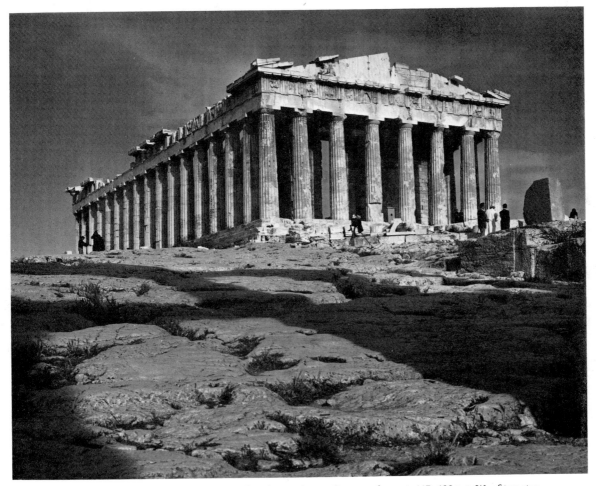

129 Athens, Acropolis: the Parthenon from north-west. 447–432 B.C. W. of top step 30·186 m.

91

the studio.[6] If so, work on frieze as well as metopes was complete by 438–7. Work on the pediment-sculptures is first recorded in that year; and marble was still being quarried, nò doubt for these, in 434–3. The accounts were closed in 432. The temples at Aegina and Olympia were, in the Doric tradition, of limestone covered with marble-stucco, only roof-tiles and sculptures being of marble. The Parthenon, like some archaic Ionian temples, was in marble entirely, from the local quarries of Mt Pentelicus.

In late antiquity Athena gave place to the Panagia, and in the fifteenth century the mihrab took over. Some sculptures were lost, others damaged, during these changes; but most, on the roofed and used building, remained in relatively good condition, as we can see from drawings made in 1674 for the Marquis de Nointel, French Ambassador to the Porte, probably by Jacques Carrey of Troyes. Thirteen years later the Venetians besieging the citadel fired the Turkish powder-store in the mosque and blew out its centre, with loss of stretches of frieze and metopes. Further damage was done in bungled attempts to remove figures from the west gable; and the condition of what was left on the ruined building rapidly deteriorated. Lord Elgin's removal of most of the remaining sculpture to London at the beginning of the last century unquestionably saved much that would have perished, as comparison of casts he took with originals he left behind demonstrates.

This temple carried more sculpture than any other we know of. The akroteria were floral; but there was figure-sculpture in both pediments, in all ninety-two metopes, and in the continuous frieze which replaced metopes and triglyphs above the inner porches and was carried also down the long sides of the inner building. To complete this work in fifteen years must

130 Plaster cast of marble relief from Acropolis. Original metope *in situ* on north side of Parthenon (west corner): two goddesses. Between 447 and 438 B.C. Cast taken by Lord Elgin. H. 1·20 m.

92

have required a great many sculptors, and many hands have been detected; but there is an overall consistency both in style and in quality. The greatest variety in both respects is seen in the surviving metopes, and it seems safe to suppose that work started on them, and that by the time the frieze and gable-figures were executed the designers could rely on a very well trained team.

The metopes on east, north and west have been deliberately defaced, presumably by Christians or Moslems, though why only these sculptures were so treated we cannot know. The westernmost on the north was spared, possibly because the two goddesses have the look of an Annunciation (fig. 130); and it has been suggested that the sparing of the south series might have been due to the fact that the twelve at the west and eleven at the east showed Centaurs, creatures which sometimes find a place in Christian iconography. Owing to their condition, the metopes other than on the south were not drawn in 1674 nor taken by Elgin, and he made a cast only of North 32 (fig. 130). Those which survive are still *in situ*, in a terrible state of illegibility, and the central ones on the north have perished without record. The east certainly show a Gigantomachy, the west a battle almost certainly of Greeks and Amazons. Episodes from the sack of Troy can be made out on the north, and this was probably the subject of most, framed in nos. 1 and 29 by heavenly bodies, such as framed the action in the east pediment and on the statue-base (below, pp. 96 and 103), while the last three at the west had deities brooding on the city's fate (fig. 130).[7] The Centauromachy on the south is the brawl at the feast, as at Olympia. The twelfth from the east (lost, but drawn by Carrey) shows two women taking refuge at an image and no doubt belongs (the same episode is found in the slightly later Centauromachy on the frieze from Bassae, below, p. 129); but the central eight as we know them in drawings cannot be fitted into a plausible version of the Centauromachy, and their interpretation is disputed and unsure.[8]

The eighteen southern metopes which survive are all from the Centauromachy. The westernmost (1) is still on the building, and shows how splendid these sculptures look in their setting (fig. 131). Others are no less fine: 27, a version of the 'strife-motive' (above, p. 83) given a special effectiveness by the sweep of the cloak behind; or 28, with a Centaur triumphing over a dead Greek.[9] Some others are much inferior, and some much more old-fashioned, in the style of the previous generation. A theory has been advanced that Cimon began a Parthenon on the pre-Persian plan with Kallikrates for architect; that the Centaur-metopes were carved for this; and that they were at last fitted into the new design made for Cimon's successful rival

Pericles by Iktinos.[10] We cannot go into the ingenious arguments of many kinds with which this is supported. I am finally unconvinced; and the stylistic argument from the Centaur-metopes seems to me both to ignore their variety and to be unnecessary for the explanation of their early classical elements. The dramatic treatment of the muscular torso in no. 27 seems to me far closer to things we shall see in the Parthenon pediments (as is the rich drapery style of the metope from the north, fig. 130) than to anything at Olympia; and those pieces which do recall Olympia I would see as the work of old-fashioned artists at the start of the new project, when the 'Parthenon-style' had not yet been forged.

The Gigantomachy was painted on the interior of the shield propped at the side of Pheidias's Athena within the temple; the Amazonomachy in relief on its outside; the Centauromachy on her sandal-rims. No Trojan scenes are recorded from the statue, but the correspondence of the other three does not look like chance. It is conceivable that there was a further link. The base of the statue had the creation of Pandora by the two divine artificers, Hephaestus and Athena; and a case has been put forward for the central metopes of the south side telling the story of Daedalus, the

131 Marble metope in position on south side of Parthenon (west corner); Lapith and Centaur. Between 447 and 438 B.C. H. of carved field of metope 1·20 m.

132 Drawings made in 1674/5, probably by Jacques Carrey of Troyes, of west pediment of Parthenon. Sculptures: between 447 and 432 B.C. Original H. at apex *c.* 3·50 m. H. of left-hand drawing 0·27 m.

legendary inventor of sculpture, who is closely associated with Hephaestus.[11] Here as elsewhere (above, p. 89) religious and civic authority will no doubt have laid down lines for the decoration of both temple and statue; but in this case we know that Pheidias was a member of Pericles's circle and the supervisor of his works on the Acropolis. His own ideas will have had weight, and might well have included a tribute to the hero as well as to the gods of craft and art.

The Doric order, so apparently rigid, is capable of considerable variety of effect. The proportions of the Parthenon are quite different from those of the temple at Olympia. Its metopes are actually slightly smaller than the Olympian, and seem much smaller in relation to the larger building. The gables on the other hand, over the eight-column span, are some ten feet longer and about a foot higher at the apex (over ninety feet by over eleven).

Pausanias tells us that the east gable showed the Birth of Athena, the west Poseidon's Strife against her for the Land (of Attica), but he gives no details. The whole centre of the east was lost when an apse was thrown out during the conversion to a church, and there is no record of the composition. The central group on the west, though with losses, was still in position when Carrey drew it (fig. 132). The Venetians after the explosion tried to take the figures down. They fell and were smashed, but fragments can be identified from the drawing and it does give us the composition; so, though more from the wings of the front pediment survives in tolerable condition, it is best to begin with the west.[12]

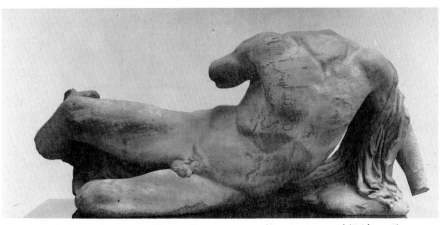

133 Marble figure from Acropolis. Parthenon, west pediment: river-god (Eridanos?).
Between 447 and 432 B.C. H. 0·82 m.

The legend is a local one poorly documented in extant literature. The gods decided each to found a city of their own, to do them special honour. Both Poseidon and Athena wanted to place theirs in Attica. Poseidon struck the Acropolis, and a salt spring welled up. Athena planted an undying olive there. Zeus, either on his own or after appointing judges, the Twelve Gods or Kekrops king of Attica, awarded it to Athena. Poseidon grew angry, and began to bring his sea over the land, and Zeus had to intervene to stop him. A brilliant recent study[13] makes these phases clear, and that it was the last phase which was shown in the gable. The earlier stages were peaceful; here we see a moment of violent confrontation. The deities have leaped from their chariots, reined in at speed, and now face each other in the classical example of the 'strife-motive' already discussed (above, p. 83). Zeus's intervention is shown by his messengers, Hermes and Iris, arriving in haste at the chariots; possibly also originally by a thunderbolt in gilded bronze issuing from the sloping cornice above the contestants. Behind the chariots are groups with a predominance of women and children, the people of Attica, probably in particular the legendary royal families. A pair on Athena's side are an old man and a girl leaning on his shoulder, a great snake between them: Kekrops, often shown with snake-legs, and one of his daughters. The angle-figures are sometimes thought to belong to this company; but the magnificent nude beyond Kekrops, heaving from the ground (fig. 133) is more often called, on the analogy of Olympia, a river-god, and this I am sure is right. The corresponding figure in the southern corner, now a total ruin, is female, and Carrey's drawing shows that she was grouped in conversation with the young male next her whose magnificent torso survives.[14] The action relates them, no doubt deliberately, to the family groups; but I suppose she is a fountain-nymph, probably Callirrhoe, very important in Attic religion and most likely to be identified with a nameless Nymph of a sanctuary on the south slope of the Acropolis.[15] Her companion will then be another river, perhaps Ilissos. This is the name traditionally given to the figure in the northern angle, but Ilissos flows to the south of the Acropolis, and he may rather be Eridanos, a stream which runs through the Kerameikos to the north-west.

The subject of the east pediment, the Birth of Athena, was popular in archaic art, particularly but not exclusively in Athens.[16] Zeus married Metis (Wisdom) and got her with child. Warned by a prophecy that the child she bore would overthrow its father he swallowed her, and subsequently gave birth to Athena from his head, split for the purpose by Hephaestus; and she was always closer to her father-mother than any other Olympian. A tiny Athena, fully armed, is shown issuing from the god's head or alighted, still doll-like, on his knee. This simple rendering of a primitive tale suits the unreal conventions of archaic art but not those of classical; and fifth-century vase-paintings of the subject are unsatisfactory and, no doubt for that reason, rare. The subject goes out of fashion, and the designer of the pediment must have rethought it. There is a Roman relief on a circular altar which presents the scene in a less naive schema (fig. 134). Athena, fully grown, is alighting on the ground in front of Zeus, still in movement but looking back at him, as though just stopping and turning. Hephaestus behind him starts away also but also looks back. Between Hephaestus and Athena are the Three Fates, proper participants at a birth. The drapery-style of the Fates seems based on fourth-century models, but the principals are of fifth-century character and can be well paralleled in the Parthenon sculptures and in work associable with

Pheidias. In view of the rarity of the subject at this time it is tempting to see here the composition of the gable-centre, but there are difficulties. The god in the pediment can hardly have been in profile, and marks on its floor suggest that he sat on a rock (Olympus's top) not a throne.[17] The Zeus of the relief is very like one in other Roman reliefs which include figures certainly copied from the creation of Pandora on the statue-base, and it has been suggested that the Athena and Hephaestus are borrowed from the same source.[18] Pheidian statue-bases, however, seem to have had a distinctive character, most figures being quiet, in-active, often standing frontally (below, p. 103); and the explosive movement here seems to suit the birth of Athena (which is certainly the subject of the relief) better than the creation of Pandora. The relief is certainly eclectic, as the Fates show (and the little Victory flying to crown Athena probably comes from some yet other source). It seems to me very likely that the Hephaestus and Athena, with their resemblance to the Athena and Poseidon in the west, give us in low relief and on a small scale (they are less than three feet high) the structure and movement of the colossal statues from the east gable.

The figures Carrey drew in the wings still survive, though more have lost their heads. The scene was framed by chariots, both moving to the spectator's right; or rather by indications that chariots are there. At the south (left) end the head, largely lost, and arms of a male seem to issue from the pediment-floor, four

134 Marble relief. Circular altar (*puteal*): birth of Athena. First to second century A.D.; design derived from classical Greek originals, perhaps in part from east pediment of Parthenon. H. 0·99 m.

horses' heads and necks rearing in front of him. At the other end horses' heads, originally four also, and a half-figure of a female charioteer seems to sink into it. Pausanias tells us that the Birth of Aphrodite on the base of Pheidias's Zeus at Olympia was framed by Helios (the Sun) in a chariot and Selene (the Moon) riding a horse or mule; and rough indications on a miniature copy of the Athena suggest that the creation of Pandora was similarly closed. The charioteers in the pediment must be the same, unless the goddess is rather Nyx (Night) or Eos (Dawn) disappearing at the moment of sunrise.

The identification of all the other figures is in doubt. Facing the sunrise a youth (the only figure in either gable with head still unbroken though terribly weathered, fig. 135) reclines on a rock over which is thrown a skin (lion or panther) and a cloak. Next two women carved from a single block sit on chests, the first leaning on the other's shoulder, who lifts her arm to greet a young girl running in from the centre. The closely knit pair suggest Demeter and Persephone, and a chest, though not of this form, was important in their mysteries. The identification is most likely right. The youth (whose nineteenth-century appellation 'Theseus' must be mistaken) has been given many

names, generally Dionysus or Herakles. The wine-god, concerned like the Eleusinian goddesses with darkness and generation, would be a suitable neighbour; but Herakles was claimed by the Athenians as the first initiate at Eleusis. After his mortal end he became a god – long after Athena's birth, but this is probably an irrelevant consideration (cf. below, p. 105); and this identity suits the powerful forms of the statue.[19] The girl beyond has been called Hebe or (attractively) Artemis, Apollo imagined next; but there can be no certainty.

Behind Selene in the other wing a goddess reclines in another's lap (fig. 136), the two carved in one block with their vaguely characterised rocky seat; and a third, separate, looks towards the centre. The indications are unsure, but it is hard not to accept the recliner as Aphrodite. Arguments have been adduced for calling her companion Artemis (closely linked to Aphrodite on the frieze), but a better case has been made out for Themis. The third has been thought Hestia.[20]

The gaps between the surviving groups and the central action are generally reconstructed with many gods and goddesses; but there are places in each wing where the floor is reinforced, as for a heavy weight, in just the same way as the floor of the west gable is for the chariot-teams. Possibly here too was a pair of

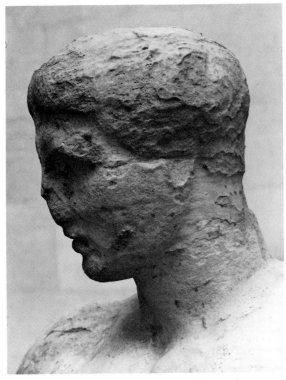

135 Head of marble figure from Acropolis. Parthenon, east pediment: reclining youth (Herakles or Dionysus?). Between 447 and 432 B.C. H. of head 0·32 m.

chariots, it is suggested for Hephaestus and Eileithyia, goddess of childbirth.[21] With Helios and Selene it makes perhaps a plethora of teams, but horses are almost an obsession on the Parthenon and it may be right. Fragments of a peplos-statue and a splendid male torso, both very large, may belong to a Hera and another deity from near the centre of this pediment. Impressive fragments are preserved also from the Athena and Poseidon of the west.[22]

Compositionally these gables show the symmetry of Olympia loosened and varied. The male figure in one angle on the west is balanced by a female in the other. On the east the chariots move crosswise, so that Helios's head and arms correspond to Selene's horse-heads, his horses to Selene herself. Next to these in each wing are a recliner and two seated figures, and in each trio two of the figures form a close group, but it is a different pair in each case, and in one the recliner is male, in the other female. Style has undergone a similar change. The musculature of the great Olympia nudes (figs. 121–8) is simple and strong but unemphatic, 'ineloquent' as Berenson says of Piero della Francesca. There is a dramatic intensity in the torso of the Parthenon river-god (fig. 133) which makes him wholly different from the Cladeus (fig. 128) – Michelangelo to Piero. In drapery the difference is if possible even more striking. Olympia is still in full reaction against late archaic virtuosity. We saw in the metope fig. 130 a new enrichment, and this is carried far further in the pediments. The figures in Helios's wing on the east are comparatively simple, though already a world away from Olympia, but a climax is reached in those of Selene's (fig. 136). The restless complexity of surface in the naturalistic yet formally satisfying drapery-patterns does not obscure but counterpoints the power of the sculptural forms beneath; or so it seems to me – there are those who find these figures overblown. In the Iris of the west (fig. 137) the modelling of the body naked under the wrinkles running in the wind-blown stuff, looks forward to a late fifth-century style (below, pp. 125ff.), which returns to the virtuosity of late archaic art but on a new basis of observation.

The head of the youth from the east (fig. 135) preserves only a beautiful ghost of style, and the battered Laborde head, certainly a goddess from one gable, is not much more help.[23] The torso of Poseidon from the west allows identification of full-size copies of the figure in Tritons adorning a Roman building in the Agora, and there is a well-preserved head from one of these (fig. 138). For all the copyist's coarsening, this grand god surely carries much of the original style.[24]

The way Helios and Selene are cut off by the gable-floor, the fusing of two figures into an indivisible whole (Themis and Aphrodite) might be seen as

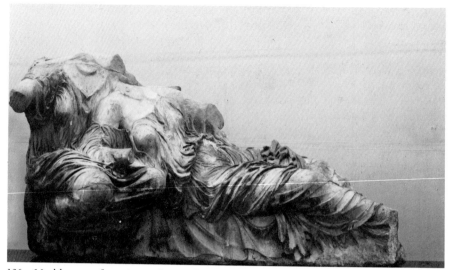

136 Marble group from Acropolis. Parthenon, east pediment: two goddesses (Aphrodite in lap of Themis?). Between 447 and 432 B.C. L. 2·33 m.

influence from painting such as we postulated at Olympia; but here any such influence is much more rigorously subordinated to sculptural character than there. Unlike many at Olympia, every piece from the Parthenon pediments was fully conceived and executed as a statue in the round, though there has been some rough hacking to fit some of them into their final positions on the narrow ledge (about three feet deep).

The most unusual as well as the best preserved part of this temple's decoration is the continuous frieze.[25] The central slab at the east (fig. 139) was taken down when the apse was thrown out; the heads on it have been defaced and it has been sawn in half. At some time in the Middle Ages a few windows were cut in the long sides. The explosion destroyed the centres of both long sides, and later other slabs fell and many were badly weathered. The comparatively sheltered position, however, and the rather low relief have combined to keep much of it in a good state.

Attempts had been made on various archaic buildings, Doric and Ionic, to find a place for a continuous carved band. In Ionic it found an accepted position above the architrave, below or replacing the dentils, as we saw in the Siphnian treasury (above, p. 40). In Doric it has no regular place, but on several Attic temples of this period it replaces triglyphs and metopes above the inner porches, sometimes with extensions (below, p. 116), but only here is it carried also down the long sides.[26] This is also the only case on any Greek temple of either order in any period where one developing theme is carried over all four sides in a unified design. The theme itself is unique: a procession (for a doubtful anticipation see above, p. 31).

The procession is all but certainly that held at the Greater Panathenaea. The Panathenaea was celebrated every year in the summer, on Athena's birthday, and every four years the Greater, with games and contests. This culminated in a procession from the Outer Kerameikos (outside the Dipylon gate) along the Sacred Way through the Agora and up to the Acropolis. In this was carried a robe, woven by citizens' daughters, for the primitive olive-wood image of the goddess, fallen from heaven in Erechtheus's reign. This image had been kept in the old temple the foundations of which lie south of the Erechtheum (above, p. 90). When the Persians came it was taken to Salamis, and found its final home in the Erechtheum, built later in the century (below, p. 121). In the interval it was kept in a temporary structure, never in the Parthenon; and the frieze omits elements which we know of in this procession.[27] For these reasons it has sometimes been doubted if the procession on the frieze really is the Panathenaic, but for most scholars and me the identification is made sure by the scene on the central eastern slab (part, fig. 139); not part of the procession but the point on which it converges from north to south, the end and climax of the whole. Here a woman, no doubt a priestess, faces two girls who carry stools on their heads, and back to back with her a man in a long-sleeved garment, a magistrate, no doubt the *archon basileus* who had charge of all religious affairs, receives from or hands to a child a folded cloth, which can surely not be other than the peplos. That the sculptor has been selective in his representation of the procession is not surprising; and since the Parthenon is all in honour of the goddess of the Acropolis and Athens,

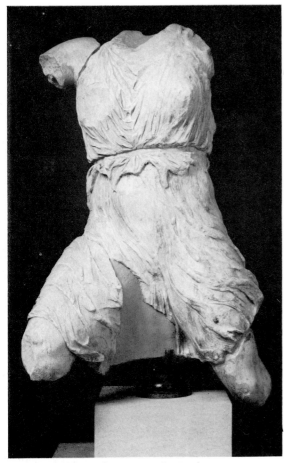

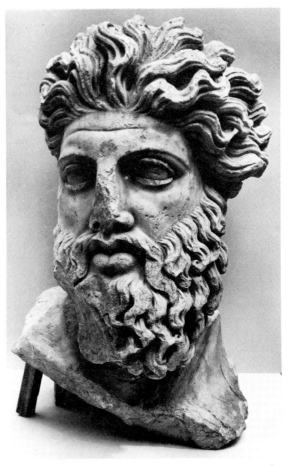

137 Marble figure from Acropolis. Parthenon, west pediment: Iris. Between 447 and 432 B.C. H. 1·35 m.

138 Marble head from Agora. Odeion: Triton; apparently copied from Poseidon in west pediment of Parthenon. Mid 2nd century A.D.; original between 447 and 432 B.C. H. 0·57 m.

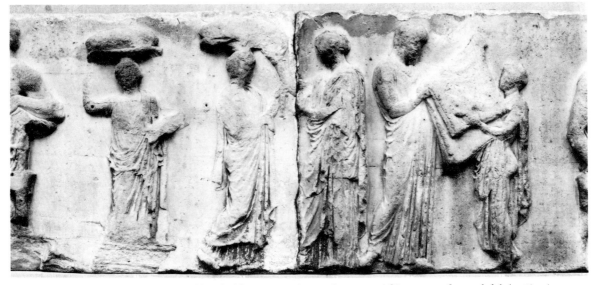

139 Marble relief from Acropolis. Parthenon, east frieze, part of central slab (cutting in two is modern): ceremony with Panathenaic robe. Probably between 447 and 438 B.C. H. 1·05 m.

the fact that the ancient image was not actually housed in it need have no significance. Besides, the Panathenaic procession was the high point of Athenian religious life, the only thing of its kind likely to have been adopted, in defiance of tradition, for the decoration of a temple.

The actual robe was woven with the battle of Gods and Giants, shown also on the statue's shield and in the east metopes; and no doubt it was painted on the marble here.

The slabs at the west, still largely on the building, show young knights (two, exceptionally with beards, are perhaps the two *hipparchs* who commanded them) with their mounts and helping lads, preparing. Many are still unmounted, horses face different ways and sometimes get out of hand, and the composition is much more staccato and episodic than on the other three sides. On the left (north) however, most are mounted and moving that way, to join the procession on the long north side, already formed though the first slab round the corner (part, fig. 140) shows preparation still going on. Up both long sides the horsemen move in overlapping groups and masses; and in front of them move more young knights, leaping in and out of chariots. Horsemen and chariots occupy more than half the length. In front are groups on foot: elders on both north and south, musicians apparently on the north only, and youths carrying objects of ritual, variously distributed between the two sides. At the eastern ends are youths driving heifers for sacrifice and (on the north only) sheep. There are no women on west, north or south; but where the procession continues round the corner on the east, no men, except for marshals who appear also at intervals up the long sides. The procession on the east front consists entirely of girls, singly or in pairs, carrying vessels and other things, those in front empty-handed (fig. 163).

The movement is very varied. The girls at the front are quite still, and it is often thought that the frieze gives us the whole course of the procession: knights preparing in the Outer Kerameikos on the west; the movement through the city up north and south; on the east, the maidens already arrived on the Acropolis.[28] This is attractive and may be right, but the treatment on the long sides does not seem quite to fit. Certainly some passages, especially among horsemen and chariots, show the procession as it looks on its way; but one is often brought back to the idea of preparation. The hindmost chariot-teams are standing still; the last of the boys with pitchers on their shoulders is only stooping to lift his from the ground. There is temporal inconsistency, as so often in classical art, a deliberate vagueness; but I incline to think that the essential idea is that of the procession about to start, while the little

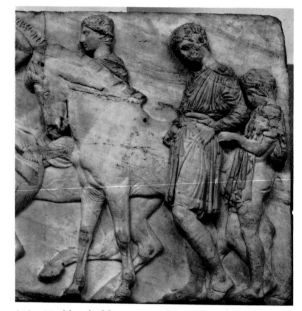

140 Marble relief from Acropolis. Parthenon, north frieze, part of slab at west corner: knights preparing. Probably between 447 and 438 B.C. H. 1·05 m.

scene at the centre of the east front (fig. 139), isolated from the procession by groups to be discussed in a moment, shows preparation on the Acropolis for its reception. In that case the peplos shown will be the old one being folded up; in the other interpretation the new one being delivered. The child helping with it is generally thought a boy. There is certainly much likeness to the little boy tying the knight's belt in fig. 140, the knight's cloak hung over his shoulder, but the garment here is actually quite different. It is a dress, seemingly an unbelted peplos, fastened abnormally on the left shoulder and open down that side. One may compare the tombstone of a little girl from Paros (fig. 141), not much earlier than the frieze, and one would not be surprised if its sculptor had come to work on that; though there fastening and opening are on the usual right and the less pronounced backward lean bares less of the bottom. The child in fig. 139 has strong Venus-rings on the neck; and a girl seems more in keeping with the make-up of the front of the procession: the peplos was essentially girls' business.

Beyond the procession stand thirteen men and youths (six to south, seven to north) in relaxed conversational groups. They might be citizens waiting for the procession to pass, but a convincing theory sees three near the procession as marshals, the others (four on south, six on north) as the eponymous heroes of the ten tribes in which the people of Attica were organised for political and religious purposes.[29] They make a transition to the final groups: twelve seated deities, six on each side of the centre. Informal and easy, they sit

141 Marble relief from Paros. Tombstone: little girl with doves. Mid 5th century. H. 0·80 m.

towards the procession though some look away. Only one, though he looks towards it is seated the other way, back to back with Hermes, on whose shoulder he leans, his feet crossing Demeter's. He seems set apart, and must be Dionysus, or possibly Herakles (cf. above, p. 97), neither of them originally at home on Olympus,[30] who here replaces (if the formal list of the Twelve Olympians was already agreed) the least commonly represented of them, Hestia. Seated, they fill the height of the frieze, so are on a larger scale than the mortals; and two child-deities stand with them, beside Hera the winged girl Iris, the winged boy Eros leaning on Aphrodite's knee.

The real meaning of the frieze is much argued over

and we shall probably never know. A processional frieze certainly designed under the influence of this one, that of the Ara Pacis set up in Rome by Augustus, represents a particular occasion, the dedication of the altar on 4 July 13 B.C., and individual participants are recognisable.[31] The Parthenon frieze is certainly not of that kind. I have called it elsewhere 'an ideal embodiment of a recurrent festival', and that it surely is, but it may be something more particular as well. An interesting suggestion makes it the first festival, under Erechtheus (above, p. 98),[32] but one might expect Erechtheus and other legendary figures to be given some kind of distinctive definition; perhaps also that the heaven-dropped image would be shown. A most attractive theory has been recently and brilliantly argued: that the young knights who occupy such a large space to the exclusion of other elements which we know took part in the actual procession, represent the dead at Marathon, who we know were heroised; and what we are shown is both the Panathenaic procession of 490 and at the same time the Gods receiving the new heroes.[33] *Se non è vero è ben trovato.*

The gable-figures are carved in the round, the metopes in high relief; the frieze in low relief, but of a subtlety unparalleled before and indeed after. The background is cut deeper at the top to tell better from below (the notion sometimes expressed that on the complete building the frieze would have been virtually invisible is surely nonsense), but never more than about two inches. In this shallow depth figures are shown, single or overlapping (among the horsemen sometimes in many layers), with often complicated three-quarterings of body and face, and a marvellously varied rhythm of movement and grouping. This unique and very distinctive relief-style must have been created by one man; and one man must have laid out the design of the whole on general lines, and indeed with some precision to achieve the balance up the long sides and the unity of style over the whole. Different hands have been discerned in the carving, and there must have been many men at work. A generation later, on the Erechtheum frieze (below, p. 122) we have documentary evidence for hired hands paid so much per figure, several working on different figures in one complex scene in a way which would be quite impossible without the existence of a detailed design; and the same surely applies here. One man must also have given the design of each pediment with some precision; but in these the detailed designing of individual figures and groups could have been spread among others. For the metopes one need not postulate more than a general indication of what was wanted on each side, at least in the combat-scenes. More freedom could have been left to the executants, but there are cases on the north, and probably in the centre of the

south, where several contiguous metopes must have been designed together.

The close connection between statue and building, with Pheidias's position as overseer of the Acropolis works, mean surely that the sculptural programme will have followed indications given by him, but it is doubtful if he can have had time to design much of it. I find it hard to suppose, however, that the unique originality and beauty of the frieze do not reflect pretty closely the art of the greatest sculptor of the time. Before work on the pediments was finished he was probably in disgrace and exile. Other artists likely to have had a part are Agorakritos and Alkamenes (below, pp. 103ff. and 118ff.) both spoken of in connection with Pheidias and both active in Athens.

II. Pheidias and his circle

Whatever the truth about the design and execution of the sculptures for the Parthenon, we surely learn from them far more about the character of Pheidian art than from any other source. However, just as we have to consider the lost and irrecoverable wall-paintings of a generation earlier because of their historical importance, so we cannot entirely pass by the huge statues, finished in ivory for the skin and gold for the rest, of Athena and Zeus; the latter perhaps the most famous of all works of art in antiquity.

These colossal figures veneered in precious materials were a new idea (above, p. 91), and the problems of their construction must have been worked out by Pheidias. Lucian describes how the interior was hollow, with a central mast (the socket can be seen in the Parthenon floor) supporting an armature of beams. Pausanias saw at Megara a Zeus by a local sculptor, Theokosmos, who was said to have had Pheidias's help. The work was interrupted by the outbreak of the Peloponnesian War in 431, and only the face was finished in ivory and gold. The rest of the surface was of clay (also mentioned by Lucian, together with pitch) and plaster. Behind the temple was a pile of half-worked timbers which, Pausanias was told, Theokosmos had been going to adorn with gold and ivory to complete the statue.

At Olympia Pheidias's workshop (seen by Pausanias) has been excavated. It yielded scraps of ivory, tools including a little jeweller's hammer in bronze, and palmette-leaves in blue glass paste with terracotta moulds in which they were cast. There are also larger terracotta moulds, a foot or two across and reinforced with metal strips at the back, for areas of drapery. The excavator believes that these were for beating gold leaf into; but this is a doubtful technical process, and it may be rather that they too were for glass: coloured panels to relieve the gold. Pausanias

says that the throne was 'variegated with gold and stones, with ebony and ivory', and that the golden robe was adorned with animals and lilies. The drapery moulds can only cover a tiny proportion of the whole, and some of them show folds on a smaller scale and must belong not to the Zeus himself but to the life-size Nike he held on his right palm, as the Athena did also. However applied, the gold at Athens was removable, and was removed almost at once for weighing when Pheidias, caught up in political attacks on Pericles, was accused of embezzlement. The weight proved correct; but the allegation was shifted to the ivory for the scales of the snake beside Athena (no doubt gold for its back, ivory for the belly; cf. fig. 113), where proof of innocence was less easy. The gold was removed again a century and a half later by the Macedonians' puppet-tyrant Lachares and melted down. It was afterwards replaced, and one supposes that under the thin veneer the structure, probably of wood as at Megara, preserved the forms.

Tradition over the relative dates of the Athena and the Zeus is contradictory. By one account Pheidias died in prison in Athens after the embezzlement charges, in which case the Zeus must have been earlier. Another version, which seems to have better historical authority, makes him flee to Olympia, where he then constructs the Zeus. The pottery found in his workshop there, including some fine Attic red-figure, clearly points to a date in the thirties or twenties, and so far as it goes the style of the drapery-moulds points the same way; so the question, is probably now settled.[34]

We have little Roman souvenir-versions of the Athena, and a free copy, above life-size, from Hellenistic Pergamon (fig. 142), all in marble. They show that she stood in a simple frontal pose not much relaxed from the archaic.[35] This was probably felt proper to a cult-figure, and no doubt the throned Zeus was similarly conceived;[36] but for the overall design of this figure we have only a tiny profile on coins of Olympia in the Roman period. (Athens, unlike marble-less Olympia, was a major centre of the copying industry.) It is impossible to recover the impression these works made. As described they do not fit naturally into our notions of good taste; but one can perhaps enter a little into the state of mind of a Greek, coming into the dark temple and seeing this huge image glittering at the back, reflected in and lit by reflected light from a pool in front, of water at Athens, of olive-oil at Olympia.[37] The Zeus was by far the more admired, was felt to have overwhelming majesty and to have 'added something to received religion'.

Pheidias was renowned especially as maker of gods, contrasted with Polykleitos, maker of men; one of those rhetorical oppositions of which ancient criticism

142 Marble statue and base from Pergamon. Athena: relief-figures on base from creation of Pandora. 2nd century, freely copied from Pheidias's chryselephantine Athena Parthenos (between 447 and 438 B.C.). H. with base 3·51 m.

is all too fond, but it surely reflects some reality. We cannot get close to him, though it was an inspired guess to see, in a lovely type of bare-headed Athena known in Roman marbles, the Lemnia, a statue dedicated on the Acropolis by colonists departing for Lemnos and held the most beautiful of the bronzes for which, after the chryselephantine figures, he was most famous.[38] The only certain full-size copies we have of his handiwork are of a different kind. There are marble reliefs with groups of Greek and Amazon (fig. 143) copied from the shield of Athena, the size of the originals and securely identified by their appearance in miniature on some of the small versions of the statue.[39] Very close to these in style are marble reliefs, likewise of the Roman age, with the dying children of Niobe. The story was shown on the throne of the Zeus, and that these are indeed copied from there is confirmed by the appearance of figures in some of these poses on the throne of a Zeus on a fourth-century Athenian vase.[40] These narrative scenes in their violence and pathos are far removed from the calm divine majesty the sources lead us to expect in Pheidias. He was evidently a more complex and varied artist, and we see the inadequacy of the literary tradition. They have points of contact with the Parthenon sculptures, and are works in their own right of much power and beauty.

Among the subsidiary decorations of Pheidian cult-statues the bases seem to have a distinctive and constant character. Pausanias, who describes the Zeus much more fully than the Athena, says that in the centre of the base was Eros welcoming Aphrodite as she rose from the sea and Peitho crowning her. At the ends were Helios in a chariot and Selene riding a horse or mule, and between these and the centre three pairs of deities on either side, each a god and a goddess. Pliny says there were twenty deities present at the creation of Pandora on the base of the Athena. The base of an unfinished miniature copy has indications of a chariot on the left, so the framing figures were no doubt the same. The defaced base of the Hellenistic copy from Pergamon (fig. 142) shows part of a row of evenly spaced figures, some frontal, and one can be identified again on a Roman relief with a row of deities, one a throned Zeus in profile much like that in fig. 134 (cf. p. 96 above), but it is not clear that all the figures could be copied from the Pheidian base.[41]

We have more evidence about a third cult-statue which was evidently closely related to these though in marble and standing on a marble base: the Nemesis at Rhamnus on the east coast of Attica. Pausanias ascribes this to Pheidias, Pliny to his pupil Agorakritos of Paros. Pausanias will have been following local tradition, Pliny Hellenistic art-historians; and one of those is quoted elsewhere as saying that among the twigs of

143 Marble relief from Piraeus (ship sunk in harbour). Greek and Amazon. Copy of the Imperial age after group on shield of Pheidias's chryselephantine Athena Parthenos (between 447 and 438 B.C.). H. 0·90 m.

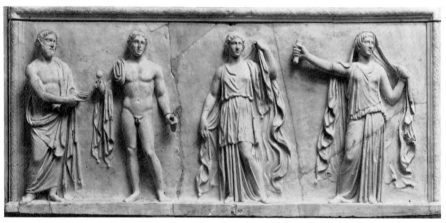

144 Marble relief, fragmentary and restored. Leda presenting Helen to Nemesis. Copy of Imperial age after marble statue-base at Rhamnus (see fig. 145) of third to last quarter of 5th century. H. (with modern frame) 0·51 m; modern also part of background, right hand of figure 1, left hand of figure 2, nose and right hand of figure 3, right forearm and hand of figure 4.

an apple-bough in the goddess's hand was a little label with Agorakritos's signature. (The bough will have been in bronze, as wreaths, bridles and other things were on the Parthenon frieze.) There are stories that Pheidias was the younger artist's lover as well as master, and that he gave him statues to pass off as his own. The Nemesis is not the only case of a disputed attribution. One should conclude, I think, that the Nemesis was signed, and no doubt made, by

Agorakritos, but that his style here and elsewhere was so close to Pheidias's as to lead to doubt.

The epiphany of a *femme fatale* is the common theme of the bases: Aphrodite at Olympia, Pandora (who in Hesiod's story is woman as man's curse) at Athens; and here Helen. In the legend we are most familiar with, Helen was hatched from an egg laid by Leda after Zeus had taken her in the form of a swan. In the version followed here, and located in this area of Attica, Zeus

pursued Nemesis, who kept changing shape and he after her, till, when she had become a goose and he a swan, he trod her. The egg she laid was given to Leda in Sparta to hatch, and she suckled Helen; and the base showed Leda presenting the grown girl to her true mother. As on the other bases, this central trio was flanked by other figures, a motley company including local heroes (perhaps at the ends as framers); Tyndareus, Leda's mortal husband, and the Dioscuri, her sons by Zeus; Menelaus, who was to marry Helen, and his brother Agamemnon; and Achilles's son Pyrrhos (Neoptolemos) who was to become the husband of Hermione, daughter of Helen and Menelaus.

Fragments of both statue and base have been found, and the base-fragments allow the identification of a restored Roman relief as part of a copy (fig. 144).[42] The right-hand figure, the centre of the original composition, is Leda who with a gesture (hand and scroll are modern) shows off Helen, who parts her cloak, to Nemesis. The goddess must have been the next figure beyond Leda, who turns her head that way. The youth and older man (again projecting arms and hands are modern) are perhaps one of the Dioscuri and Tyndareus. The central figures are united by gesture and look, but they are spaced evenly and stand frontally, like statues; and the others, spaced statues again, stand by and take no part in the action. Indeed they can hardly really be thought of as present at it; rather they are assembled by association. In mythological chronology Achilles was always held too young to have been one of Helen's wooers (a famous company); and when his son was born she had already married Menelaus and left him with Paris. The boy is here because he was to marry her daughter. Similarly at Olympia Herakles was one of the gods shown on the base although, mortal son of Zeus raised late to Olympus, he cannot actually have been present at the birth of Aphrodite, one of the oldest goddesses who rose from the sea after its impregnation when Zeus's father Kronos gelded his own father Uranus. He may, as we saw, be similarly associated with Athena's birth in the Parthenon pediment, but on the bases this timelessness seems peculiarly emphasised, in accord with the static, undramatic composition: an extension and adaptation to a particular purpose of the spirit of the west gable at Olympia.

From the sparse fragments of the statue of Nemesis it has been brilliantly demonstrated that copies exist, smaller than the colossal original but over life-size and some of fine quality (fig. 145).[43] The rich drapery-style has affinities with that of Aphrodite and Themis in the east pediment of the Parthenon (fig. 136). Differences seem due not only to the copyist's hardening but to the different purpose of the hieratically posed cult-figure. The temple at Rhamnus was never finished, almost

145 Marble statue. Nemesis. Reduced copy of Imperial age after colossal marble statue of Nemesis at Rhamnus by Agorakritos of Paros (third quarter of 5th century). H. 1·93 m.

certainly because of the outbreak of war in 431 and the Spartan invasions of Attica which took place most summers in the next seven years. The statue, with its likeness to the Parthenon pediments, was perhaps already finished. The fragments of the base, fresh but not very careful work, perhaps by pupils rather than the master, show also in the faces a softer treatment which suggests that it may not have been carved until later, probably in the lull which followed the Peace of

146 Bell-krater. Attic red-figure: return of Persephone; (other side, woman and two men).
Name-piece of Persephone Painter. Third quarter of 5th century. H. of picture c. 0·25 m.

Nikias in 421. We have Helen's head, very worn but showing up the harshness of the copy, and a beautiful one with a veil over the hair which must belong to Nemesis.

Agorakritos was perhaps Pheidias's principal assistant in his Parthenon period. Another pupil, Kolotes, is said to have helped him on the Zeus and himself made chryselephantine statues of Athena in a temple at Elis (this again sometimes given to Pheidias) and of Asklepios at nearby Kyllene.[44] Another name often cited as pupil or rival of Pheidias in Athens, and particularly as a rival of Agorakritos, is Alkamenes (above, pp. 87f.; below, pp. 118ff.).

III. Painting and vase-painting in Periclean Athens

Besides its sculptural adornments the Zeus at Olympia had, on 'barriers' the position and purpose of which is not clear, nine panels painted by Panainos, who also painted the interior of the shield for Kolotes's Athena (above). He is often called Pheidias's brother, but by Strabo his nephew, and he may have been son of a painter-brother Pleistainetos who is once mentioned. The most important work ascribed to him, by both Pausanias and Pliny, is the Battle of Marathon in the Stoa Poikile at Athens, given by others to Mikon and once, doubtfully, to Polygnotos. This confusion over what was probably the most celebrated picture in the city is strange. The stoa (above, p. 78) belongs to the buildings associated with Cimon, whose father Miltiades was the hero of Marathon. It seems possible that the picture was begun under his patronage by

Mikon or Polygnotos, interrupted by his exile, and finished later by Panainos, as Filippino Lippi finished Masaccio's frescoes in the Carmine.

Pausanias describes the picture: at one end the battle still undecided, then the Persians fleeing and caught in the marsh, and at the other end the slaughter at the ships. The leaders on both sides were individualised as well as other fighters, Aeschylus and his brother, who was killed (Pliny refers in this connection to Panainos's advances in portraiture); and divine helpers were shown: the hero Marathon and another, Echetlos; Herakles and Athena; and Theseus, who seemed to be rising out of the earth.[45]

One might perhaps picture Theseus's rising somewhat in the manner of Persephone's on a beautiful red-figure vase of the Parthenon time (fig. 146).[46] The sharply foreshortened and shaded chasm from which the lost daughter issues, together with the still figure of Hermes facing the spectator from its other side, mark a stage in the conception of pictorial space beyond anything in the work of Polygnotos and Mikon, at least as we glimpse it in vase-painting (figs. 108–9, 112–14, 116). Nevertheless, the main movement is straight across a shallow shelf parallel to the surface plane, as from the description it seems to have been in the Marathon also. The application of the sharper realisation of spatial depth seen in the Persephone and Hermes to a large, complex composition may however have been made at this time. One of the little copies of the shield of the Athena Parthenos has traces of the painted Gigantomachy inside. A group can be faintly made out which recurs on a number of vases with the subject painted in

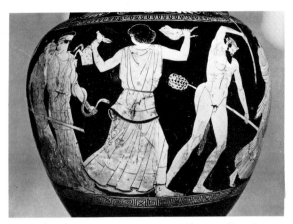

148 Pointed amphora. (Dionysus with) maenads and satyrs. Ascribed to Achilles Painter. Third quarter of 5th century. H. of picture *c*. 0·25 m.

147 Neck-amphora (not, as long believed, from Melos; probably from Italy). Attic red-figure: Gigantomachy. Ascribed to Suessula Painter. About 400 B.C. H., with lid which does not belong, 0·76 m.

Athens around 400, a time when there is considerable evidence of artistic nostalgia (cf. below, p. 116). The vase-pictures vary a good deal, but a distinctive principle of composition is common and surely derives from the original: the Gods, high in the picture, are fighting down towards us, while the Giants tend to have their backs to us or to retreat in our direction (fig. 147). Some are in *profil perdu*, and that this innovation is not something introduced by the vase-painters from the art of their own time but belongs to the original is indicated by its isolated occurrence on another fine vase contemporary with the Persephone krater (fig. 148). We do not know who painted the shield. Panainos is a possibility, or Pleistainetos, but so is Pheidias himself. Pliny records a story that Pheidias started as a painter, and that he painted a shield, or *the* shield, in Athens.[47]

Panainos's panels at Olympia were two-figure compositions. Some were action-groups: Herakles and the lion; Achilles and Penthesilea; Ajax and Cassandra; but several can only have been quietly standing pairs: Hellas with Salamis; Sterope with Hippodameia, the Hesperids holding apples. This was presumably paired with an Atlas and Herakles (they are mentioned first and last, so perhaps came either side of an entrance), and that too, on the analogy of the metope, was probably a quiet grouping: as could also have been the Herakles and Prometheus Bound. As with the subsidiary decoration of the Athena in the Parthenon, some of these seem to allude to the temple-sculptures, which Pheidias's narrative groups on the Zeus's throne and footstool do not (Niobids, two Amazonomachies).

We may be helped to envisage the quiet pairs by a class of often beautiful vases produced in Athens at this period, the white lekythoi used at funerals and put in graves.[48] There are many red-figure lekythoi, but it is one of the shapes that during the first half of the fifth century continued to be decorated in black-figure, often on a white slip, many small and rough but with some more careful pieces, commonly for funeral use but without any special iconography. Towards the mid century the white cups with drawing in outline and colour by good red-figure painters go out of fashion (above, figs. 110–14), and around the same time begins a new taste for white-slipped lekythoi finely decorated in the same way, specifically for funeral use and with a limited range of subjects, some directly alluding to death. The painters who specialise in these are at first generally also painters in red-figure, but the genre derives directly from the late black-figure tradition. On most earlier pieces the skin of women is added in a purer white over the cream slip, a clear heritage from black-figure, not found on the

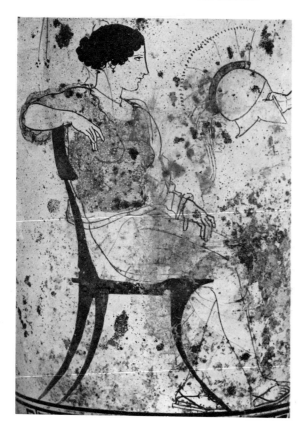

149 Lekythos from grave at Eretria. Attic white-ground: warrior and wife. Ascribed to Achilles Painter. Third quarter of 5th century. H. of picture 0·21 m.

white cups; but the effect is unsatisfactory and the practice soon given up.

A fine late white cup with Hera is an early work of a red-figure artist, the Sabouroff Painter,[49] who was to become one of the major producers of white lekythoi in the Periclean age, but we may illustrate them rather with a work by the greatest master of the art, his contemporary the Achilles Painter (fig. 149).[50] This artist started in red-figure, an old-age pupil of the great late archaic Berlin Painter (above, figs. 104–6), and the vase in fig. 148 is his work, fig. 146 that of a colleague. His early white lekythoi have the added white, but those of his maturity are drawn in thinned glaze with washes of the same (fig. 149) and of the various reds used already on the cups. In his latest work he adopted a practice, found earlier in the Sabouroff Painter, of drawing not in thinned glaze but with a matt colour, black or more often red. This becomes the norm, and is used by his pupil the Phiale Painter, who worked primarily in red-figure but has left a few wonderful white lekythoi.[51] One (fig. 150) shows Hermes Psychopompos and a dead woman. Other lekythos subjects directly connected with the purpose of the vase are Charon in his boat, occasionally the laying-out of the dead (as on the Geometric vases figs. 1 and 2), and very commonly two figures at a tomb. A great many, however, have simple domestic scenes, often a

woman with a slave-girl who holds a jewel-box or a bundle of clothes. The young warrior of fig. 149 seems to be taking leave of the seated woman, and here one can read an allusion to death in battle; but whether the domestic scenes are intended to suggest preparation for the journey to the Underworld it is impossible to be sure. The woman in fig. 150, making herself ready while Hermes waits, can only mean that. Of two figures at a tomb one is often bringing offerings, the other standing quietly by, and it is natural to think of the quiet one as the dead; but the distinction is not always clearly made and one cannot be sure that it is ever intended.[52] We shall meet a similar ambiguity on the marble gravestones which begin again in Athens about this time and will be considered in the next chapter.

That the drawing and composition of vase-pictures like these is very close to contemporary panel-painting is suggested by the remains of painting on a small marble tombstone of the time, with a pair which might come straight off a lekythos; and more importantly by two little pictures of panel-pictures, evidently copied from fifth-century originals, which are incorporated in the wall-decoration of a house in Rome of Augustan date. They illustrate domestic subjects, and are strikingly like the lekythoi even to the colouring.[53] Pliny

150 Lekythos from grave at Oropos (Attica). Attic white-ground: Hermes and woman. Ascribed to Phiale Painter. Third to last quarter of 5th century. H. 0·37 m.

has a reference to improvements in colour, in connection with the portraits in the Battle of Marathon which he ascribes to Panainos, but it is not clear that he is crediting the artist himself with these. If he did make innovations in this direction they are lost to us; but the spirit and even the draughtsmanship of the beautiful two-figure compositions on the lekythoi surely give us something of the Olympia panels.

Two other painters credited with important developments, Apollodoros of Athens and Agatharchos of Samos, both active in Athens, may have been so already in the Periclean era; but their innovations are so directly connected with the break-through of late fifth-century painters which led to the new world of fourth-century painting, that it is preferable to treat them in the next chapter.

IV. Other works and names in sculpture

Another echo reaches us from Periclean Athens in several marble heads of Roman date: a bearded man with a helmet pushed up on his head; evidently copies after one original, and in two cases inscribed with the name of Pericles. They are no doubt copied from a famous statue in bronze by Kresilas of Kydonia in Crete.[54] We saw a tendency to particularity in some early classical sculpture as well as painting, and this may possibly have crystallised in realistic portraiture. There is a Roman marble head inscribed 'Themistocles', on which hair and beard are treated in the manner of the Tyrannicides (above, p. 52), but the features have a marked individuality.[55] I incline to the belief that this is a true copy of a contemporary portrait, but arguments have been adduced for the copyist having followed a Hellenistic adaptation, and this may be right. If Pliny's remarks about the portraits in the Marathon, and his ascription of them to Panainos, are right, some degree of realism in portraiture was to be found in high classical painting. Whether there was anything of the kind in contemporary sculpture we may doubt; in the Pericles at least an ideal type has obliterated almost any trace of individual personality (Pliny refers to Kresilas's portrayal as 'Olympian'). The figure was probably naked, as we see in a bronze statuette, probably of Roman date, which must reproduce a statue from the later fifth century.[56] This type of official portrait of a statesman and military leader (*strategos*, general, but Greek strategoi were not professional soldiers as that word implies) becomes regular. These heads are a good example of the maiming a Greek conception suffers when the head only is copied from a statue. To me at least they say very little, but I can imagine that the whole figure was eloquent.

We hear of several statues by Kresilas, but copies of

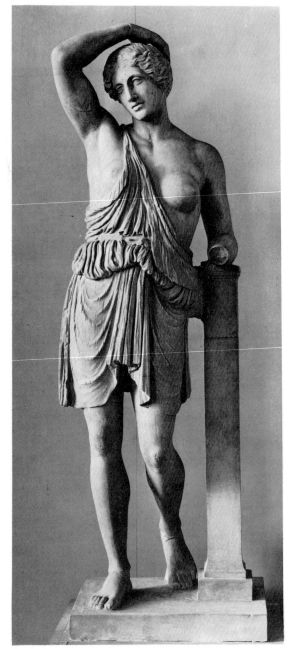

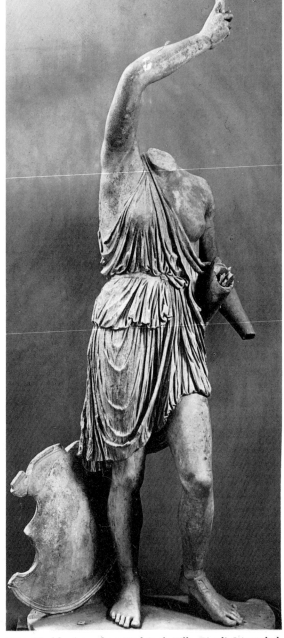

151 Marble statue. Wounded Amazon ('Lansdowne type'). Copy of Imperial age after bronze of third quarter of 5th century. H. 2·03 m.

152 Marble statue from Hadrian's Villa, Tivoli. Wounded Amazon ('Mattei type'). 2nd century A.D. copy after bronze of third quarter of 5th century. Approximately same size as fig. 151 and fig. 153.

none can be identified with any assurance.[57] He is named by Pliny, along with Pheidias, Polykleitos and two others, in a famous anecdote about a competition at Ephesus for a statue of an Amazon, the prize awarded to Polykleitos on the votes of the artists themselves: each put his own work first and that master's second (who was Polykleitos's second choice

is not recorded). The anecdote is suspect; but there are three interesting types of Amazon-statue (known as the Lansdowne, the Mattei and the Capitoline; figs. 151–3), popular in Roman marbles, all seemingly of fifth-century classical style and with some evident relation to one another. All have shortish hair centrally parted (the Mattei's head is identified in a relief-copy),

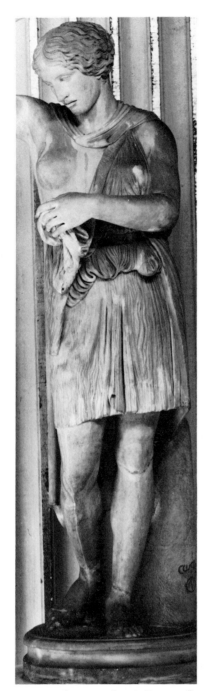

153 Marble statue. Wounded Amazon ('Capitoline type').
Signed by copyist, Sosikles. Copy of Imperial age after
bronze of third quarter of 5th century. H. 1·98 m.

and wear a short chiton with one breast exposed.
These features can be found in many Amazon-
representations, but the three have further in common
that all are wounded, and this has allowed the artist in
each case to experiment with a pose in which, for the
first time in a substantive statue, part of the weight is
taken outside the body. The Mattei and Capitoline lean

lightly on their spears, the Lansdowne rather more
markedly on a pillar.[58]

A recent study[59] argues that only the Capitoline (fig.
153) reproduces a true fifth-century type, the others
being pastiches in the classical manner; and concludes
that a statue by Polykleitos (or rather two; see below)
was dedicated at Ephesus in the fifth century and the
others were added at intervals during the Hellenistic
age, the anecdote woven around them by guides of the
imperial period. The Capitoline does indeed seem to me
so close in pose and face to statues we can associate
with Polykleitos that I believe it goes back to a work
by him; but the other two types seem to me also of
genuine fifth-century derivation. I suppose, therefore,
that the anecdote contains some core of truth (a
number of the copies and adaptations come from
Ephesus). As to the other two: the striking, dramati-
cally posed Mattei (fig. 152) could illustrate the side of
Pheidias reflected in the Niobid and Amazon reliefs
(fig. 143); while the face of the Lansdowne (fig. 151)
does not seem incompatible with the idea that the
original was by the same hand as the original of the
Pericles; but these are hardly grounds for attribution.
Moreover we have left out of account the other two
sculptors whom Pliny names in the story. Phradmon of
Argos is mentioned by several authors, but of his work
we know nothing whatever. The fifth, Kydon, is never
mentioned elsewhere, and is sometimes spirited away
altogether by supposing that his name arose from a
misreading of Kresilas of Kydonia's ethnic. Two more
figures have been put forward as independent related
types to make up the tally, but they do not seem to me
to be so. One is a head and torso which somewhat
resemble the Lansdowne, but the chiton covers both
breasts and it is restored, perhaps correctly, as an
Artemis. The other is a fragmentary Caryatid from
Ephesus, of beautiful quality, which seems a mirror-
image of the Capitoline.[60] This is a class of variation
found several times in copies from other originals (cf.
below, pp. 125 and 166), and was presumably dictated
by the decorative demands of the position the copy
was designed to fill. In the case of this Caryatid that
explanation seems to me the simple and obvious one,
but the scholar who rejects the other types curiously
thinks this a copy of a figure designed by Polykleitos
as a pair to the Capitoline.

In spite of the negative conclusions, the Ephesus
Amazons are perhaps worth this rather extended
discussion, for two reasons: the intrinsic interest of the
statues; and as a text-book example of the difficulties
inherent in using (as we must) the evidence of the
literary tradition and Roman copies.

Pheidias and Polykleitos are the two great names in
fifth-century sculpture, and Polykleitos was perhaps
the more influential.[61] He was probably an Argive,

though Sicyon also claimed him. Both cities had celebrated schools of bronze statuary in the first half of the fifth century. Pliny names Ageladas of Argos as Polykleitos's master, and he was certainly regarded as the heir and flower of the Peloponnesian bronze tradition. Dates are difficult. One of Pheidias's most important commissions, the huge Athena Promachos in bronze on the Acropolis, cannot be dated much later than about 460.[62] Polykleitos is credited with a gold and ivory cult-statue in the Heraion of Argos. The old temple was burned down in 423, and the new one, in which the chryselephantine image stood, is dated from its architectural and sculptural remains, to the end of the century. If the statue was really Polykleitos's he must have long outlived Pheidias and was probably a considerably younger man; but there were later sculptors of the same name and the attribution is not quite sure.[63] In any case he was certainly active at the time Pheidias was working on the Zeus, if not at the time he was working on the Athena.

Polykleitos was primarily a bronze-worker, and he specialised in statues of victorious athletes dedicated at Olympia. Bases survive there with his name, and these show that the figures were life-size. A beautiful statue of a boy, the 'Westmacott athlete' (fig. 154), known in many Roman marbles, his right arm raised to crown himself, would fit the footmarks on the base of Polykleitos's statue of a boy boxer, Kyniskos.[64] This position of feet is not uncommon, but the head is very like those of statues which can certainly be associated with Polykleitos. The pose is looser, freer than in those, and it is sometimes considered that the original was rather a work from the Polykleitan school. Others have thought of an early piece by the master himself, and I incline to believe it his, whether the Kyniskos or another. The posture is strikingly like that of the Capitoline Amazon (fig. 153), but the composition, curiously open on the spectator's left in the athlete-statue, was closed in the Amazon by the vertical spear. The boy's face is impersonal, ideal; these victor-statues were surely 'portraits' only in a highly abstract sense.

Polykleitos's most famous statue was of a young man, but was probably not a victory-dedication. Its purpose is unknown, but it was of heroic size, and might have been dedicated by the artist at the Argive Heraion. It was evidently a work of personal importance to him; and that it remained in or near Argos is suggested by its reproduction in a figure of a youth leading a horse on a relief from that city, probably of the fourth century. It represented a young man walking with a spear on his shoulder, and was known as the Doryphoros (spear-bearer), but also as the Canon.[65] Polykleitos was an intellectual artist, with the faith in mathematics, so important in Greek thought, strongly developed. He sought to establish, or perhaps

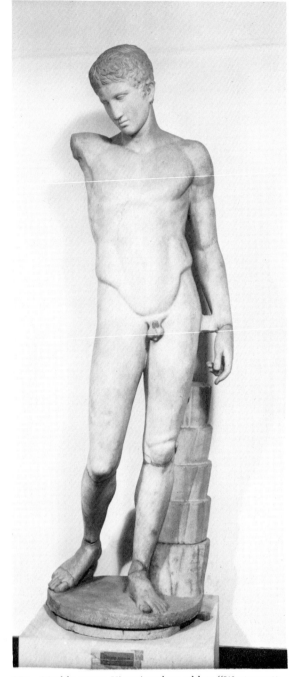

154 Marble statue. Victorious boy athlete ('Westmacott boy'). Marble copy of Imperial age after bronze of third quarter of 5th century. H. 1·50 m.

rather to discover, a system of ideal proportions for the human body; and feeling that in this statue he had achieved it, or come as near it as he could, he took it as text for a treatise on the subject, the *Canon*, and the name was sometimes transferred to the statue. The treatise is lost, but the great doctor Galen, writing six hundred years later, notes that Chrysippos, the Stoic

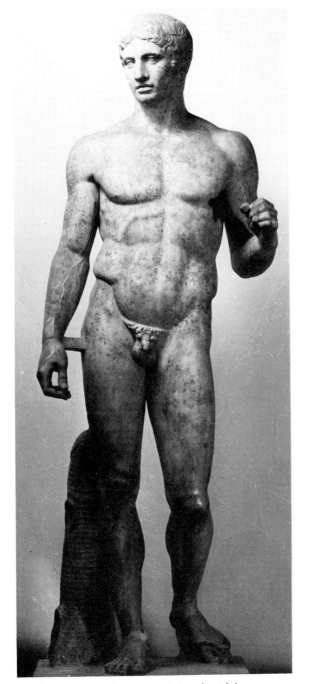

155　Marble statue from Pompeii. Youth with lance ('Doryphoros'). Copy made before A.D. 79 after bronze by Polykleitos of third quarter of 5th century. H. 2·12 m.

philosopher of the third century, 'thought that beauty consisted in the symmetry not of the elements but of the numbers' (that is, not of the parts but of the relation between the parts), 'of finger to finger and of all these to hand and wrist, and of those to forearm, of forearm to arm and of all to all, as it is written in Polykleitos's *Canon*'.[66]

The system is hardly recoverable, but more interesting than the details is the fact of this intellectual approach. The principles of perspective deeply excited certain Quattrocento artists and determined the way they constructed their pictures or reliefs. For an understanding of their art it is important to appreciate this fact; much less important to read Piero della Francesca's treatise on the subject. Copies of the Doryphoros in marble and basalt, and one head in bronze, have been recognised with virtual certainty, the best preserved a marble from Pompeii (fig. 155) from which only the spear (originally perhaps in wood) is missing. This is a mechanical production which excites little aesthetic pleasure; but looking at it with some knowledge of Polykleitos's approach in mind we can see that the construction of the statue, quite apart from the system of proportions, is a highly conscious intellectual exercise. The youth stands with his weight on the right leg, left foot back with only the toes on the ground. The right arm hangs at the side, the left is sharply bent to hold the spear on the shoulder. The torso is twisted slightly to the proper right, the head turned further in the same direction and very slightly bent. The essential character of the statue is that inaugurated in the Kritian boy (fig. 71), the 'relaxed kouros'. A feeling (of archaic derivation) is still strong; that a statue must have a manifestly controlled rhythm, never very far removed from absolute symmetry. In the Kritian boy the relaxation was very slight; as it becomes more marked there is a tendency to impose new controls. Already in the Choiseul-Gouffier/Omphalos Apollo (figs. 77, 78), a product perhaps of the school in which Polykleitos was trained, the head is turned in the direction of the firm foot and a balance is preserved across the body between taut and relaxed limbs: at least it seems that the right arm hung loose beside the taut leg while the left arm was tensed. In the Doryphoros this balance is certain and much more emphatic; and there are other significant differences. The Apollo, like the Kritian boy, is quite at rest, 'a statue standing still'; the Doryphoros is rather walking. He has come to rest on his right foot and is on the point of lifting the left; but in fact there is no sense of arrested movement, of a caught moment. Rather, by purposed distortions of observed nature, the artist has created a stillness with an implication of activity: a timeless crystallisation of movement. This achievement is one of the greatnesses of classical art, and the form in which Polykleitos realised it was long and deeply influential.

Of similar significance is the unnaturally simplified and emphasised anatomy, with the very heavy forms of breast and particularly of hip-muscles. They tell more crudely in the marble than they would in the reflective surface of burnished bronze; but they

would still have shown distinctively there, and are surely meant as a reimposition in a new and subtler form of the pattern inherent in the kouros.

The Doryphoros was evidently a programme-piece, and perhaps for that reason a deliberately simple statement of these compositional principles, since what the statue was designed to demonstrate was the ideal proportions. Whatever the details of the system, it produces a sturdy figure with a large head. Varro, who wrote in Rome in the first century, is quoted as saying that Polykleitos's figures were foursquare and almost on a pattern. We have many variants in Roman marbles, which may all go back to the Doryphoros itself or reflect closely similar pieces by the master. Others are different: the Westmacott boy (fig. 154) if that is truly Polykleitan; and there is a figure very popular in copies (fig. 156) which almost certainly give us the design of Polykleitos's Diadoumenos (youth tying a fillet round his head).[67] This action, like the self-crowning of fig. 154, is proper to an athletic victor; but Pliny seems to pair the Diadoumenos with the Doryphoros, and the copies reproduce a figure of heroic size. This statue is freer in construction and tenderer in feeling than the Doryphoros: head more strongly bent, both arms up and out in action. The feet are very slightly further apart, no doubt to balance the spread of the arms, but the stance is very nearly identical. So is the anatomical mapping, and the softer transitions in the best copies may be just a more sensitive craftsman's response to the problem of translating bronze into marble. It is however generally thought, surely rightly, that the Diadoumenos, less rigidly intellectual and programmatic than the Doryphoros, was a later work; and softness is a quality developed in fourth-century sculpture. Both figures show the stumps and struts which disfigure copies so intolerably in our eyes but were evidently accepted in their time; perhaps rather as we tolerate, or used to tolerate, the obscurations of protective but reflecting glass on pictures in galleries.

Another name often mentioned with Pheidias and Polykleitos is Myron, from Eleutherae on the borders of Attica and Boeotia, but by Pausanias regularly called an Athenian.[68] He is cited exclusively as a bronze-worker, and Pliny says that he was a pupil of Ageladas of Argos, like Polykleitos with whom Myron's work is often compared. It seems to have been felt more old-fashioned, and he was probably an older man. Both he and his son Lykios made statues of victors at games in the forties. We have descriptions of one of his most celebrated works, the Diskobolos (discus-thrower), which makes the identification of copies certain (fig. 157).[69] All the substantive statues we have so far looked at in this chapter have been 'repose-figures', scions of the kouros and kore. The

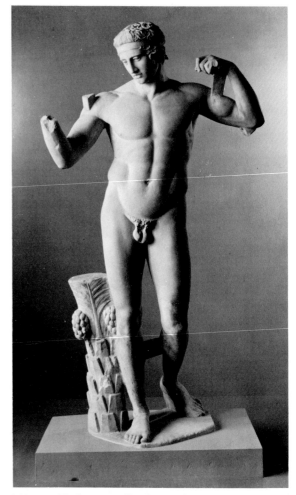

156 Marble fragments (head, arms, lower legs and feet, support) made up with cast of marble statue from Delos. Youth tying victor's fillet round his head ('Diadoumenos'). Copies of Imperial age after bronze original by Polykleitos of third or last quarter of 5th century. H. 1·95 m.

Diskobolos is an 'action-figure', a type developed by early classical bronze-workers on the analogy of the narrative art of pedimental sculpture. Like the Zeus from Artemision (fig. 79) the Diskobolos is a spread, 'two-dimensional' composition, only telling effectively from an area in front (the figure's right side) and another behind; the views in between collapse in a jumble of lines. The moment chosen is that when the discus is swung furthest back, immediately before the athlete straightens up for the actual cast. As with the Doryphoros's walk, however, the artist has not here reproduced a position actually held, but has modified observation to produce the stillness proper to a statue yet to inform it with the implication of action.

Both dramatic action and formal pattern are manifest in the composition of this figure, so it is not

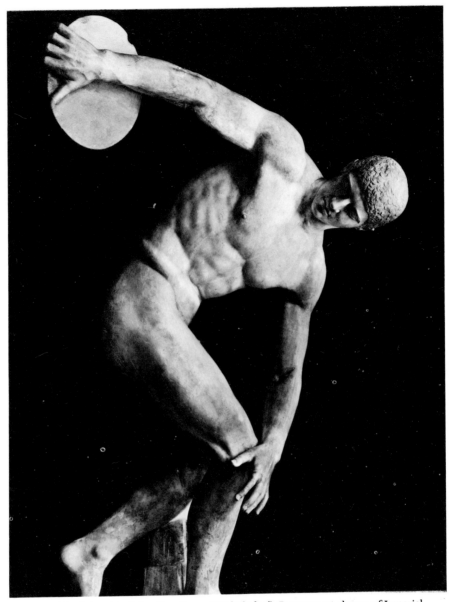

157　Marble statue. Youth hurling discus ('Diskobolos'). Reconstructed copy of Imperial age after bronze by Myron of mid 5th century. H. 1·53 m.

surprising that the anatomy has neither the heavy formal emphasis of the Doryphoros's nor the excitement of the nudes in the Parthenon gables. In repose-figures Myron may have approximated more in this respect to Polykleitos; but the resemblance to early classical anatomy is marked, and it is likely that he carried on that tradition into the full classical period, like some sculptors of metopes for the Parthenon and those who worked on the 'Theseum' (below, p. 116). Myron too made victor-statues, but the heroic-sized Diskobolos, with no recorded name, was probably not one. Many of those, like most of the statues of gods and heroes attributed to him, are likely to have been repose-figures; but the famous Ladas, which seemed about to spring from its base, must have been of the action kind, and the artist seems especially to have favoured that.

One other work of this kind, a group, can be recovered in copies and probably associated with Myron. Pausanias saw on the Acropolis an Athena and Marsyas, a satyr who heard the goddess playing the pipes she had invented, and when she discarded them because blowing them distorted her cheeks, picked them up. She warned him off; but he took them and was so intoxicated by the sweet sounds that he challenged Apollo to a musical contest, the Muses to

judge. He lost, and the vengeful god had him flayed: another savage story, like the Niobids or Actaeon. Pausanias does not name the sculptor; but in the middle of Pliny's list of works by Myron come a satyr wondering at the pipes and Minerva (Athena). From the structure of the sentence these might be two independent statues, but it is more likely that they go together and are the group seen by Pausanias. Representations of such a group, which look like free versions of one original, are on Roman coins and reliefs and an Athenian vase (fig. 158) of about 400, the period when the Pheidian Gigantomachy was being copied in vase-painting (above, p. 106). Copies of two statues in fifth-century style correspond in some points to some of the other representations and combine in an effective group (fig. 159). Athena held a spear in her right hand (preserved in some copies); Marsyas's hands and forearms are modern.[70]

The satyr's anatomy is again in the trim, firm unemphatic style of the early classical tradition; but the vivid, complicated movement – starting back and yearning forward – is a new creation of a great artist. The Athena too has much of the early classical peplos statue, fluted skirt broken by one knee, but slenderer, younger, and relaxed in a subtle movement; and the two motions balance each other in an effective stillness.

Scenes from the story of Marsyas become popular in Attic vase-painting in the thirties. The group is probably earlier. A fifth-century poet, Melanippides of Melos, produced a dithyramb (a sort of oratorio) on the subject; and it has been attractively suggested that he dedicated the group to celebrate victory with the poem in a contest (cf. below, p. 119). That would account for the first appearance of a satyr in monumental art.[71]

It is worth noting that the most famous of all Myron's bronzes was a cow, likewise dedicated on the Acropolis in what circumstances we do not know.[72] This is unusual in man-dominated Greek art. The beautiful heifers of the Parthenon frieze are, like the horses, an adjunct of human activity, and that is the rule. Only on the lovely seal-stones and coin-dies (below, p. 130, figs. 175–6) do birds and beasts figure prominently in their own right at this time.

The sculptures of the 'Theseum'[73] may be considered next, since, as just noticed, they stand closer to Myron and to some Parthenon metopes than to the developed 'Parthenon style' and the Pheidian circle. This little temple which stands, more complete than any other in Greece, on a low hill to the west of the Agora seems to have been begun about the same time as the Parthenon. It was early identified as the shrine of Theseus (above, p. 72), because the metopes show deeds of his alongside some of Herakles's; but this is

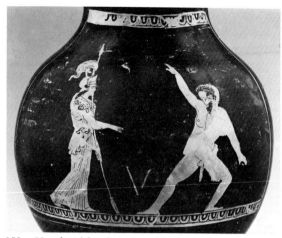

158 Oinochoe (*chous*). Attic red-figure: Athena and Marsyas. About 400 B.C. H. of picture *c.* 0·14 m.

impossible on many grounds. It is widely considered a temple of Hephaistos, and though none of the surviving sculpture can be in any way associated with him there are good arguments supporting the identification. Serious doubt, however, has recently been thrown on it, and the suggestion made that it was dedicated to Artemis Eukleia.[74] We do best, perhaps for the moment to speak conventionally of the 'Theseum'.

Both pediments had sculptures, but they are totally lost. A pretty group of two girls, one on the other's back (the game of *ephedrismos*), was found near by and may be an akroterion; but the only sculptures which certainly belong are the metopes and friezes still in position. The friezes are over porch and false porch within the colonnade, not (like the Parthenon frieze) also down the long sides. That over the entrance at the east, however, is strangely extended across the aisles to rest on the architrave of the outer colonnade; and the little area so marked off at the east is further emphasised by the carving of the metopes only on the east front and the first four down north and south. An analogous treatment of the same area, presumably for some cult purpose, is found in the temple of Poseidon at Sunium, which is ascribed to the same architect.

The ten metopes on the front show labours of Herakles, the other eight of Theseus. Only one shows a quiet scene, the northernmost on the east: Herakles and a Hesperid (or Athena); and this is also the only female, and the only clothed, figure. In the rest a naked hero fights brigand or beast. They are in bad condition, but the Kerkyon has a distinct look of Myron's Marsyas, and the general character is much like that of the Centaur-metopes from the Parthenon. This likeness is even more marked in the west frieze: a Centauromachy, not the brawl at the feast but the

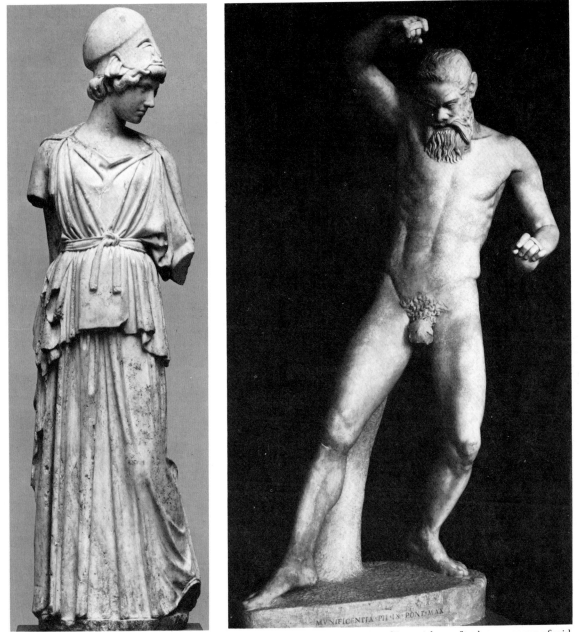

159 Marble statues. Athena and Marsyas. Copies of Imperial age after bronze group of mid 5th century. H. 1·73 and 1·59 m.; modern, Marsyas's hands and much of forearms.

older theme of the battle on the mountain. Kaineus beaten into the earth is given central place. The composition is episodic, and some groups could be isolated as metopes with hardly any change; but there are some many-figured groupings, and the whole is not without a rhythmical design. It is strikingly violent, with bold and successful effects: a Centaur tipped on his back, horse-legs in the air, human part dragged forward by a Greek who stamps on the horse-belly (cf. below, p. 129). The less well-preserved east frieze

shows a battle fought partly with huge boulders, interpreted as Theseus against the Pallantidai, who disputed his right to the lordship of Attica. It is interrupted by two groups of deities sitting quietly on rocks: to north, a goddess between two gods (perhaps Apollo, Artemis and another),[75] behind them a quiet scene, prisoners led away; to south, Zeus, Hera and Athena, beyond them the scene partly shown in fig. 160: warriors hurrying towards the fray, and across them what seems the execution of a bound prisoner.

117

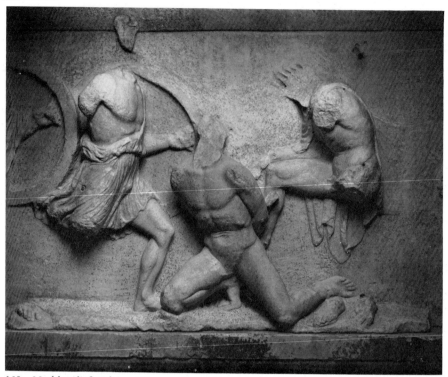

160 Marble relief. Athens, 'Theseum', east frieze, part of slab: battle. Third quarter of 5th century. H. 0·85 m.

The relief in these friezes is high, like that of the metopes, as remote from the Parthenon frieze in technique as in feeling. The positioning of the groups of seated deities, however, breaking up the composition of the east frieze, was hardly thought of independently by the two designers. There is naturally mutual awareness and interaction among different artists working in one city at one time.

For the temple of Hephaestus, whether this building or another, bronze statues were made between 421 and 415, as we know from an inscription. They represented Hephaestus and beside him the other craft-deity, Athena, worshipped with him under the title Hephaistia. A Hephaestus in Athens by Alkamenes is recorded; and since cults and statues of this god were rare it was probably this.[76] The regular type for the god in later statuettes and reliefs probably derives from it: standing, in the workman's conical cap (*pilos*) and short chiton baring the right shoulder, right hand hanging with hammer or tongs, left either hanging with tools too or raised on a tall staff. Bearded heads in marble, life-size or over, with the *pilos*, are most likely reduced copies of this colossal original, but like most copies from the heads of classical statues they say little by themselves. Various types have been proposed for the goddess, and recently a good case has been made for the 'Velletri Athena'. She stands, right arm raised

on a spear, wearing helmet and aegis thrown back to expose himation and chiton in a rich style of Pheidian or Parthenonic derivation. Stylistic links exist between this figure and two Roman reliefs with the Birth of Erichthonios, the one mythological narrative which joins Athena and Hephaestus; and these are probably copied from the centre of the statue-base. The composition seems to have been rather more dramatic and *mouvementé* than the earlier Pheidian bases we considered (above, p. 104).[77]

Alkamenes made the statue of Ares for his temple in Athens, and it is perhaps copied in the 'Ares Borghese': a naked youth in a helmet, vaguely Polykleitan at a glance, but the ponderation quite other: weight on the left leg, left arm tensed, right hanging loose by the slack right leg which is advanced, head turned and bent in that direction. Remains of the temple have been found in the Agora, and near it fragments of fine relief which show stylistic links alike with the Velletri Athena and the Erichthonios reliefs and with another work which we have grounds for associating with Alkamenes.[78]

Pausanias saw on the Acropolis a statue of Procne and Itys 'dedicated by Alkamenes'; and a marble statue of heroic size found there, a woman with a small boy pressed against her skirt, must be the one (fig. 161). It is in the Parthenonic tradition, like the works

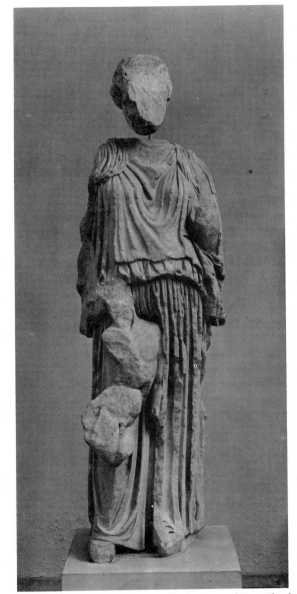

161 Marble group from Acropolis. Procne and Itys. Third or last quarter of 5th century. H. *c.* 2·00 m.

we have been considering but simpler, heavier, perhaps to suit the subject. Tereus, king of barbarous Thrace, married an Attic princess Procne, then rudely forced her sister Philomela; and the sisters in vengeance killed the son of Tereus and Procne, Itys. The mother is here, as Pausanias says, meditating the deed. An Alkamenes in Athens at this date is likely to be the sculptor, and he is likely to have carved his own dedication; but it is perhaps more probable that something has dropped out of the text, and what Pausanias wrote was 'dedicated by X, made by Alkamenes'. The rare subject would be a suitable offering after a dramatic victory, and we know of two

tragedies *Tereus* at this time, one by Sophocles. The *Europa* (above, p. 57) might likewise have been a dedication for Aeschylus's *Carians*; and compare the suggestion on Myron's Marsyas (above, p. 116). The group, which some see as a copy but most, I think rightly, as the original, shows a modernisation of the early classical peplos-figure with broken-fluted skirt.[79] It is a work of emotive power, and had an influence on the treatment of a similar subject often represented later, Medea about to kill her children.[80]

Two other works ascribed to Alkamenes need mention. Pausanias saw a Hermes Propylaios on the way up the Acropolis. He does not describe it, but a Herm (a pillar with a bearded head of Hermes and a phallos) of Roman date, found at Pergamon, bears an epigram which calls it *epi pylon* (at the gate) which could be periphrasis for Propylaios, and claims it for Alkamenes. Another, from Ephesus, has the same claim. They are not identical, but both, like most Herms, are archaistic in style; that is, while basically of obvious classical character, they make play with archaic mannerisms. There are true archaic Herms, and those at the street-corners of Athens, whose mutilation on the eve of the disastrous expedition against Syracuse in 415 caused scandal, panic and the ruin of Alcibiades, had been set up by Hipparchos son of Peisistratos. The form was adapted later to carry portrait and other heads; but the true Herm, with the head of Hermes, is regularly archaising, and the inscribed pieces strongly suggest that Alkamenes was regarded as the creator of the type. Not far from the Hermes Pausanias saw a statue of Hekate Epipyrgidia, 'on the bastion' (of Athena Nike; see below, p. 123). He gives this too to Alkamenes, and says he was the first to show her in triple form (Myron made her single). Hekataia, little images of the triple goddess, very popular in the Roman period, show her as three figures back to back. These too vary, but regularly show archaistic treatment of the drapery.[81] It seems a safe conclusion that Alkamenes in some of his works used archaic formulae for decorative effect; and his is the first name we can associate with such a notion. Athenian coins for economic reasons, and prize-vases at the Panathenaic games for religious, retained traditional forms from the archaic period through the fifth century and on, but this is not decorative archaism. (For another special use of archaic forms, see below, p. 145.) Early in the fourth century, however, the Athena on the Panathenaic amphorae ceases to be reproduced as like as possible to the old pattern, but is turned round and recreated with deliberate exaggerations of archaic mannerisms in the drapery, particularly flying swallow-tail ends. Such deliberate decorative archaism appears from time to time throughout the Hellenistic age, and becomes a consistent and

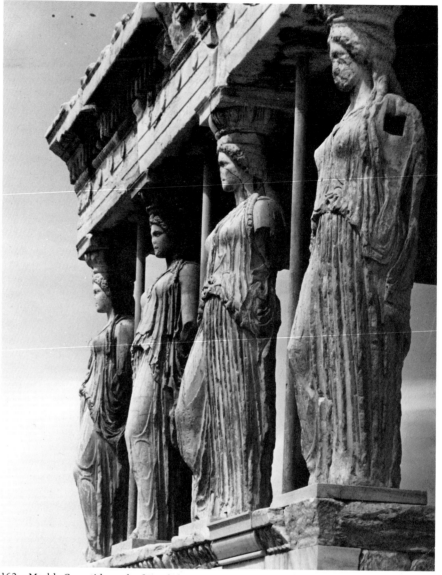

162 Marble Caryatid porch of Erechtheum, from south-east. Last quarter of 5th century. H. of figures (with capitals) 2·30 m; the supports between them are modern.

popular style of sculpture under the late Republic and early Empire.

Other Athenian marbles of the later fifth century which show touches of archaism are the Caryatids of the Erechtheum (fig. 162); and since in other respects they have much in common with the Procne it is tempting to suppose that Alkamenes was their designer. Work on the last Periclean building on the Acropolis, the Propylaea, Mnesicles's original and lovely entrance, was interrupted by the outbreak of war in 432/1 and it was never finished. This gatehouse, which had no sculpture, incorporated like the Parthenon elements from Ionic, but was externally a

Doric building. When work resumed on the Acropolis during the Peace of Nikias, Doric was abandoned for Ionic. This order, with its greater elaboration of carved pattern, suited the taste of the time, but there may have been another reason. Doric was at home in the Peloponnese, Ionic east of the Aegean, and the choice may reflect the growing polarisation: Athens claiming to be the mother-city of Ionia against Sparta, the Dorian queen. The orders may even have acquired their names at this time in Athens where it was necessary to distinguish them; Doric was still used there, not for temples but, for example, for the Stoa of Zeus in the Agora (below, pp. 127, 152).[82]

The first Ionic temple on the Acropolis seems to have been that of Athena Nike (p. 123 with fig. 166, below). Inscriptions show that work was begun on the Erechtheum in 420, and again after an interruption in 409/8.[83] It lies north of the old temple of Athena, on the foundations of which its Maiden Porch impinges. The building was planned for several cults (Poseidon, Athena, Hephaestus and various Attic heroes including Erechtheus) and to cover sacred spots at two levels; but if, in consequence, the general design is not quite coherent, the handling, especially of the elaborate carved ornament, is of unexampled quality. Figure-carving consists of the Caryatids on the south and of two friezes, one round the main building, the other round the monumental North Porch which leads into the lower level. This level is reached also by a narrow stair down from the Maiden Porch, which was clearly not in fact meant as an entrance, since the way into it from the outside is equally narrow and inconspicuous, at the back of its east side. On a wall about five feet high the six girls, of heroic size, stand four in front, one behind at each end, and support an entablature with coffered ceiling and flat roof. This verandah must have been designed for some religious activity. The temple was to house the ancient olivewood image (above p. 98), and Athena's area was probably the room at the west end, at the bottom of the stair.[84] The marked resemblance of the girls in the porch to those of the Parthenon frieze (fig. 163) is surely deliberate and suggests that some ritual with the robe might have taken place here. These are peplos-figures like the Procne, the fluted skirt broken by the right knee of the

three to the east, the left of the others. Lifeless copies from Hadrian's Villa at Tivoli show that they held empty phialai (as do some of the girls on the Parthenon) flat against the skirt in the right hand. The left, as one can see best from behind, draws some of the drapery to the side, surely a conscious reminiscence of the gesture of archaic korai; and the elaborately braided hair, different in each, bound round the head, hanging down the back and brought in locks over the shoulders, is also an archaic and early classical fashion and deliberately archaic in treatment.[85]

The friezes are in a most unusual technique. Instead of the background being painted, it is of dark Eleusinian stone (already used in the Propylaea for decorative contrast with marble) and the white marble figures were carved separately and fastened on. This technique is also found on blocks apparently from the base of the cult-statue in the 'Theseum'. Were that sure, and were the temple securely identified as that of Hephaestus, this would give further support to the idea that Alkamenes was in charge of the Erechtheum sculpture. A fine group, a woman crouched against the legs of a man in a himation (fig. 164) is reminiscent of Itys against his mother's skirt.[86] The nature of the technique makes it impossible to get far in reconstructing the scattered fragments into a design; but an inscription which records payments to the frieze-sculptors in 408/7 is a document of exceptional importance.[87]

One well preserved passage lists seven payments to five men for contiguous figures, some evidently engaged in harnessing a chariot (a scene we can clearly

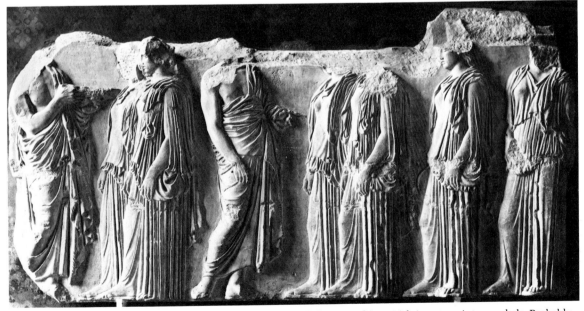

163 Marble relief. Parthenon, slab from east frieze: girls in procession; marshals. Probably between 447 and 438 B.C. H. 1·05 m.

164　Marble relief from Acropolis. Erechtheum, group from main frieze: standing man and crouching woman. Last quarter of 5th century. H. 0·59 m.

165　Marble relief from Eleusis. Demeter and Persephone with boy. Second half of 5th century. H. 2·20 m.

envisage from black-figure vases).[88] The payments are at a flat rate of 60 drachmai for the figure of an adult human or a horse (80 is paid for a woman embraced by a girl). Phyromachos of Kephisia receives three separate payments for single figures, one before the chariot-scene, one in the middle of it, and the last the other side of it. Others do more in one stretch: Praxias resident at Melite, the horse and the man seen behind it who is turning it (120 dr.); Antiphanes of Kerameis, the chariot and the youth and the pair of horses being yoked (240 dr.); Mynnion resident at Agryle, the horse and the man striking it; he afterwards added the pillar (127 dr.). This arbitrary division in the execution of a complicated scene is unequivocal evidence for the provision by a master sculptor of a detailed model or cartoon which the hired hands here listed must have been following; and we should surely envisage the execution of the Parthenon frieze on similar lines (cf.

below, p. 125; and for a different way or organising payments, p. 143). Kephisia and the rest are *demes*, local divisions of Attica, but also constitutional headings under which all citizens were enrolled, and the phraseology is significant. Phyromachos and Antiphanes were citizens; Praxias and Mynnion not. They may have been *metics* (resident aliens with certain privileges), short term visitors, or slaves.

None of these possible associations with Alkamenes offers convincing links with the west pediment at Olympia, which Pausanias ascribes to him (above, p. 87); and if he really carved a colossal relief with Athena and Herakles at Thebes in 403 (again attested only by Pausanias), he can hardly have been given the Olympia commission sixty years and more earlier. Colossal reliefs are very rare, and we may perhaps envisage this as something like the great 'altarpiece' from Eleusis (fig. 165), which shows Demeter and

166 Temple of Athena Nike from east. Third to last quarter of 5th century. W. of top step
c. 5·40 m.

Persephone with one of their mortal protégés.[89] The latest elements in the style seem to put it well down in the second half of the century, but there are old-fashioned, even archaising, features, and a connection with Alkamenes seems not out of the question.

There is no sure inscriptional or other evidence for the date of the little temple of Athena Nike (fig. 166) raised on the bastion outside the Propylaea; but it is universally accepted that it must belong to the twenties.[90] An inscription speaks of bronze gilt akroteria; and another, recording bronze akroteria with Bellerophon and the Chimaera (cf. fig. 206 below) and a Nike, has been plausibly associated.[91] The pediments had sculpture, but all that survives is from the balustrade (below, p. 125) and the friezes. These are about eighteen inches high. That on the east (fig. 166) shows deities in quiet groupings, but the subject is not clear. The other faces have battles, that on the south of Greeks against orientals. There seems no doubt that these are Persians and the subject the battle

of Marathon. It is the only known example in temple-sculpture of a conflict from near-contemporary rather than legendary history; but the Marathonomachai had been heroised (above, p. 101) and the battle had assumed a legendary character in Athenian thought. The fights on the other faces are sometimes thought to show Athenians against Peloponnesians in fifth-century wars, but I find this much more difficult; much easier to suppose that the defeat of the Persians has been taken into the company of legendary struggles, such as those in which young Athens saved herself but lost her kings Kodros and Erechtheus. These of course could have been seen as antetypes of the contemporary situation. The design is interesting for the emphatic lean of many fighters and the play made with their flying cloaks, both devices developed in the next century, especially in the Amazonomachy of the Mausoleum (below, p. 164).

Another little Ionic temple, down by the Ilissos, was drawn in the eighteenth century before the Turks

123

167 Marble relief from Athens. Temple by the Ilissos, frieze-slab: unidentified subject. Third to last quarter of 5th century. H. 0·47 m.

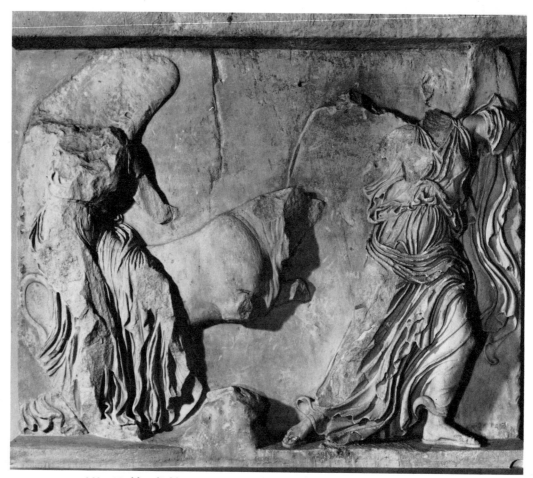

168 Marble relief from Acropolis. Temple of Athena Nike, balustrade-slab: two Victories with bull. Last quarter of 5th century. H. 1·40 m.

124

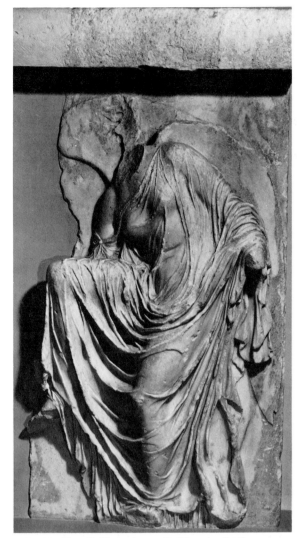

169 Marble relief from Acropolis. Temple of Athena Nike, balustrade-slab: Victory adjusting her sandal. Last quarter of 5th century. H. 1·40 m.

than classical relief commonly is (fig. 167). The subjects defy interpretation; and it is odd and interesting how often we are baffled by the content of fifth-century Attic temple-friezes.

The precipitous bastion on which the Nike temple stands must always have needed fencing, but cuttings show that the marble slabs, carved in relief and known as the Nike balustrade or parapet, were put in place after the temple-steps.[93] They are sometimes dated in the last decade of the century, but I see no grounds for thinking that they are much later than the temple. They were crowned with a heavy moulding which supported a grille, and they went round south, west and north, with a short return on the east where steps went up to the temple. The reliefs, over four feet high, faced out, so were looked up to like a temple-frieze. Many slabs are lost, others much damaged, but some relatively well preserved and of superb quality. There were at least two seated figures of Athena, possibly three (one on each face); all the rest are winged Victories variously engaged (figs. 168–9). The style varies considerably and six hands have been distinguished. The scholar whose brilliant analysis established this called them 'masters' and equated them with famous names; but the division is sometimes odd (the two Victories in fig. 168, leading a restive bull, are by different hands), and I see them as executants working to a single design, like Phyromachos and his companions in the Erechtheum inscription (above, p. 122). The Nike in front of the bull has mannerisms reminiscent of Agorakritos's Nemesis (above, fig. 145) and related works, while the famous sandal-binder (fig. 169) is close to another statue known in many Roman marbles (fig. 170). I could imagine that the original of this beautiful work and the design for the balustrade were both made by Agorakritos, perhaps in the late twenties or early teens, and that the assistant who executed the leading Victory in fig. 168 had been with him since the days of the Nemesis ten or fifteen years before and still reproduced his earlier manner. The gesture of lifting the cloak – the monumentalisation of a trivial action – is found on the Nemesis base (fig. 144), but it becomes popular at this period. The statue-type is known as the 'Venus Genetrix' because it appears on Roman coins with that inscription (and perhaps was the model for a statue of that name for the Forum of Julius Caesar by a classicising sculptor Arkesilaos); or as the 'Aphrodite of Fréjus', since a copy in the Louvre (fig. 170), actually from near Naples, was mistakenly supposed to have been found at Fréjus in Provence. Aphrodite she must be. Many of the Roman copies are adapted as portraits, when the bare breast is often covered; and there is a version in mirror-image, the 'Palatine Charis' (cf. above, p. 111, below, p. 166).[94]

destroyed it; and it is clear that it was very like indeed to the Nike temple. By a widely accepted interpretation of difficult epigraphic evidence, the Nike temple was designed in the forties and the designs only slightly modernised when it was actually put up some twenty years later; and the same designs had already been adapted, at the earlier date, for the building by the Ilissos. However, as a recent study has demonstrated, it is far more probable that design and erection of both buildings are to be set in the twenties.[92] Some slabs survive from the frieze of the Ilissos temple, which may have been dedicated to Artemis Agrotera or to Demeter (the Metroon in Agrai) or to some other deity. They are dreadfully worn, but of interest for their unusual style, much more pictorial

171 Marble statue from Olympia. Nike (Victory) by
Paionios of Mende. Third to last quarter of 5th century.
H. 1·95 m.

170 Marble statue, not as long believed from Fréjus but
probably from South Italy. Copy of the Imperial age after
original of last quarter of 5th century ('Venus Genetrix' or
'Aphrodite of Fréjus'). H. 1·65 m. Neck modern, and head
not quite rightly set.

Sandal-binder and Genetrix are examples of the
clinging drapery style, a distinctive sculptural fashion
of the later fifth century already adumbrated in some
figures of the Parthenon pediments (above, p. 97). The
female nude was not yet accepted as a subject for
sculpture except in certain contrived contexts (above,
fig. 83; below, p. 129); but this drapery style allowed
the body to be carved as though naked, and combined
this with opportunities for great virtuosity in the play
of decorative folds. It is almost a translation into the
modern naturalistic idiom of the late archaic kore-
fashion (so a kind of parallel to Alkamenes's archaism),

and like that sometimes sinks into mannerism. The
grandest example is a great marble Victory at Olympia
by Paionios of Mende (fig. 171) which can be dated
with assurance to near 420.[95] The inscription on the
tall triangular pillar-base states that it was dedicated
by the Messenians and Naupactians 'from the spoils of
their enemies'. Pausanias says, no doubt rightly, that
this vague phrase refers to the Spartans, powerful at
Olympia. He hesitates between a mid-century battle
and the capture of the Spartans at Sphakteria in
425. The Messenians, including exiles settled in
Naupaktos, were allies of the Athenians and took part
in the Sphakteria operation, and Pausanias's second
suggestion is certainly right, though the dedication
could rather have been made after the Peace of Nikias
in 421 and include spoils from other successes.

126

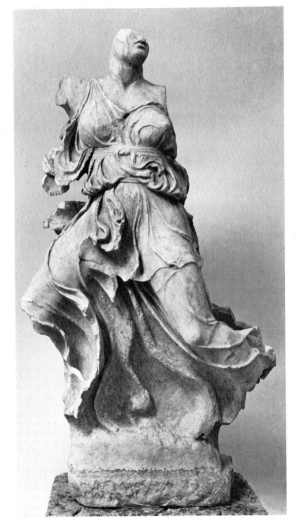

172 Marble statue from Agora. Stoa of Zeus, akroterion: Nike. Late 5th century. H. 1·20 m.

Archaic Victories were shown in a conventional run (fig. 26), and the development of that type in classical sculpture is seen in an akroterion from the Stoa of Zeus in the Agora (fig. 172), a case where the clinging style is reduced to a trivial mannerism.[96] Paionios's figure is altogether different. A marble Nike from Paros, at the transition from archaic to classical, is shown alighting towards the spectator; but the brave idea is not successfully realised in the conventions of that time.[97] It comes to fruition here. The goddess hovers in the air, an eagle winging out from under her, the rush driving her clothes back so that the left leg is quite free and the rest of the body clearly modelled under them. They gather behind in a wide mass which serves as the practical support for the statue and was once aesthetically balanced above by a spread of big wings. The forms have a weight and power which make

Pausanias's ascription to the same artist of the east pediment of the temple (above, p. 87) not wholly implausible in spite of the totally different idiom. It remains hard, however, and can perhaps be explained away as a misunderstanding of a claim in the inscription that Paionios also won a competition for *akroteria* for the temple (bronze Victories which do not survive). The only other statue in this style which approaches this in power is a small marble, the 'Palatine Aura' (fig. 173), found in Rome, a Greek original, probably an akroterion of the end of the fifth or the beginning of the fourth century.[98]

Two other fifth-century temples have left sculpture which requires consideration. Both are outside Attica, but one is Athenian, dedicated to Apollo on the holy island of Delos, again probably soon after the Peace of Nikias. This Doric building, without external colonnade owing to its cramped site, had as sculptural decoration only (a unique device) elaborate akroteria. Each showed an Attic hero or heroine abducted by an amorous deity.[99] Over the east front Eos (Dawn) carried Kekrops's grandson, the boy hunter Kephalos; on the west Erechtheus's daughter Oreithyia was swept away by the north wind, Boreas. Much of this group, terribly worn, survives. Boreas is a direct reminiscence of Poseidon in the west gable of the Parthenon, on a smaller scale and the spirit wholly changed by the changed action. There is a vivid power in the pyramidal composition: his strong torso contrasting with the curve of the girl's body, revealed by her wind-blown clothes, her head bent over his rough one, upright and pressed back against her.

The temple of Apollo at Bassae-Phigaleia in Arcadia also has Athenian connections, but of a less clearly defined sort.[100] Pausanias says it was built by Iktinos, architect of the Parthenon, and dedicated to Apollo Epikourios (Succourer) for help in averting the great plague which devastated Athens in 430/29, with Pericles among the victims. We cannot go far into the manifold problems raised by these statements. The temple is Doric, abnormally facing north, as we know its predecessor did. At the back (south) end of the main room was a door in the east wall, and the small area so entered was separated from the rest by a single column. The larger part, to the north, has Ionic columns engaged to the wall, and an entablature including a carved frieze runs round all four sides of this area. The isolated column had a different base-moulding and a Corinthian capital, the first known (possibly the two southernmost engaged columns had the same, though their bases are like the others). There are many conflicting opinions about the date or dates of this building and its relation, if any, to Iktinos, but we must by-pass these problems to concentrate on the sculptures. Fragments of metopes from above the two

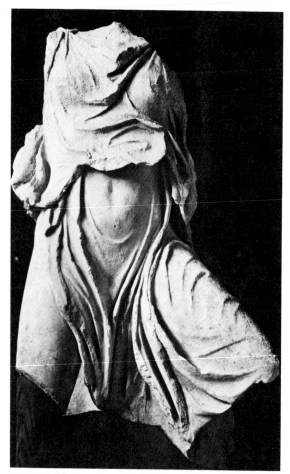

173 Marble torso from the Palatine. Akroterion (?): running woman or goddess ('Palatine Aura'). Late 5th or early 4th century. H. 0·81 m.

porches, though more accomplished than the frieze, do not seem to me earlier in style; and I accept a view that, though the building may have taken some time to complete, perhaps with interruptions and changes, the exceptional concept of exterior and interior was there from the start essentially as carried through. The style of the sculpture cannot be earlier than the twenties, but I do not see that it need be of the the end of the century, as some think. Points of contact have been noted with Paionios, and an attribution of the design to him proposed, but this does not seem justified.

The twenty-three slabs of the frieze, mainly well preserved, illustrate two subjects: Amazonomachy and Centauromachy. Each slab is not only carved but designed as a unit, with no *enjambement*; and there is little agreement on compositional associations from one to another, nor even on how the two subjects were divided.[101] All place the long Amazon-slab with Herakles (fig. 174) in the centre of the south side, over the Corinthian column. Herakles and his opponent are strikingly reminiscent of the central group in the Parthenon west pediment (fig. 132); and that this was really in the designer's mind seems proved by the way the group is flanked by inward-facing horses, and the likeness of the fallen Greek to the river-god of the gable (fig. 133). The brutal action of another Greek, however, heaving an Amazon's body from her falling horse, is very unparthenonic. Classical artists often show violence, but generally it is subdued to a harmony of design. In this frieze there is a recurrent tendency to express violence through a staccato, violent composition. So here; and in a slab from the Centauromachy a stabbed Centaur bites his killer in the neck and kicks out at another Greek over the foreshortened corpse of another Centaur. The action is

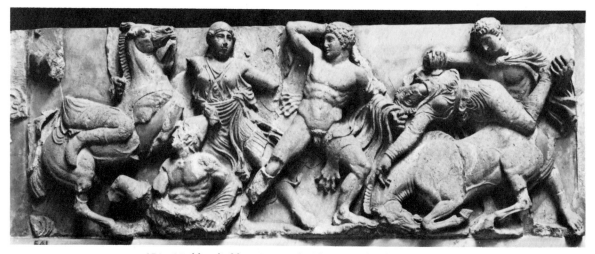

174 Marble relief from Bassae-Phigaleia. Temple of Apollo Epikourios, frieze-slab: Amazonomachy. Third or last quarter of 5th century. H. 0·64 m.

128

not more savage than the scene we noticed on the 'Theseum' frieze (above, p. 117), but the savagery here informs the style to a greater degree.

Drapery is generally treated in an idiosyncratic version of the clinging style, though more of the body tends to be covered by thick massings of stuff; but there is also a remarkable rendering of observed ugliness in the way skirts are shown pulled tight across straining thighs in broad horizontals of sharp parallel folds. The observation is already present in some figures seated in the Parthenon east pediment; but it is there used for a subordinate part in the overall harmony of design.

This Centauromachy is a combination of the two versions (above, p. 87), or a new one incorporating elements from both. Kaineus is shown; but also women, one of whom, taking refuge at an image, has had her garment torn from her and is naked. Sculptors still needed some such narrative excuse to carve a naked woman (above, p. 58). Similar is a Niobid, falling to her knees as she reaches to an arrow in her back, her garment slipping from her. She is the best of three figures which seem to belong together; perhaps from a provincial pediment of the second half of the fifth century, taken to Rome in antiquity.[102]

V. Coins and seal-stones

The production of these small works continues and even increases through the classical period. Many are masterpieces, but there is not room here for more than a glance. Athenian coinage, accepted all over the Mediterranean and beyond as a constant standard of exchange, kept the old types of Athena-head and owl in almost the old form (above, p. 119; below, fig.

176 Impression from scaraboid seal-stone. Chalcedony: heron. Attributed to Dexamenos of Chios. Late 5th century. H. 0·02 m.

175 Coin of Akragas. Silver decadrachm: eagles and hare; (other side, chariot between eagle and crab). Late 5th century. D. 0·04 m.

177 Impression from scaraboid seal-stone from Kara (Attica). Chalcedony: man's head. Signed by Dexamenos of Chios. Late 5th century. H. 0·02 m.

129

248);[103] but many cities produced exquisite dies in fully classical style. Outstanding on the mainland are the coins of Elis, with heads of Zeus or of his eagle, or of Hera, and an enchanting run of winged Victories in varied action;[104] but there are innumerable others. The west continues to lead in this field, as it had from early in the century (above, p. 58 and fig. 84). The wonderful Syracusan series with chariot and Nymph's head goes on but, unlike the Athenian, in ever developing style.[105] The faces are sometimes in three-quarter view, a thing successfully managed now in vase-painting too as well as marble relief; but on the coins, though exquisitely done, it is unsatisfactory because of the inevitable rubbing of the nose. Animals and birds abound, as rarely elsewhere in classical art (above, p. 116). We may illustrate them by the eagles and hare of Akragas, the city's regular type most splendidly realised on a decadrachm (ten drachma piece) of late in the century (fig. 175) where a cicada is thrown in for good measure.[106] Even more exquisite are some of the creatures on engraved seal-stones. The standing heron on a chalcedony scaraboid (fig. 176) is so like two, one standing preening, the other flying, on stones from South Russia signed by Dexamenos of Chios, that it too can hardly be other than his work. His other two signed stones were found in Attica, one a jasper with a bearded head (fig. 177).[107] Reasons have been found for questioning if this is strictly a portrait of an individual, but it is certainly portrait-like. Identified portraits are found on a few coins, issued in special circumstances, from the late fifth century on (below, p. 184 with fig. 249); and Dexamenos's head, which cannot be far in date from Kresilas's much more idealised Pericles (above, p. 109) makes a link between the late archaic and early classical taste for individualised naturalism (above, p. 45) and the beginning of true portraiture.

Artists' names, sometimes in an abbreviated form, are found on coins too, the most famous Euainetos and Kimon in late fifth-century Syracuse.[108] It is likely that some artists practised in both fields. A name Phrygillos does appear on a gem with a baby Eros crawling from an open sea-shell, and on a coin-die of Syracuse with a head of Persephone instead of the usual Arethusa. *Phry* occurs on Arethusa-head dies and on one of Thurii in South Italy (below, p. 149) with a bull; *Ph* on Thurian dies with a bull and an Athena-head, and on Nymph-head dies of Hyele in South Italy and of Terina in Sicily. The coin-dies all certainly, and probably the gem, belong in the second half of the fifth century. The heads at least are close to each other in style; and it is probable that we have here a wider glimpse than we are usually given of the activity of one man.[109]

6

Developments into the fourth century

I. Grave-reliefs, votive reliefs and others

We saw that figured tombstones were a limited, aristocratic phenomenon in archaic Attica, which went out of fashion, if they were not actually forbidden by law, in the time of the new democracy and the Persian threat (above, pp. 31, 57) but continued in varied forms in other parts of Greece. In Attica plain marble stelai of the old tall, narrow form with palmette finial seem to have continued to be put on some graves, or to have started again after the Persian invasion. Then suddenly, some time in the third quarter of the century, the figured stone comes into fashion again there, and a rich series runs for more than a century, till brought to an abrupt end, this time by a known law, in or just after 317.[1] There is a great number of these tombstones, ranging in quality from very high indeed to hackwork; and this continuous run of works, serving one purpose over many generations, helps us to trace changes in spirit and in sculptural style from the time of the Parthenon to the edge of the Hellenistic age.

I name the Parthenon advisedly. We saw that many hands have been detected in the sculptures; and the Erechtheum accounts (above, p. 122) reveal such hands as those of craftsmen paid by the piece for work to a given design. As work on the temple-sculptures drew to an end, there will have been many highly trained journeymen-sculptors available in Athens; and the resemblance to the frieze of many early tombstones (fig. 178)[2] is such that it seems a safe assumption that their makers had been among the Parthenon team. Whether a hypothetical law forbidding expenditure on tombs was repealed to give these men employment, or rather their presence in Athens, together with the high standard of living enjoyed by a large part of the population of the imperial city, brought about a revival of this fashion, we have no means of knowing, and it is not important: the connection seems certain.

This series differs in important ways from the archaic. First, in its range: it is no longer the preserve of a privileged few but open to anyone who could afford it, and many evidently could. 'Hegeso daughter of Proxenos',[3] 'Demokleides son of Demetrios' (fig. 180) show the formula for citizen-families; but Sosinos (fig. 178) is described as of Gortyn (in Crete) and a bronze-smith; his bellows are shown beside him, the surface roughened, perhaps for finish in stucco. He was a *metic* (above, p. 122). A slighter relief, but which

178 Marble relief from Athens. Tombstone: Sosinos of Gortyn, bronzeworker. Third quarter of 5th century. H. 1·00 m.

131

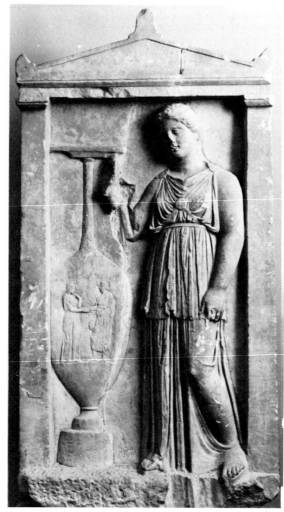

179 Marble relief from Athens. Tombstone: Hagnostrate daughter of Theodotos. Mid 4th century. H. 1·31 m.

180 Marble relief from Athens. Tombstone: Demokleides, son of Demetrios, at the prow. Early 4th century. H. 0·67 m.

like this is strongly reminiscent of the gods on the frieze, shows a man, his small daughters at his knee, holding what seems to be a cobbler's last, and his name, Xanthippos, has no additions at all. This probably means that he was a slave (so also a charming little stone with a short-haired girl spinning, inscribed Mynno). The criterion is not quite safe, since the unadorned name does occur in contexts where a citizen must be in question: so, on the wonderful relief fig. 187, the life-size armed youths Chairedemos and Lykeas. In that case the stele is of unusual form, and a fuller epitaph was no doubt engraved on the base into which it was set, or on another stone in the plot. This is a possibility to be borne in mind in other cases; but it would not apply to Xanthippos' and Mynno's humble stones.[4]

The form is another point of difference from the archaic series. The tall, palmette-topped type is still

used, bearing a single standing figure, as in archaic, or sometimes later a small squarish panel with several figures; but much commoner is a broader type, sometimes used for seated women in the archaic period and developed outside Attica in the interim. Now it is treated architecturally, with side-pilasters supporting a cornice crowned either by a pediment with akroteria (fig. 179) or a row of antefixes, as though it were the side-view of a building (figs. 178, 180). Often there is a single seated figure, often one seated, one standing, sometimes on a taller shape two standing. A figure standing by one seated is sometimes a spouse, sometimes a slave, and in general one takes a seated figure for the dead; but it is often difficult to be sure, and perhaps one is not always meant to be. Family groups occur with many figures named; and since all have lived and all must die it is possible that one should not always look to see the dead distinguished from the living (cf. above, p. 108, on white lekythoi).

A quite different form, which begins early in the series, is an imitation in marble, enlarged and adapted, of one of the clay grave-vases, the lekythos, or the

132

loutrophoros which was meant to bring water from the sacred spring of Callirrhoe (above, p. 95) for use in weddings or at the funerals of those who died unwed. Such vessels are sometimes carved as independent monuments, sometimes represented in relief on stelai as in fig. 179, a slight work datable well into the fourth century by the fashion of dress, girt high up under the breasts. This is an instructive piece for meaning, since we seem to be able to read more clearly than usual a precise message. The girl is named Hagnostrate, daughter of Theodotos. The loutrophoros shows that she died unmarried; but on the vessel she is shown again, named, and clasping the hand of a youth named Theodoros (the hand-clasp is often found on stelai). Greeks regularly used similar-sounding names in one family, and it has been suggested that Theodoros was her brother; but the way the scene is set on the loutrophoros makes it likely I think that he was her betrothed. She looks very young, but that is no obstacle.[5]

Small figures in low relief are put not only on marble vases or panels on tall stelai but sometimes on stones of the broad, architectural type. An outstanding piece is that of Demokleides son of Demetrios (fig. 180).[6] He sits in an attitude of musing or brooding, shield and helmet beside him, on the prow of a ship (which must have been finished, with the sea, in paint): death in a naval campaign? journey to the Islands of the Blest? or both?

Hagnostrate, in spite of the later fashion of her dress, shows how the tradition of the broken-fluted skirt lives on. The stele is traditional in form too: lowish relief, carved in one block with the architectural frame; and many fourth-century stones are the same. The most important, however, of the later pieces are different, more monumental; but before we go on to those we may glance at some other uses of relief over this same period.

Most numerous are the votive reliefs. This was an old practice (examples above, pp. 31, 50); but like the gravestone it now takes on a new and much more popular character. Favourite recipients are deities who in the past had been humbly worshipped with perishable offerings: the Nymphs and Pan, Asklepios, god of healing, and his numerous family, especially his daughter Hygieia (Health);[7] and heroes credited with healing powers, in particular Amphiaraos who had a sanctuary at Oropos in Attica. The worship of Asklepios was introduced to Athens about 420, Sophocles taking a prominent part; and the god's country home at Epidaurus received in the first or second quarter of the fourth century a new temple with a gold and ivory image (below, pp. 143ff.), and became one of the great sanctuaries of Greece. Here and elsewhere incubation was practised, as Aristophanes describes in his last play, *Plutus*, of 388. A

181 Marble relief from Oropos, Attica. Dedication to Amphiaraos by Archinos: healing in sanctuary. First half of 4th century. H. 0·49 m.

patient would sleep in the sanctuary, and the god or hero might heal him in a dream, or point him to a cure; and many of the reliefs are gifts of thanks. One such (fig. 181) was dedicated to Amphiaraos at Oropos by one Archinos.[8] We see him asleep, a friend gesturing wonder as a snake licks the sleeper's shoulder (a snake regularly accompanies any healing divinity or hero). In the foreground Asklepios himself (on a larger scale as gods and heroes often are on these reliefs) dresses the shoulder; this perhaps is what Archinos dreamed while the snake was licking him. The sanctuary is characterised by a relief or painting raised on a pillar; Archinos's own, like many others, has a tenon at the bottom to fix it to such a support. Such reliefs normally have an architectural frame, like the gravestones; but here, among the antefixes along the cornice, are set two big stylised eyes. The meaning of these is lost on us, though a connection has been suggested with the Egyptian Eye of Horus. These votive reliefs bring us into touch with popular belief as Greek art seldom does, and as with the tombstones exact meaning often escapes us. Topographical indications are carried further on some reliefs. Those to the Nymphs and Pan (with whom is often associated the river-god Acheloos, in the form of a bull with a man's head) are sometimes shaped as the entrance to a cave, plants and grazing goats sketched on the rim.[9]

A tree is prominent in fig. 182, but this is a relief of different intention. Over much of the period in which these gravestones and votive reliefs were being produced, the Athenians adopted a practice of putting a relief at the head of many of the inscriptions recording official decrees; and since the name of the archon for the year was an essential part of the

182 Marble relief from Athens. 'Record relief' on inscription recording work on
Erechtheum: Erechtheus and Athena. 409/8 B.C. H. 0·70 m.

preamble to such a decree, these 'record reliefs' are precisely dated.[10] Their value as points of reference for dating other works is however limited by two things: they are small and generally slight works, seldom of good quality; and, more importantly, dating by stylistic comparison becomes more difficult at this period. Up to about the time of the Parthenon Greek art does seem to have progressed, on the whole, in a very steady and consistent way; but from this 'classical moment' on we find artists much readier to follow divergent lines. If there are a few years between the carving of the Procne and the carving of Paionios's Victory, the profound difference in their styles has nothing to do with that: they represent different approaches. This is the beginning of a tendency which increases and reaches its apogee in the eclecticism of the late Hellenistic age.

The relief in fig. 182, of better quality than most of its class, heads one of the inscriptions concerning the Erechtheum and is dated 409/8. It shows Erechtheus and Athena flanking the sacred olive which grew in the ambience of the temple. Athena has the broken fluted skirt, while the hero's robe shows more influence from the clinging drapery style. Another such

relief, much damaged, heads a list of men from one tribe killed in action in Boeotia and at Corinth in 394. As it happens we have an imposing stone (fig. 183; not strictly a tombstone since those killed in battle were buried together by the state) of Dexileos, one of the young knights who fell at Corinth.[11] It shows him riding down an enemy, and was designed to dominate a carefully laid out and conspicuous corner plot in the great cemetery outside the Dipylon Gate. A similar scene appears on a large relief of even finer style in Rome, but that is much closer to the Parthenon frieze. The heads on Dexileos's stone have already some of the softness and expressiveness which mark one line of development in the fourth century. The Rome relief may have been for another private monument, but its quality sets it apart, and an attractive theory makes it a public memorial to the dead in the first year of the Peloponnesian War (431), whose last rites were the occasion for the great funeral speech which Thucydides puts into Pericles's mouth.[12]

So far we have looked only at originals; but reliefs as well as statues were copied in Roman times. Besides the versions of the bases and other adjuncts of Pheidian cult-statues, we have a fragmentary copy of the big

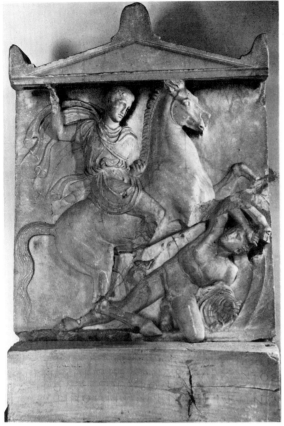

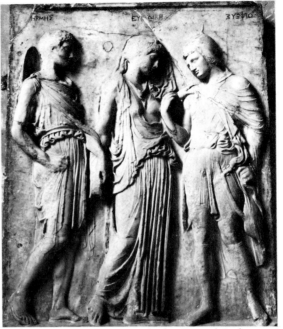

184 Marble relief. Hermes with Eurydice and Orpheus. Copy of the Imperial age after original of late 5th century. H. 1·18 m.

183 Marble relief and base from Athens. Cenotaph: Dexileos son of Lysanias of Thorikos in action. 394/3 B.C. H. with inscribed base 1·75 m.

relief from Eleusis (fig. 165), which exactly corresponds to the original, as well as adaptations of figures and groups from the Nike balustrade and apparently from slabs of the Ilissos temple frieze.[13] Four fine compositions, the so-called 'three-figure reliefs', are known only in copies, corresponding very closely to each other and in a pure style of the later fifth century; no doubt accurate reproductions of famous originals. They fall into two pairs. In one pair all three figures are upright: Eurydice between Orpheus and Hermes; Medea and the daughters of Pelias. In the other (slightly broader) the central one is seated: Herakles between two Hesperids; Peirithous in Hades, between Herakles and Theseus who must leave him there. A central feature of the Athenian Agora was the Altar of the Twelve Gods, probably the same as the Altar of Eleos (Pity, Mercy) seen by Pausanias and mentioned by others. The excavator has identified this and shown that a parapet was put round it in the last quarter of the fifth century, with two entrances; and the spaces on either side of each entrance are suitable for marble panels carved in relief of just the dimensions of the four three-figure types. That this is where

the originals stood is an attractive and plausible conjecture. Movement and gestures in the Eurydice composition (fig. 184; Orpheus turning to Eurydice and raising his hand to clasp hers laid on his shoulder, Hermes's hand laid on her other wrist) surely intimate the story of the fatal look, half-regained Eurydice snatched back to the Underworld, though it only appears later in extant literature.[14]

Closer in style to the Orpheus relief than any Attic tombstone is one of the few fine pieces in this kind at this period from elsewhere: a lovely stele from Rhodes inscribed with the names of Krito and Timarista (fig. 185). The attractive shape is unattic. So is the way the names are cut on the background but that may not be original. Epigraphists date the lettering towards the middle of the fourth century, but it is hard to suppose the figures carved much after 400. The girl's hair has been chiselled away, apparently to remake the coiffure in stucco; and this and the added names probably belong to a re-use of the stone.[15] The figures are surely mother and daughter, and the inescapable thought of Demeter and Persephone suggests the daughter lost; but perhaps rather she is the mourner, and the mother, standing more calmly detached, the dead: the old, insoluble problem. Beautiful fragments of gravestones have been found on Samos and Cyprus, and an island school in some degree independent of Attic developments postulated, but there are pieces from Attica which are very close to these.[16]

135

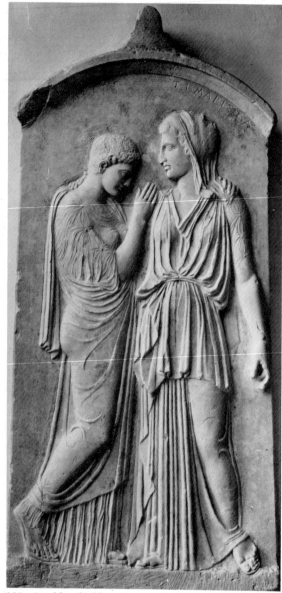

185 Marble relief from Rhodes. Tombstone: Krito and
Timarista. End of 5th or early 4th century; inscriptions and
reworking of girl's hair perhaps mid 4th. H. 2·00 m.

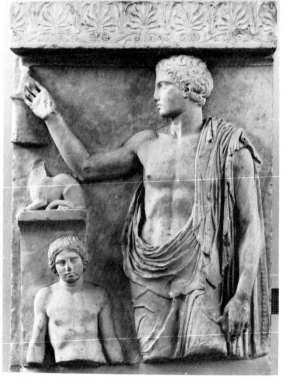

186 Marble relief, probably from Aegina. Tombstone:
youth and boy. Third to last quarter of 5th century.
H. 1·10 m.

One exceptional piece, the work surely of a great
artist, has something in common with these but also
much of the Parthenon tradition (fig. 186).[17] It seems to
have been found on Aegina. There is no architectural
frame, though the delicate flower-band is reminiscent
of mouldings on the Erechtheum. The scene is again
hard to interpret at all precisely. The youth holds a
bird in his left hand and reaches with his right to an
object which can hardly be other than a bird-cage.
Below that is a pillar on which lies a cat-like animal or
statue of an animal, and in front of it (standing? leaning
against the pillar? seated on its steps? – the lower part

is lost) a naked little boy. Birds are often held on Attic
tombstones, generally by children or young people.
They surely have a symbolic value, underlined here
by the cage, but we cannot pin-point the precise
intention. One, with a girl holding a bird above a small
boy on the ground is inscribed with the girl's name
only, Timarete; but another on the same scheme names
Mnesagora and Nikochares, and a verse tells us that
they were brother and sister and are both dead.[18]
Perhaps the youth and the child on the Aegina stone
are brothers.

Mnesagora's drapery is close to that of Krito, and
her hair perhaps shows how the Rhodian girl's was
originally done, but it is a work of much less quality
and feeling than either the Rhodes or the Aegina stele.
A splendid large Attic piece from Salamis has both:
that of Chairedemos and Lykeas (fig. 187; and cf.
above, p. 132). The two young men, again probably
brothers, with their spears and shields, died one
supposes on service. The naked Chairedemos in-
evitably recalls the Doryphoros (fig. 155), but the
weight is shifted to the other foot, changing the
rhythm to something nearer that of the Borghese Ares
(above, p. 118). Lykeas walks like the Doryphoros, but
his spear is on the right shoulder and his look is turned

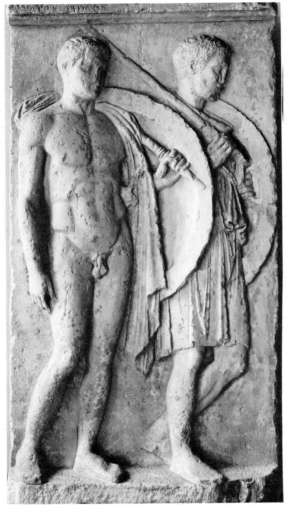

187 Marble relief from Salamis. Tombstone: Chairedemos and Lykeas. End of 5th or early 4th century. H. 1·81 m.

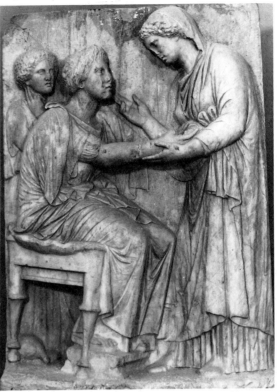

188 Marble relief from Athens. Tombstone: two women and slave-girl. Third quarter of 4th century. H. 1·70 m.

the other way. The artist seems engaged in variations on the Polykleitan theme. One scholar has dated this masterpiece towards the middle of the fourth century; an illustration of the difficulty of dating in this period, since to me it seems inseparable from the works we have been considering and I cannot put it much after 400.[19]

In scale and in solemnity this stone does look forward to later developments. It has no architectural frame, only a narrow moulding at the top. The most important of the later slabs, which are very large and carved in full high relief, have no mouldings carved with them but were built into a deep architectural framing: pilasters, cornice and pediment forming a kind of shrine. On an early and beautiful example a bearded man sits like a god, his wife and daughters standing about him.[20] There is much of fifth-century tradition here, and it can hardly be later than the first quarter of the fourth, but most of this type belong to

the middle or later. Best known is a marvellous piece from beside the Ilissos, a young hunter lolling against a post, his little slave-boy and his dog with him, an old man gazing at him.[21] This must be very late in the series. A little earlier perhaps is a stone from the Kerameikos (fig. 188).[22] An old woman leans forward on her stool, looking up at a younger who bends towards her, taking her arm and touching her face. There is more overt emotion here than we have met hitherto, and one is reminded of the Visitations of Christian art, though the mystery here is death not birth. The little slave-girl, hand to chin, watching, is a recurrent figure, comparable in character to the chorus in Attic tragedy, itself often composed of slaves. Slavery was basic to Greek life; but thinking Greeks were uneasily aware of the moral problem it presented.

The moving piece in fig. 189 comes from Rhamnus.[23] The display of feeling is less pronounced here but is clearly present in the two still figures with their portrait-like faces, gazing at each other. This, like the Ilissos stele, shows the new proportions – taller, slenderer bodies, smaller heads – which become fashionable during this century and were codified by Lysippos (below, p. 165), and it too must be among the last set up before 317.

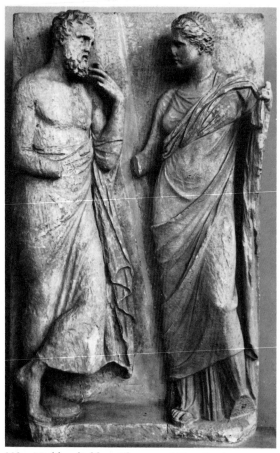

189　Marble relief from Rhamnus, Attica. Tombstone:
man and woman. Third to last quarter of 4th century.
H. 1·81 m.

II. Kephisodotos and Praxiteles

The reliefs show us, mainly in originals if not for the
most part masterpieces, some of the ways in which
Greek sculpture developed from the classical moment
of the Parthenon to the verge of the Hellenistic age. For
sculpture in the round we depend as before largely
though not entirely on Roman copies; and for the great
names on what links we can find between copies (a
few originals) and the literary tradition. Three names
dominate the fourth century: Praxiteles, Skopas,
Lysippos. All three are seminal for the following age.
The connections of the last two with early Hellenistic
are clearer than their own artistic genesis, and they
will be treated in the next chapter. Praxiteles seems to
have an evident precursor in the early fourth century,
whose own roots are in the fifth, and a consideration of
this line follows naturally on that of the reliefs.

Pliny knew of two sculptors called Kephisodotos.
One was a son of Praxiteles, given a *floruit* in the early
third century. The other he places in the hundred and
second Olympiad (371–368). He does not connect him

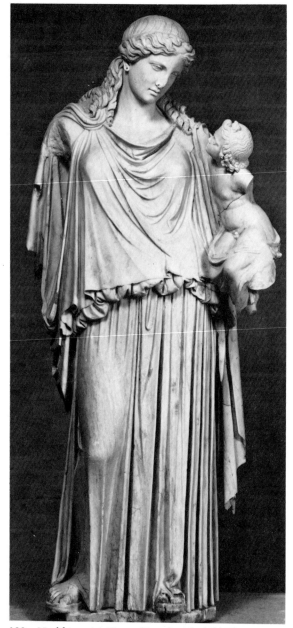

190　Marble group. Eirene (Peace) with child Ploutos
(Wealth). Copy of the Imperial age after original by
Kephisodotos of first or second quarter of 4th century.
H. 1·99 m; modern: goddess's nose and child's head.

with Praxiteles (whose father's name is not recorded);
but given Greek practice of handing down names and
crafts in the family, it is likely that if not Praxiteles's
father he was a relation. Certainly there are links
between works associable with the elder Kephisodotos
and with Praxiteles.

Pausanias saw in the Athenian Agora a statue of
Eirene (Peace) with the child Ploutos (Wealth) by
Kephisodotos (he is not aware that there were two).

Isocrates, writing not much later, tells us that annual sacrifices to Eirene began in Athens at the Peace of Kallias concluded between Athens and Sparta in 371. This is a likely moment for the erection of the statue in the Agora, and could have given Pliny the *floruit* of the elder Kephisodotos. That could alternatively have been derived from the foundation of Megalopolis by Epaminondas in 369, since Pausanias saw in the principal temple there marble statues carved by the Athenians Kephisodotos and Xenophon. He further records at Thebes a figure, which he compares to the Eirene, of Tyche (Fortune) with the child Ploutos, by the Athenian Xenophon and a local, Kallistonikos.[24] The personification of abstract qualities begins early in Greek thought and art (Eros, Love; Nike, Victory); but it increases markedly in this period.[25] We have Roman copies of a statue of a woman holding a child (fig. 190), the original of which was certainly standing in Athens by 360/59, since it is pictured on Panathenaic prize-vases bearing the name of the archon for that year.[26] It seems a safe conclusion that we have here copies of a work by the elder Kephisodotos. It is often assumed to have been in bronze, but there is no proof. The artist appears in Pliny among the bronze-workers, but the Megalopolis statues were of marble, and the division of labour on the Tyche at Thebes (head and hands by Xenophon, the rest by the local artist) suggests an 'akrolith': head and hands in marble, the rest in wood; a known form (cf. the Selinus metopes, above, p. 59).

The broken-fluted drapery is strongly in the tradition of the Procne and the Caryatids – one could easily suppose this artist a pupil of Alkamenes – but the softness of feature and the tenderness are things we have seen coming into tombstones in the fourth century. Pliny ascribes another group of divine adult and child to this Kephisodotos, a bronze Hermes with the baby Dionysos;[27] and the same subject recurs in a marble statue which was found in the temple of Hera at Olympia and corresponds to one Pausanias saw there and ascribed to Praxiteles. This statue, however, (fig. 191; lower legs and left foot are modern) has features – the strut, the unconcealed tooling on the tree-trunk and the back (though there it may be reworking) and the naturalism of the crumpled drapery – which are almost inconceivable in a fourth-century original. On the other hand the carving has a strength and sensitivity rarely found in copies. A suggestion that it is a late Hellenistic work by a sculptor of the same name is unhelpful because the design – a leaning figure with a strong *déhanchement* – is typical of the great Praxiteles, as we know from certain identification of his work in copies. The least difficult hypothesis is perhaps to think it a copy made at the end of the Hellenistic period, before the age of mass-production, by an artist

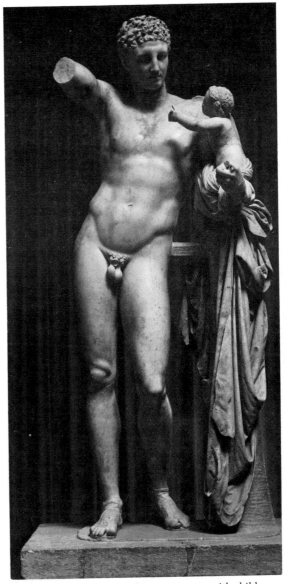

191 Marble group from Olympia. Hermes with child Dionysus. Perhaps copy of 1st century after original by Praxiteles of second half of 4th. H. 2·13 m; modern: lower legs and left foot of Hermes.

who allowed himself some freedom, especially in the cloak; and that Pausanias took it for an original; but the question is still wide open.[28]

Similar leaning figures, all other views sacrificed to the careful harmony of the broad frontal design, are known in copies: the Apollo Sauroktonos (Lizard-slayer; a certain identification with a famous original by Praxiteles),[29] and a dreamy young satyr, most probably one which an anecdote makes, with an Eros, the artist's own favourite.[30] The leaning motive is made part of the narrative in the Apollo: a lizard crawls up the trunk and the boyish, almost girlish,

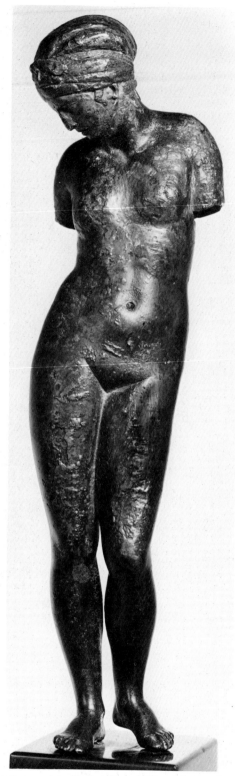

192 Bronze statuette from Beroea (Verroia), Macedonia. Naked girl. Possibly end of 5th to beginning of 4th century?; or rather classicising, late 2nd or 1st century? H. 0·25 m.

young god aims a dart at it. One reduced copy is in bronze, and we know that was the material of the original, but much of the sculptor's most celebrated work was in marble; and it is notable that the leaning figure, with its built-in support, is well adapted to execution in either material.

Praxiteles's most famous masterpiece, certainly the most popular of all statues in antiquity, was a marble: the naked Aphrodite of Knidos. We have seen that Greek art, which from the start welcomed nakedness in men in any circumstances, was slow to admit it in women. It appears in occasional narrative scenes of the fifth century, where motivated by the action (above, p. 129), but the nearest substantive statues get to it is the revelation of form by blown or clinging drapery (figs. 170–1). A figure known as the Esquiline Venus has been thought to copy a fifth-century nude, but to my eye is unquestionably a classicising pastiche of much later date. A lovely bronze statuette, from Beroea in Macedonia, of a naked girl with scarfed hair (fig. 192) is claimed for around 400. With many others I have been used to think of this too as a later piece of classicism, but now wonder if the early date may not perhaps be right. Very like it in reverse is a magnificent marble torso, presumably of Roman date but exceptional quality, which I think probably does give us an early fourth-century creation (fig. 193).[31] Whatever their dates these two seem to me the most beautiful female nudes that have come down to us from antiquity; and in their clear-cut, compact structure they could naturally, the marble in particular, follow on such figures as the 'Genetrix' (fig. 170).

The copies of Praxiteles's Cnidia[32] (identified from representations on coins of Knidos) are lamentable objects from which it is impossible to derive any aesthetic pleasure (fig. 194), but studied they can give us some intellectual idea of the artist's revolutionary approach. The figures in figs, 170, 192, 193 are thoroughly feminine in form, but as statues they are constructed on a traditional pattern: a firm upright stance used equally for both sexes. Praxiteles seems to have tried to start again, to create a statue to illustrate the feminine principle. The knees, close together, make an extraordinarily narrow point from which the thighs spread rapidly to the ample buttocks and hips, equally emphasised by the shrinking, stooping movement of the upper torso. The innumerable Hellenistic Aphrodites (figs. 282–3) could not have existed without the example of this statue, but all to a greater or less degree retreat towards a more conventional concept of a statue. This stance of the Cnidia needs external support, and that is provided by the waterpot with the garment draped over it (in folds much more traditionally stylised than those of Hermes's mantle, fig. 191). The function in the *statue* is just that

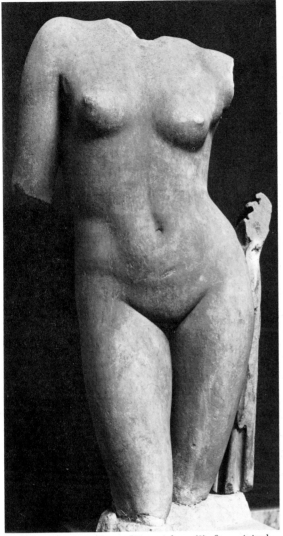

193 Marble torso. Copy of Imperial age (?) after original probably of early 4th century. H. 1·04 m.

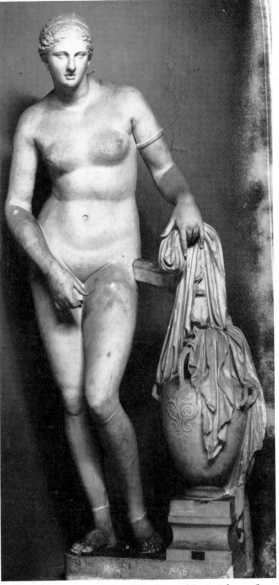

194 Marble statue. Aphrodite. Copy of Imperial age after marble original by Praxiteles of middle or later 4th century. H. 2·05 m; modern: right forearm and hand; the head, which comes from another copy of the same statue, should be turned a little more to figure's left.

of Hermes and Apollo's tree-trunks; but the objects here are not as there *represented* as supports: the goddess is not leaning but lifting her garment. It is, however, an integral part of the representation, motivating the nudity (something Greek artists never felt necessary in a male figure). Surprised washing, Aphrodite reaches one hand across her body and picks up her wrap with the other.

The idea of showing a goddess naked was still not readily accepted, and the people of Kos were later laughed at for having rejected this statue (to the advantage of the people of Knidos) in favour of a draped Aphrodite by the same sculptor. A repertory of clothed Praxitelean women is given by a statue-base from Mantinea. Pausanias saw there a group of Leto with her children by Praxiteles, and on the base 'a

Muse and Marsyas piping'. A base for three statues can hardly have been adorned with only two figures, and three slabs found there (figs. 195–7) which show Apollo seated with the lyre, Marsyas piping, between them a Scythian slave waiting to inflict the dreadful punishment (cf. p. 195 below), and six Muses, are surely from the base in question. They are no doubt studio work, not from the master's hand.[33] The movement of the satyr is surely inspired by Myron's Marsyas on the Acropolis (above, fig. 159), but the other evenly spaced, still figures are in the tradition of

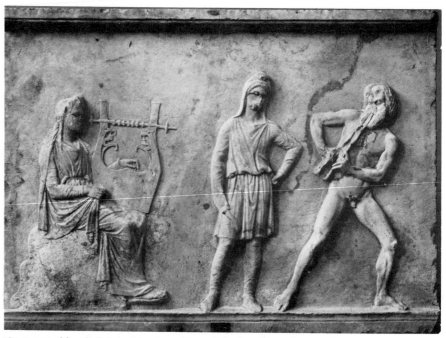

195–7 Marble reliefs from Mantinea. Three slabs from base of statues by Praxiteles: Apollo, Scythian slave, Marsyas and six Muses. Late 4th century. H. 0·96 m.

the Pheidian bases. They have the new proportions (above, p. 137; below, p. 165) and the heavy, muffling drapery is a new fashion too. There are copies of several statues in this style which must go back to Praxiteles or his school, as must the Fates on the Roman relief with the Birth of Athena (above, p. 96).

The terracotta statuettes known as Tanagras, which began to be produced in Athens in the generation of Praxiteles's sons, carry on this tradition (below, pp. 170, 198, 199).[34]

Archaic and earlier classical sculpture makes its effects with sharply defined forms; and the muscu-

lature of an athletic male lends itself to such treatment better than the softer ideal preferred for the female form. As virtuosity increases, softer forms and subtler transitions are seen as offering an interesting challenge, and this surely helped to bring about the development of the female nude in the fourth century. Work of this kind loses even more in copying than robuster styles do. There is a Praxitelean Aphrodite, the Leconfield head, which looks like an original and certainly gives us some notion of what we lose in the copies of the Cnidia, but it is only a head.[35] We also have a beautiful complete bronze, the boy found in the sea off Marathon (fig. 198), which must be an original from the Praxitelean circle: not a leaner, but with the same kind of sinuous contour and broad frontal design. He may have been pouring wine into a vessel held on his left palm; and a similarly posed young satyr known in Roman copies may perhaps go back to a 'satyr offering a cup' by Praxiteles, which Pausanias saw in Athens.[36]

III. Other works and names in sculpture

There are scanty remains of carved metopes and gables from the temple of Hera at Argos, apparently rebuilt about 400 (above, p. 112), and from metopes on a beautiful Doric *tholos* (round building) put up at Delphi perhaps a little later; one of the first buildings to employ the Corinthian order (above, p. 127) on the interior.[37] More survives from the pediments and akroteria of the temple of Asklepios at Epidaurus cf. above, p. 133). Since their publication more pieces have been identified and radical changes made in the reconstruction, and any remarks must be provisional until these are made public; but the existence of an inscription recording in detail the accounts for the building and decoration, though fragmentary, makes them of peculiar interest.[38]

The date is not given, but must certainly lie in the first half of the fourth century, perhaps early in the second quarter. Building and adornment took between four and five years, the architect Theodotos being paid 350 drachmai for each year (a retaining fee?). The first payment to a sculptor is in the second year, 900 drachmai to Timotheos for *typoi*; we shall come back to the question of what this means. In the third year, when the building was nearly complete, Hektoridas received 1,610 drachmai for 'half the gable'; the other half was not paid for (1,400 drachmai) till the fifth year, the last payment to a sculptor. Meanwhile Timotheos had received 2,240 drachmai for the akroteria above 'the other gable', Theo . . . the same sum for those above 'the other gable', i.e. Hektoridas's; and an artist whose name is completely lost 3,010 drachmai for the statues in the second gable, i.e. the one under Timotheos's akroteria.

These sums, though on as fixed a scale as those to the Erechtheum sculptors, evidently imply a different

198 Bronze statue from sea off Marathon. Boy pouring wine (?). Second half of 4th century. H. 1·30 m.

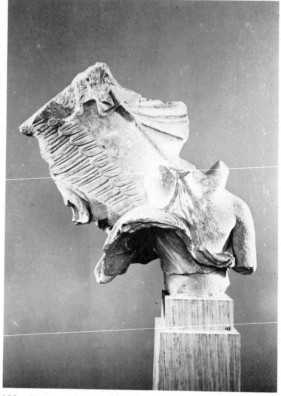

199 Fragmentary marble statue from Epidaurus. Temple of Asklepios, akroterion from east end: winged *daemon* (?Eros). First to second quarter of 4th century. H. 0·25 m.

system of payment. Hektoridas, Timotheos, Theo... and the unknown must have been masters who designed their respective assignments and made their own arrangements for the execution, whether carrying out all or part themselves or themselves paying workmen by the piece as the state paid those on the Erechtheum. A very distinctive drapery-style is seen in figures from the east gable, a beautiful akroterion from the east end (fig. 199), a statue from the sanctuary (fig. 200) and some Roman copies (fig. 201). The sculptures from the west end, though with a general similarity of style, lack the particular character of these. It is therefore tempting to restore the name of Timotheos for the missing artist, thus giving him all the eastern sculptures. *Typos* can certainly later mean 'model', and one might then further argue that Timotheos (the only one of these names known from the literary record)[39] was sculptor-in-charge, supplied small models for the whole scheme, himself took the

east front and delegated to Hektoridas and Theo... the detailed designing of the west. However, at this date *typos* normally means 'relief', and it may be rather that the metopes over the inner porches were supplied by Timotheos.[40] When this payment was made the building was at a suitable stage for the putting up of metopes. It is a little odd that not a scrap of carved metope should have been identified, but the sculptures are very incomplete. Hektoridas was also paid 54 drachmai for unspecified work at the end of the third year, and 16 drachmai $\frac{1}{2}$ obol in the last year for a pattern for the painting of the lion-head gutter (cf. below, p. 173). A statue-base with his signature was found in the sanctuary. Rather than supposing that he supplied half his pediment at the very beginning and the other half at the very end, I should guess that the first payment was an advance; but there can be no certainty.

The west pediment had an Amazonomachy, the east, as two fragments prove, an Iliupersis:[41] Priam's head, face distressed, the hand of Neoptolemos in his hair; and a hand clasping a small image with archaic drapery, Cassandra at the image of Athena. There is a similar fragment from the same scene in the west

200 Marble statue from sanctuary of Asklepios, Epidaurus. Hygieia. First half of 4th century. H. 0·87 m.

201 Marble statue. Leda. Copy of the Imperial age after original of first half of 4th century. H. 1·32 m; modern: upper right arm and swan's head and neck.

pediment of the Argive Heraion. This is a particular use of archaism (above, p. 119), to distinguish a statue among living figures in a narrative scene. Already Cassandra in the Kleophrades Painter's Troy (fig. 102, just visible on left) clutches an Athena which looks like the Peplos kore (fig. 39). The image at which a woman on the Bassae frieze takes refuge has an archaic

stiffness of pose, but the specifically archaic detail in the drapery of these two Athenas relates them to the development of the archaistic style.

A good torso from this gable of a woman kneeling with a child (Andromache and Astyanax) illustrates the peculiar drapery-style mentioned above. The belly is modelled through the thin stuff in the 'clinging drapery' tradition, but there is a special character in the way the stuff hangs at the sides, separated by deeply cut furrows which frame the body in a dark outline. The effect is clearly seen in a statue of Hygieia from the sanctuary (fig. 200);[42] and dramatically adapted to a figure in movement in an akroterion from

above this pediment (fig. 199).[43] The slight figure, borne on huge wings, has a garment blown against and off the body, baring left shoulder and breast and curving free to tangle with the pinion: a marvellously exciting creation. Eros is rarely clad, and this figure is often thought Nike or Iris shown as a child; but I think a Greek sculptor would be likely to give even a very young girl some fullness of breast to distinguish her from a boy, and I suppose this is Eros or some other male *daimon*.

The akroteria from the west[44] are in a tamer version of the clinging drapery-style: a woman with a bird; and two riding horses which seem to issue from the sloping cornice and begin to climb towards the centre – Nereids, perhaps, or Aurai (Breezes). The face of one is preserved, delicate and with the more expressive look we see in some fourth-century tombstones. The Amazons' garments in the west gable again do not show the particular character of the eastern drapery, but fine wiry male nudes from the two pediments do not seem distinguishable on style.

The most interesting of the Roman copies which show the Epidaurian drapery-style is a Leda (fig. 201). The subject is popular later as an erotic joke; here the treatment is deeply serious. The artist is perhaps illustrating a known version in which Zeus had himself as swan pursued by his eagle, and Leda took him to her breast for protection. In any case the lifted look and the hieratic gesture with the cloak make a moving and strange effect not easily paralleled in Greek art. Nearest is an Athena, surely from an original by the same hand. Helmet on head and spear resting in hand, she wears a chiton, the aegis over it, and wrapped about her the himation – a different use of drapery, but the dark channel contouring the left leg is not the only element that betrays a likeness, and the set of the head is just Leda's. The young goddess stands like Joan of Arc listening to her voices.[45]

A fine and interesting artist lies behind these works; perhaps Timotheos, but no link can be traced with the few references to Timotheos in literature, and in particular it is hard to make a connection with the remains of sculpture from the Mausoleum, with which some ancient writers associate his name (but see below, p. 163). That was a good deal later; but for the present it is safest to keep inverted commas in calling this style 'Timothean'.

A later development of the style, in a new personal idiom, seems exemplified in a fine colossal torso of Apollo from the Agora at Athens (fig. 202). A harsh copy shows that he was playing the kithara, and there are numerous adaptations in Attic reliefs. This was probably the cult-statue in the temple of Apollo Patroos on the west side of the Agora, which was by Euphranor. This artist was also a painter (below,

202 Fragmentary marble statue from Agora. Apollo. Third quarter of 4th century. H. 2·54 m.

p. 152) and I do not think it fanciful to see a pictorial character in the play of light and shade introduced in the broken-fluted drapery. Pliny dates the artist, with Praxiteles, in the hundred and fourth Olympiad, probably because the battle of Mantinea, which he painted, fell in 362; but he lived to represent

146

Alexander with his father Philip, and the Apollo seems to belong to his later time.[46]

To the earlier fourth century belong two buildings adorned with sculpture by Greek artists working abroad for foreign patrons. The rulers of Lycia at Xanthos had employed Greek sculptors from the archaic period. To the very end of that phase belongs the 'Harpy Tomb', a tower-tomb of local form, bearing round its top reliefs in a provincial Greek style. A little later are relief friezes and peplos-figures of better quality from what was perhaps a hero-shrine.[47] Probably late in the first quarter of the fourth century a Greek architect and sculptors were employed on a more ambitious project, the 'Nereid Monument'.[48] This tomb takes the form of a small Ionic temple set, in un-Greek fashion, on a tall podium which probably contained a burial-chamber. There were carved akroteria and pediments, a frieze round the inner building, as in the Parthenon; and the external architrave was carved with a frieze, a practice avoided in Greek buildings after some archaic experiments. There were also two friezes on the podium, and the monument takes it name from figures of girls, birds or dolphins beneath their feet, placed between the columns and carved in variations of the clinging drapery-style. The chief importance of this provincially sumptuous work is as a predecessor of the Mausoleum at Halicarnassus (below, p. 158). Also there are city scenes in one of the friezes, of oriental derivation but Greek in treatment, which are of interest for the development of perspective and the history of painting. These will be mentioned in the next section, together with even more remarkable examples from the second Greco-Lycian building, a hero-shrine at Gjölbaschi-Trysa (below, p. 150, fig. 207).

We can trace the wanderings of Greek sculptors further. In a royal tomb at Sidon were found four large sarcophagi carved in Greek style. The first, the 'Satrap sarcophagus', seems to be by an artist who got his training in the early classical period, but tell-tale elements, especially in the ornament, suggest that its date is late in the fifth century. The shape of the second, the 'Lycian sarcophagus', is certainly imitated from a type of tomb native to Lycia, where the artist must have worked before he reached Sidon. Part of the decoration shows clear influence from the riders of the Parthenon frieze, but again there are later features and it probably dates from the early fourth century. The other two are much finer and have nothing to suggest a time-lag. The last, the 'Alexander sarcophagus' is already Hellenistic and will be treated in the next chapter (below, p. 170); but the 'Sarcophagus of the Mourning Women' belongs here. Chest and lid are in the form of an Ionic temple, and (besides subsidiary reliefs) between the columns are eighteen figures of

mourning women, close in character to many on Attic tombstones and looking forward to the Muses of the Mantinea base. This fine work belongs to the third quarter of the fourth century. Such activity of Greek artists in the service of oriental patrons, and the mingling in various ways of Greek and eastern ideas, anticipates in some degree the Hellenistic situation.[49]

IV. The painters of transition and echoes of their work

We saw that Polygnotos and his companions opened the way for European painting by setting figures up and down the field and inaugurating the notion of a picture as a window on a feigned world. This position was secured in the later fifth and earlier fourth centuries by the development of chiaroscuro (shading and highlights) and perspective; and Greek painting in the second half of the fourth century was certainly something a Renaissance painter would have recognised as the art he himself practised.

The age of transition is dominated by four names: Apollodoros of Athens, Zeuxis of Herakleia, Parrhasios of Ephesus and Agatharchos of Samos; all sometimes active in Athens. Apollodoros was called *skiagraphos*, shadow-painter, and said to have found out how to model with shadow. Pliny in one passage dates him to the ninety-third Olympiad (407–404), and says that in the fourth year of the ninety-fifth (396) 'Zeuxis entered through the door Apollodoros had opened'. He adds that Apollodoros accused Zeuxis of stealing his ideas, and that Zeuxis is sometimes erroneously placed in the eighty-ninth Olympiad (423–420; a picture referred to by Aristophanes in a play of 425 is said by a late commentator to have been a Zeuxis). We know that he worked for Archelaos of Macedon, who reigned from 413 to 399.[50]

Quintilian says that Parrhasios and Zeuxis were much of an age and worked about the time of the Peloponnesian War (431–404). Parrhasios is credited with the design for a Centauromachy which an engraver Mys set on the shield of Pheidias's bronze Athena Promachos (above, p. 112). This, if contemporary with the statue, would push his activity back beyond the mid century, which nothing else makes likely. Perhaps it was a later addition; or Parrhasios's name has got in in place of Panainos's or Pleistainetos's. An anecdote connecting him with the capture of Olynthus in 348 must be wrong. Quintilian contrasts Zeuxis's discovery of the 'relation of lights and shades' with the practice of Parrhasios who 'examined lines more closely'. This, taken with a passage of Pliny, has been convincingly interpreted as showing that Parrhasios, like some Renaissance painters (Pollaiuolo, Botticelli), developed the traditional

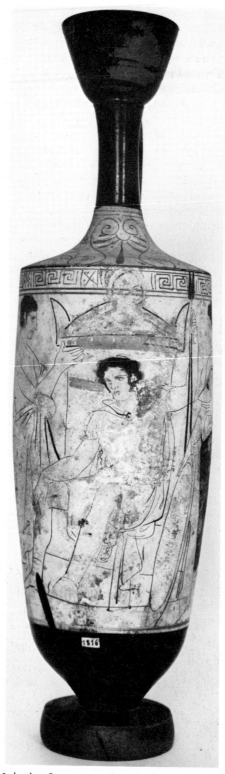

203 Lekythos from grave at Eretria. Attic white-ground: youth and companions at tomb. Ascribed to Group R. Late 5th century. H. 0·48 m.

204 Oinochoe from Locri. Attic red-figure: love-making. Ascribed to Shuvalov Painter. Third to last quarter of 5th century. H. of picture *c.* 0·06 m.

use of contour into a means for expressing tactility and depth. Not that he, any more than Botticelli, will have rejected chiaroscuro outright: the well-worn anecdote of the grapes by Zeuxis that deceived the birds and the curtain by Parrhasios that deceived Zeuxis implies that he was thought to have used it; and, on the other side, Zeuxis's most famous picture was a naked Helen, and we shall see that shading was probably not at this time applied to women's skin. It is a matter rather of taste and tendency.[51]

We noticed that painters of white lekythoi had developed a technique of drawing in a matt colour which encouraged a much sketchier, more vivid line than the old glaze (above, p. 108 and fig. 150). A group from the end of the fifth century, often showing a youth seated in three-quarter view at a tomb, between two companions (fig. 203), employs a broken, nervous contour to build a powerful effect of volume and weight. These perhaps give one an idea of Parrhasios's method. The vase-figures have a gravity which is also reported from his work, as is the expression of feeling and character. A suffering Prometheus was famous; and a suffering Philoctetes (Sophocles's great play was produced in 409), which is perhaps reflected in a relief on an Augustan silver cup where the hero is posed just like the youths on the lekythoi.[52] He had a lighter side, however, painting 'by way of relaxation' little erotic pictures, one of which the emperor Tiberius was to keep in his bedroom.[53] One may perhaps envisage them in the spirit of an exceptionally charming little red-figure vase painted in Athens in the twenties of the fifth century (fig. 204).[54] The best Athenian red-figure in the later fifth century tends to be on a small scale. Larger vases are often overweighted with fussy detail. There are exceptions, but the simplicity of the best white lekythoi is seldom achieved.[55] Contemporary

148

with the 'Parrhasian' lekythoi is a group of huge vases, painted white from mouth to foot and evidently imitated from the marble tombstones in vase-form used at this time (above, p. 132). Some of those had painted instead of carved scenes, though no legible picture survives.[56] On these clay imitations, all in very bad condition, men's skin is painted brown and shading is shown on it; so they correspond in some degree to the rival movement of Apollodoros and Zeuxis. Women's skin is shown in the traditional way, outlined on the white ground and without shading. Thus we return to the old distinction we saw in black-figure; and many late red-figure vases have women's skin (and that of Eros and sometimes Dionysos) in white. Shaded male and unshaded female skins appear also in three paintings from Herculaneum, on marble, which must be copies or pastiches after work of this period.[57] The shading on these and on the lekythoi is not accompanied by highlights, and this gives a sombre effect. Indeed the painting of this time in the forms in which it reaches us is full of uneasy compromises, and we might have felt the same even in the works of the masters.

Highlights do begin to be shown in work of this period, but only on substances like metal where they jump to the eye. A good example is on a fragmentary red-figure krater made at Tarentum in the early fourth century (detail, fig. 205).[58] Red-figure vases were made by Greeks in South Italy from the third quarter of the fifth century, on the Attic model and no doubt at first by immigrant Attic craftsmen. These may have been colonists of Thurii, founded by Pericles in 443, but from early there were two main centres of production: at Herakleia in Lucania, founded from Thurii in 432

and probably the place of that name of which Zeuxis was a citizen; and at Tarentum in Apulia. The Apulian class flourished until vase-painting died out in the early Hellenistic age; the other, after an interesting start, declined into provinciality, though it had offshoots in a number of centres in south-west Italy and Sicily. In the early phases of both classes the better work is often simpler and stronger than most contemporary Attic.[59]

Red-figure, in Athens and South Italy alike, remains a linear technique, eschewing chiaroscuro, so gradually loses touch with developments in major painting. Yet every now and then it gives us glimpses, as in fig. 205. The picture, an assembly of gods, is in traditional linear red-figure (very pretty); but behind Apollo is his temple, and through the open doors we see his bronze statue modelled in accomplished shading and highlights. The temple itself shows another new interest of this time. It is linear in drawing, though a little shading is tentatively introduced (under the front architrave, in and around the doorway); but it is drawn in perspective, or rather, though he follows no rules and gets very confused, some notion of perspective is in the artist's mind. He has made a serious attempt to show the building as it would appear in recession, looked up to at the south-east corner.

Ancient pictorial perspective is a thorny subject. Some deny that it was ever more than empirical. This seems to me absolutely ruled out by the evidence; but how well developed a theory there was and at what times is less easy to establish. Vitruvius, writing under Augustus, says that Agatharchos painted a stage-set for Aeschylus and wrote a treatise on it which influenced the optical theories of the philosophers

205 Fragmentary calyx-krater from Taranto. South Italian red-figure: (assembly of gods); detail, Apollo's temple and statue; (other side, Dionysus with satyrs and maenads). Ascribed to the Painter of the Birth of Dionysus. Beginning of 4th century. H. of part shown *c.* 0·09 m.

149

(scientists) Anaxagoras and Democritus. On even the most hostile interpretation this passage makes it clear that some *theory* of pictorial perspective had been evolved at some time before Vitruvius; and I personally see no reason to doubt that it was first put forward by Agatharchos in fifth-century Athens, in connection with scene-painting. Sophocles, whose first production was in 468, is credited by Aristotle with the introduction of scene-painting. Aeschylus died in 456; so Agatharchos's set and treatise ought to come between those dates; but we know that Aeschylus's plays were revived in the second half of the century, and that at such revivals they were formally presented in the dead poet's name, so the early date is not quite sure.[60] An anecdote, recorded in two late versions which have been shown to be independent variants from an early source, has Agatharchos decorating a house for Alcibiades. This could hardly have happened before about 430, and is most likely between then and Alcibiades's exile some fifteen years later. He invited the painter to dinner, and then held him prisoner till he had done the job. This is the earliest evidence we have for the decoration of a private dwelling with paintings; and it is possible that part of the outrageousness of Alcibiades's behaviour was in wanting to have his house so adorned at all. There is a reference in one version to Agatharchos at last slipping the guard 'as though from a king's house'. We know that Zeuxis decorated Archelaos's palace at Pella (above, p. 147); and if the incident could be dated to Alcibiades's brief return in 406–404, one might think him fired by that example. (On developments in palace and house-decoration, see below, pp. 176ff.)[61]

An architectural style of painted decoration popular in late Republican Italy certainly owed much to Hellenistic palace decoration, and also made direct use of stage-sets. In some examples many more lines recede to a single vanishing-point than can be due to chance (below, fig. 293), and in one room the consistency is absolute. Later examples do not show this, and it is clear that the Roman decorators were not themselves interested in this problem; but equally clear that the Hellenistic designers of the stage-sets they were adapting had a well worked-out system. This is borne out by passages of Vitruvius, and he sometimes uses *scaenographia* (stage-painting) as equivalent to perspective design. There is very little trace of this interest in other forms of painting, and one may conjecture that Greek painters were generally content with an empirical approach, but that stage-designers worked out a system. A few names of Greek stage-painters are recorded: Eudoros in Pliny; Apatourios of Alabanda in Vitruvius. Pliny also, in the same section in which Eudoros's name occurs and which seems mainly concerned with the Hellenistic age, names one Simonides who painted Agatharchos and Mnemosyne (Memory, the mother of the Muses): surely a Hellenistic scene-painter paying tribute to the founder of his art.[62]

That Agatharchos already had a theory seems to me evident, but how far it went we cannot tell. It is natural that such echoes as we have on the small scale and curved surface of vases only tell us that perspective was in the air. There are a number of examples like that in fig. 205 from Athens[63] as well as South Italy.[64] A fragmentary krater from Taranto (Tarentum, where it was made; fig. 206), probably still before the middle of the century, comes nearer to showing us what a set by Agatharchos may actually have looked like. It is painted in a technique known as 'Gnathia', in white and other colours over the black glaze. We see what is evidently a scene from a tragedy (adapted, in that the characters are not masked), set, like many tragedies, in front of a palace which is rendered, in a fancifully proportioned mixture of Ionic and Doric elements, as a colonnade with two projecting pedimented porches leading to open doors. A king greets a young traveller, and from behind each double door (only the left visible in the illustration) peeps a girl, perhaps the leaders of the chorus about to enter. For the purposes of Greek stage-action, real doors must have been incorporated in any painted scene. Men's skin is brown, with shading but no highlights; women's unshaded white. None of the lines of the architecture here recede to a vanishing-point; but in the large-scale flat set from which this must derive a single vanishing-point, or several vanishing-points, could very well have been used.[65]

There is one other class of contemporary work which illustrates this interest: the city-reliefs of early fourth-century Lycia. These are found on the Heroon at Gjölbaschi-Trysa and the Nereid Monument (above, p. 147), on rock-cut tombs at Pinara and Tlos, and on a few sarcophagi. They have recently been fully studied, and it is now clear that they are mainly derived from oriental traditions.[66] The idiom is Greek, and they are profoundly influenced by the developments in the rendering of space taking place at this time in Greek painting, but it is most unlikely that they reflect any actual Greek pictorial type. Nevertheless a siege-scene like that from Gjölbaschi-Trysa in fig. 207 does show the pictorial possibilities inherent in the new ideas. The way the defenders fight down towards us against the besiegers whom we see from behind is very like the scheme in the Gigantomachies derived from Pheidias's shield (above, p. 106); but the tower seen from below at an angle, the gabled building rising further within the city, give the setting an entirely new reality.

206 Fragmentary calyx-krater from Taranto. South Italian Gnathia (colours over black): scene from tragedy. Mid 4th century. H. 0·23 m.

207 Limestone relief from Gjölbaschi-Trysa, Lycia. Heroon, frieze-slab from interior of temenos-wall: siege. First to second quarter of 4th century. H. 1·20 m.

V. Euphranor and Nikias; fourth-century vase-painting and Roman wall-painting

Many names survive of painters contemporary with those we have been considering, and more of their successors, but we can only look at a few. Euphranor, whom we met as a sculptor (above, p. 146) was an equally celebrated painter. He worked as both in Athens, though he was said to be from the Isthmus or Isthmia and a pupil of a Theban painter. There was an important family of painters in Thebes at this time,[67] which also saw the city's rise under Epaminondas to dominate Greece for a brief season. In the Stoa of Zeus in the Agora at Athens (above, p. 127), built in the late fifth century, Euphranor painted three pictures. One was the Battle of Mantinea, where in 362 Epaminondas defeated the Spartans but was himself killed, after which the power of Thebes melted. The Athenians were allied to their old enemy Sparta and had a contingent in the battle. The picture, which appears to have glorified Athens' part in the action in a most unhistorical way, was probably commissioned soon after. The other two pictures showed the Twelve Gods, and Theseus with Demos (the People) and Democracy. Euphranor is said to have remarked that Parrhasios's Theseus was fed on roses, his own on beef, perhaps partly in allusion to the more advanced chiaroscuro he no doubt used, beside which Parrhasios's more linear style would have looked ethereal. Parrhasios also painted a famous Demos, and one wonders whether this and his Theseus might have formed part of one composition, anticipating Euphranor's, possibly in this very stoa which was erected at a time when Parrhasios was active. Proximity would have given added point to Euphranor's remark. If it were so, Parrhasios's painting had been removed and broken up before Pausanias's visit (his Theseus was in Rome before Pliny's time); but since much Greek wall-painting was on panel not plaster, this is perfectly possible.[68]

Euphranor also wrote on art. Proportions and colour are mentioned among his subjects, and the colour of the Twelve Gods is often praised. This is something which quite eludes us, but it is possible that we can say something of his composition. The best Attic red-figure vases of the middle decades of the fourth century have a very distinctive style (known as 'Kerch', from the area of South Russia where many have been found – a new field for the Attic pottery trade, now largely excluded from the west by local competition). Many of these (a detail of one fig. 245) show assemblies of deities or mortals, large figures quietly posed, often frontal, not much concerned with each other or the action, rather in the spirit of the Pheidian statue-bases (above, p. 103) but more pic-

torially organised. Euphranor's battle cannot have been of this kind (and there are battles on Kerch vases which are not) but the Twelve Gods one can very easily envisage in these terms. In this connection there is interest in a little 'record relief' (above, p. 133) of 336, at the top of a decree invoking sanctions, under the Macedonian threat, against the establishment of a tyranny. Reference is made to people who might try 'to overthrow the people (*demos*) of Athens or the democracy in Athens'. The relief shows an old man enthroned and a woman crowning him, and they are interpreted, surely rightly, as Demos and Democracy. The woman stands facing us, and the man has his face and upper body turned towards us too, just in the manner of the Kerch vases, and one wonders if they were inspired by Euphranor's picture.[69]

Many pupils of Euphranor are named, but we must move to one described as a pupil's pupil, Nikias of Athens. Since Nikias worked with Praxiteles he was probably closer in age to Euphranor than the artistic genealogy might suggest. He was a very famous artist, and one we can perhaps get closer to than many.[70]

Pliny says that Nikias 'painted women with particular care. He preserved the light and shadows and took pains that the paintings should stand out as much as possible from the panels.' This has suggested that Nikias began putting shading on women's skin; and we have an example of it about the mid century on a painted alabaster sarcophagus from Tarquinii in Etruria.[71] Pliny also tells us that Praxiteles preferred those of his statues which Nikias had coloured, and it seems possible that the effect of natural light and shadow on the Aphrodites he had painted for the sculptor encouraged Nikias to imitate it in his pictures. This is, I think, the only reference we have to painters in their own right being employed in Greece to colour sculpture, but the practice is known elsewhere.[72]

Nikias is one of the few Greek painters from whose work we can perhaps identify copies in Roman wall-painting. Among his larger works Pliny lists an Io, an Andromeda and two of Calypso, one distinguished as 'seated'. In the Macellum (market-hall) at Pompeii were painted an Io with Argus and (a pair to this) an Odysseus seated with a standing Calypso; and versions of both compositions recur at Pompeii and at Rome. The compositions are similar, and that of Io is very close to one of Perseus and Andromeda, likewise extant in several versions (one, fig. 208).[73] It seems perverse to doubt that Nikias's compositions lie behind these; but how much beyond the general lines survives one can hardly know. A large version of the Andromeda has sculptural forms and makes a very different effect from the small one illustrated, lightly sketched and coloured and with far more grace. The

208 Wall-painting from Pompeii. Perseus and Andromeda. Before A.D. 79, probably copied from original by Nikias of middle or late 4th century. H. 0·38 m.

first may be formally nearer to the fourth-century original, but the second perhaps conveys more of the quality. The constituent colours are basically the same: dark Perseus with red cloak; fair Andromeda in a white dress; a ground of blues and greens. The background is very simplified, as no doubt Nikias's was: sky, sea with the dead monster, rock to which the heroine was fastened. In the smaller version a second rock appears, with a nymph. This may be an addition by this copyist rather than an omission by the other; but such supernumerary figures, local personifications, are common on fourth-century vases, and I am not sure.

These compositions are not echoed on vases, but a Theseus deserting Ariadne is found in versions on fourth-century vases and in Roman wall-paintings which look as though they go back to one original.[74] A more interesting relation is seen in figs. 209–10. A bad painting from Pompeii with an uncertain subject (fig. 209) shows the principal actors in front of a parapet from behind which others look on. Columns behind

support a flat ceiling drawn in recession, and a big swag of curtain hangs in front of the columns. A red-figure krater made at Paestum in the mid fourth century and signed by a painter Assteas (fig. 210), has the mad Herakles breaking up his home and killing his children in the presence of distressed witnesses. There is no curtain, but that apart the spatial structure is extraordinarily similar. Something like it is found in many Roman wall-paintings, and the vase shows that it was an established formula for interior settings in the fourth century. A slightly later and very much finer vase from Sicily, with the madness of the daughters of Proitos, shows the scheme flattened out into a more conventional vase-painter's model by setting all figures in front of the parapet, so that the architecture becomes a background only, not an enclosing space.[75]

Assteas, like all Paestans, was a heavy-handed draughtsman, but they are better when they are being funny. A large class of vases, made in all centres of production in South Italy and Sicily, shows scenes from the comic stage (*phlyax* vases, from a type of

209 Wall-painting from Herculaneum. Uncertain subject. Before A.D. 79, probably based on original of 4th century. H. 1·45 m.

comic popular in the area at the time). Fig. 211 is another krater signed by Assteas. The columns here are the supports of the stage, where a tormented miser is seen protecting his chest. Similarly burlesque drawing is found in Attic also, and especially in a class of drinking-cups made in Boeotia for the sanctuary of the Kabeiroi (popular deities unconnected with the Olympian pantheon) outside Thebes; they had another on Samothrace, which became important in the Hellenistic age. They had connections with the sea, and Odysseus is a favourite figure of fun – on his raft in fig. 212.[76] A painter Pauson, alluded to by Aristophanes in plays as early as 425 and as late as 388, is spoken of by Aristotle as making men worse than

they are (whereas Polygnotos made them better) and, again in contrast to Polygnotos, as not being suitable for contemplation by the young.[77] Caricature had a considerable future in Hellenistic art.

One fourth-century composition comes down to us in a different form: on an engraved cista (cylindrical box; fig. 213) made late in the century at Rome by a craftsman, Novios Plautios, from neighbouring Praeneste. The design is certainly copied, with some adaptations, from a Greek painting of rather earlier date. It must have been in Italy, since it has left other traces in Etruscan and Italic art, and it seems here to be copied almost complete and in drawing of high quality. It shows the punishment by the Argonauts of

154

212 Skyphos from Thebes. Boeotian black-figure (Cabiric): Odysseus on the raft; (other side, Odysseus and Circe). Early 4th century. H. 0·15 m.

210 Calyx-krater from Paestum. South Italian (Paestan) red-figure: madness of Herakles; (other side, Dionysus with satyrs and maenads). Signed by painter Assteas. Mid 4th century. H. 0·55 m.

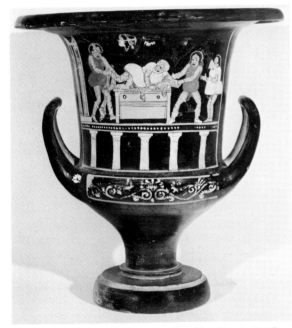

213 Bronze box (*cista*) from Praeneste (Palestrina). Argonauts and Amykos. Signed by Novios Plautios at Rome and given by Dindia Macolnia to her daughter. Late 4th century, the engraving copied from a near-contemporary Greek painting in Italy. H. (with figures on lid) 0·74 m.

211 Calyx-krater from Nola. South Italian (Paestan) red-figure: scene from comedy ('Phlyax'). Signed by painter Assteas. Mid 4th century. H. 0·39 m.

Amykos, who refused to let them land on Lemnos to draw water. The prow of the *Argo* appears at what was evidently one end of the original, Argonauts drawing water at the other; near the centre Amykos bound to a tree by Polydeukes, between Athena and a bearded winged figure, probably Thanatos (Death). A light hatching indicates shading on tree-trunk and male skin but not on Athena's. The setting is a shallow space closed by a rocky background, much as in the pictures which seem copied from Nikias and not essentially very different from 'Polygnotan' space, only rather more consistently organised. Agatharchan perspective does not interest these artists.[78] It is tempting to identify this picture with one of the Argonauts by Kydias of Kythnos. Pliny calls him a contemporary of Euphranor, and says that Hortensius, a late Republican statesman, bought the Argonaut picture for a very large sum and built a gallery for it on his estate at Tusculum.[79]

7

The second change: classical to Hellenistic

I. The historical background

The moment of change from archaic to classical and the speed with which it was accomplished may have been precipitated by the violent jolt of the Persian threat and its repulse; but this profound revolution was inherent in the nature of Greek art, which without it must have sunk into the academic formalism of Achaemenian. The change from classical to Hellenistic is both much less profound and much more a reflection of outward events.

During the late fifth and fourth centuries the cities of mainland and island Greece continued in their independence and internecine strife, while Persia resumed control of the Asia Minor coast and to the north the big kingdom of Macedon grew into a major power. It was Greek, but on the periphery of the Greek world it had developed a different social and political structure. During the fifth and fourth centuries it became more and more impregnated with the culture of the city-states. At the end of the fifth Archelaos had tempted not only the painter Zeuxis but the poet Euripides to his court; and a new era opened with the accession in 360 of Philip II. As a boy he had been a hostage in the Thebes of Epaminondas, and he dreamed of uniting Greece under Macedon as Epaminondas had tried but failed to do under Thebes. For the first ten years or so he encouraged the disunity of the city-states by his great diplomatic gifts and the free use of gold from the mines of Mt Pangaeum which were making Macedon rich; while he employed the man-power of his big country to build a powerful standing army. He trained it in campaigns against Thracian tribes and Greek cities to his north and east, a phase which culminated in the sack of Olynthus in 348 (a useful archaeological dating-point, since much Attic red-figure has been found there).[1] Athens, and most Greek cities, were now divided between a party anxious to unite Greece against Macedon (its great spokesman is Demosthenes) and the appeasers who hoped to live at peace under its benevolent patronage.

In the event the activities of the resisters provided Philip with an excuse to attack, but they could only raise a belated and imperfectly united front against him. Athens and Thebes were defeated at Chaeronea in 338, and victorious Philip called a congress at Corinth where he was made head of a Hellenic League to attack Persia. Two years later, before preparations were complete, he was murdered. His twenty-year-old son Alexander promptly put down a Greek revolt, razed Thebes, and showed himself as much master as his father. In 334 he invaded Persian lands, and with astonishing rapidity conquered the whole empire from Asia Minor and Egypt to the borders of India, pushing beyond but forced back by his troops' mutiny. As King of Persia he accepted oriental ceremony and custom, and in 327 married a Persian princess, Roxane. In 324 he took a second Persian wife, daughter of the late King Darius, and at the same time married eighty of his generals and ten thousand of his troops to Persians; but his concept of a Macedonian-Persian empire dissolved with his death at Babylon next year. His generals divided the kingdom, ruling their provinces nominally as viceroys for Alexander's posthumous child by Roxane, but fighting each other like independent monarchs. Before the end of the century the old house was extinct and most of the Successors had assumed the name as well as the actuality of king.

Thus in less than forty years the character of the Greek world was utterly changed. The old cities continued to exist. Sparta retained her independence for centuries; Athens from time to time regained hers and remained a centre of academic culture; Rhodes retained freedom and importance. Even outside the big kingdoms new forms like the Aetolian and Achaean Leagues, however, federations of small towns and villages, had more political and military significance than the old cities; and it is the great new capitals, some with mixed populations, all court-dominated – Alexandria, Antioch, Pella and later the slightly different Pergamon – which give its character to the culture of the new age.

157

II. The Mausoleum and its sculptors

As we noticed above (p. 147) the Hellenistic situation was in some degree anticipated when oriental monarchs employed Greek artists, as on the sarcophagi from Sidon and the Lycian tombs. In the architecture and sculpture of the Nereid Monument the style is pure Greek, but the building is set in an un-Greek manner on a tall podium, and some motives in the friezes (city-scenes, rows of offering-bearers) are also not Greek but eastern. The same character is found in a much grander as well as more famous, though less well-preserved structure, the Mausoleum of Halicarnassus in neighbouring Caria. Halicarnassus was a Greek city (Herodotus came from here) and the Carians had absorbed much Greek culture. Early in the fourth century Hecatomnus of Mylasa made himself ruler and was recognised as satrap of Caria by the Great King. He established a dynasty, and his children, perhaps in emulation of Pharaonic Egypt, practised brother-and-sister marriage to keep the blood pure, Mausolus taking Artemisia and Idrieus Ada. In 377 the first pair succeeded, and moved the capital to Halicarnassus. Mausolus laid out the city on a new plan, which probably had provision for his own temple-tomb, but our authorities say that it was only begun after his death in 353 by Artemisia. Two years later, when she died too, it was unfinished, but according to Pliny the Greek artists agreed to finish it 'for their own glory'. It became of vast renown, getting into most lists of the Seven Wonders of the World. The ruined building was systematically plundered by the Knights of St John when they built their castle of St Peter in 1402, and particularly in 1522 when they put the castle in repair again. A good deal was recovered in the nineteenth-century excavations, and some more in a recent re-excavation and from the walls of the castle, but it is a pitifully small proportion of the whole. However, from accounts in ancient writers, especially Vitruvius and Pliny (though these bristle with difficulties), taken with recent careful restudy both of the site and of the sculptural and architectural remains, it is possible to learn much about this strange and influential monument.

The building consisted in an Ionic colonnade almost certainly, as in a temple, surrounding a walled room, but of squarer proportions (11 × 9 columns; cf. above, p. 90). This stood on a tall podium and itself supported a stepped pyramid, crowned by a chariot. The architects, Vitruvius tells us, were Satyros (below, p. 162) and Pytheos, who is known from other works in Asia Minor. Pliny ascribes the chariot on top to Pythis, probably the same as Pytheos whose name gets variously spelt. They agree that the rest of the sculpture was the work of other famous Greek artists.

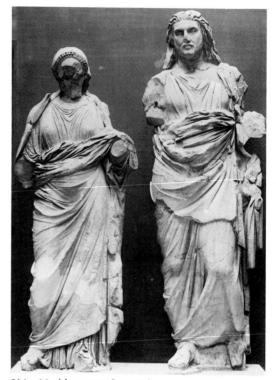

214 Marble statues from Halicarnassus. Mausoleum: ancestors of Mausolus ('Artemisia and Mausolus'). Third quarter of 4th century. Modern: part of male figure's hair; see fig. 250. H. 2·66 and 3·00 m.

Both name Skopas, Bryaxis and Leochares, who took, Pliny says, the east, north and west sides respectively. He gives the south to Timotheos; but Vitruvius, after the first three, names Praxiteles, adding 'some think also Timotheos'. Besides the chariot-team and a series of passant gardant lions facing in two directions, there are remains of three friezes (from one of them many relatively complete slabs); and very many fragments, as well as a few substantially preserved figures, of sculpture in the round on three scales: colossal, heroic and life-size. It is plain that these statues, not the friezes, were the principal, most significant, part of the decoration.[2] There were also figured ceiling-coffers.

The disposition of the sculpture in the round was for long a matter of guess-work; but recent study of the fragments, together with the architectural remains from old and new excavations, has produced a well supported and thoroughly convincing reconstruction.[3] According to this the podium receded from ground-level to the foot of the colonnade in three steps (which may account for an apparent implication in Pliny's wording that the podium too was in the form of a pyramid). The lowest step, not far above the ground, will have supported battle-scenes with life-size figures; the second, figures of heroic size standing quietly; the third, high up, colossal figures grouped in action; while at the top, between the columns, stood

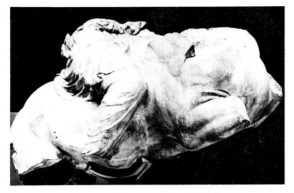

215 Fragmentary marble statue from Halicarnassus. Mausoleum: rider in Persian costume (probably from hunt). Third quarter of 4th century. H. 1·10 m.

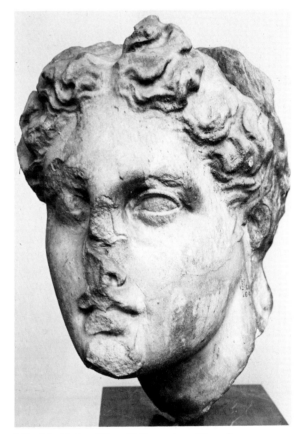

216 Marble head from Halicarnassus. Mausoleum: Apollo. Third quarter of 4th century. H. 0·40 m.

quiet colossal figures. The lions, of which we have many, since the Knights used them for decoration instead of burning them for lime, stood along a ledge above the cornice at the bottom of the pyramid, on each side in two rows meeting in the middle.[4] Of the friezes, one with a Centauromachy, on heavy slabs but of which very little exists, is convincingly assigned to the support of the chariot at the top of the pyramid;

the Amazonomachy, of which more survives than of any other part of the sculpture, to the top of the podium; and the third, which has racing chariots, to the top of the building within the colonnade, like the Parthenon frieze. An alternative position for this last might be round the interior of the burial chamber. Chariot-races are painted round the interior of two burial chambers, one of perhaps about this date in the royal cemetery at Vergina (Aigai, the ancient capital of Macedon),[5] the other an early Hellenistic tomb at Kazanlak in Bulgarian Thrace (below, p. 176).

Of the colossal statues one male and one female survive, apart from the loss of the woman's face, in reasonable condition: the so-called 'Mausolus' (a masterpiece) and 'Artemisia' (fig. 214). They have sometimes been assigned to the chariot; but though that, from the way it is constructed, was certainly not left empty, its occupants or occupant (Mausolus driven by Nike? Mausolus alone as Helios?) must have been on an even larger scale.[6] The very large number of fragments now identified as being from figures on the same scale as these two makes it virtually sure that they are not in fact the ruling pair but members of a long series of ancestors (real or claimed) standing between the columns. They were found to the north, the side Pliny ascribes to Bryaxis; but questions of style and possible authorship are discussed below.[7]

The colossal action-figures, restored as occupying the upper ledge, come from at least one hunting-scene and one of sacrifice; and find-spots put a hunt on the short west side, a sacrifice on the long north. It would be possible to distribute the fragments among two representations of each subject (this is more compelling for the hunt than for the other), and it may be that the groups on east and south were of the same kind (but see below, p. 163). The finest fragment is the torso of an oriental rider from a hunt (fig. 215). There is also a seated figure (headless) which is tentatively identified as Mausolus receiving sacrifice.[8] A splendid Apolline head (fig. 216), on a scale between the colossal and the heroic figures, is probably from a god among the mortals of one of the smaller sets.[9] There are fine fragments from those series too, but mostly in a terribly ruined state.[10]

The 'Mausolus' (fig. 214) is an outstanding work. Of the splendid head (fig. 250) there will be more to say in the next chapter, when we consider the development of portraiture. Here we may notice how the rough mane leads down to drapery bunched and wrinkled with a new naturalism, but its form and line cunningly balanced against the clearly felt mass of the body underneath. The sculptor must have been in the forefront of his time, and much in his work looks forward to Hellenistic developments; but there are no proper grounds for suggesting, as has been done, that

this figure (and the Artemisia because of her hairstyle) were added to the monument in the second century. Historical circumstances make this grossly improbable; the second-century parallels are not close; and both statues (especially the more conventional 'Artemisia' but she takes the 'Mausolus' with her) are indissolubly linked to a number of works firmly placed in the fourth. One is a colossal Themis, of poor quality, dedicated at Rhamnus and dated to the end of the century by letter-forms. Several other types, known in Roman copies, are so like the 'Artemisia' that they must go back to works of the same school if not the same hand. One stands with arms raised, praying; and this is repeated on a humble little relief, dedicated at Tegea, in which style and letter-forms are again of the fourth century. It shows the Carian Zeus (a bearded god endowed like the Artemis of Ephesus with many breasts), flanked by the praying woman, named Ada, and a man with one arm raised in prayer, named Idrieus: Mausolus's and Artemisia's espoused brother and sister, who succeeded to the satrapy.[11] The downdating of the figures from the Mausoleum is an example of the rigid application of a mechanical concept of the development of Greek art, which led another scholar to postulate that the sculptors did not, as Pliny says, finish the work after Artemisia's death, but were recalled nearly twenty years later by Alexander.[12] Certainly the surviving fragments show great differences of style. A bearded head of heroic size[13] is purely classical, quite without the expressiveness of the Apollo (fig. 216), the baroque drama of the rider (fig. 215) or the realism of 'Mausolus' (figs. 214, 250). A number of artists were certainly at work, and there is no reason to tie the differences to chronology. To allot the sculptures to names seems to me virtually impossible; but before we consider this problem, with reference also to the friezes in which (though they are surely executed by assistants) different basic principles of composition are discernible, we may look at what else can be associated with artists named as working on the Mausoleum.

Praxiteles (named by Vitruvius, not by Pliny) and Timotheos (named by Pliny, doubted by Vitruvius) have already been considered (above, pp. 138ff. and 143ff.; see also below, p. 163). Bryaxis signed a marble base for a bronze tripod in Athens, on which are three reliefs each showing a horseman riding to a tripod. They are small and slight, no doubt studio work, and afford little basis for an assessment of style. Pliny mentions him both for bronze and marble works, and a late writer says that the cult-statue of Sarapis, brought to Alexandria from Sinope by Ptolemy I probably early in the third century was a work of Bryaxis 'not the Athenian but another craftsman of the same name'. The implication seems to be that the Athenian was the

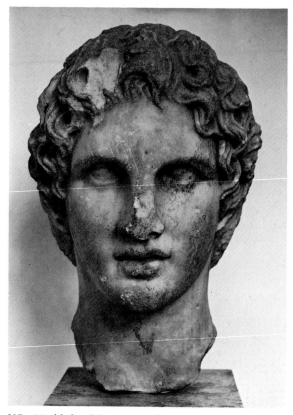

217 Marble head from Acropolis. Young Alexander. Third quarter of 4th century. H. 0·35 m.

famous one, but if there were really two, we cannot be sure which worked on the Mausoleum.[14]

Leochares of Athens is perhaps slightly less shadowy. Apart from his work on the Mausoleum Pliny mentions him only for his bronzes, but Pausanias tells us that he made six gold and ivory statues of Philip and his family in the Philippeion, a circular Ionic building with Corinthian interior, dedicated at Olympia in the mid thirties. In bronze he collaborated with Lysippos in a famous group at Delphi of Alexander and Krateros hunting the lion. His most celebrated work was a Ganymede carried off by the eagle. Several small marbles of this subject exist, ill-suited to the medium but which could reflect an interesting original in bronze; and an exquisite pair of late fourth-century gold ear-rings repeats a similar composition. It is likely that Leochares' composition is reflected, and the best marble has much in common with another Roman marble, famous since the fifteenth century, the Belvedere Apollo. Apart from details of likeness in the heads, both have a twist and an unsettled movement which look forward to the new age.

A different approach to the artist has been attempted. A good marble head of the boy Alexander (fig. 217) was found on the Acropolis, surely an original

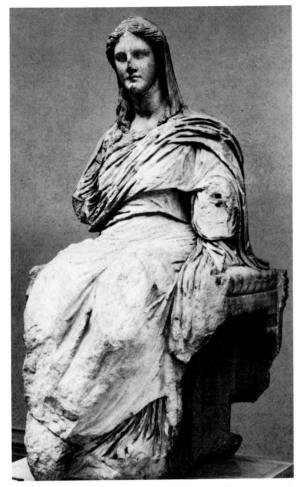

218 Marble statue from Knidos. Sanctuary of Demeter: cult-statue of the goddess. Second half of 4th century. H. 1·47 m.

(a copy also exists). It is plausibly suggested that the Athenian sculptor who made the chryselephantine statues of Philip and his family (including Alexander) at Olympia would naturally have been chosen when his countrymen wished to honour the prince on the Acropolis. Close similarities in the treatment of feature tie this head to that of a seated Demeter from Knidos (fig. 218), and they are ascribed, no doubt rightly, to the same hand. The goddess, as befits a cult-statue, sits quietly and is a creation in a very different mood from the Ganymede or the Apollo. The Alexander seems a little nearer them, especially to a subtler copy of the Apollo's head; and I do not think it is out of the question that the bronze originals of the Roman copies were by the same master as the Greek marbles. The Demeter's head is carved separately in a finer piece of marble, and the body may have been carried out by assistants. The bunched and crumpled drapery shows the same new spirit as that of the 'Mausolus', and this

figure too has been unnecessarily and improbably dated down to the second century.[15]

The most famous name among the Mausoleum sculptors is Skopas of Paros.[16] Apart from two unsure references in Pliny's section on bronze-workers he appears only as a sculptor in marble. Many works are recorded, including a naked Aphrodite thought by some to surpass the Cnidia (might we see her in fig. 193?). Pausanias says that he was architect of the temple of Athena Alea at Tegea in Arcadia, built to replace one burnt in 395/4, and that he carved statues of Asklepios and Hygieia beside the ancient image of Athena which had been saved from the fire. The temple, a big Doric building with an interesting interior of engaged Corinthian columns, had sculptural decoration, and Skopas must have provided designs for those. Battered fragments survive in a highly individual style. The little relief from Tegea with the Carian dynasts (above, p. 160) confirms that one sculptural team worked both there and at Halicarnassus. The Tegea temple may have been begun before the Mausoleum, but it has recently been suggested that work on the two projects may well have overlapped.

Metopes over the porches, gable-figures and akroteria were carved. Of the metopes very little survives, but the names of figures were carved beneath them on the architrave and one wonders if it may not have been common practice to paint them there. They concerned the Arcadian princess Auge, her son by Herakles, Telephos; and their descendants. Telephos, who became later king of Mysia in Asia Minor, figured also in the east gable, in fight with Achilles. The west showed the hunt of the Calydonian boar, prominent being the dying Ankaios, a Tegean hero traditionally killed by the quarry. It seems that neither here nor at Epidaurus (above, p. 144) was either gable dominated, in fifth-century tradition, by a deity. In its purely narrative character temple art is becoming more secular. Atalanta faced the boar, Pausanias says; and a rather summary torso, clad Amazon-fashion in a short chiton exposing the right breast and much of the right thigh, used to be identified as hers. A pair, however, has been recognised, and they were certainly akroteria. Four heads from the gables survive (fig. 219). They are rather square, with the basic classical structure of the straight forehead–nose line, but the surface broken up by pronounced modelling in lumps and hollows, a character noticeable also in fragments of nude male torsos. The eye-socket is very deep, the eye at the back large and upturned, lending a look of unrest, 'expressive' in a general sense which must have taken the colour of a particular emotion from the circumstances in which the figure was involved. This emotionalism, however generalised, is new in classical

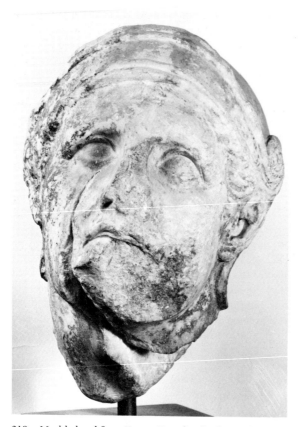

219 Marble head from Tegea. Temple of Athena Alea, east pediment: warrior from battle-scene. H. 0·30 m.

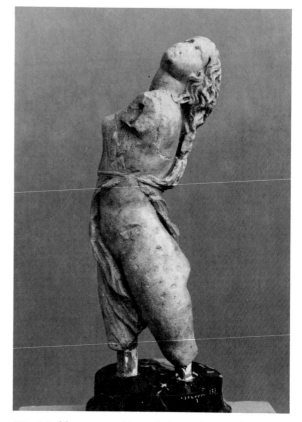

220 Marble statuette. Maenad. Copy of Imperial age, probably after marble statue by Skopas of mid 4th century. H. 0·45 m.

art, and when it appears elsewhere is perhaps due to Skopas's influence. Certainly it was found in much of his work. There was a frenzied maenad, of which we have what is surely a copy: a ruined statuette (fig. 220), but it has a tremendous emotional impact. The twist and movement align it with other works, such as the Apollo Belvedere, which show artists breaking with the formal structure of classical statues (more of this in the next section), but the feeling, and so far as one can tell in the worn condition the modelling of the face, bring it close to the Tegea heads. Of just the same kind is a Tritoness from Ostia, no doubt copied from a famous group of marine deities by the artist which was brought to Rome.

To return to the Mausoleum: it is among the free-standing statues and groups that one might hope to find the personal work of the artists, rather than in the relief-friezes; and the quality of much suggests that this is right; but any stylistic association with the names is desperately difficult. The 'Mausolus' and 'Artemisia' were found to the north, and an attempt has been made to relate them to Bryaxis through a type of Sarapis, known in Roman statuettes, in which the god stands with one arm raised like Idrieus in the

Tegea relief. Commoner, however, is a throned type, and this is more likely to echo the cult-statue. Moreover a base has been found at Delphi which bore bronze statues of Idrieus and Ada, and she was standing, it seems, much like the praying woman in the Roman copies. The base is signed by Satyros son of Isotimos of Paros. Vitruvius gives the name Satyros for one of the architects of the Mausoleum. The other, Pytheos, seems to have been responsible for the chariot at the top, and Satyros might well have provided sculpture too. Many sculptors may have been involved, and the idea of four, one taking each side, be a guide's story the acceptance of which led to the loss of some names – a process reflected in Vitruvius's hesitation over Timotheos and Pliny's omission of Praxiteles. The Apollo-head (fig. 216) is 'expressive' and no doubt shows the influence of Skopas, but the forms are not Scopasian. The very classical bearded head (above, p. 160) might possibly be thought Praxitelean, but the association is not compelling. Both were found to the north, like the 'Mausolus' and 'Artemisia'. It seems best to note differences but refrain from names.[17]

Before we look at the friezes there is one other group of statues we should consider. Pliny says of a marble group of the dying Niobids then in Rome that it was disputed between Skopas and Praxiteles. Copies in Rome and Florence, which almost certainly go back to this, include a colossal Niobe sheltering her youngest daughter in a composition strikingly like that of the earlier 'Timothean' Leda with the swan (fig. 201). Many-figured action groups in bronze begin in this period (the lion-hunt at Delphi, for instance, above, p. 160) and continue in the following centuries. Earlier 'groups', like the memorials to Marathon and Aeguspotami, were rather arrays of independent statues. Such action-groups in marble are much less commonly recorded. There is an obvious affinity between those on the Mausoleum and pedimental sculpture, and one would think that the original Niobids too were designed for some architectural setting. The association with Skopas, Praxiteles and Timotheos prompts the thought that it might even have been removed from the Mausoleum itself, perhaps from the south where there is not much evidence for a sacrifice. This is only a guess, however, and a wild one at that; and it is perhaps unlikely that if it had come from such a famous monument its pedigree would have been lost.[18]

The lovely head of a charioteer (fig. 221) from the chariot frieze of the Mausoleum has been associated with the Demeter and Alexander thought to be Leocharean.[19] There is real likeness, but the comparison of sculpture in the round to smaller work in relief is difficult, and I am less convinced by the same

association for certain slabs of the Amazon-frieze (1013–15). These were reported found where they had fallen from the east end, and have therefore been ascribed to Skopas; but it seems that they had in fact been re-used in a building, and we have in any case seen reasons for caution in accepting Pliny's sides and names. The almost naked Amazon on 1014 (fig. 222), a wonderful figure, does indeed powerfully recall Skopas's maenad; and combining this with the find-spot I used to believe that Skopas was the designer of these slabs; but I now see that it could rather be a case of his influence. The three slabs are certainly by one designer: many figures have an exceptionally strong lean, and much less play is made with flying cloaks

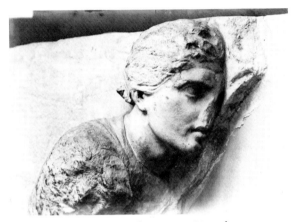

221 Marble relief from Halicarnassus. Mausoleum, chariot-frieze: head of charioteer. Third quarter of 4th century. H. of head *c*. 0·08 m.

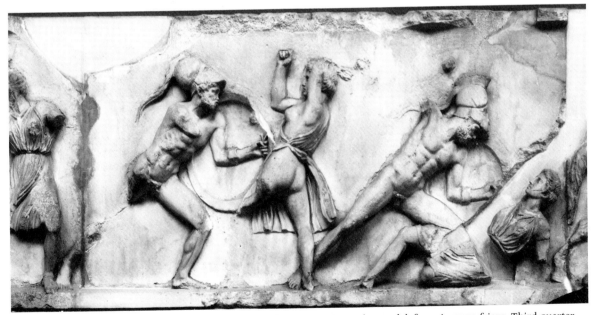

222 Marble relief from Halicarnassus. Mausoleum: slab from Amazon-frieze. Third quarter of 4th century. H. 0·89 m.

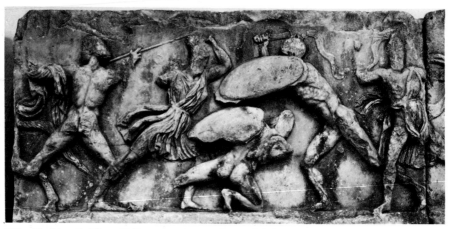

223 Marble relief from Halicarnassus. Mausoleum: slab from Amazon-frieze. Third quarter of 4th century. H. 0·89 m.

than on some slabs.[20] 1009 and 1022 have similarly leaning figures, making a pyramid where two attackers converge on a collapsing victim, but here the calligraphy of flying cloaks over the background is a marked feature of the design. Similarly composed but with very striking muscular figures, lean and long (the new proportions) are 1018 and 1020 (fig. 223). These are perhaps the finest of all; and the knobby anatomy taken with the fiery spirit make an ascription to Skopas as designer attractive.[21] A much more rectangular basis for the composition – figures leaning little from the vertical; a prone Amazon horizontal – is found on 1007 and 1008/1110: these two now shown to have formed originally one exceptionally long slab, with Herakles and probably Theseus, surely the centre of one side.[22]

These groupings seem to show four designers at work, and one may think of Skopas for the third and possibly Leochares for the first, but with great hesitation. Other slabs do not seem to fit easily into any of these: 1006, 1019, perhaps 1016 though that might go with 1013–15, with which it was found, if executed by a different hand. Others (1017, 1023–31) are too fragmentary for their compositions to be analysed. There are many smaller fragments, some of superb quality, in particular a dying Amazon where the carving of the naked body has an exceptional sensitivity.[23]

Skopas is also credited by Pliny with one of the carved column-drums in the temple of Artemis at Ephesus, burned down in 356 and built anew on the old scheme during the second half of the century. The best preserved and best known drum, with several figures including a woman (Persephone? Alcestis? Iphigeneia?) between Thanatos and Hermes, has been ascribed to him. The execution is summary, however, and the agreeable style eclectic. One figure is copied

from the Eirene of Kephisodotos (fig. 190) or a related work; and even the head of Thanatos, with its deep-set eyes and dreamy expression, can only be said to show Skopas's influence in a very generalised way. More interesting if not so pretty is a ruined corner of a square pier (fig. 224). On one face a man sits on a lion-skin over a rock, and seems to be pulled backwards by a woman on the other face.[24] This dissolving of the formal framework of relief is analogous to the approach to the third dimension we shall meet in the statues of Lysippos and his school, and looks on to Hellenistic developments.

III. Lysippos and his pupils

The clearest formulation of a change in the character of Greek sculpture accompanying the changing situation in the Greek world can be found in the work of Lysippos and his pupils. He was a Sicyonian who became court-sculptor to Philip and Alexander (on the connection between Sicyon and Macedon, see below, p. 176). He is said to have started as a bronze-smith and to have had no formal training in the statuary art; and though we have a marble base with reliefs which supported one of his statues and was presumably made in his workshop, there is no record of the master working in anything but bronze. Pliny gives as his *floruit* the hundred and thirteenth Olympiad (327–324). He is said to have begun making portraits of Alexander (born 356/5) when the prince was still a boy; and the base for an athlete-statue dedicated for a victory won in 372 is dated by its letter-forms to the mid century. Such statues were often set up well after the event, and that Lysippos made one for a victory of 408 is irrelevant to his dating. At the other end he is recorded as designer of an amphora for the export of wine from the new city of Cassandreia founded by

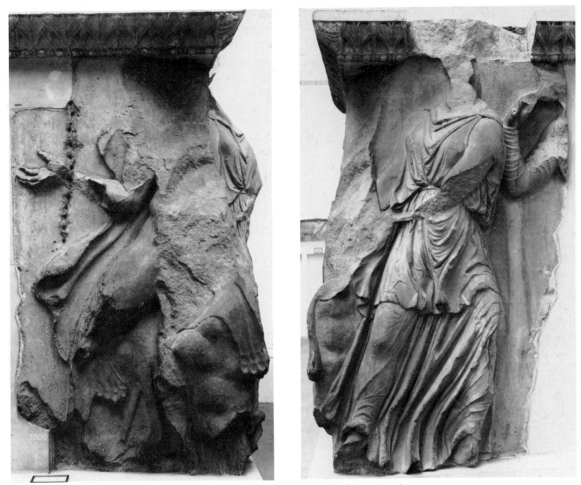

224 Marble relief from Ephesus. Temple of Artemis, pier:
Herakles (?) and woman. Second half of 4th century.
H. 1·85 m.

Cassander of Macedon in 316. A statement sometimes made that he was still active about 305 is based on a misinterpretation of the evidence, though he probably could have been. He is said to have lived long and to have made some fifteen hundred statues (post-humously reckoned from a piece of gold he put aside from each payment). Thirty or forty are mentioned, including deities, some on a larger scale than anything in earlier Greek sculpture; many figures of Herakles, standing or seated, one possibly a miniature (see below, p. 168); portraits, especially of Alexander and his court, which will be considered in the next chapter (below, p. 185); and athletic victor-statues.[25]

An athlete-statue, which may not have been of that kind but rather a private programme-piece like Polykleitos's Doryphoros, was in Rome under the early Empire and immensely admired: the *apo-xyomenos* (one scraping oil off himself). Lysippos is recorded as having been inspired to take up art by a remark of his fellow citizen the painter Eupompos

(below, p. 172), who, asked what master he followed, waved his hand at a crowd and declared that Nature herself was to be imitated, not a craftsman. Lysippos, however, is also reported as saying that Polykleitos's Doryphoros was his master. The context in which Cicero quotes this remark perhaps suggests that the sculptor meant that the Doryphoros taught him what *not* to do; but whether one takes it negatively or positively, it does look as though Lysippos saw himself as a new Polykleitos, setting the course of sculpture for his time. He codified the growing taste we have noticed for long-limbed, small-headed figures in a new canon of ideal proportions; and in other respects works which can be plausibly considered to reflect his bronzes show what seems a studied rejection of earlier ideals.

The Apoxyomenos has been recognised in a heroic-size marble of the subject (fig. 225; the right hand holding the die is modern). The identification is not documented and is sometimes questioned, but impor-

165

225 Marble statue. Athlete scraping off oil ('Apoxyomenos'). Copy of Imperial age after bronze by Lysippos of second half of 4th century. H. 2·05 m.

tant characteristics of the figure recur in other works which can be shown to be Lysippic, and I do not doubt that it is right. Another copy of the torso is looking-glass to this (cf. above, p. 111), and we cannot be sure which gives the original design.[26]

The athlete rests most heavily on one leg, but the other, not back and relaxed like the Doryphoros's (fig. 155), is out to the side and takes a noticeable part of the distributed weight. One arm, as in the earlier statue, is bent, the other straight; but the straight one is not hanging loose at the side but thrust out in front, as tensed as the other. The small, small-featured head is bent and turned much as the other's, but the effect above the differently animated body is not at all the

same. The Doryphoros shows a man walking, but the action is subdued to the stillness of the statue. The effect in the Apoxyomenos is of a momentary, caught movement. The statue is composed with as careful an art as the Doryphoros. The wide-set feet, for instance, not only help the effect of momentariness but serve to balance the action of the arms above – an aesthetic device; but the art is employed not to build an evidently harmonious statue but to suggest a directly observed moment.

Fifth-century statues are designed for one principal view from an area in front, to which other views are in some degree sacrificed. The twist on some fourth-century figures (the Apollo Belvedere; the maenad, fig. 220) seems to show some discontent with this principle; but Praxiteles, with his wide-fronted, leaning compositions even exaggerates it. The violent appropriation of the third dimension in the Apoxyomenos, one arm lifted forwards, the other brought across the body under it, is a radical departure, and leads on to a new idea: a statue designed to present an effective composition from many different angles. That development, strikingly exemplified in works of Lysippos's pupils, is not reached in the Apoxyomenos; but the way his limbs are brought forward and across the body is repeated in other works which must copy the master's.

The hand of the copyist lies heavy on the Apoxyomenos, but a charm which was evidently felt in Lysippos's bronzes come faintly through in some other marbles. One, a statuette, shows Eros bending his bow (fig. 226).[27] The momentary stance, the action with the arms forward and across the body, link this closely with the statue we have been considering; and Pausanias tells us that Lysippos made a bronze Eros for the god's sanctuary at Thespiai where there was already one in marble by Praxiteles. Praxiteles also made one for Parion, which is shown on coins of the city, and Erotes in Praxitelean poses are known in Roman marbles.[28] This is not the only case where we seem to see Lysippos deliberately contrasting his approach with that of the more traditional master; but here the manner in which Pausanias brackets the two statues might even suggest that the rivalry was something retailed in the guides' patter.

Then there is a young satyr in an animal-skin leaning on a trunk, like Praxiteles's (above, p. 139); but instead of the willowy curve he is almost upright, his loose leg crossed over the firm one, arms raised across the chest with a flute he bends his head to play; a work of considerable appeal. Pliny reports a satyr by Lysippos in Athens, where Pausanias saw Praxiteles's favourite piece.[29] Another fine figure known in several copies is a bearded satyr with the child Dionysos (fig. 227); and here we have the same

226 Marble statuette from Castello di Guido (near Rome). Eros stringing bow. Copy of Imperial age, probably after bronze by Lysippos of second half of 4th century. H. 0·60 m.

purposed-looking contrast with the Hermes of Olympia (fig. 191). This satyr too leans on a trunk, but again more stiffly; and the large child, instead of being held out to the side above the support, is dandled in both arms right in front of the chest. The satyr's slack leg is thrust forward, resting on the outside of the heel. There is no direct evidence connecting this statue with Lysippos, but the very distinctive posture of the legs is repeated in the many versions of a resting Herakles, the best known the huge and gross Farnese Hercules, found in the vast Baths raised in Rome by Caracalla more than half a millennium after Lysippos and no doubt specially made for its place there. Another copy has an inscription ascribing it to Lysippos. This has been thought a forgery, but apparently on no sufficient grounds, and the attribution is entirely plausible. The elderly hero leans heavily on his club, his over-developed muscles sagging round him: an interesting if charmless study of the athlete in decay.

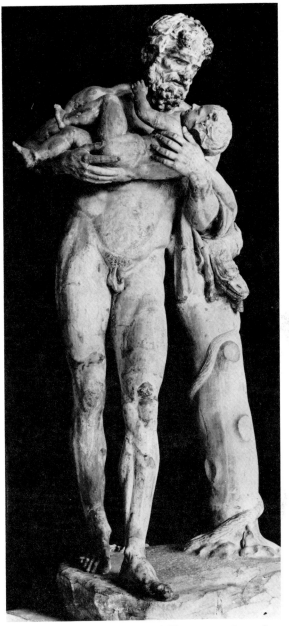

227 Marble group. Satyr with child Dionysus. Copy of Imperial age probably after bronze by Lysippos of second half of 4th century. H. 1·90 m; modern: satyr's arms and hands, child's legs.

Nothing here is brought in front of the body, but one arm rests behind the back in an observed gesture of tired age.[30]

Two famous figures of Herakles by Lysippos were seated. One, a colossus, was at Tarentum (where there was also a Zeus by the master, the largest Greek bronze until Lysippos's pupil Chares of Lindos surpassed it with the Colossus of Rhodes). The Herakles was resting, head on hand. It is reflected in statuettes. Other statuettes show him seated, one hand on his

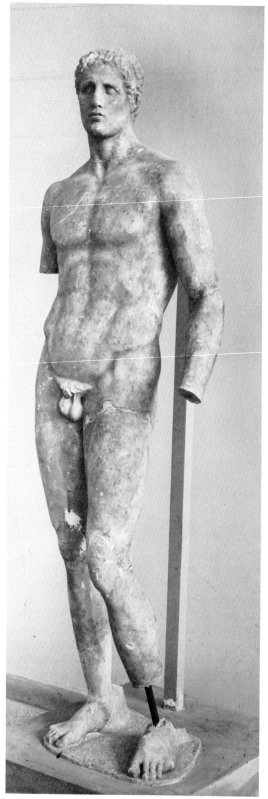

228 Marble statue from Delphi. Dedication of Daochos of Pharsalos: Agias. Third quarter of 4th century, possibly based on earlier bronze by Lysippos. H. 1·97 m.

club, the other holding out a cup. They correspond to descriptions of a statuette which belonged to a Roman collector under the early Empire and was said to have been made for Alexander and passed through the hands of Hannibal and Sulla. It had Lysippos's name on the base, and was called Herakles *epitrapezios*, which can mean 'on the table' or 'at table'. Discovery of fragments from a copy of this type on a colossal scale raise doubts whether Nonius Vindex's table-centre was really the original by Lysippos it was claimed to be.[31]

A more interesting problem is posed by another work, a fourth-century marble statue. In the thirties of the century a Thessalian dynast, Daochos II of Larisa, set up a row of statues at Delphi: Apollo, himself, his son, and six ancestors. The best preserved shows Agias (fig. 228) who had won athletic victories in the late fifth century. A verse on the base beneath this figure is repeated with slight variations on the base of a lost bronze statue of the same man at Larisa, signed by Lysippos. Is the Delphi marble a near-contemporary version of the Larisa bronze? Except for a certain restlessness it has none of the characteristics we have noted as specifically Lysippan; but it is a work of quality. His style cannot have been born fully fledged, and I can see this as a free marble replica of a work from his youth. If so, the bronze will have been made long before the marble, since by the thirties Lysippos's style must have been formed.[32] The Agias belongs to a class of fourth-century works which carry on a vaguely Polycleitan style. Another is an original bronze from a shipwreck off Antikythera.[33]

The only marble work certainly issuing from Lysippos's studio is a base at Olympia which carried his bronze statue of a wrestler Poulydamas and was adorned with now ruined reliefs.[34] A better preserved and much finer relief is on a fragment of a base from the Acropolis of Athens, with athletes scraping themselves (fig. 229), surely from Lysippos's school. If the Mantinea base (figs. 195–7) looks like a pattern-book of types produced in Praxiteles's workshop, this has rather the effect of a leaf of studies by an artist working on an *apoxyomenos*, or a *perixyomenos* (one scraping round himself), the name given to a statue by Lysippos's son and pupil Daippos. The difference in name between the father's and son's figures is perhaps significant, since a marked feature of statues by Lysippos's pupils is a liking for spiral compositions designed to produce effective views from many angles.[35]

A programme-piece of the new age seems to have been the Tyche of Antioch by Lysippos's pupil Eutychides of Sicyon. Alexander's general Seleucus had secured the eastern part of the empire – 'Syria', but it extended from Asia Minor originally to Bactria

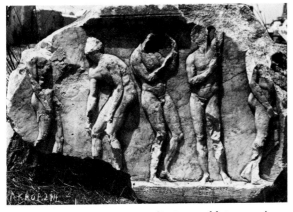

229 Marble relief from Acropolis. Base: athletes scraping themselves. Late 4th century. H. 0·48 m.

(Afghanistan). In 300 he founded a new capital on the Orontes, Antiocheia (Antioch) named after his son Antiochus whom around 293 he associated with himself in the rule. Pliny gives Eutychides a *floruit* in the hundred and twentieth Olympiad (295–292), and it may be that the dedication of the statue in the new city coincided with the elevation of the prince after whom it was called. Citizens of the old cities felt themselves under the protection of a deity, whose image they might approach at the end of a dark temple-room. It is in the new spirit to put a city under the protection of its own Tyche (Fortune, Luck), and to erect her statue in the open air; and this will have encouraged the growing aesthetic preoccupation with composing a statue to be looked at from many directions. The bronze, no doubt colossal, was beside the Orontes. The goddess sat on a rock, right knee crossed over left, leaning on her left hand, the right arm, shoulder lowered, laid across her lap, and looked slightly up and to her left. Missing from the bronze statuette (fig. 230) but present in other copies is the river-god, a young naked half-figure swimming out under her hanging right foot and looking up at an angle to her gaze. The informal pose is built into a marvellously complex spiral design, carried through in the pulling and pleating of the various stuffs in her clothes. With her turreted crown she became the model for a long line of similar personifications.[36] A very charming under life-size marble of a young girl (fig. 231) must be copied from a bronze, perhaps a tomb-statue, from the same circle if not by Eutychides himself, and gives us more of the quality.[37]

Another young girl, a larger marble found at Anzio (fig. 232), must again copy a bronze of the Lysippic school, possibly the *epithyusa* (female attendant at a sacrifice) of Phanis, another pupil. Whoever the artist he is less concerned than Eutychides with the formal all-round composition, carries on rather the naturalis-

230 Bronze statuette. Tyche (Fortune) of Antioch. Copy of Imperial age after colossal bronze by Eutychides of beginning of 3rd century. H. 0·20 m.

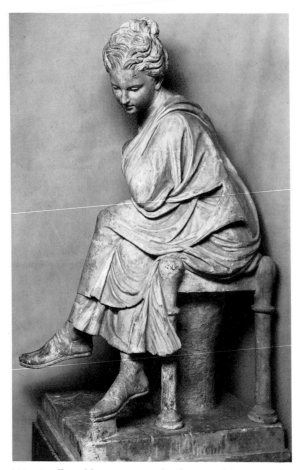

231 Small marble statue. Seated girl. Copy of the Imperial age after bronze of early 3rd century. H. 1·03 m.

232 Marble statue from Antium (Anzio). Young girl with tray. Probably copy of the Imperial age after bronze of early 3rd century. H. 1·70 m.

tic tendency of the master. This is a work of great freshness and has sometimes been thought a Greek original. It might possibly be a studio replica in marble of a bronze such as we know Phanis's work to have been.[38]

The complex patterns of naturalistic dress, a preoccupation of the time, is combined in some works with a much more traditional frontal stance. Examples are two types, extremely popular in copies and adaptations, especially as tomb-statues, perhaps originally a Demeter and Persephone but generally known today as the Matron and Maiden of Herculaneum, where examples of the types were first noticed. A fine copy of the Maiden comes from Delos (fig. 233), and a beautiful fragment of original bronze from the sea off Smyrna (fig. 234) is close in character to the Matron. The bronze, and the originals of the marbles in whatever material they were, must belong to the early Hellenistic age. They have affinities with the figures of the Mantinea base and the terracotta Tanagras (above, p. 142) and perhaps belong to the school of Praxiteles rather than that of Lysippos.[39]

One important set of marble reliefs belongs to this phase, those on the last of the royal sarcophagi from Sidon (above, p. 147), made almost certainly for Abdalonymos, who was installed or confirmed in the satrapy by Alexander, probably in 333, and seems to have outlived his patron. It is known as the Alexander

170

233 Marble statue from Delos. Girl (type of 'Herculaneum Maiden'). Copy of Imperial age after bronze (?) of late 4th or early 3rd century. H. 1·80 m.

234 Fragmentary bronze statue from sea off Smyrna. Veiled woman or goddess. Late 4th or early 3rd century. H. of fragment 0·81 m.

sarcophagus because it has two representations of the king, in battle (fig. 235) and at the hunt.[40] A battle and a hunting-scene occupy one long and one short side each. The relief is much more complex than that of the Mausoleum friezes. The massing of the figures in the compositions perhaps owes more to the tradition of

painting than that of sculpture, and the well-preserved colour shows such purely pictorial devices as highlights in the eyes. The pigments, which include two skin-colours, lighter for the Greeks, darker for the Persians, are delicate and do not mask the nature of the marble. The mixture of tradition and innovation is remarkable. Some Greeks, though not Alexander, are shown in heroic nudity, but the details of Persian costume are much more carefully observed than in earlier Greek art. Alexander, though the only identifiable, is certainly not the only individual portrait. There will be more to say of the battle-scene in connection with a related work, the Alexander mosaic (below, p. 180ff., fig. 247).

Reliefs of another kind should be mentioned here: those on a huge bronze krater (nearly three feet high) of consummate workmanship (fig. 236), which served as an ash-urn in a grave at Derveni in Macedonia, though an inscription identifies its owner as a man from Larisa in Thessaly.[41] The main frieze, about a foot

171

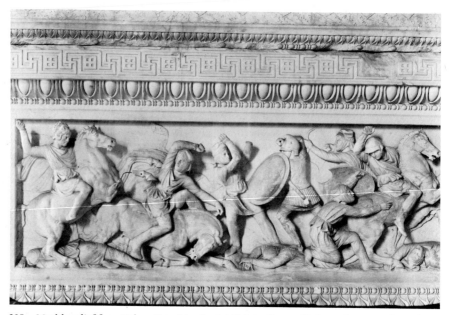

235 Marble relief from Sidon. Royal tomb, detail from front of 'Alexander sarcophagus':
Alexander in battle. Last quarter of 4th century. H. of figured frieze 0·69 m.

high, shows a wild Dionysiac revel. In the centre sits the naked young god with his leg flung across Ariadne's knee, around them maenads, one with a child, a satyr, and a bearded man whose peculiar character we cannot go into here. The context shows that it was buried before the end of the fourth century, and the work has been dated to the twenties, could perhaps even be earlier. Several of the figures have close affinities in various works, some of Roman date, some of about 400. It is possible that these and other repetitions of Dionysiac motives reflect elements in a series of paintings recorded by Pausanias in the temple of Dionysus in Athens.

The quality of the work on the bronze vessel is throughout superb, but the heaping on of elaborate detail is overwhelming. The statuettes on the shoulder, quiet against the abandon of the relief-scene, are in themselves of great beauty, but the whole effect perhaps founders under them. A satyr and a maenad on the back, Ariadne on the front, are asleep, Dionysus seemingly just waking. They look forward to the sleepers of later Hellenistic statuary (below, pp. 194f., 203, figs. 275, 286–7). Small-scale works often anticipate experiments only made later in monumental art.

IV. The School of Sicyon; Apelles and other painters; vase-painting and mosaic

Local schools of painting, as of sculpture, in Greece are not easy to make out now and perhaps were never so clear-cut as, for instance, the local Italian schools of the Renaissance. Pliny, in his note on Eupompos (above,

p. 165), says that before his time two schools were distinguished: Helladic (of the mainland) and Ionian (of East Greece), but that after him Helladic was divided into Attic and Sicyonian. Athens always drew so much talent to herself that an Attic school does not show as a very distinct entity, but Sicyonian seems a preciser concept. Pliny calls Eupompos a contemporary of Zeuxis and Parrhasios; a younger contemporary, perhaps, but we know little about him, more of his pupil Pamphilos who headed the school after him. Pamphilos was not a native Sicyonian but came from Amphipolis in Macedonia, a Greek (originally Athenian) foundation, annexed by Philip in 358. He was a mathematician and geometer, and thought that art could not be perfected without these skills. Pliny says that he made panel-painting a regular part of a liberal education in Sicyon, and that the practice spread to the rest of Greece; and it is interesting to find Aristotle defining the elements of education as letters, gymnastic and music and adding 'and some say also drawing'. Among Pamphilos's pupils (who had to pay a very high fee) were two Sicyonians, Melanthios and Pausias, and the most famous of all Greek painters, Apelles, who came from east of the Aegean and was to become court-painter to Alexander.[42]

Pliny says further that Pamphilos practised 'encaustic' and taught it to Pausias. This, literally 'burning in', was a technique of painting certainly known earlier but becoming the most esteemed among painters of this time. Pliny says that Nikias (above, p. 152) used it, and once signed with a word meaning 'burnt

236 Masked volute-krater from Derveni, Macedonia. Bronze: Dionysus and Ariadne with their rout; on shoulder, Dionysus and sleeping Ariadne; (other side, satyr and maenad, both asleep). Second half of 4th century. H. to top of handles 0·90 m.

in' instead of the usual *'egrapsen'*, drew or painted. It is regularly distinguished from 'the brush'; and it seems that coloured waxes were applied with a kind of palette-knife and fixed by heating with a metal rod. It may have been used originally for securing the colour on marbles meant to stand out of doors. Nikias is

recorded as painting a marble tombstone as well as colouring Praxiteles's statues, and the word occurs in the Epidaurus inscription for the painting of a gutter to the design of Hektoridas (above, p. 144). The only picture we have of the process shows a marble statue being painted (fig. 237). On this South Italian vase of

173

237 Column-krater. South Italian red-figure: man painting statue in encaustic; (other side, deities). Early 4th century. H. 0·51 m.

238 Masked volute-krater. South Italian (Apulian) Gnathia: on neck, girl's head among florals; body, red-figure, offerings at heroon and stele. Second half of 4th century. H. of part shown *c.* 0·42 m.

the early fourth century the artist is at work on a marble Herakles while the rods heat in a brazier tended by a slave. By a nice touch the hero himself looks on, as well as his father Zeus and Nike. The technique was considered a slow one, but Pausias developed some speed in it.[43]

Pliny speaks of a big picture by Pausias, then in Rome, of a sacrifice, as the beginning of a new kind of painting, much imitated but never equalled; and cites in particular a black ox seen in foreshortening which yet gave a full sense of its size and solidity. One thinks of the foreshortened horses in a great work to be discussed shortly, the Alexander mosaic (fig. 247), but the passage is obscure.[44] Other recorded aspects of Pausias's work can be more surely related to things we actually have. Pausanias describes a picture of Methe (Drunkenness), in the Tholos at Epidaurus, drinking from a glass bowl through which her face could be seen: the first allusion to clear glass and its representation. Such vessels are a favourite motive in the still-life decorations of Roman houses (fig. 296). Those derive from Hellenistic work, and it is doubtful if still-life as a genre of its own existed already in the fourth century, but another side too of Pausias's work looked forward to it: his flower-painting. Pliny tells of his love for the flower-girl Glykera, 'inventor of garlands', and how they rivalled with one another, she with the real thing, he in paint, in the ingenious variety of their woven flowers; and he mentions a very famous picture by him of a garland-weaver at work, supposed to be Glykera.[45]

A quite new and very distinctive system of floral decoration becomes popular in the middle and later fourth century, in many contexts but especially, in identical form, in two distinct areas and media: vase-painting in South Italy (fig. 238); and mosaic floors in Greece and particularly Macedonia (fig. 239). The vases sometimes show, as here (on a masked volute-krater, like the great bronze from Derveni, fig. 236), the flowers surrounding a girl's head rising from a calyx, and this too is precisely repeated on one floor, in Dürres (Dyrrhacchium, Epidamnos) in Albanian Epirus. Perhaps a design like this gave rise to the story of Glykera. With or without the head, constant features of the style are the uniting in what seems a single growth, of many different kinds of flower; and the vivid three-dimensionality effected by the spiralling of the corkscrew tendrils. I cannot doubt that this style reflect Pausias's.[46]

The scrolls on the vases are in the Gnathia technique (above, p. 150). The floors are laid in natural pebbles of a few colours. Flooring of natural pebbles laid in plaster is an old and widespread technique, but arrangement in careful designs, known in Phrygian Gordion from the eighth century, only begins in Greece late in the fifth. Examples with animals have been found at Corinth and at Motya in west Sicily in contexts datable to the end of the century. The biggest series we have are from Olynthus and Pella. Olynthus became capital of a Chalcidian League in 432/1, and the mosaics there, which range from simple patterns to mythological compositions, belong to the extension of

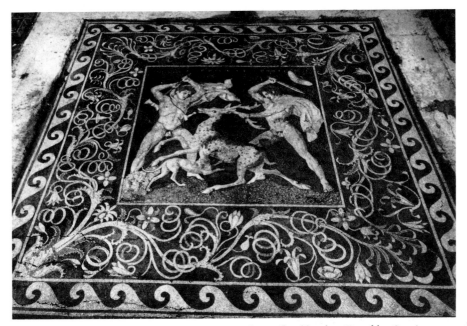

239 Mosaic floor from Pella. Pebble-mosaic: stag-hunt; floral border. Signed by Gnosis. Late 4th or possibly early 3rd century. H. of figured panel 3·10 m.

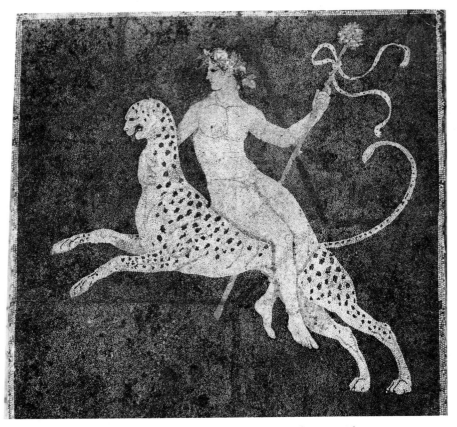

240 Mosaic floor from Pella. Pebble-mosaic: Dionysus on panther. Late 4th century. H. 2·65 m.

175

the city which took place between that date and its destruction in 348. The League had close relations (of varying character) with its large neighbour, the kingdom of Macedon. Between 413 and 399 Archelaos moved his capital from Aigai to Pella and built the palace there which he had Zeuxis decorate. The magnificent mosaics we have from Pella are in great houses of a century later; but it seems possible that the fashion for figured mosaic floors was initiated in Archelaos's palace and spread from there to Olynthus and the rest of Greece.[47]

The Olynthus mosaics are laid in pebbles of very roughly regular size, rather loosely spaced in the plaster, the design in whitish stones standing out against a darker ground, bluish grey to black or reddish brown, with an effect like red-figure vase-painting which was probably an influence. This light-on-dark effect remains the rule, though it is occasionally reversed, but in technique the Pella floors have become incomparably more sophisticated. The stones are carefully graded, smaller ones being used for details, and very closely set so that no plaster is visible; there is a subtle range of colour; and some forms are contoured with strips of lead, making an effect like that of relief-contour in red-figure (above, p. 61). The simplest and most beautiful shows Dionysus on a panther (fig. 240), but a more pictorial example like the stag-hunt (fig. 239), with its over life-size figures, strongly modelled and set on receding ground within the enchanting Pausian border, is a very remarkable achievement. Examples from other parts of Greece lie between those from Olynthus and those from Pella in character and probably in date. It is noteworthy that, though Sicyon has not been systematically excavated, chance finds have revealed an unusual number of such floors or fragments of floors there. The latest and best have complex and attractive Pausian designs over the whole rectangle, and are closely paralleled in a larger and even finer example from a palace of the late fourth or early third century at Vergina in Macedonia, now securely identified as the ancient capital Aigai.[48]

Pliny makes the further statement about Pausias that he was the first to paint coffered ceilings and vaults. Painted ceiling-coffers are in fact attested earlier, but the vault is a rarity in Greek architecture. Macedonian tombs are often barrel-vaulted, from the fourth century; and one of probably third-century date is painted with florals of Pausian derivation. A provincial tomb of the late fourth or early third at Kazanlak in Bulgarian Thrace has a small cupola painted with figure-scenes; and a larger circular building at Pella with a mosaic floor, as well as a circular room in the palace at Aigai nearly forty feet across, were very possibly domed and painted. There

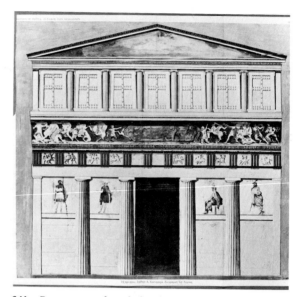

241 Reconstructed tomb-façade. Lefkadia (Leucadia), Macedonia. Moulded and painted plaster on limestone. Late 4th or early 3rd century. H. *c.* 8·20 m.

is a demonstrably close relation between Macedonian tomb and palace architecture (see below), and it is likely that Pausias's painted vaults were in a palace at Sicyon. The city in his time was ruled by a tyrant Aristratos, an admirer and ally of Philip and Alexander; and the cultural association between Sicyon and Macedon (Pamphilos came from Amphipolis; his pupil Apelles became Alexander's court-painter, as Lysippos had become Philip's and remained Alexander's sculptor) was doubtless linked to the political one.[49]

A Macedonian tomb at Lefkadia near Naoussa, also dating from the decades around 300, has a façade (fig. 241) which closely resembles that facing the court in the palace at Vergina (Aigai). There too the lower order was Doric, the smaller one for the upper storey Ionic, in just the same proportions; only the long, continuous frontage on the court has no pediment (suitable to the centralised tomb-façade), nor is there a continuous frieze intercalated between the orders. The tomb-front is finished in plaster over limestone. The continuous frieze is modelled in plaster, lightly coloured against a blue ground, and the gable decoration, now lost, was the same. The rest of the decoration is in paint only. There are appropriate patterns on the mouldings, including a Pausian scroll on the Doric cornice. Between the blue triglyphs the metopes (with Greek against Centaur, very much as on the Parthenon) are in monochrome: *trompe-l'oeil* imitations of marble sculpture, *uncoloured* marble sculpture which is interesting.[50] The Doric order at Vergina is an open colonnade, the palace-rooms

242 Detail of painting from fig. 241: Rhadamanthys. H. of part shown *c.* 0·42 m.

opening off it behind. On the tomb-front the columns are engaged in a wall, on which are figure-paintings such as may have adorned the interior of major rooms in the palace. The dead man in armour, is led by Hermes to the dark door of the tomb, beyond which sit two of the Judges of the Dead, their names beside them: Aiakos seated, and Rhadamanthys (fig. 242) leaning on his staff. He is defaced by a rift, but the surface is well preserved and shows the wonderfully strong and sensitive stippled modelling; this is painting as we understand it.[51] A newly found picture in a tomb-chamber perhaps a little earlier than this in the royal cemetery at Vergina has a fine composition of Hades carrying off Persephone, where the drawing is similar but freer, more impressionistic.[52]

Rhadamanthys at Lefkadia very closely resembles an old man in a painting cut from the wall of a late Republican house at Boscoreale near Pompeii (fig. 243); and the figure on the same wall, just beyond the unfinished column (part of the painted framework of the room's decoration) has a Macedonian shield and royal Macedonian head-dress. There can be no doubt that these figures are faithful (though coarsened) copies from early Hellenistic wall-paintings, probably

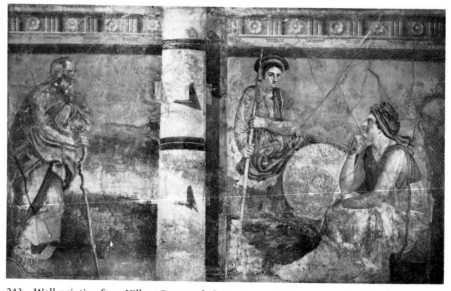

243 Wall-painting from Villa at Boscoreale (near Pompeii). Uncertain subject from Macedonian history. Mid 1st century, copied from paintings of early 3rd. H. 2·37 m.

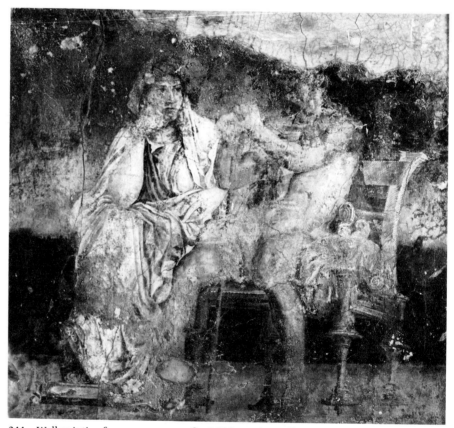

244 Wall-painting from same room as fig. 243 (opposite wall). Royal couple. Mid 1st century, copied from painting of early 3rd. H. 1·76 m.

in a Macedonian palace. There is no agreement on the subject. The old man is generally thought a philosopher, but many names are canvassed. I have no doubt (but others have) that the figure with shield and spear is a personification of Macedonia and her companion another such (Persia perhaps, or Asia). The tremendous couple from the wall opposite must be a Macedonian king and queen (fig. 244). The stillness and power of these figures recalls the description of those in Polygnotos's Underworld, and the same tradition is surely at work; but they are rendered with full control of all the hard-won technical achievements of the intervening generations. If they look back to Polygnotos and Olympia they also look forward to Piero della Francesca and Michelangelo.[53]

We noticed that much Greek painting on walls was probably executed on panelling rather than plaster, and there is evidence for this as late as the third century in a stoa at Delphi.[54] Macedonian tomb-paintings and Roman wall-paintings are on plaster, and this may well have been true also of the paintings in palaces; for vaults and cupolas at least it is likely.

The acknowledged king of Greek painters was Apelles.[55] He came from Kos or Kolophon, settled in Ephesus where he was taught by one Ephoros, went to sit at the feet of Pamphilos in Sicyon, and became court-painter to Alexander. In one portrait he showed the monarch with a thunderbolt, and bolt and hand seemed to start from the picture. This recalls what Pliny says about Pausias's ox, and shows that he learned the tricks of the trade in Sicyon. He was also interested in technique, inventing a black from burnt ivory and a glaze meant both to soften the tints and protect the painting; but what he himself claimed, and was agreed, to excel in was *charis* – grace, charm. We know the names of some thirty of his pictures and have descriptions of several, notably the Calumny so often recreated in the Renaissance. We have seen that there is now some solid evidence for the character of Greek painting in this its *grand siècle* (from Philip to the Successors of Alexander, Quintilian says),[56] but the personal style of Apelles is quite lost to us. A Hellenistic sculptural type shows Aphrodite crouching, her upper body turned at right angles to her legs, hands raised to either side of her head, wringing out her hair. The composition is strikingly two-dimensional and the junction of the two halves of the body awkwardly managed. The posture might well

245 Calyx-krater from Al Mina, Syria. Attic red-figure: detail, bound Marsyas (from picture of his punishment). Mid 4th century. H. of figure *c.* 0·12 m.

179

have been suggested by a painting, and Apelles's risen Aphrodite was squeezing the water from her locks; but if these trivial figures give us her pose they give us little more.[57] One may like to imagine his War bound on a chariot in front of Alexander in terms of a splendid bound Marsyas awaiting punishment (fig. 245), on an Attic vase of Kerch style (above, p. 152), but that is earlier than Apelles's picture, and in linear red-figure.[58] One thinks too of Love bound on triumphant Chastity's car in Italian pictures from Petrarch.

We are no better off for his great rival and friend, Protogenes of Kaunos or Xanthos, settled in Rhodes.[59] Rhodes managed to hold her independence; and Protogenes seems to have set his face against the new courts and their art. It is perhaps worth remarking that, whereas in sculpture the 'classical moment' of Pheidias and Polykleitos coincides with the fullest development of the city-states (even though, by their mutual hostility they were already engineering their own destruction), the stage at which Greek painters became complete masters of their craft falls at the time of the collapse of the old order, denying this art a 'classical moment' in quite the same sense.

One of Protogenes's most famous pictures was of Ialysos, eponymous hero of one of the three ancient cities which in the late fifth century had joined together to form the polity of Rhodes. He was shown with a dog, and it would be nice to picture him in the guise of a young hunter on a bowl painted by a Greek in central Italy (fig. 246).[60] However, in this case too the vase is generally thought to be rather earlier than the picture can have been, though here the handling of the Gnathia technique is very much like that of major painting as we see it in the Macedonian tombs.

If the individual styles of the great names (and we have plenty more from this time) elude us, we have seen that in the tomb-paintings and the Boscoreale copies we can get some real sense of this climactic phase of Greek painting. There is one other visual record of a complex masterpiece: the Alexander mosaic (fig. 247).[61] Though pebble-mosaics probably continued long in production for humble work, the sophisticated use of the medium at Pella led in the third century to the development of the tessera-mosaic, in which the units are not natural pebbles but artificially shaped cubes of stone or glass (below, p. 207), allowing a far subtler and more pictorial treatment. (The sharp distinction between pebble and tessellated floors is a simplification but approximates to the truth.)[62] In most Hellenistic and early Roman floors the figured scene is a small, central emblema; here, unusually, the whole floor is covered with a large composition. It occupied a kind of verandah opening off the court of the House of the Faun at Pompeii. The house was built in the second century, and the mosaic probably laid at

246 Bowl. Italian Gnathia: young hunter. Work of Greek settled in Latium or Etruria. Second half of 4th century. D. of picture with border *c*. 0·12 m.

the same time. The dimensions, with the *trompe-l'oeil* frame, are nearly twenty by over ten feet, but the foot-wide strip of grey tesserae at the bottom is a space-filler added by the mosaicist, and it is possible that the white sky did not in the original extend so far above the nearly level line of spear-points and tree-trunk top: a very long, low composition. The original must have been a wall-painting in the tradition of the Marathon and Mantinea at Athens (above, pp. 106, 152), though perhaps in a palace rather than a stoa. The style has always seemed pure Greek, and that it is indeed a copy of a late fourth-century painting is now confirmed by the discovery of a picture very similar in character and proportion on the front of a royal tomb at Vergina. This, in bad condition, not easily legible in the original and not yet published, shows a hunt. The vigorous figures are grouped in a shallow stage-space like that of the battle, defined as there by bare trees. If the tomb is, as has been suggested, that of Philip II, it is dated to 336; it must at any rate be still fourth century.[63] The battle could have been painted any time after 333, when Alexander and Darius met at Issus, but the original of the picture may be some years later.

The mosaic is damaged, especially on the left, but enough of the principal figure there remains to preserve the main accent of the design. Alexander charges in from the left in a transverse movement parallel to the picture-plane. He spears a Persian noble who was trying to disengage himself from his mount, killed under him. Macedonians follow their king in the same movement, and the background is closed quite near by a bare tree. Other fleeing Persians crowd

247 Mosaic floor from Pompeii. House of Faun: Battle of Alexander and Darius ('Alexander mosaic'). 2nd century, copied from painting of late 4th or beginning of 3rd. H., with frame, 3·42 m.

beyond the stricken noble, but their grouping is more complex and the movement is developed across the right-hand part of the picture in quite a different way. Alexander's look, lifted from the stricken Persian, meets that of Darius, who dominates this half of the picture and whose confrontation with the Macedonian is the subject of the whole. Confrontation; but he is neither moving towards nor directly away from his foe. The organisation of this half of the picture, and so of the whole, is more complicated and subtler.

In the centre foreground a groom has brought up, too late, a horse to remount Alexander's victim. The beast is sharply foreshortened from the back, and the terrified heads of man and horse are framed in the huge circle of the car-wheel. The man looks towards Alexander, and above him the King's face almost repeats his position and look. Darius stands out, the highest figure in the picture, still the Great King in his upright tiara, turned towards us, hand stretched out in the direction of his enemy. The chariot is still virtually parallel to the picture-plane, but the charioteer leans forward over the sharply receding front of the car and whips the four-horse team round out of that line towards us. Above the team appear heads and arms of Persians, uncoordinated, under a faltering banner, and the whole movement is motivated by the spears

against the sky: a second squadron of Macedonian cavalry circling in from behind against the Persian flank. They are riding in from the left, their spears still on their shoulders. Only a few at the front are turning and bringing their weapons down for the charge; but the lean of the lances all one way behind King and charioteer produces pictorially the effect of the irresistible pressure which is forcing the chariot round. As it turns it crushes fallen men of its own side. One has snatched up a Greek shield for protection, and in its polished front we see, behind the highlighting, his desperate face reflected – a piece of virtuosity which sums up the representational skills gradually mastered over the last century and a half. The foreshortened horse, the turning black chariot-horses, suggest Pliny on Pausias's ox; and another new skill in which the artist takes manifest pleasure is that of cast shadows. Darius, high in the picture, facing towards us, the fallen man in back view at the bottom, recall the structure of the Pheidian Gigantomachies (above, p. 106, fig. 147), though used to a different purpose. The artist has created his complex composition out of a combination of that idea with the older one of a simple cross-movement. Colour is deliberately restricted.

The group of Alexander riding down the Persian and his fallen horse is paralleled with interesting

181

differences in the battle-scene of the Alexander sarcophagus (fig. 235). In both the Persian has one arm bent up over his head; but while in the relief he is unwounded and striking back, in the mosaic it is a gesture of agony. The use in two such similar groups of the same action with two quite different meanings suggests a common source; that is, that the sculptor was adapting his composition from the picture copied in the mosaic. In other respects there are interesting contrasts. There is no heroic nudity in the mosaic; and though Persian costume is well observed on the sarcophagus, the details of this and of the royal waggon in the mosaic are rendered with an accuracy and precision of quite a different order.

The battle represented is no doubt Issus, but we should probably not look for tactical correspondences. Euphranor's Mantinea seems to have shown a shameless adaptation of actual events to the glorification of Athens; and the artist here was surely chiefly concerned to illustrate the symbolic conflict of the two powers rather than details of an actual engagement. Pliny records a battle of Alexander and Darius painted by Philoxenos of Eretria for Cassander, who controlled Macedon from 319 to 297. His bitter hatred of Alexander makes the commission an odd one. Philoxenos is called a pupil of Nikomachos of Thebes, who was famous for the speed of his work; and Philoxenos himself is said to have invented several new short-hand formulae in painting. Whatever this precisely means it does not seem to fit well with the elaboration of this masterpiece, and I cannot feel the identification as certain as is sometimes held. A contemporary Battle of Issus by Helen daughter of Timon of Egypt is mentioned by a late writer. Support has been found for this attribution in the presence of a Nilotic mosaic on the threshold of the room with the battle; but Egyptian scenes are common in Roman decorative art, and this is hardly significant. A more famous pupil of Nikomachos, his son Aristides, is said to have painted the spirit and its perturbations, which suits the character of this work, and he is credited with 'a battle with Persians containing a hundred men', but that would be a gross exaggeration applied to our picture.[64] I do not think we can name the painter; but I do believe that the mosaic does give us a true notion of a great work from this high moment of Greek painting.

8

Hellenistic art

I. Portraiture: coins and sculpture

The Greek approach to portraiture had a built-in ambivalence. The passion for observation, for mastering the rendering of appearance, would naturally lead to its development, but this is countered by the dominant idea of realising an ideal form of humanity.[1] We saw that at the change from archaic to classical the first interest led Greek artists in the direction of naturalistic portraiture; possibly even to its realisation, but the status of the Ostia Themistocles (above, p. 109) remains doubtful. A few decades later the Pericles (above, p. 109) is unequivocally idealised. We are told of Demetrios of Alopeke (an Attic deme) who at the beginning of the fourth century made bronze portrait statues of an almost caricatured individuality. It is possible that a copy of his Lysimache (an aged priestess of Athena) is preserved in a marble head in which, below a very formal classical hair-style, the features of extreme old age are vividly rendered. This has been plausibly associated with a round-shouldered torso, classically draped; but, as with the Themistocles, this work is too isolated and odd to build on with any certainty.[2]

It is in this period, however, that we do find the first sure instances of personal likeness which lead on to the flowering of the art in the generation after Alexander. Even then, though, the pull of the other attitude can still be felt. All Greek portraits, until at the end of the Hellenistic age the influence of Roman ideas begins to tell, are of public figures, and all are endowed to a greater or less degree with a public character: the artist is at least as interested in *what* the sitter is as in who.

It is interesting that several of the early examples occur in a mixed Greek and oriental context; as though Greek artists felt freer to modify the ideal towards individual likeness when working for a foreigner. (The fact that Themistocles ended his days as satrap to the

248 Coin of Athens. Silver tetradrachm: head and owl of Athena. Mid 5th century. D. *c.* 0·02 m.

183

250 Head of marble statue from Halicarnassus.
Mausoleum: ancestor of Mausolus ('Mausolus'). Third
quarter of 4th century. H. of head *c.* 0·35 m. Cf. fig. 214.

249 Coins of Persian satrap Tissaphernes. Silver
tetradrachms: portrait-head and owl. Late 5th century.
D. *c.* 0·02 m.

Persian king might possibly have some bearing on the
evaluation of the Ostia head.) From early times Greek
coins often bear the head of a deity. Those of Athens
keep unchanged their archaic design: Athena's head
on the front; on the back her owl, with the three first
letters of her and her city's name (fig. 248). In 412/11
the satrap Tissaphernes, allied with the Spartans
against Athens, arranged to pay their troops in silver
coins on the Attic standard, the most generally
acceptable. A tetradrachm of Attic weight has on the

back the owl and three other Greek letters, the first of
the word *basileus* (king; fig. 249). On the front is the
head of a Persian, with individualised features, wear-
ing the subject's folded tiara, not the king's high one
(cf. fig. 247): the satrap Tissaphernes. The head in fig.
249 actually comes from a slightly later coin struck for
the same purpose, with a different reverse but the
same man's features. A little later still, after
Tissaphernes's fall from royal favour and death, his
successful rival Pharnabazos issued another such coin,
with not only *bas* on the reverse but on the obverse,
round the portrait-head, his own name in full, likewise
in Greek characters. These vivid likenesses of eastern
rulers are certainly the work of Greek artists.[3]

During the fourth century other satraps struck
Greek-style coins with their portraits by Greek die-
sinkers; and it is in this context precisely that our first
great Greek sculptural portrait appears, the 'Mausolus'
(fig. 250; cf. above, p. 159 with n. 6 and fig. 214). The
immediate impression the head makes is of a personal
likeness, but this is brilliantly imposed on a severely
classical structure: the T-shape produced by an almost
unmodulated forehead–nose line, with the consequent
unnaturally deep set of the eyes. It is instructive to
compare it with a roughly contemporary masterpiece,

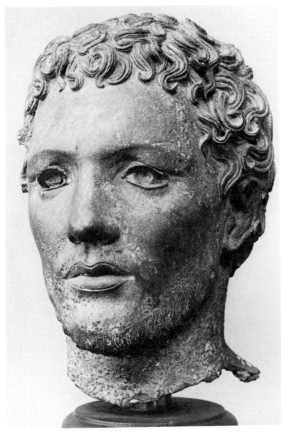

251 Head of bronze statue, from Cyrene. Berber(?). Second half of 4th century. H. 0·30 m.

a bronze head from Cyrene (fig. 251).[4] This, for its combination of strong and subtle modelling with exquisite finish, is perhaps the best Greek bronze that has come down to us. Pliny, in a corrupt passage, appears to say that Lysippos's brother Lysistratos introduced a practice of taking plaster moulds from living features and working on a wax cast from the mould.[5] If Greek sculptors ever really did that, they worked on the wax to great effect; but a face like that of the Cyrene bronze *is* basically different from that of the 'Mausolus'. The sculptor of the marble started from the classical ideal and modified it towards a likeness. The modeller of the bronze seems rather to create his work of art on the basis of observed natural forms. His work is no less nobly idealised than the other; the 'Mausolus' indeed makes perhaps the more personal impression of the two. Its artist was aiming at an effect of individuality, the creator of the Cyrene head perhaps rather at an effect of ethnic difference. It is often felt not to represent a Greek, and from something in the features as well as the find-spot a Berber is suggested. The likenesses and differences between these two works stress the complexity of the Greek approach to portraiture.

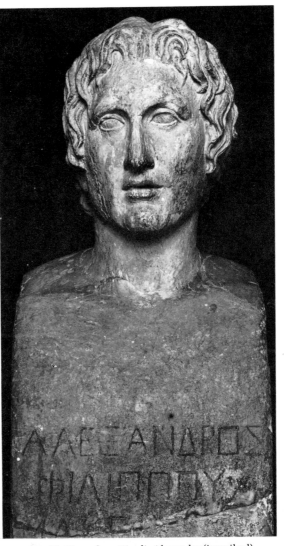

252 Marble Herm from Tivoli. Alexander (inscribed). Copy of Imperial age, probably after bronze by Lysippos of second half of 4th century. H. of head 0·25 m.

Alexander is said to have ordered that his portrait should be painted only by Apelles, cut on gems only by Pyrgoteles, and cast in bronze only by Lysippos;[6] but such a rule can only have prevailed for a short time. In marble we saw (fig. 217) a young head that can perhaps be associated with Leochares, and we know that he made a chryselephantine likeness of the prince which is perhaps copied in a class of Roman marbles.[7] A marble Herm (fig. 252) and a bronze statuette (fig. 253) are convincingly thought to copy Lysippos's most famous rendering of the king, Alexander with the lance.[8] His image is constantly recreated throughout the coming age (e.g. fig. 278), and we cannot go into this complex study here.[9] He did not put his own head on coins, but his Successors put it on theirs, and the splendid issue by Lysimachos of Thrace (fig. 254,

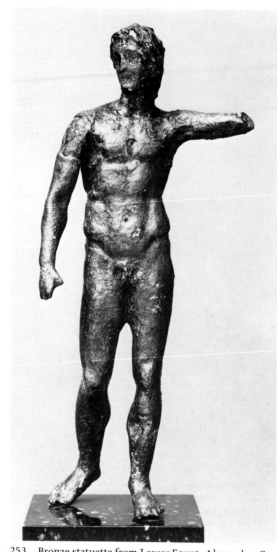

253 Bronze statuette from Lower Egypt. Alexander. Copy of Imperial age probably after same statue as last. H. 0·16 m.

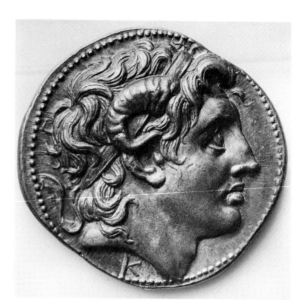

254 Coin of Lysimachos of Thrace (306–281). Silver tetradrachm: Alexander with horn of Ammon. D. *c.* 0·03 m.

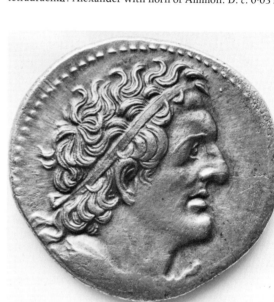

255 Coin of Ptolemy I of Egypt (305–283). Silver tetradrachm: king's portrait. D. *c.* 0·03 m.

showing Alexander with the ram's horn of Zeus Ammon whom he claimed as his father) is attractively conjectured to go back to Pyrgoteles.[10] Then, early in the third century, it becomes the custom for rulers to strike coins with their own portraits, the first, perhaps, Ptolemy of Egypt (fig. 255).[11] With these a more emphatic naturalism becomes fashionable, which reaches its acme in the late third- and early second-century coinages of some peripheral kingdoms which had broken away from Seleucid Syria: Pontus on the Black Sea, and Bactria in the far east (fig. 256). A marble head has been recognised from its likeness to coin-portraits as representing the founder of the Bactrian kingdom, a Macedonian adventurer named

Euthydemos (fig. 257).[12] This perhaps comes nearer than any other Greek work to the Roman ideal of warts-and-all realism. Another piece which has some of the starkness of late Republican Italian heads is a marble (fig. 258; both this and the last probably Roman copies from bronzes) representing Antiochos III of Syria (223–187), one of the great opponents of Roman expansion.[13] Two marble originals of approximately the same date as these, showing Ptolemy IV and his sister–wife Arsinoe III of Egypt, display rather the strength of the tradition exemplified earlier by the

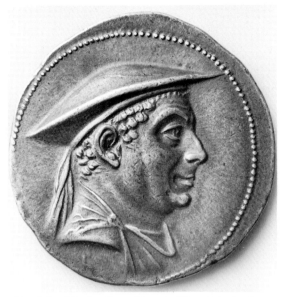

256 Coin of Antimachos of Bactria. Silver tetradrachm: king's portrait. First quarter of 2nd century. D. *c.* 0·03 m.

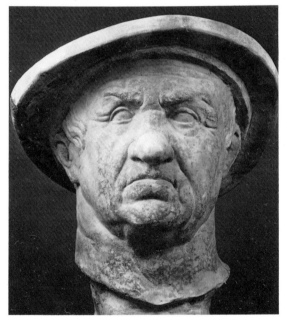

257 Marble head. Euthydemos of Bactria in wide-brimmed helmet. Copy of the Imperial age after bronze (?) statue of late 3rd century. H. 0·33 m; modern, front of brim.

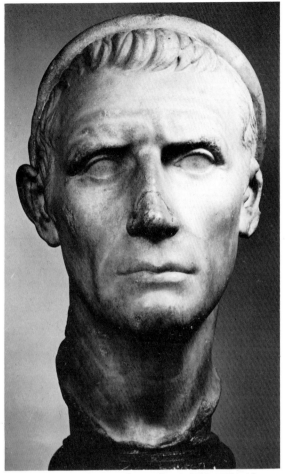

258 Marble head. Antiochos I of Syria (223–187) with royal diadem. Copy of the Imperial age after bronze (?) statue of sitter's time. H. 0·35 m; modern, part of nose.

'Mausolus': delicate characterisation imposed on a firmly classical structure (figs. 259, 260).[14]

Royal coins and royal courts certainly fostered the growth of naturalistic portraiture, but the usage soon spread, to Athens for instance. We saw an approach to portraiture in the still ideal features on some late tomb-reliefs (above, p. 137), and we have copies of other portraits of this time. Two types representing the fifth-century tragedian Sophocles are identified by inscriptions on copies. One (the Lateran type) almost certainly goes back to a bronze set up in the theatre in the thirties of the fourth century. The face has been reworked, but a cast taken before that happened shows that the classical features were always only faintly touched with individuality. The other (Farnese) type is slightly more expressive and probably later. It served as the basis for a Hellenistic recreation of which the head survives (fig. 261), a magnificent bronze perhaps of the second century. A marble statue which must be copied from a bronze very close indeed to the original of the Lateran Sophocles represents Aischines, the pro-Macedonian politician, Demosthenes's enemy, who left Athens in 330 and died in 314. Both figures are swathed tightly in the himation, like (though simpler) the Herculaneum matron and maiden (fig. 233). The face of the con-

259　Marble head. Ptolemy IV of Egypt (221–204). From contemporary statue. H. 0·35 m.

260　Marble head. Arsinoe III of Egypt (217–205), sister and wife of last. From contemporary statue. H. 0·28 m.

temporary Aischines, though still clearly classical, has more individuality than the long-dead Sophocles's.[15]

An interesting special case is that of Socrates, executed in 399. Much later in the century the Athenians raised a statue to him by Lysippos. The many Roman heads go back to two or three types, one (fig. 262, which comes from a seated figure) probably Lysippos's, the other later variants. None resembles the classical ideal, but they are scarcely individualised: they are versions of the old comic type of satyr or silenus. His friends and followers Plato and Xenophon both mention the master's likeness to this type, so it was chosen for his portrait (as no doubt it had been for the theatre-mask long before, when in his lifetime he was guyed on the stage by Aristophanes and others). A portrait of Plato was dedicated in the Academy by a Persian admirer and made by a statuary Silanion. A popular type in Roman marbles (fig. 263) is identified as the philosopher by inscriptions and the original was no doubt Silanion's. This again is known to be a seated type, which was to become usual for philosopher-portraits. Even if, as is likely, the Plato was made after his death in 347, it cannot have been long after (Pliny dates Silanion, with Lysippos, by

Alexander's reign) and his features must have been known; yet there is a clear deliberate approximation to the satyr-type adapted for the representation of the master whose persona Plato had assumed in his writings. This is important evidence for the approach of the Greeks to portraiture: the person's actual appearance does not seem to have been necessarily the prime consideration.[16]

Silanion also made athlete-statues in bronze, including a boxer Satyros at Olympia. A fine head found there has been claimed for this (fig. 264).[17] It belongs much more emphatically to the new age than the Plato, but an attribution of the two to the same master does not seem out of the question. The eye-sockets of this head are closed behind, the coloured filling having been inserted from the front. This rather unusual method is used also in a complete bronze of heroic size found in Rome and known as the Hellenistic Ruler (fig. 265), though the absence of a diadem (contrast fig. 258)

261 Bronze head from Asia Minor. From statue of
Sophocles. Probably 2nd century. H. 0·29 m.

262 Marble head. Socrates. Copy of the Imperial age
probably after bronze statue by Lysippos of second half of
4th century. H. of head and neck *c.* 0·36 m; modern, Herm-
bust.

suggests that at the time the sitter was not a reigning
monarch.[18] This powerful piece is an example of the
difficulty of dating. A real resemblance to coin-
portraits has led to identification with Demetrios I of
Syria, who reigned in the mid second century and was
before that a hostage in Rome. It has alternatively been
thought a portrait of a first-century Roman general
(Lucullus or Sulla) or a work of the early Hellenistic
age. The cunning spiral composition, giving many
well-composed views, together with a certain likeness
to Lysippos's weary Herakles, and the technical link
with the Olympia boxer, lead me to see it as a work of
the early third century, but there is no certainty.
Similar is the dispute over a beautiful head extremely
popular in copies, which has been called Menander
and Virgil as well as other names but the identification
as Menander is now decided by an inscription.[19]

 We are on sure ground with another popular type,
Epicurus, who established his school in Athens at the
end of the fourth century and died in 270. The best
copy of the head (fig. 266) is of superb quality. Here
powerful individuality is combined in a high degree
with an abstract idea: the Philosopher; and it is no less
instructive than in the case of Socrates and Plato to

compare with this the tame heads of his followers,
Metrodoros (fig. 267) and Hermarchos. Both faces
show a stronger resemblance than is at all likely to
have occurred in nature to the structure of their
master's.[20]

 While Epicurus was teaching at Athens, in 280/79,
the city temporarily got free of its Macedonian
masters, and bronze statues were set up to some of the
great resisters, amongst them Demosthenes, who had
died by his own hand forty years before after a failed
insurrection following Alexander's death.
Inscriptions identify Demosthenes in a widely copied
type, of which we have whole figures as well as heads
(figs. 268, 269). The foursquare pose, the simply
draped mantle of this great statue are surely a de-
liberate rejection of the new tendencies of Lysippic
and court sculpture. In the face the new realism is fully
accepted, but adapted to a special purpose. How far
Polyeuktos used records or traditions of the man's

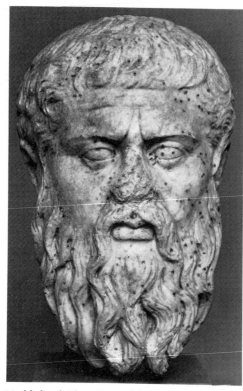

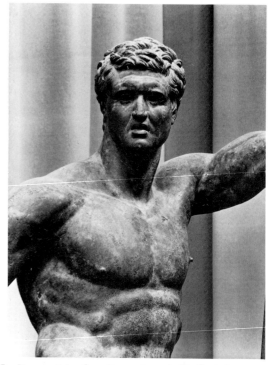

263 Marble head. Plato. Copy of the Imperial age probably after bronze statue by Silanion of second half of 4th century. H. 0·35 m.

265 Bronze statue from Rome. Portrait ('Hellenistic ruler'). Perhaps early 3rd century. H. of part shown *c.* 0·60 m.

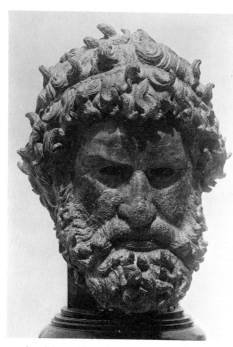

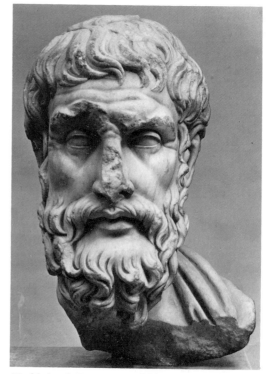

264 Bronze head from Olympia. From statue of victorious boxer, conceivably Satyros by Silanion. Late 4th century. H. 0·28 m.

266 Marble head. From statue of Epicurus. Copy of Imperial age probably after bronze statue of first half of 3rd century. H. 0·40 m.

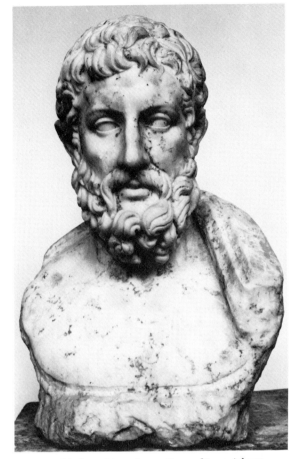

267 Marble bust. Metrodorus. Copy of Imperial age probably after bronze statue of first half of 3rd century. H. 0·59 m.

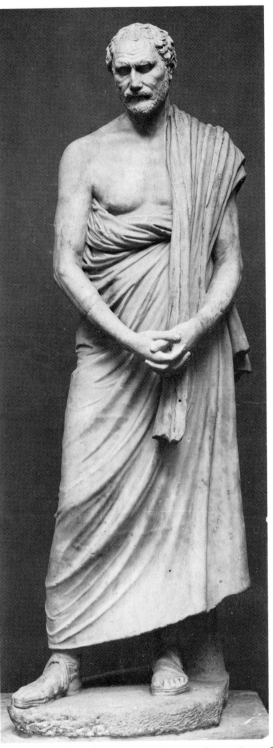

actual appearance we cannot know, but surely he was primarily concerned to create, in the face and the whole figure, a fitting image for the last great patriot and martyr to the city's freedom.[21]

We shall touch on portraiture again in our study of mid-Hellenistic 'Baroque' in the next section. We may close this one with a glance beyond that to a philosopher-portrait from the end of our period, that of Posidonius who in old age numbered among his pupils in Rhodes young men who were to be the last defenders of the Roman Republic, Brutus and Cicero. The moving head (fig. 270), with its rather linear treatment which looks forward to Augustan classicism, has something in common with such pre-Baroque work as the Demosthenes, and helps to explain the difficulties of dating.[22]

II. Sculpture in Pergamon and 'Hellenistic Baroque'

In the confusion of concurrent styles and uncertain

268 Marble statue from Campania. Demosthenes. Copy of Imperial age after bronze by Polyeuktos set up in 280/79. H. 2·02 m; modern, the hands, restored after a pair in the Vatican.

191

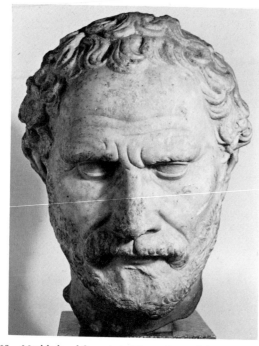

269 Marble head from Asia Minor. Copy of the Imperial age after same original as last. H. 0·30 m.

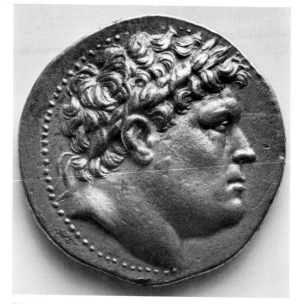

271 Coin of Attalos I of Pergamon (241–197). Silver tetradrachm: head of Philetairos. D. *c.* 0·03 m.

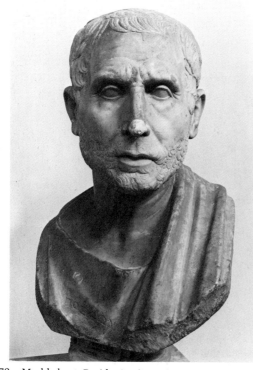

270 Marble bust. Posidonius (inscribed). Copy of the Imperial age after bronze (?) statue of early 1st century. H. 0·44 m.

dates some help is given by sculptures produced in or for Pergamon in connection with events of the half century or so around 200. This impregnable citadel in north-west Asia Minor was used by Lysimachos of Thrace for his treasury. The officer in charge, Philetairos, by treacherous and dexterous manoeuvring among the warring Successors of Alexander succeeded in making himself ruler, under Antiochus of Syria, of a virtually independent Pergamon. His formidable head (fig. 271) appears on the coins of his followers,[23] first Eumenes his nephew who succeeded in 263. By this time, though there was a constantly shifting pattern of alliances and wars, gains and losses of territory, the three big dynasties of the Hellenistic world had become established on a relatively stable basis: Ptolemies in Egypt, Seleucids in Syria, Antigonids in Macedonia. Following in his uncle's footsteps, Eumenes transferred his allegiance to the Ptolemies and with their help defeated Antiochus and enlarged the territory of his own state. His nephew Attalos succeeded in 241, and it is under him that Pergamon becomes important.

In 279 a body of Gauls from central Europe (like those who a century before had invaded Italy, burned Rome and permanently settled the Po valley as Cisalpine Gaul) descended into Greece, defeating and killing the reigning monarch of Macedon and penetrating as far as Delphi. There they were repulsed by a miraculous snow-storm and through human resistance, mainly organised by the Aetolian League. They moved on into Asia Minor, where they settled Galatia and exacted tribute from Antiochus and the Greek

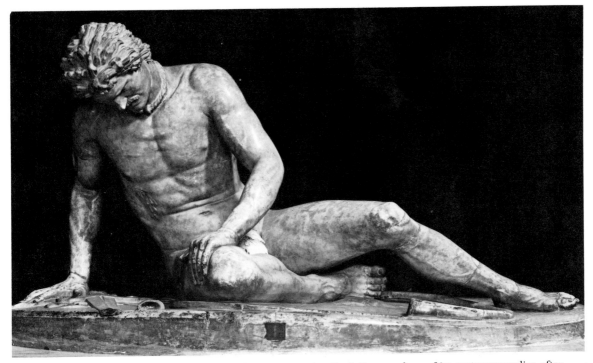

272 Marble statue from Rome. Dying Gaul. Copy, perhaps of 1st century or earlier, after bronze of 3rd to last quarter of 3rd. H. 0·93 m.

cities. Some time in the thirties Attalos refused the tribute and repulsed a Gaulish attack. When they made an alliance against him with Antiochus he defeated their combined forces and for a time controlled Asia Minor. In 222 Antiochus III (fig. 258) defeated him and the territorial status quo was restored; but the Gauls had been broken, and though Pergamon was small she had glory as well as wealth. Attalos and his successors, Eumenes II and Attalos II, made their city one of the great centres of culture, with a library second only to that at Alexandria and outstanding patronage of the arts.

We have copies of two sets of statues which directly commemorate the defeat of the Gauls. One set is recorded as dedicated by Attalos on the Acropolis of Athens: half life-size figures of Gods and Giants, Athenians and Amazons, Athenians and Persians at Marathon, and 'the destruction of the Galatians in Mysia'. They seem to have been in bronze; and marbles on this unusual scale, of fighting or dying Giants, Amazons, Persians and Gauls are certainly copied from them. (The victors, who were also shown, are not copied.) The other set is not recorded, but over life-size figures of defeated Gauls exist in marble copies of exceptional quality, the best the Dying Gaul of the Capitol (fig. 272). There is an upright group: a Gaul stabbing himself to avoid capture while supporting the body of the wife he has just killed. Bases found at Pergamon could have supported bronze statues of

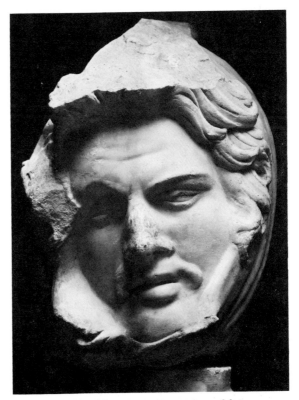

273 Marble head from Rome. From statue of dying or dead Persian (or Gaul?). Copy, perhaps of 1st century or earlier, after bronze statue of 3rd to last quarter of 3rd. L. 0·34 m.

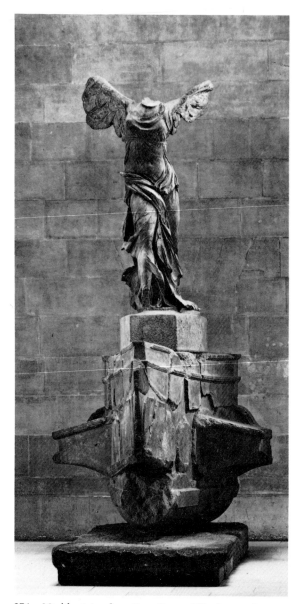

274 Marble statue from Samothrace. Nike (Victory) on ship's prow. Late 3rd or early 2nd century. H. of figure *c.* 2·00 m.

trumpet. The statues are composed for effective views from many angles, but more loosely and freely than in the first essays of this kind from Lysippos's school, and they have a distinctive weight and power of their own. The small figures are more histrionically conceived and set in more calculatedly complex poses. There is little agreement on the relation of the two. It seems to me probable that the big ones were the first victory monument set up at Pergamon itself; later, the little ones at Athens with their overt equation of the action with legendary glories. This goes with a Pergamene cultivation of the ancient city, aimed to show Pergamon as the Athens of the new age, which becomes very marked in the second century. Inscriptions, and some fragments of marble sculpture, show that large statues of Gauls were dedicated at Delos; and it is possible that the big ones in Rome, which are in Pergamene marble, are contemporary versions of the bronzes at Pergamon, made for dedication in other sanctuaries.[24]

Formally very close to the Gaul and his wife is a group of Menelaus with the body of Patroclus known in many copies. The originals must have been from the same circle, but the mythological group lacks the urgency of the contemporary one, seems an academic exercise.[25] That traditional themes could still inspire, however, is shown by the Victory of Samothrace (fig. 274). This grand colossal figure stood on a base in the form of a ship's prow in the open above a pool. It has been held to celebrate naval triumphs from one shortly after Alexander's death to Antony's and Cleopatra's defeat at Actium in 31, but excavation has shown that the base was constructed around 200, and the powerful forms make it a natural near-contemporary of the large Gauls. Here the free all-round structure is effected by a wrench of the forward-moving body and by the swags and masses of drapery, blown partly against the skin, partly free under the spread wings.[26] Drapery is similarly used on a still figure, a sleeping Ariadne known in two rather dissimilar copies, neither of them of great quality, which must go back to a contemporary original.[27] There is no reason to associate the original of either these or the Menelaus and Patroclus with Pergamon; nor the Victory, which there are some grounds for connecting with a Rhodian sculpture, Pythokritos. Artists in this age seem to have moved around, and there was not necessarily a 'Pergamene school'.

Experiments with sleeping figures, naked and draped, were made in the statuettes on the fourth-century Derveni krater (above, p. 172, fig. 236). One on the back is a satyr, and from this later period we have a colossal sleeping satyr, a masterpiece in Pergamene marble, surely an original, the Barberini Faun (fig. 275). The young satyr sprawls on a rock in

dying figures with this group in the centre. A wonderful dying head in what seems a Persian cap should belong (fig. 273) and may perhaps be another Gaul rather than a Persian. There is no other evidence for parallels like those at Athens, and none for the victors having been represented.

There is a mixture of observant naturalism and ideal tradition in these figures, much as on the Alexander sarcophagus of a century earlier (above, p. 171, fig.235): heroic nudity (the Gauls wore trousers), but the beardless, moustached faces and lumpy hair carefully noted, as are the Dying Gaul's torque and

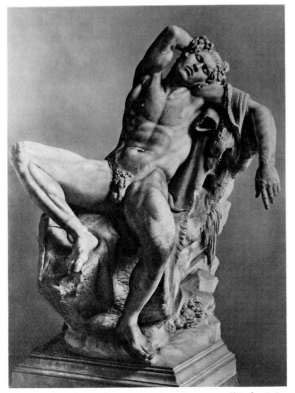

275 Marble statue from Rome. Drunken satyr ('Barberini Faun'). Probably original of late 3rd century. H. 2·15 m; substantial 17th-century restorations include whole right leg and pendent left forearm.

drunken slumber – a theme impossible in monumental art at an earlier date. The figure was heavily restored in seventeenth-century Rome, but the Baroque idiom of that time was entirely in keeping with the original style; so that, even though the right leg and left forearm are not exactly as the Greek sculptor made them, they are perfectly harmonious with his work. The natural abandon of the posture is most cunningly used to create a satisfying aesthetic structure, and both natural observation and artistic skill are equally carried into the detail, as in the sensitive modelling of the torso.[28]

A Marsyas hanging from a tree awaiting punishment exists in copies which show an extraordinary variety of treatment, emphasising in varying degrees, in face and strained muscles, the satyr's agony. It seems to have formed a group with a seated Apollo and a Scythian slave sharpening a knife (cf. above, p. 141). Of this last figure a very impressive copy survives, and its character suggests that the group in its original form belonged in the area we are now considering.[29] Another seemingly related work is the Belvedere torso, beloved of Michelangelo, which has been cleverly though doubtfully interpreted as a piping Marsyas from a group paired with the last.[30] The

originals of these need not have been made for Pergamon, but we return there for one more major monument, the Great Altar of Zeus.[31]

The growing power of Rome was being drawn into the quarrels of the Hellenistic kingdoms, much as Macedon had once been drawn into those of the city-states, seeming to protect one against another and swallowing all in the end. Wars at the beginning of the second century, which involved Philip V of Macedon, Antiochus III of Syria, Rhodes, Pergamon and Rome, ended in 188 in a peace virtually dictated by the Romans, in which much territory accrued to Eumenes II's Pergamon, and the kingdom became Rome's watchdog on both Syria and Macedon. It was probably then that the Great Altar was conceived, though it must have taken some time to build and adorn.

The altar proper stood on a platform some twenty feet high, approached by steps on the west between projecting wings and surrounded on the other sides by a wall which had an Ionic colonnade outside and in. Below the colonnade the supporting wall of the platform was adorned with a sculptured frieze which occupied over three hundred feet and was about seven and a half feet high, except at the two ends where it tapered to a point as the steps cut it. At these points there is no frame, and the colossal figures in high relief, Giants and Gods whose combat is portrayed, set foot, knee or hand on the actual steps up which the worshippers mounted. This mingling of the world of art, normally set apart within a distinct frame, and the world of ordinary life is a new and revolutionary idea, though the action across the corner of a pier from Ephesus (above, p. 164, fig. 224) perhaps looks forward to it. It is this which most persuasively justifies the transfer to this art of the term 'Baroque', proper to a different time and place, though one can feel it suitable to other aspects of the style as well. Exaggerated musculature we have met before: in some Lysippic works; on the Mausoleum frieze; even in the Poseidon of the Parthenon pediment; but here there is not only exaggeration but distortion of form, found also in some heads. The young Giant dragged by Athena and his mother Ge interceding (fig. 276) are examples. The classical structure is still discernible, and the raised faces with deep-set eyes derive from Skopas; but a violent twisting in the bone-formation of the brows, and the huge eyeballs rolling in pits beneath them, are equally foreign to nature and to the classical ideal.

The primly conventional little Ionic colonnade above contrasts strangely, and to my eyes unsatisfyingly, with this sculpture. Nevertheless, a marked feature of the frieze is its wealth of allusion to classical motives, in particular to the Parthenon. The Zeus and Athena (fig. 276) are separated by their opponents, but

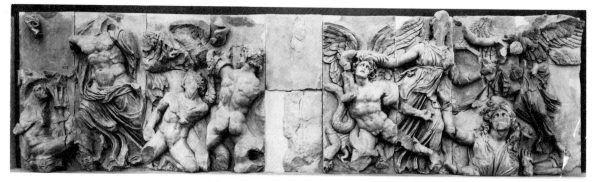

276 Marble reliefs from Pergamon. Great Altar of Zeus, slabs from east frieze (near north end). Zeus and Athena in Gigantomachy. First to second quarter of 2nd century. H. 2·30 m.

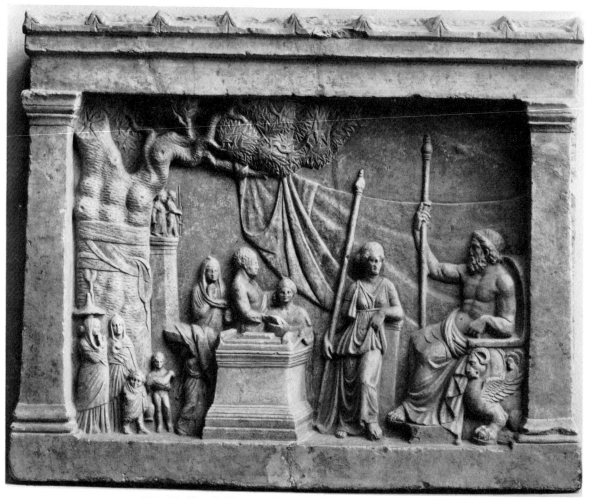

277 Marble relief from Corinth. Dedication to Asklepios and Hygieia: family sacrificing to deities at altar; sacred tree. Probably late 3rd century. H. 0·61 m.

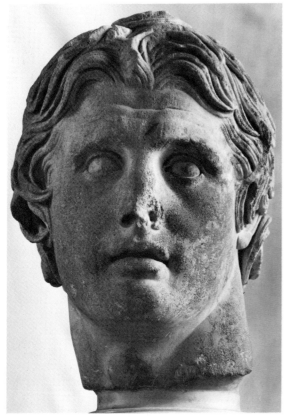

278 Marble head from Pergamon. From statue of Alexander. Late 3rd or early 2nd century. H. 0·42 m.

279 Bronze head from Herculaneum. 'Seneca'; almost certainly in fact imaginary portrait of Hesiod. Copied, before A.D. 79, after statue of probably early 2nd century. H. of detail *c.* 0·30 m.

are still strikingly reminiscent of Poseidon and Athena in the west gable of the Parthenon (fig. 132). Zeus, though half wrapped in a falling mantle, is almost Poseidon in reverse. Athena is closer in detail to the Athena of the Madrid relief (fig. 134), probably derived from the east pediment. Apollo on the altar is sometimes compared to the Apollo Belvedere (above, p. 160), but he is far more like a Lapith on a Parthenon metope;[32] while a Giant driven down by a chariot is almost a transcript from the north frieze, where a marshal in violent movement gestures at a charioteer to hold back. This is an art extremely conscious of its past, quoting from the classics, like Eliot, to emphasise its difference in its different situation. That Periclean Athens is the particular point of reference is surely connected with the idea (above, p. 194) of Pergamon as the New Athens.

Another example is the colossal marble already mentioned (above, p. 102, fig. 142) which reproduces, though without the mechanical accuracy aimed at in a Roman copy, Pheidias's gold and ivory Athena and the base on which it stood. The place for which this figure was made again brings before us the profound change that had come over the Greek world: not a temple, but the famous Library. True, that formed part of the precinct of Athena, and there was no doubt a religious intention in placing it under the protection of the goddess of wisdom; but readers in the Library surely looked at the statue much more nearly in the way we look at a work of art than did fifth-century Athenians when they faced Pheidias's image in the Parthenon.[33]

To return to the altar: fragments survive from a second frieze which seems to have been carved on the back wall of the colonnade surrounding the altar itself. This told the story of Herakles's son Telephos (above, p. 161; below, p. 206) who became king of Mysia, the region in which Pergamon lay. This frieze is on a smaller scale and in lower relief than the Gigantomachy, and in a very different style. It is often thought later, and was no doubt executed after the other, but there is no reason not to suppose it part of the original design or to postulate any great interval of time. The same characters reappear in scenes not framed off from each other: the first example in Greek relief of the 'continuous style' which is exploited later at Rome in the Columns of Trajan and Marcus Aurelius. The style is very pictorial (perhaps because the back wall of a colonnade was a traditional place for

painting, very unusual for relief), with landscape elements and in some parts figures set up and down the field.[34] The same character is found in some Hellenistic votive reliefs. A fine early example, probably still third century, is from Corinth and dedicated to Asklepios and Hygieia (fig. 277). The form follows fourth-century tradition (fig. 181). The deities are larger than the mortals, but here the principal mortals are also larger than others, evidently conceived as more distant; and it is possible, until one looks closely, to read all the diminution as a function of distance. The naturalism in this cleverly ambiguous design is emphasised by the setting: a huge gnarled tree (part of the sanctuary, for it has fillets tied round it) with a curtain hung from it, and a pillar supporting small statues. The women in the background, one with a wide brimmed hat, are just like the terracotta Tanagras (above, p. 142) popular through the third century.[35]

A splendid head of Alexander from Pergamon (fig. 278) shows the recreation of the king's image in the Baroque idiom (cf. figs. 217, 235, 252).[36] This mood is also found in portraits of contemporaries,[37] but the most interesting, known in many marble heads and one bronze of superlative quality, from Herculaneum (fig. 279), is of another kind. There is good reason for identifying it as an imaginary likeness of the early peasant-poet Hesiod. A recent study has shown that the grouping of the gods in the Gigantomachy frieze is carefully related to their genealogies in Hesiod's *Theogony*, and it is attractively suggested that the portrait originated in the same time and circle as the altar-programme.[38]

One work of highly Baroque character has close affinities with the frieze, but the relation is difficult to determine: the Laocoon (fig. 280). This marble group, found in 1506 and influential in the emergence of the Baroque, is rapturously described by Pliny and said to be the work of three Rhodians, Hagesandros, Athenodoros and Polydoros. An identification, long accepted, of these sculptors with men mentioned in Rhodian inscriptions of the first century is arbitrary and now abandoned. The evident resemblances to the Pergamene frieze have led to its being dated to the same period; but it has now been shown that one of the blocks of which it is made is of Italian marble, not exploited before Augustus. It might be a copy, but there are other difficulties. The two-dimensional composition, almost an *ajouré* relief, is hard to parallel (but cf. below, p. 201), and there are curious inconsistencies in style. The elder son (on his father's proper left) has often been noted as being both weaker and more 'classical' than the others, and not very well tied in with them. Then, there have been discovered in the 'Cave of Tiberius' at Sperlonga fragments of two huge narrative groups (the Blinding of Polyphemus; Scylla

280 Marble group from Rome. Laocoon and his sons. 1st century A.D., perhaps adapted by Rhodian sculptors Hagesandros, Athenodoros and Polydoros from two-figure bronze group of late 3rd or early 2nd century. H. 2·42 m; as restored in the 16th century; the most serious mistake is the father's raised right hand, which should be brought down near the head.

and the ship of Odysseus) as well as smaller ones, including the Menelaus and Patroclus (above, p. 194), disposed about the carefully landscaped natural cave. On the ship is a plaque with the names of Pliny's three Rhodian sculptors in letter-forms of approximately Pliny's own time. the style here too is a curious mixture of effective Baroque and other tamer elements. The most economical explanation seems to be that these artists were in fact of the first century A.D. and adapted and recreated earlier Hellenistic works for their Roman patrons. The Laocoon might then be an adaptation of a third- or second-century two-figure group in bronze (like the Menelaus and Patroclus and others) to a two-dimensional composition for a special setting, and to bring it into line with Virgil's description, the first we know to have father and two sons killed by the snakes (earlier accounts have the father and an only son, or two sons but not the father destroyed).[39]

It was long supposed that with the establishment of the Empire all originality among Greek artists ceased; that when they were not working on portraits or

281 Bronze statuette. Muffled dancer. Late 3rd or early 2nd century. H. 0·21 m.

triumphal monuments for the Romans, they were mechanically copying the masterpieces of the past. That alongside these undoubted avocations a limited originality of adaptation and recreation went on is much more plausible. That it continued a long time is suggested by the gross monument with the punishment of Dirce by her step-children, the 'Farnese Bull'. This was found in, and no doubt made for, the Baths of Caracalla in the early third century A.D. (cf. above, p. 167), but it stands in some relation to a simpler group described by Pliny and attributed to Apollonios and Tauriskos of Rhodes. In this case the sculptors named, to judge from his confused account of a confusion over their parentage, were not his contemporaries but belonged to an earlier time.[40]

III. Other trends in sculpture

The Baroque tendency, which seems to have its sources in the school of Lysippos, is the nearest thing to a central stream in Hellenistic sculpture. For the rest, the best we can do is to point to certain classes and trends.

A tradition can be traced through the third century and well beyond in swathed figures, from Praxitelean

beginnings (figs. 196–7) through such things as the Matron and Maiden of Herculaneum (fig. 233; cf. fig. 234) and the terracotta Tanagras (above, pp. 142, 170; cf. the relief, fig. 277). Perhaps towards the end of the third century a new virtuosity is introduced: a thin upper garment over a thicker lower one, the folds of which show through it, cut across by its own folds. Good representatives of the style are marbles copying six Muses, evidently a famous set; but the finest original which survives is a wonderful bronze statuette of a muffled dancer (fig. 281) where the folds are brilliantly used to support the all-round spiral structure. She recalls Theocritus's description of a mime-dancer in Alexandria, and the bronze may but need not be Alexandrian.

A late original in this style, firmly dated in the second quarter of the second century, is a marble portrait-statue of one Kleopatra on Delos, set up with one of her husband Dioskourides in a simpler, more classicising style.[41] In 166 Rome opened a free port on Delos (in a successful attempt to ruin the commerce of Rhodes) and a big colony of Roman and Italian merchants grew up there, and introduced their own notions of portraiture: private individuals naturistically rendered, their heads sometimes oddly set on heroic Greek bodies.[42] Two years earlier Rome had crushed Macedon, and twenty years later absorbed it as a Roman province. In 133 Attalos III of Pergamon died and bequeathed his kingdom to the Romans, and it became the Province of Asia. The Romanisation of the eastern Mediterranean had begun, to be completed a century later with the defeat of Antony and Cleopatra at Actium and the conquest of Egypt.

The naked or partly draped Aphrodite is a favourite figure in Hellenistic and Roman sculpture, and it is very hard to distinguish Hellenistic creations from variants on them made under the Empire. Adaptations of the Cnidia (fig. 194) are frequent. The two most famous are the Medici (fig. 282) and the Capitoline. They are much closer to one another than to the Cnidia herself, and one may wonder if one of them (the Capitoline?) is not a Roman variant on the other. They are compacter, more conventionally 'classical' than Praxiteles's statue (see above, p. 140); to most modern eyes charmless things, but if Botticelli had not known something of the kind his Venus would not be quite as she is, so we should be grateful. A headless statue from Syracuse is posed just like these, but the ends of a wrap are tucked under the left hand. It fans out behind, and serves both to strengthen the statue and to add piquancy to the nude. Again we cannot say whether this is a 'Hellenistic' or a 'Roman' idea.[43]

A different, 'bold' type, not covering her body but raising both hands to a necklace or her hair, is also very popular, and was surely created in the Hellenistic age.

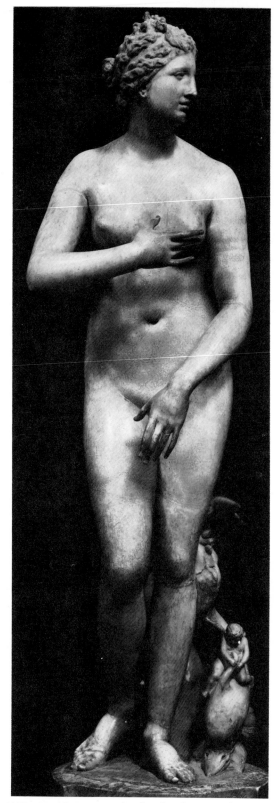

282 Marble statue. Aphrodite ('Medici Venus'). Copy of
Imperial age after original perhaps of 2nd century.
H. 1·53 m; modern, nose and some patches.

200

283 Marble statue from Cyrene. Work of the Imperial
age, perhaps copied from Hellenistic original. H. 1·49 m.

A beautiful example is a headless statue from Cyrene
(fig. 283); but the most interesting adaptation of this
concept is in the group of the Three Graces. The
composition, two facing one way, the third (between
them) the other, their arms about each other's shoul-
ders, is one of the most satisfying and enduring
creations of ancient art. Since the fifteenth century
artists in every medium have imitated or recreated it;
and from the Imperial period we have many versions:
in the round, in relief (of every scale and material), and
in painting and mosaic; none, however, of good
quality. We do not know when it was invented, nor

284 Marble group. Cupid (Eros) and Psyche. Copy of the Imperial age after original probably of the 2nd or 1st century. H. 1·25 m; modern, boy's hands and feet, nose, and back of head with girl's hand; girl's nose and other patches.

285 Marble statue. Aphrodite washing. Copy of the Imperial age after bronze of probably later 3rd or earlier 2nd century. H. 0·97 m.

even in which form, though a composition in the round is more likely to be adapted effectively to a flat design than a painting or relief to a sculptural group. As a group it is, however, a 'two-dimensional' composition, like the Laocoon (above, p. 198, fig. 280) except that it is equally effective from two opposite views.[44]

Another Aphrodite type is naked above but has a thick mantle wrapped about legs and hips. Most famous is the Venus of Milo (Aphrodite of Melos), an over life-size marble original probably of the later second century. Statues with drapery of this kind, the Aphrodites of Arles and Capua, have been thought to go back to fourth-century originals, respectively by Praxiteles and Skopas, but this is very unsure.[45] Again

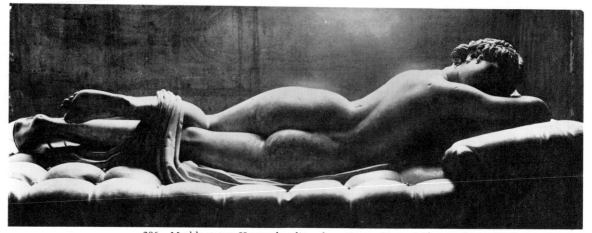

286 Marble statue. Hermaphrodite asleep. Copy of Imperial age, perhaps after bronze by Polykles of the mid 2nd century. L. 1·47 m; modern, mattress (17th century, by Bernini).

287 Bronze statue. Eros asleep. Probably original of 2nd century. L. 0·78 m.

the most effective use of the type is not as Aphrodite but adapted in a group: the girl Psyche kissing the boy Cupid (Eros; fig. 284). This, like the Graces (with which it shares the union of unabashed charm and cunning formal structure) was immensely popular both under the Empire and in later times; and again we cannot say when it was created.[46]

We noticed earlier (above, p. 179) a naked Aphrodite not standing but crouching, which may possibly be derived from a painting by Apelles. There exists a much more sculpturally powerful crouching type (fig. 285). In some copies it is grouped with an Eros, but this may not be part of the original design. The strong forms and the pyramidal composition relate this to works in the Baroque tradition, the Dying Gaul (fig. 272) and more closely the Knifegrinder (above, p. 195). Pliny knew of a marble Aphrodite washing herself,

apparently of Hellenistic date. This could be it, but the ascription to one 'Doidalsas of Bithynia' depends on emendation of two corrupt passages and is extremely doubtful.[47]

Related to the Aphrodites is a new creation of this age, the Hermaphrodite. The effeminising of young male types, which begins with Praxiteles in such works as the Apollo Sauroktonos (above, p. 139) and is carried further in many Hellenistic figures of Apollo and Dionysus, leads on to this development; and aesthetically the fusing of male and female in one image can be seen as the logical conclusion of the idealising tendency in Greek art. Mostly the figure is distinguished from a woman only by its male organs. It is shown alone, sometimes with drapery hung to reveal the sex, or in a group romping with a satyr like any nymph. Most are trivial; but there is one powerful

statue, known in several copies, of a Hermaphrodite asleep (fig. 286), which seems a considered study of the dual nature. Pliny speaks of a famous Hermaphrodite in marble by one Polykles, probably identical with a bronzeworker to whom he gives a date in the fifty-sixth Olympiad (155–152); and these fine copies may well go back to that. The Hermaphrodite lies on side and front in restless sleep, one ankle across the other leg with a tangle of drapery, head on arms. The way the face is turned to be seen at the same time as the bottom, making this the principal view, gives an impression of exaggerated pliancy; and this seems part of a calculated effect of slightly unnatural character, felt also in the elongated head and the very large eyeballs under the closed lids. A disturbing work.[48]

There is much variety in the sleepers of Hellenistic sculpture: the Faun (fig. 275) and Ariadne propped up; both restless, like the prone Hermaphrodite. Much sounder asleep lies a charming Eros, known in marble copies and a bronze which may be the original (fig. 287), one wing crumpled under him, one arm hanging loose.[49] Children – older, like Cupid and Psyche, or younger like this Eros are favourites now. Many, as a celebrated boy hugging a goose,[50] are plump and cared for, like these. Others are different. An exquisite bronze statuette (fig. 288) shows a thin black slave-boy, rapt in the music he is drawing from an instrument now lost.[51] The structure, though simpler, is on similar lines to that of the dancer (fig. 281), and this too has been thought Alexandrian, perhaps rightly. It was found at Chalon-sur-Saône – the treasure, I suppose, of some Gallo-Roman connoisseur.

The greatest of all Greek child-statues is skinny,

288 Bronze statuette from Chalon-sur-Saône. Negro musician. Probably 2nd century. H. 0·20 m.

289 Bronze statue from sea off Cape Artemision. Boy jockey. Perhaps not later than mid 2nd century. H. 0·84 m.

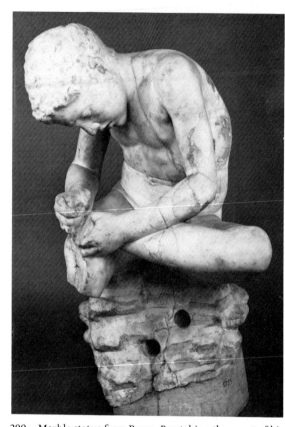

290 Marble statue from Rome. Boy taking thorn out of his foot. Copy of the Imperial age, probably after bronze of 2nd century. H. 0·73 m.

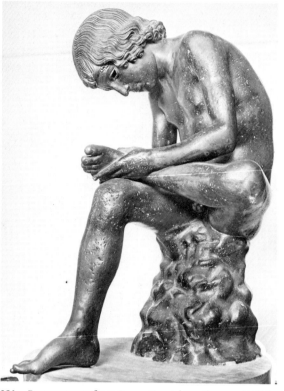

291 Bronze statue from Rome. Boy taking thorn out of his foot (the 'Spinario'). Pastiche, probably of 1st century, based on type of fig. 290 with a head of early classical character. H. 0·70 m.

ragged and rough: a boy jockey (fig. 289), a bronze original dredged from the same wreck as the great fifth-century Zeus (above, p. 55, fig. 79). He is generally dated around 100, but a good case has recently been made for the ship having been wrecked a generation before that, and we have seen how difficult dating in this period is.[52] The work marks in any case the culmination of the naturalistic tendency in Hellenistic art. Parts of a large horse were found in the wreck, and he is now mounted on it; probably rightly, but so much of the beast is restored that it is difficult to gauge the effect.

Marble copies reflect similar works, but much of the force is lost even in the finest, a fragment showing a quarrel over a game.[53] Another, found like the last in Rome, has a boy taking a thorn out of his foot (fig. 290). This is of special interest because of its relation to the famous bronze Spinario (fig. 291), known in Rome since the Middle Ages. The Spinario's head is of early classical type; and it has been argued that this is indeed a fifth-century creation, the other a Hellenistic reworking of it. This does not seem possible, however. The Spinario is surely a classicising pastiche adapted from the Hellenistic model, the forms idealised and

an early classical head substituted.[54] Such eclectic classicism was a fashion in late Republican Rome, in a school dominated by a South Italian sculptor, Pasiteles, though it rarely attains the beauty of this masterpiece. It leads on to the court art of Augustus where, in the Ara Pacis (above, p. 101) and in imperial portraiture, classicism is used as a way of expressing his new world, and where Greek art becomes Roman.[55]

IV. Painting and mosaic

From the beginning of the Hellenistic age we have the paintings in Macedonian tombs (above, pp. 176ff., figs. 241–2); from the end or just beyond wall-paintings in late Republican Italian houses. Some early examples of these are certainly, as we saw, faithful reproductions of early Hellenistic wall-paintings (figs. 243–4), as is the Alexander mosaic (fig. 247). Later examples probably give us the compositions of fourth-century paintings (pp. 152f., figs. 208–9), but how much more is difficult to judge. The tomb-paintings show that the fine freedom of handling found in much Roman wall-painting is already present in Greek painting at the beginning of the Hellenistic age. On the other hand the atmosphere, aerial perspective, notable

292 Wall-painting from Rome. Adventures of Odysseus: the Laestrygones; Circe's island. Mid 1st century, copied probably from original of 2nd. H. 1·16 m.

293 Wall-painting from Boscoreale (near Pompeii). Palace-front with tragic masks. Mid 1st century, copied from stage-set, probably of late 2nd or early 1st. H. *c.* 3·40 m.

295　Wall-painting from Herculaneum. Herakles in Arcadia, finding his son Telephos suckled by a hind. Before A.D. 79, copied from picture of late 3rd or early 2nd century. H. 2·02 m.

294　Wall-painting from Pompeii. Thetis in Hephaestus's smithy. Before A.D. 79, copied from picture of late 4th or early 3rd century. H. 1·30 m.

in the Roman work, is conspicuously absent from the Greek. This is sometimes claimed as a Roman discovery; but there is evidence for landscape painting in the Hellenistic world, and the atmospheric effect was probably developed by Greek painters during these centuries. The great *Odyssey* landscapes from Rome (fig. 292) have it, and they, painted like the Boscoreale figure-pieces in the mid first century, seem to be faithful copies of a Greek cycle from the century before.[56] Another wall from the Boscoreale villa, painted at the same time, has a splendid tragic stage-set (fig. 293), the original of which is probably likewise to be dated in the second century or not much after its end. It gives us an echo of developments in perspective since the time of Agatharchos (above, pp. 150f., and cf. fig. 206).[57]

We saw a type of composition developed for interiors in fourth-century painting: columns supporting a receding ceiling; a low cross-wall behind the principal figures; sometimes a curtain (above, p. 153, figs. 209, 210). Other Italian wall-paintings show more sophisticated variants, and surely derive from Hellenistic works. The finest of several versions of a picture of Thetis in Hephaestus's workshop (fig. 294) is an example.[58] The low wall is there, but farther back, leaving a greater depth for the figures. A single large

column rises to left of centre, and near the right edge, instead of a second column, a great swag of curtain is festooned from a shield hanging behind the architrave and hangs over the parapet wall, while another swag is taken back to a second shield on the far wall through which windows open on the sky. The figures too are disposed in a more complex way, and with a more dramatic balance of light and shade. In the foreground some of the finished armour the god is making for Achilles lies in a heap, and a workman in three-quarter back view is chiselling the helmet. The principals are set further in and three-quartered towards us: Hephaestus holding up, with a workman's help, the great shield for Thetis who, a maid standing behind her, sits hand to cheek, gazing. Her reflection appears in the shield (we noticed the same device on the Alexander mosaic); but she is surely not conceived as looking at it, nor even admiring the work; rather perhaps practising catoptromancy (mirror-magic) seeking against hope a better fate for her doomed son.

Thetis here resembles the Macedonian queen from Boscoreale (fig. 244), and even more a grand personification of Arcadia in a big picture from the Basilica at Herculaneum, with Herakles finding his son Telephos suckled by a hind (fig. 295).[59] Herakles appears here almost exactly as he does in relief in the small frieze of the Pergamon altar (above, p. 197), in a

296 Part of wall-painting from Pompeii. Still Life. Before A.D. 79, probably derived from a tradition, if not copied from a painting, of 3rd to 2nd century. H. 0·70 m.

297 Mosaic floor-centre from Pompeii. House of Faun: Still Life with cat and bird. 2nd to 1st century, probably copied from painting of 3rd or 2nd. H. 0·53 m.

298 Fragment of mosaic floor-centre from Pergamon. Palace V: signature of Hephaistion. First half of 2nd century (palace dated to reign of Eumenes II, 197–159 B.C.). H. of *cartellino* c. 0·20 m (?).

representation of the same scene. The subject was of Pergamene interest, and it is extremely probable that the original of this picture was painted in Pergamon, during its great period in the later third or earlier second century.

The Still Life in this picture – grapes heaped in a basket – is paralleled in many independent still-lifes: paintings, often of great freshness and charm (fig. 296), and mosaics (fig. 297). They are often of this particular form: a squarish design divided into two unequal halves by a shelf. They surely derive from a genre of Hellenistic panel-painting, perhaps what Vitruvius calls *xenia* (guest-gifts).[60] The mosaic in fig. 297 is evidently copied from a picture of this sort; but mosaic is a craft with an independent tradition of its own which runs unbroken from the Hellenistic kingdoms into the Roman Empire. We can trace it through the third, second and first centuries at Alexandria, Pergamon, Delos and Pompeii;[61] and a particular form of still-life exists in this tradition too.

The pebble-mosaic at Pella with the stag-hunt (fig. 239) is signed by the artist, Gnosis; and we have signatures on tessellated floors of the third and second centuries from all four of the places named; but only one mosaicist got into the literary tradition: Sosos of Pergamon. We possess none of his work, but one famous piece was called the Unswept Floor. There are Roman imitations of that; and from Pergamon itself comes a fragment by another artist but in just the same spirit. In one of the palaces was found a second-century mosaic floor, from which the emblema at the centre is lost except for one corner (fig. 298). This has the signature of the artist, Hephaistion, as though written on a piece of parchment held down by wax at the corners, but one piece has come away and the corner has curled. This charming fancy is the first instance of the *cartellino*-signature, so favoured by Giovanni Bellini and other Renaissance painters. The border of Hephaistion's floor has a scroll of 'Pausian' derivation (above, p. 174) but more sculptural in

299 Part of border of same mosaic floor as last. Peopled scroll. First half of 2nd century. H. of scroll-band *c.* 0·45 m.

treatment, and among the fronds play little winged insects and Loves (fig. 299): an early example of the 'peopled scroll'.[62] It is almost repeated, in a slightly coarsened form, in a border from a floor at Pompeii, but the great future of the 'peopled scroll' was not in mosaic or painting but in decorative architectural sculpture. It was particularly developed, in an enchanting form, at Aphrodisias in Asia Minor, where there was a flourishing school of sculpture in the second and third centuries A.D., and spread from there over the empire.[63]

It is from one point of view arbitrary to exclude the development of Greek art under the Roman Empire from this book. There is unbroken continuity, certainly. Its independent creativity, however, does seem to fail in the first century B.C., and the enormous contributions it made to the art of the following centuries were moulded by the needs of a foreign idea.

NOTES

The numbers in brackets after each section-title are the pages in Robertson *History* (see Bibliography) where the material in that section is treated. References without author or title are to Robertson *History* by chapter and note number, and where applicable Plate number. See Preface.

Chapter 1 The seeds of Greek art: Geometric and Orientalising

(i) *Geometric* (15–21)

[1] Prologue, with notes and pls. 1 and 2.
[2] 1.3 and 6.
[3] 1.7.
[4] 1.8. Desborough pls. 5 and 6.
[5] 1.11.
[6] 1.9. *Schweitzer* pl. 2.
[7] 1.15–17; pl. 3d and e.
[8] 1.8; pl. 3a–c.

(ii) *Orientalising* (21–33, 147)

[9] 1.21–6; pl. 7c.
[10] 1.40–3.
[11] 1.27; pl. 6.
[12] 1.20.
[13] 1.27. Payne pls. 1–10.
[14] 1.28; pl. 12a.
[15] 1.33.
[16] 1.30; pl. 12b.
[17] 1.31.
[18] 1.32.
[19] 1.36.
[20] 1.46–9; pls. 7b, 8b–d.
[21] 3.154; pl. 43b–e.

Chapter 2 The beginning of monumental Greek art: the early archaic period

(i) *The 'Daedalic' style and the early stages of monumental sculpture* (34–49, 71).

[1] 1.49; pl. 7d.
[2] 2.1, 2 and 6.
[3] 2.7; 3.4. BDFH pl. 85 (69) left.
[4] 2.5.
[5] 2.13. Harrison in *JWAG* 36 (1977) 37f.
[6] 2.4 and 12.

[7] 2.23. Ridgway 49–59.
[8] 2.26–7; pl. 9c and d.
[9] 2.21.
[10] 2.30; pl. 8d.
[11] 2.32.
[12] 2.33.

(ii) *The beginning of free painting* (49–56)

[13] 2.40.
[14] 2.41.
[15] 2.43–4.
[16] 2.45; 4.152. Thermon metopes: BDFH pl. 93 (77), colour pl. vii and p. 160 fig. 116 (p. 94 fig. 142).

(iii) *The beginning of relief and architectural sculpture* (39, 47–9, 56–69, 116–20)

[17] 2.17, 53 and 60.
[18] 2.61–2.
[19] 2.53; pl.9e. Stucchi in *Levi* 89–119.
[20] 2.57. *JdI* 16 (1901) 18–22, figs. 1–25.
[21] 2.64, 69 and 71; fig. 3 (p. 781).
[22] 2.70. Lawrence 123f., fig. 68.
[23] 3.44 and 49; 4.11. Boardman 1978 figs. 190–1.
[24] 2.39; pls. 8a, 11c and d, 12.
[25] 2.72.
[26] 3.102; pl. 33d. Richter 1970 fig. 405.
[27] 3.96.
[28] 3.145; pl. 32a.
[29] 3.100–1; pl. 33c. Giuliani.
[30] 3.97.
[31] 2.39; pl. 11c.
[32] 2.74.
[33] 2.36 and 62; pl. 14a.

Chapter 3 Ripe archaic art

(i) *Sculpture: the rise and influence of an East Greek style* (37, 70–116, 159–63)

[1] 3.11 and 12; pls. 20a, 21b. Much material in Pedley (colossus, no. 37, pl. 27; clothed kouros, no. 28, pl. 38).
[2] 3.5.
[3] 3.6. Pedley no. 46, pl. 32.
[4] 3.10, 29 and 31; pls. 18b, 19a. Didyma heads: Pedley pls. 42–3; Miletus head: Pedley pl. 41.

5 3.37; pl.21c and d. Pedley nos. 8–9, pls. 5–6.

6 3.8. *Samos* xi (Freyer-Schauenburg) 106–230, nos. 58–63, pls. 44–53. Pedley nos. 49, pl. 34 (Philippe) and 50, pl. 35 (Ornithe).

7 3.8–9. Boardman 1978 figs. 94–6.

8 3.13.

9 3.14–16, 67–8 and 71.

10 E.g. 3.70; pl. 26c and d.

11 3.44–9; pl. 23a–c. By a recent theory pl. 23b is not the centre of a small pediment but from the wing of a large one: I. Beyer in *AA* 1974 639ff.; Boardman 1978 fig. 192.

12 3.44 and 49. Boardman 1978 figs. 190–1, 193.

13 3.51; pl. 25a.

14 2.10.

15 3.89 (cf. 3.39–40, 88, 90–1, 95; pls. 20, 22, 27c, 28b).

16 3.60–2; pl. 26a.

17 3.63; pl. 25d.

18 4.11; pl. 27d.

19 4.14; pl. 49b.

20 4.13.

21 3.79–85; pls. 29–31.

22 3.81–2; pl. 30.

23 3.82.

24 3.80–1 and 84; pl.29b.

25 3.38–40; pls. 20c, 22. Much material collected in Pedley.

26 3.88, 90–1; pl. 20b.

27 3.83. *AM* 58 (1933) 22ff. with figs. and pl.

28 3.92 (cf. 93). Richter 1970 fig. 468.

29 3.21. Paribeni nos. 1–9, pls. 1–15.

30 3.95.

(ii) *Painting and vase-painting* (54f., 120–40)

31 3.104.

32 3.105–6 and 108; pls. 34a and b, 84b.

33 2.47. Boardman 1974 figs. 3–10.

34 3.109–10 and 118; pl. 35a. Boardman 1974 figs. 11–33.

35 3.11–17 and 120; pls. 12c, 35b, 37a. Boardman 1974 fig. 46. My fig. 48: hydria, Athens N.M. Acr. 594, Graef pl. 24; *ABV* 77 no. 8.

36 3.120 and 129. Boardman 1974 figs. 108–21 and 123.

37 3.122. Boardman 1974 figs. 49, 50.

38 3.125. Tiverios. Moore in *AJA* 83 (1979) 79–99. Boardman 1974 figs. 64–71.

39 3.126–30, 132–3; pls. 36b and c, 70a. Boardman 1974 frontispiece, figs. 97–106 (cf. 93–6, 107); and in *AJA* 82 (1978) 11–25.

40 3.134–5; pl. 32c. Boardman 1974 figs. 77–91. Bothmer in *AK* 3 (1960) 71–80, pls. 3–11; *Mad. Mitt.* 12 (1971) 123–30, pls. 1 (colour) and 24–30.

41 3.141.

42 3.142; pls. 40d, 42.

43 3.137–8; pl. 32b.

44 2.50; 3.139–40; pls. 12b, 40a.

45 Other Attic painters and workshops: 3.121, 124, 129, 131, 135–6; pls. 35c and d, 38a, 40b. Boardman 1974.

(iii) *Other arts* (140–51)

46 3.31 and 146–8; pls. 15c, 44.

47 3.143; pls. 44e, 46a.

48 3.144. *BCH* 63 (1939) pls. 19–42; 64 (1940) pls. 18–20.

49 3.152–3; pl. 15d, e.

50 3.154–7; pl. 43. Boardman 1970.

51 3.158–64; pl. 43. Kraay and Hirmer.

Chapter 4 The great change: late archaic and early classical

(i) *Late archaic architectural marbles* (89, 152–9, 163–71, 183f.)

1 4.1 and 2.

2 4.3.

3 3.41 (cf. 3.20; pl. 18a).

4 4.10; pl. 23d.

5 4.4–9; pls. 46b–48. Moore in *Études Delphiques* (*BCH* Suppl. 4, 1978) 305–35.

6 4.23.

7 4.18–19.

8 Richter 1970 figs. 281, 442. Technique: Adam.

9 4.20–1. Ohly *Aegineten* (full publication of east pediment, and important information on the whole); and *Ägina* (brief but important general account, in form of text to wooden models in Munich Glyptotek; see next note). Robertson in *JHS* 98 (1978) 208ff. (review of *Aegineten*); Delvoye in *Acad. Royale de Belgique, Bull.* 65 (1979) 272–91.

10 Ohly *Ägina* 33f. with long note 32 (pp. 43–6).

11 Ohly *Aegineten* pls. 36ff. A large piece of the torso joining the neck has now been found.

12 4.46, 48 and 72; pl. 52b.

(ii) *Sculpture at Athens in the time of the Persian wars* (171–80)

13 4.27.

14 4.28.

15 4.29.

16 4.30.

17 4.37.

18 4.35.

(iii) *Bronze statuary and Roman copies* (162, 180–97)

19 4.72.

20 3.156; 4.41.

21 4.43–5; pl. 53b.

22 4.42 and 46; pl. 59.

23 4.49. Richter 1970 figs. 565–77.

24 4.15; pl. 50a.

25 4.54–5.

26 4.56; pl. 58a.

27 4.58.

28 4.65.

29 Richter 1955 34–55 and 105–11. Bieber 1977.

30 4.69. Wünsche in *JdI* 94 (1977) 77–111.

31 4.61.

32 4.60 and 63; pls. 60c, 61a.

(iv) *Early classical relief* (197–214)

33 4.74. Man and dog stelai: Ridgway in *JdI* 86 (1971) 60ff. with refs. Alxenor: Richter 1970 fig. 425.

34 4.76.

35 4.34; pl. 63b.

36 4.88 and 90–4. Richter 1970 figs. 183, 189, 477–9.

37 4.86; pl. 65a.

38 4.97–9; pl. 67. Splendid collection of coin-pictures in Kraay and Hirmer.

39 4.102; pl. 69.

40 4.95–6; pls. 63c, 65b. Richter 1955 figs. 158–67. Greek replicas: Strocka in *JdI* 94 (1979) 143–73, figs. 1–8.

(v) *The revolution in painting, 1: the red-figure technique and the Pioneers of the new style (214–39)*

41 H. Thompson, in a lecture.

42 4.103–6. Archaic Attic red-figure: Boardman 1975.

43 4.107; pls. 70b, 72b. Boardman 1974 figs. 160–6; 1975 figs. 2–10.

44 4.109; pl. 70c. Boardman 1974 figs. 169–71; 1975 figs. 11–15.

45 4.106 and 108.

46 4.104. Seiterle in *Vasenforschung* 34 (an impossible theory, I think).

47 Epiktetos: 4.112; pls. 70c and d, 78a and b. Boardman 1975 figs. 66–78. Oltos: 4.111; pl. 71c. Boardman 1975 figs. 54–65.

48 4.116; pls. 39c, 71d, 75c. Boardman 1975 figs. 22–30. Bothmer in *AA* 1976 485–512, figs. 1–29.

49 Robertson in *Burl.* 119 (1977) 78–86, figs. 1, 8–21.

50 4.117; pls. 72d, 74c. Boardman 1975 figs. 33–7, 52–3.

51 4.122.

52 4.123.

53 4.121. Boardman 1975 figs. 52–3.

54 H. Thompson (above, n. 41).

55 4.109. Boardman 1974 figs. 186–92.

56 4.113. Boardman 1974 figs. 199–213, 299, 300.

57 4.144. Boardman 1974 figs. 295–308. Brandt in *IRNA* 8 (1978) 1–23, pls. 1–16.

58 3.129, 141; 4.110; pl. 70a and b.

59 3.129; 4.125; pl. 75c. Boardman 1975 fig. 26, 1 and 2.

60 3.118.

61 4.127–9; pl. 76a. Boardman 1975 figs. 222–35 (cf. 215–17, 219–21).

62 4.128.

63 4.127 (Elpinikos Painter). Boardman 1975 fig. 115 (cf. 113, 114, 116–18; p. 62).

64 Douris: 4.132–3; pls. 77, 78c–d. Boardman 1975 figs. 281–99 (cf. 300–2). Makron and Hieron: 4.130; pl. 79. Boardman 1975 figs. 308–18.

65 4.131 and 134; pls. 76b and d, 80a and b. Boardman 1975 figs. 218, 245–61.

66 4.135–41; pls. 81a, 82b. Boardman 1975 figs. 129–42; 1974 fig. 301; in *Getty* 1 (1975) 7–14; *AK* 19 (1976) 3–18.

67 4.142–6; pls. 81b, 83b–d. Boardman 1975 figs. 143–61, 383; 1974 fig. 302 (303, there given to the Berlin Painter, is actually by his pupil the Achilles Painter; below p. 108).

68 4.141; pl. 82b.

69 4.143–4.

70 Cup-painters: 4.46; pl. 59 (Foundry Painter); 4.126; pl. 75b (Sosias Painter); 5.81; pl. 73a (Nikosthenes Painter); Boardman 1975 55–88, figs. 54–128; 132–40, figs. 214–318. Pot-painters: Boardman 1975 33, 35f., figs. 38–47; 111–14, figs. 162–213.

(vi) *The revolution in painting, II; wall-painting and vase-painting after the Persian wars (240–70)*

71 4.147.

72 4.149–66, 189–200.

73 4.150, 169–70.

74 4.175.

75 4.178–9.

76 4.180.

77 4.176; 7.143; but see now Bruno, especially 87.

78 5.185; pls. 90–1. Hoffman in *AK* 9 (1973) 20ff., pl. 10.

79 4.134, 138; pl. 80. Boardman 1975 figs. 135, 245.

80 4.157–66.

81 4.173.

82 4.184.

83 4.167. Boardman 1975 fig. 350; other followers of the Berlin Painter, figs. 351–63.

84 4.168. Boardman 1975, figs. 335–49; other Mannerists, figs. 319–34; minor painters of this time: figs 364–82; the Niobid Painter and his circle, the Pistoxenos and Penthesilea Painters, and others of this time like the Villa Giulia and Chicago Painters, as well as later artists, will be represented in a further volume.

(vii) *The sculptures of the temple of Zeus at Olympia (271–84, 289–91)*

85 2.36 and 62.

86 4.202 and 204.

87 4.242.

88 4.206.

89 4.209–14; fig. 4 (pp. 782f.); pls. 92–3. Ashmole and Yalouris fig. 18, pls. 143–211 and pp. 181–4 (Yalouris).

90 4.211–12.

91 Pl. 93d. Yalouris in Ashmole and Yalouris 184 with fig.

92 4.213.

93 Lion: 4.214; pl. 93a. Apples: 4.210; pl.93c.

94 4.215–21. Ashmole and Yalouris pls. 1–61.

95 Ashmole in Ashmole and Yalouris 15, pls. 58–61.

96 4.222–6. Ashmole and Yalouris, frontispiece and pls. 62–142.

97 Ashmole and Yalouris pls. 118–21, 92–7; the rest of these two groups, pls. 98–101, 105, 110–17.

98 Pl. 95a. The two groups: Ashmole and Yalouris pls. 71–81, 127–42.

99 4.226. Ashmole and Yalouris pls. 62–70.

100 Ashmole and Yalouris pls. 82–91, 122–6.

101 4.222.

102 Ashmole and Yalouris pls. 28–30, 53–4.

103 Ashmole and Yalouris, frontispiece and pls. 101–9 (seer, pls. 31–40).

104 Cladeus: pl. 97a (head); Ashmole and Yalouris pls. 1 and 4–12 (Alpheus, pls. 2–3).

105 4.240.

106 Furrowed brow: Ashmole and Yalouris pls. 34, 90, 97, 148; young bodies: pls. 41–3, 50–2, 124–6.

Chapter 5 The classical moment

(i) *The Parthenon (292–311)*

1 5.2.

2 5.3 and 9. Brommer 1977 and 1979.

3 5.4.

[4] 5.6.

[5] 5.1.

[6] Brommer 1977 168f.

[7] 5.13 and 16.

[8] 5.14 and 15.

[9] Pl. 99c. and d.

[10] 5.5.

[11] Robertson in *Blanckenhagen* 78–87.

[12] 5.18–22; and next note.

[13] Simon in *Hampe* (1980) 239–55, pls. 51–4.

[14] 5.21; pl. 102c.

[15] 6.26.

[16] 5.23.

[17] 5.24–8. Berger 1976 (and in later numbers of *AK*).

[18] Berger 79 n. 6.

[19] 5.25.

[20] 5.26. Figure with Aphrodite, Artemis: Berger 41ff.; Themis: Harrison in *Brommer* 155–61. Hestia: Harrison in *AJA* 71 (1967) 45ff.

[21] Fuchs in *Gnomon* 39 (1967) 163; Berger 26f.

[22] 5.20 and 28.

[23] 5.30.

[24] 5.31.

[25] 5.36–42; and see following notes. Full publication: Brommer 1977. Convenient pictures in Robertson and Frantz.

[26] 5.34–5.

[27] 5.36–7.

[28] 5.38.

[29] Most recently, Harrison in *Thompson* 71–85.

[30] Robertson in *Blanckenhagen* 75–8.

[31] Epilogue 35.

[32] 5.39.

[33] Boardman in *Brommer* 39–49.

(ii) *Pheidias and his circle* (311–22, 351–5)

[34] 5.69–73.

[35] 5.45–50 and 52–6.

[36] 5.59 and 63–6.

[37] 5.58.

[38] 5.68; pls. 109d, 110b.

[39] 5.51–5; pl. 105b. New reconstruction of shield: Hölscher and Simon in *AM* 91 (1976) 115–48, pls. 43–8; see also Preisshöfer in *JdI* 89 (1974) 50–69.

[40] 5.66; pl. 105d.

[41] 5.47 and 63.

[42] 5.144–55. Base: Kallipolitis.

[43] 5.145 and 156.

[44] Pliny xxxiv 87, xxxv 54; Overbeck 151 nos. 844–50.

(iii) *Painting and vase-painting in Periclean Athens* (312, 317f., 322–7, 422)

[45] 5.60 and 74.

[46] 5.83.

[47] 5.46 and 77. Traces of painting on interior of Strangford shield (B.M. 9802): Rumpf (1953) pl. 35,2 (cf. 35,1).

[48] 5.78–82.

[49] *ARV²* 837–57; cup (Munich 2685) no. 9; Rumpf (1953) pl. 30,3.

[50] 5.79–80.

[51] 5.82; pl. 108a.

[52] 5.80.

[53] 5.78; 6.166. Tombstone: *AM* 71 (1956) pl. A, Beil. 69–70, fig. 1 Roman painting: Rumpf (1953) pl. 37,1.

(iv) *Other works and names in sculpture* (187f., 284–9, 309f., 328–51, 356–9, 364).

[54] 5.106; pl. 112a.

[55] 4.50; pl. 62d.

[56] 5.106; pl. 112b.

[57] 5.105, 107–9 and 121; pl. 112c and d.

[58] 5.99–104. Dohrn in *JdI* 94 (1979) 112f., with bibliography; and see next note.

[59] Ridgway (5.100); against this, Devambez in *CRAI* 1975 162ff.

[60] 5.100.

[61] 5.85–98.

[62] 4.229.

[63] 5.85.

[64] 5.94.

[65] 5.88.

[66] 5.86–7. Stewart in *JHS* 98 (1978) 122–31.

[67] 5.93.

[68] 5.112–20 and 122.

[69] 5.114–15.

[70] 5.116–17.

[71] 5.118.

[72] 5.122.

[73] 5.124.

[74] Harrison in *AJA* 81 (1977) 137ff.; *XI Int.* 65.

[75] Harrison in *Blanckenhagen* 94f. Friezes: now, S. von Bockelberg in *Antike Plastik* 18 (1979).

[76] 4.228; 5.125. Brommer *Hephaistos* 75–89, with refs.; and see next note.

[77] Harrison in *AJA* 81 (1977) 137–78, 265–87, 411–26.

[78] 5.135. BDFH pl. 229 (213) r.

[79] 4.232.

[80] 8.240; pl. 188b.

[81] 4.230–1.

[82] 5.134.

[83] 5.126–30.

[84] Travlos 213ff.; Wycherley 149f.

[85] 5.130.

[86] 5.126.

[87] 6.4.

[88] E.g. *JHS* 47 (1927) pl. 13 (Antimenes Painter, above p. 66).

[89] 5.43.

[90] 5.137.

[91] P. N. Boulter in *Hesp.* 38 (1969) 133–40.

[92] Picòn in *AJA* 82 (1978) 47–81. See now also A. Krug in *Antike Plastik* 18 (1979).

[93] 5.138.

[94] 5.141.

[95] 4.227.

[96] 5.139.

[97] 4.78. BDFH pl. 183 (167) left.

[98] 5.139.

[99] 5.159. *BCH* 3 (1879) pl. 11. Bruno in *Brendel* 55–67, pls. 14–15.

[100] 5.160–5. Cooper in *XI Int.* 58f. and see next note.

[101] 5.161; pl. 119d. Full illustration in Hofkes-Brukker and Mallwitz, where the attribution to Paionios is proposed.

[102] 5.64. BDFH pl. 187 (171).

(v) *Coins and seal-stones* (359–62)

[103] 3.161.
[104] 5.170. Kraay and Hirmer pls. 154–8.
[105] 5.171–2; pl. 120f. Kraay and Hirmer pls. 28–46.
[106] 5.177. Kraay and Hirmer pls. 59–63.
[107] 5.181; pl. 120b.
[108] 5.172.
[109] 5.180.

Chapter 6 Developments into the fourth century

(i) *Grave-reliefs, votive reliefs and others* (363–82)

[1] 6.2 and 8.
[2] 6.9.
[3] 6.14; pl. 121d.
[4] 6.9–11.
[5] 6.26–7, 29 and 57.
[6] 6.25.
[7] 6.37 and 42.
[8] 6.43.
[9] 6.40.
[10] 6.30 and 32.
[11] 6.21.
[12] 6.20. Lullies and Hirmer pls. 177–9 (179–81).
[13] 5.138. Richter 1970 figs. 505, 507. Bieber 1977 figs. 36–7. *AJA* 82 (1978) 59ff. with fig. 12.
[14] 6.34–5; pl. 122c. *Hesp.* 21 (1952) pls. 14–18.
[15] 6.23–4.
[16] 6.24 and 145. Cyprus fragments: Megaw in *Studies . . . Dikaios* 142ff., pls. 17f.
[17] 6.15.
[18] 6.17.
[19] 6.22. Ares: above, chapter 5 n. 78. Late dating: 6.24.
[20] 6.53; pl. 124b.
[21] 6.61. BDFH pl. 264 (248).
[22] 6.55.
[23] 6.62.

(ii) *Kephisodotos and Praxiteles* (383–96)

[24] 6.64–5.
[25] 6.63.
[26] 6.67–8.
[27] 6.66.
[28] 6.73–4. R. M. Cook in *Brommer* 77f., pl. 23.
[29] 6.76. Richter 1970 figs. 673, 675, 676.
[30] 6.80. Satyr: Richter 1970 fig. 51. Eros and satyr: see also below, pp. 166f.
[31] 6.84 and 133. Bronze girl: Maass 28f. no. 11, dated to late second or early first century.
[32] 6.85–8.
[33] 6.94.
[34] 6.98.
[35] 6.90. Stewart in *RA* (1977) 195–202.
[36] 6.81. BDFH pl. 251 (235).

(iii) *Other works and names in sculpture* (396–410)

[37] 6.100–2.
[38] 6.103 and 108. Pictures in Crome.
[39] 6.104.
[40] 6.106.
[41] 6.111–12.

[42] 6.113.
[43] 6.110.
[44] 6.109. Yalouris in *Brommer* 30f., pls. 83–5.
[45] 6.114; pl. 129c.
[46] 6.72 and 132–3. Palagia.
[47] 4.81–3.
[48] 6.116.
[49] 6.117–18; pl. 128d. Gabelmann (*AA* 1979 163ff.) dates the Lycian *c.* 400, the Satrap *later* (*c.* 380–370).

(iv) *The painters of transition and echoes of their work* (411–32, 586ff.)

[50] 6.136–7, 139, 141–2 and 147. for this and other things in this section now see Bruno.
[51] 6.137–8 and 140.
[52] 6.164–5.
[53] 6.139.
[54] 6.156. Lezzi-Hafter no. S.47, pls. 25, 111a and c.
[55] 6.155–7; pls. 132–3.
[56] 6.169. *Mad. Mitt.* 10 (1969) pls. 18–24. Rumpf (1953) pl. 39, 1 and 4.
[57] 6.172. Rumpf (1953) pls. 36,9; 41, 1 and 4.
[58] 6.184.
[59] 6.174–6, 178, 181–2 and 184; pl. 135a and b.
[60] 6.144.
[61] 6.146–7.
[62] 8.230–4. Consistent room: 232 (Room of the Masks in the House of Augustus on the Palatine).
[63] 6.158–9 and 162; pls. 132e, 133a.
[64] 6.182; pl. 134a.
[65] 6.186.
[66] 6.188–9; pl. 136b. Full discussion in Childs.

(v) *Euphranor and Nikias; fourth-century vase-painting and Roman wall-painting* (432–44, 491)

[67] 6.192.
[68] 6.193, 195 and 199.
[69] 6.200–1. Kerch vases: Rumpf (1953) pl. 43, 2–6. Relief: *Hesp.* 21 (1952) pls. 89–90.
[70] 6.203–5.
[71] 6.208. Rumpf (1953) pl. 47, 3.
[72] 6.89.
[73] 6.207 and 209; pl. 138.
[74] 6.213.
[75] 6.212.
[76] 7.117–19; pl. 154. Braun in *Vasenforschung* 40ff.
[77] 6.153–4.
[78] 6.219. Robertson in *Gnomon* 46 (1974) 826f.; *JHS* 97 (1977) 159.
[79] Pliny *NH* xxxv 130; Overbeck 368 nos. 1967–70.

Chapter 7 The second change: classical to Hellenistic

(i) *The historical background* (445ff.)

[1] 7.2.

(ii) *The Mausoleum and its sculptors* (407–9, 447–63)

[2] 7.5–6. For this section Waywell is now of paramount importance.

3 Waywell, especially 54–62 with figs. 8 and 9.

4 Waywell 27–34 and 180–209, nos. 401–649, pls. 37–42.

5 *XI Int.* pl. 29.

6 7.29. Waywell 16–26 and 85–96, nos. 1–25, pls. 6–12.

7 7.29–33. Waywell 40–3 and 97–105, nos. 26–8, pls. 13–15.

8 7.28 (rider). Waywell 44–6 and 108–13, nos. 33–41, pls. 17–18.

9 7.28. Waywell 118f., no. 48, pl. 22.

10 Waywell 47–53.

11 7.7 and 31–2. Ashmole in *Brommer* 13–20, pls. 5–8.

12 7.7.

13 Waywell 115, no. 45, pl. 20.

14 7.33.

15 7.35–6 and 39. See Ashmole (n. 11 above). Ganymede and Apollo: Bieber 1961 figs. 198–200.

16 7.17–18 and 20–7. An important and full study of Skopas now in Stewart.

17 7.31–2. Waywell 79–84.

18 7.37. Robertson in *Burl.* 121 (1979) 183f. Bieber 1961 figs. 253–65.

19 7.16.

20 7.9–11; pl. 142a.

21 7.13; pl. 142b and c.

22 7.12; pl. 142d.

23 7.14–15.

24 6.125–9 and 131.

(iii) *Lysippos and his pupils* (389f., 463–84)

25 7.40–4. Moreno 1973, 1974. Stewart in *AJA* 82 (1978) 163–71, 300–13, 473–82.

26 7.44–6. Moreno 1973.

27 7.49.

28 6.80.

29 7.52; pl. 147d. Praxiteles's satyr: above, Chapter 6 n. 30.

30 7.50–1. Moreno 1974 figs. 39–40.

31 7.71.

32 7.56f.

33 6.130; pl. 148b.

34 7.58. Richter 1970 fig. 752.

35 7.47 and 82.

36 7.61–3. Richter 1970 figs. 753–5.

37 7.67.

38 7.83.

39 7.84. *AM* 84 (1969) pls. 69–73.

40 7.87; pl. 151.

41 7.93–4. Full publication with superb pictures in Yuri. Greifenhagen in *Neutsch* 145–8. The marble relief with the central group quoted in *HGA* 483 and ch. 7 n. 94 was for a time at the J. Paul Getty Museum, Malibu (71.AK.452), but was returned to the dealer as a fake. Dr Jiri Frel, who tells me this, has shown me better pictures of it and convinced me that it is false, no doubt copied from the krater, and so of no significance. It is illustrated in a catalogue: *Michel Dumes-Onof. Ancient Works of Art* (London, 1971) 17 and 18.

(iv) *The school of Sicyon; Apelles and other painters; vase-painting and mosaic* (484–503, 557f., 565–74)

42 7.96–8. Keuls 139–50.

43 7.99–102.

44 7.112.

45 7.102.

46 7.103 and 107; pl. 152c.

47 7.104.

48 7.105 and 107–10. Sicyon: *JHS* 87 (1967) pl. 24; Salzmann in *AA* 1979 290–306, figs. 1–13. Vergina: *AJA* 61 (1959) pl. 80, figs. 14–16.

49 7.106; 8.164–8.

50 Vincent Bruno, who studied and sketched the paintings very soon after they were unearthed, tells me that he noted indications of colouring and believes the artist intended to show coloured reliefs with the paint eroded by time, as the Parthenon metopes might have appeared at this date. I am most grateful to Professor Bruno for communicating this observation to me in anticipation of an article he is writing.

51 8.169–77. Bruno. Lehmann in *Blanckenhagen* 225–7.

52 Andronikos in *AAA* 10 (1977) 8ff., 46f., pls. 4–5.

53 8.181–4; pl. 182a. Andreae and Kyrieleis 71–92 (Andreae), 93–100 (Fittschen).

54 7.129.

55 7.121–8 and 132–3.

56 xii 106 (7.120).

57 8.140. BDFH pl. 315 (299).

58 6.200.

59 7.130–2.

60 Epilogue 16.

61 7.136–51. Splendid pictures in Andreae 1977.

62 This is a simplification: see K. M. Dunbabin in *AJA* 83 (1979) 265–77, pls. 37–9.

63 Andronikos in *AAA* 10 (1977) 10ff., 48ff., fig. 6.

64 7.147–9.

Chapter 8 Hellenistic art

(i) Portraiture: coins and sculpture (504–27)

1 Most of the works mentioned in this section are illustrated in Richter 1965.

2 8.3–6; pls. 157a, 158a and d.

3 8.8.

4 8.35–6.

5 8.23.

6 7.121.

7 8.24–5; pl. 162a.

8 8.26.

9 8.24; pl. 162c.

10 8.27.

11 8.30–2; pl. 156f–g. Kraay and Hirmer pls. 218–20 (Ptolemies), 203–8 (Seleucids), 174–5 (Antigonids).

12 8.44–7; pl. 156i. Kraay and Hirmer pls. 210–11 (Pontus), 212 (Bactria).

13 8.41.

14 8.51.

15 8.18–20 and 63; pl. 161a (Aeschines). Lateran Sophocles: Richter 1970 fig. 249.

16 8.11–17; pl.158c.

17 8.34.

18 8.39–40; pl. 163c.

19 8.37–8; pl. 160b and d.

20 8.57–8.

21 8.21. Robertson in *Burl.* 121 (1979) 650f., figs. 50–3.

22 8.65.

(ii) *Sculpture in Pergamon and 'Hellenistic Baroque'* (514, 527–48, 608)

[23] 8.67.

[24] 8.69–75 and 77–80; pls. 167b, 168a–c.

[25] 8.81; pl. 167a.

[26] 8.85–6.

[27] 8.84; pl. 169c.

[28] 8.83.

[29] 8.87; pl. 169b. Bieber 1975 figs. 438–44.

[30] 8.104; pl. 169a.

[31] 8.89–95. See also below, notes 34, 36. Pictures in Schmidt.

[32] 5.14; pl. 99d.

[33] 8.111.

[34] 8.107.

[35] 8.110.

[36] 8.28.

[37] 8.60–1; pl. 161d.

[38] 8.64. Simon 1975.

[39] 8.97–103. Full publication of Sperlonga finds in Conticello and Andreae; see also Hampe; Säflund; M. Schmidt in *Ludwig* 239–48.

[40] Epilogue 48. Bieber 1961 fig. 529.

(iii) *Other trends in sculpture* (548–65, 597–8, 602–5)

[41] 8.155–60. Kleopatra and Dioskourides: BDFH pl. 311 (295). Muses: Pinkwart.

[42] Epilogue 22–3; pl. 190d.

[43] 8.116–17; pls. 127d, 174b.

[44] 8.118–20. Richter 1951 figs. 243–4.

[45] 8.132; pl. 174d–f.

[46] 8.137.

[47] 8.139.

[48] 8.122–8.

[49] 8.129; pl. 176a.

[50] 8.151; pl. 175b.

[51] 8.142.

[52] 8.145. Wünsche in *JdI* 94 (1979) 105ff.

[53] 8.146. Herrmann in *Blanckenhagen* 163–73, pls. 46–8.

[54] 8.147.

[55] Epilogue 31–40.

(iv) *Painting and mosaic* (575–90, 598–600, 606)

[56] 8.235.

[57] 8.228–34.

[58] 8.224–6.

[59] 8.201–2.

[60] 8.213; pl. 186b and c.

[61] 8.205–13; pls. 184a and b, 185, 186a and b.

[62] 8.214–15.

[63] Epilogue 49–51.

ABBREVIATIONS AND BIBLIOGRAPHY

Only books and periodicals referred to in the notes or list of illustrations are listed. Those which do not appear in the bibliography of Robertson *History* (below; see Preface) or the addenda to it (p. 759) are marked with an asterisk.

AA *Archäologische Anzeiger*. Berlin, from 1889; part of *JdI* until 1963.

AAA *Athens Annals of Archaeology* (Ἀρχαιολογικὰ Ἀνάλεκτα ἐξ Ἀθηνῶν). Athens, from 1968.

ABV See Beazley.

**Académie Royale de Belgique Bulletin de la classe des lettres et des sciences morales et politiques*. Brussels, 5ᵉ Série from 1911.

AD *Antike Denkmäler*. Berlin, 1887–1931.

Adam, S. *The Technique of Greek Sculpture in the Archaic and Classical Periods* (*BSA* Supplementary Paper 5). London, 1966.

AJA *American Journal of Archaeology*. Princeton, Norwood, Concorde, from 1885.

AK *Antike Kunst*. Basle, from 1968.

AM *Mitteilungen des deutschen archäologischen Instituts: Athenische Abteilung*. Athens, from 1876.

**Andreae, B. Das Alexandermosaik aus Pompeii*. Recklingshausen, 1977.

*** and Kyrieleis, H. *Neue Forschungen in Pompeii*. Recklingshausen, 1975.

Antike Plastik. ed. W. H. Schuchardt, F. Eckstein. Berlin, from 1962.

ARV² See Beazley.

Ashmole, B., Yalouris, N. and Frantz, A. *Olympia, the Sculpture of the Temple of Zeus*. London, 1967.

BCH *Bulletin de correspondance hellénique*. Paris, from 1877.

BDFH See Boardman.

Beazley, J. D. *Attic Black-figure Vase-painters*. Oxford, 1956. (*ABV*).

 Attic Red-figure Vase-painters. Oxford, second edition 1963. (*ARV²*).

**Berger, E. Die Geburt der Athena im Ostgiebel des Parthenon* (*Studien der Skulpturhalle, Basel* 1). Basle, 1976.

Bieber, M. *The Sculpture of the Hellenistic Age*. New York, 1961 (1955).

*** *Ancient Copies*. New York, 1977.

**Blanckenhagen Studies in Classical Archaeology. A Tribute to P. H. von Blanckenhagen*, ed. G. Kopcke and M. Moore. New York, 1978.

Boardman, J., Dörig, J., Fuchs, W. and Hirmer, M. *The Art and Architecture of Ancient Greece*. London, 1966 (*Die griechische Kunst*. Munich, 1966). Refs. are to the English edition, followed in brackets by those to the German. (BDFH).

 Greek Gems and Finger-rings. London, 1970.

*** *Athenian Black Figure Vases*. London, 1974.

*** *Athenian Red Figure Vases*. London, 1975.

*** *Greek Sculpture: the archaic period*. London, 1978.

**Brendel Essays in Archaeology and the Humanities, in memoriam O. J. Brendel*. Mainz am Rhein, 1976.

**Brommer, F. Der Parthenonfries. Katalog und Untersuchungen*. Mainz am Rhein, 1977.

*** *Hephaistos. Der Schmiedegott in der antiken Kunst*. Mainz am Rhein, 1978.

*** *The Sculptures of the Parthenon*. London, 1979.

**Brommer Festschrift für Frank Brommer*. Mainz am Rhein, 1977.

**Bruno, V. Form and Colour in Greek Painting*. London, 1977.

Burl. *The Burlington Magazine*. London, from 1903.

**Childs, W. A. P. The City-reliefs of Lycia* (Princeton Monographs in Art and Archaeology 42). Princeton, 1978.

**Conticello, B. and Andreae, B. Die Skulpturen von Sperlonga* (*Antike Plastik* 14). Berlin, 1974.

CRAI *Comptes-rendus de l'Académie des inscriptions et belles-lettres*. Paris, from 1882.

Crome, J. F. *Die Skulpturen des Asklepiostempels zu Epidauros*. Berlin, 1961.

Desborough, V. R. d'A. *Protogeometric Pottery*. Oxford, 1952.

**Études Delphiques* (*BCH* Suppl. 4). Paris, 1978.

Freyer-Schauenburg, B. See *Samos* xi.

**Getty The J. Paul Getty Museum Journal*. Malibu and Chicago, from 1975.

**Giuliani, L. Die archaischen Metopen von Selinunt*. Munich, 1979.

Graef, B. with others *Die antiken Vasen von der Akropolis zu Athen* I. Berlin, 1901–25.

**Hampe, R. Sperlonga und Vergil*. Mainz am Rhein, 1972.

**Hampe Tainia: Festschrift für R. Hampe*. Mainz am Rhein, 1980.

Hesp. *Hesperia*. Athens, from 1932.

**Hofkes-Brukker, Ch. and Mallwitz, A. Der Bassai-Fries*. Munich, 1975.

IRNA Institutum Romanum Norvegiae Acta ad archaeologiam et artium historiam pertinentia. Rome, from 1971.

JdI *Jahrbuch des deutschen archäologischen Instituts*. Berlin, from 1886.

JHS *Journal of Hellenic Studies*. London, from 1881.

*JWAG *Journal of the Walters Art Gallery*. Baltimore, from 1933.

*Kallipolitis, V. G. *I vasi tou agalmatos tis Rhamnousias Nemeseos* ('Η βάση τοῦ ἀγάλματος τῆς 'Ραμνουσίας Νεμέσεως), *Arch. Eph. Studies*. Athens, 1978.

*Keuls, E. *Plato and Greek Painting*. Leiden, 1978.

Kraay, C. and Hirmer, M. *Greek Coins*. London, 1966.

Lawrence, A. W. *Greek Architecture*. London, 1957.

*Levi *Antichità Cretesi: Studi in onore di Doro Levi* II. Catania, 1974.

*Lezzi-Hafter, A. *Der Schuwalow-Maler, eine Kannenwerkstatt der Parthenonzeit* (Kerameus 2). Mainz am Rhein, 1975.

*Ludwig *Antike Kunstwerke aus der Sammlung Ludwig*. Mainz, 1979.

Lullies, R. and Hirmer, M. *Greek Sculpture*. London, 1965 (1957).

*Maass, M. *Antikensammlungen München. Griechische und römische Bronzewerke*. Munich, 1979.

Mad. Mitt. *Madrider Mitteilungen* (Deutsches archäologisches Institut, Madrider Abteilung). Heidelberg, from 1960.

*Moreno, P. *Testimonianze per la teoria artistica di Lisippo*. Rome, 1973.

* *Lisippo* I. Rome, 1974.

Napoli, M. *La Tomba del Tuffatore*. Bari, 1970.

Neutsch *Forschungen und Funde: Festschrift für Bernhard Neutsch* (Innsbrucker Beiträge zur Kulturwissenschaft, 21). Innsbruck, 1980.

Ohly, D. *Die Aegineten* I. Munich, 1976.

* *Ägina: Tempel und Heiligtum der Aphaia*. Munich, 1977.

Overbeck, J. *Die antiken Schriftquellen zur Geschichte der bildenden Künste bei den Griechen*. Leipzig, 1968.

*Palagia, O. *Euphranor*. Leiden, 1980.

Paribeni, E. *Catalogo delle sculture di Cirene*.
Statue e rilievi di carattere religioso. Rome, 1959.

Payne, H. *Necrocorinthia: a study of Corinthian art in the archaic period*. Oxford, 1931.

*Pedley, J. G. *Greek Sculpture of the Archaic Period. The island workshops*. Mainz am Rhein, 1976.

Petsas, Ph. *O taphos ton Lefkadion* ('Ο τάφος τῶν Λευκαδίων). Athens, 1966.

Pinkwart, D. *Die Relief des Archelaos*. Kallmunz, 1965.

Pliny Jex-Blake, E. and Sellers, E. *The Elder Pliny's Chapters on the History of Art*. London, 1896.

RA *Revue Archéologique*. Paris, from 1844.

Richter, G. M. A. *Three Critical Periods in Greek Sculpture*. Oxford, 1951.
Metropolitan Museum of Art, New York. Catalogue of Greek Sculpture. Oxford, 1954.
Ancient Italy. Ann Arbor, 1955.
The Portraits of the Greeks. London, 1965.
The Sculpture and Sculptors of the Greeks. New Haven, Conn., 1970 (1929, 1930, 1949).

*Ridgway, B. S. *The Archaic Style in Greek Sculpture*. Princeton, 1977.

Robertson, M. and Frantz, A. *The Parthenon Frieze*. London, 1975.

* *A History of Greek Art*. Cambridge, 1975.

Rumpf, A. *Chalkidische Vasen*. Berlin, 1927.
Sakonides (Bilder griechische Vasen 11). Leipzig, 1937.
Malerei und Zeichnung (Handbuch der Archäologie 4,1). Munich, 1953.

*Säflund, G. *The Polyphemus and Scylla Groups at Sperlonga*. Stockholm, 1972.

*Samos xi Freyer-Schauenburg, B. *Bildwerke der archaischen Zeit und des strengen Stils*. Bonn, 1974.

Schmidt, E. M. *The Great Altar of Pergamon*. London, 1965.

Schweitzer *Zur Kunst der Antike: ausgewählte Schriften; zum 70. Geburtstag von B. Schweitzer* (ed. U. Hausmann). Tübingen, 1963.

*Simon, E. *Pergamon und Hesiod*. Mainz am Rhein, 1975.

*Stewart, A. F. *Skopas of Paros*. Park Ridge, 1977.

Studies presented in memory of Porphyrios Dikaios. Nicosia, 1979.

*Thompson *Greek Numismatics and Archaeology. Essays in honour of Margaret Thompson*, ed. O. Mørkholm and N. Waggoner. Wetteren (Belgium), 1979.

*Tiverios, M. *O Lydos kai to ergon tou* ('Ο Λυδὸς καὶ τὸ 'Εργον τοῦ). Athens, 1976.

Travlos, J. *A Pictorial Dictionary of Ancient Athens*. London, 1970.

Vasenforschung nach Beazley: Symposion, Tübingen 24–26.11.1978 (Schriften des deutschen Archäologen-Verbandes iv; ed. E. Olshausen). Mainz, 1979.

*Waywell, G. B. *The Free-standing Sculpture of the Mausoleum at Halikarnassos in the British Museum. A Catalogue*. London, 1978.

*Wycherley, R. E. *The Stones of Athens*, Princeton, 1978.

*XI Int. *XI International Congress of Classical Archaeology, London, 3–9 September, 1978. Acta*. London, 1979.

*Yuri, E. *O kratiras tou Derveniou* ('Ο κρατήρας τοῦ Δερβενίου). Athens, 1978.

LIST OF ILLUSTRATIONS

All photographs are reproduced by courtesy of the Museum, collector, scholar or photographer named.

Frontispiece: Marble fragment of gravestone from Attica. New York, Metropolitan Museum of Art 42.11.36 (Rogers Fund). Museum phot.

1 Grave-vase from Athens. Athens, National Museum 804. Phot.: Alison Frantz.

2 Picture on grave-vase from Athens. Louvre A 517. Phot.: Giraudon.

3 Bronze horse from near Phigaleia. British Museum 1905.10-24.5. Museum phot.

4 Terracotta figurine from Lefkandi (Euboea). Chalkis Museum. Phot.: M. Popham; courtesy of Mr Popham and the British School at Athens.

5 Detail of bronze tripod-leg from Olympia. Olympia Museum. Phot.: German Institute in Athens.

6 Bronze griffin-protome from Rhodes. British Museum 70.3-15.16. Museum phot.

7 Protocorinthian aryballos from Lechaion (Corinth). Corinth Museum. Phot.: J. L. Benson.

8 Protocorinthian kotyle from Rhodes, probably Kameiros. British Museum 64.4-4.18. Museum phot.

9 Protoattic grave-vase from Eleusis. Eleusis Museum. Phot.: German Institute in Athens.

10 Neck of relief-pithos from Mykonos. Mykonos Museum. Phot.: German Institute in Athens.

11 Marble statue from Delos. Athens, National Museum 1. Phot.: Alison Frantz.

12 Limestone statuette. Louvre 3098. Phot.: Alison Frantz.

13 Bronze statuette from Delphi. Delphi Museum 172. Phot.: German Institute in Athens.

14 Marble statue from Sunium (sanctuary of Poseidon). Athens, National Museum 2720. Museum phot.

15 Marble head of youth, grave-statue, from Athens. Athens, National Museum 3372. Museum phot.

16 Pair of marble statues from Delphi. Delphi Museum 467 and 1524. Phot.: Alison Frantz.

17 Fragment of Argive krater from Argos. Argos Museum. Museum phot.

18 Drawing of picture on Protocorinthian oinochoe (olpe) from Formello (Veii). Rome: Villa Giulia. After *AD* pl. 44.

19 Limestone relief from west pediment of temple of Artemis, Kerkyra (Corfu). Kerkyra Museum. Phot.: German Institute in Athens.

20 Limestone relief from same pediment. Kerkyra Museum. Phot.: German Institute in Athens.

21 Limestone metope from Sicyonian *monopteros*, Delphi. Delphi Museum. Phot.: Alison Frantz.

22 Limestone metope, as last. Delphi Museum. Phot.: Alison Frantz.

23 Limestone metope from Selinus. Palermo Museum. Phot.: Alison Frantz.

24 Sandstone metope from Foce del Sele. Paestum Museum. Phot.: German Institute in Rome.

25 Terracotta metope (?) from Reggio (Rhegium). Reggio Museum 786c. Phot.: M. Hirmer.

26 Marble statue from Delos. Athens, National Museum 21. Phot.: Alison Frantz.

27 Ivory figurine from temple of Artemis at Ephesus. Istanbul, Archaeological Museum. Museum phot.

28 Marble statue from Samos. Louvre 686. Phot.: Alison Frantz.

29 Marble face from temple of Artemis at Ephesus. British Museum B 89. Phot.: B. Ashmole.

30 Part of marble statue from Acropolis. Athens, Acropolis Museum 677. Phot.: Alison Frantz.

31 Reconstruction of base with marble statues from the sanctuary of Hera on Samos. Samos Museum. Phot.: German Institute in Athens.

32 Marble statue from Acropolis. Athens, Acropolis Museum 594. Phot.: Alison Frantz.

33 Marble statue from Acropolis. Athens, Acropolis Museum 674. Phot.: Alison Frantz.

34 Marble head from Acropolis. Athens, Acropolis Museum 643. Phot.: G. M. Young.

35 Marble statue from Acropolis. Athens, Acropolis Museum 681. Phot.: Alison Frantz.

36 Limestone pediment-figure from the Acropolis. Athens, Acropolis Museum 35. Phot.: Alison Frantz.

37 Marble statue on limestone base from the Acropolis. Athens, Acropolis Museum 624. Phot.: Alison Frantz.

38 Marble torso from Megara. Athens, National Museum 13. Museum phot.

39 Marble statue from the Acropolis. Athens, Acroplis Museum 679. Phot.: Alison Frantz.

40 Marble relief from Acropolis. Athens, Acropolis Museum 1342. Phot.: German Institute in Athens.

41 Reconstruction of marble gravestone from Athens. New York, Metropolitan Museum of Art 11.185 (Hewitt Fund, Munsey Fund and Anonymous Gift); the girl a cast from Berlin (E) A 7. Museum phot.

INDEXES

Figures in italics refer to illustrations

1. GENERAL

2. MUSEUMS AND COLLECTIONS